D0761380

Icons and Saints
of the Eastern
Orthodox Church

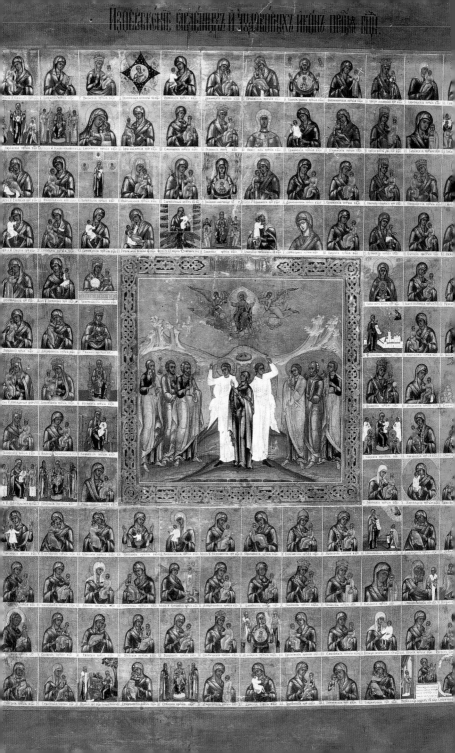

Alfredo Tradigo

# Icons and Saints of the Eastern Orthodox Church

*Translated by* Stephen Sartarelli

The J. Paul Getty Museum
Los Angeles

*A Guide to Imagery*

Italian edition © 2004 Mondadori Electa S.p.A., Milan
All rights reserved. www.electaweb.it

Series editor: Stefano Zuffi
Original graphic design: Dario Tagliabue
Original layout: Elena Brandolini
Original editorial coordinator: Cateriana Giavotto
Original editing: Antonella Gallino
Original image research: Sonia Serra
Original technical coordinator: Andrea Panozzo
Original quality control: Giancarlo Betti

English translation © 2006 J. Paul Getty Trust

First published in the United States of America in 2006 by
The J. Paul Getty Museum

Getty Publications
1200 Getty Center Drive, Suite 500
Los Angeles, California 90049-1682
www.getty.edu

Second printing

Mark Greenberg, *Editor in Chief*

Ann Lucke, *Managing Editor*
Mollie Holtman, *Editor*
Georgi R. Parpulov, *Consulting Editor*
Robin H. Ray, *Copy Editor*
Pamela Heath, *Production Coordinator*
Hespenheide Design, *Designer and Typesetter*

Library of Congress Cataloging-in-Publication Data
Tradigo, Alfredo.
  [Icone e santi d'Oriente. English]
  Icons and saints of the Eastern Orthodox Church / Alfredo Tradigo ;
    translated by Stephen Sartorelli.
    p. cm. – (A guide to imagery)
  Includes bibliographical references and index.
  ISBN 978-0-89236-845-7 (pbk.)
    1. Icons—Dictionaries—Italian. 2. Christian saints in art—
    Dictionaries—Italian. I. Title. II. Series.
  N8187.5. T7313 2006
                    2005033206

Printed in Hong Kong

All biblical quotations are taken from the Revised Standard Edition
unless otherwise noted.

*Page 2: The Ascension with Replicas of Miracle-Working Icons of the Virgin,*
north-central Russia, early nineteenth century. Private collection.

# Contents

# Introduction

To understand what the icon represents to Orthodox Christians one need only enter a church that follows the Byzantine rite. There, sacred images of Christ, the Virgin Mary, and the local saints are gently illuminated by lamps and candles, and the faithful kneel before them, cross themselves (with thumb, index, and middle finger held together, to symbolize the Trinity), and kiss the icons. The icon (from the Greek eikon, "image") is a sign of the presence of God. It is the simplest, most immediate form of religious self-awareness that the Byzantine and Slavic peoples possess. Before the icon, each believer can say: "Behold my faith, that in which I believe, in these divine personages and saints, made visible in forms and colors."

Far from being a form of idolatry, the icon—rooted in a solid theology that has passed through the gauntlet of ideological as well as physical strife (violent persecutions, destruction of images)—emerged victorious in the year 843, with the Triumph of Orthodoxy. The victory of the icon is the victory of Orthodoxy itself against the early heresies that, in denying the incarnation of Christ, also rejected any representation of his image. It thus becomes clear that what people worship in the icon are not the wood and colors, but what it represents as it travels a path from the visible to the invisible, the material to the spiritual. During the celebration of the Divine Liturgy, the Orthodox faithful always have before their eyes the iconostasis, a wall of icons behind which the officiant consecrates the bread and wine. A veritable theological and visual summa of Orthodox Christianity, the iconostasis, while it appears to hide, actually reveals, like a window open onto the mystery. This is why tradition considers the origin of the icon to be divine and revealed, just as Christians consider the Gospel texts to be the work of divine revelation.

The very first icons of the Virgin with the Christ child in her arms are attributed to Saint Luke the Evangelist, a physician and painter. The cloth (Mandylion) that Christ sent to King Abgar of Edessa, and which bore his portrait, formed the original icon of the Holy Face, "not made by human hands"; a variant of this tradition has the image deriving from the veil of Veronica, which she used to wipe the face of the suffering Christ and which retained the imprint of his face. Some scholars assert that these images, like the Holy Shroud, are true "copies" of the face of Christ. Indeed the shroud in which

Jesus was wrapped, bearing a "negative" image of his face, was on display in Constantinople until at least 1204, the year of the Fourth Crusade. In accordance with the ancient and medieval Christian notion of what constitutes a "copy," the authenticity of each image depends on its resemblance to the original. The authenticity of the icon as a copy (or a copy of a copy) proves the truth of the Incarnation, as derived from the written testimony of the Gospels, but also from the tradition of the icons themselves, which faithfully reproduce the physical features of Jesus Christ: eyes, nose, mouth, cheekbones, and hair. For this reason, the icon is not merely the product of artistic activity; the painting manuals used by iconographers point out, through specific drawings, the true features of the faces of Christ, Mary, and the saints. The icon painter, usually a monk, is supposed to faithfully copy these models. Every attitude of the body, every movement of the hand, every color used for the clothing, every building or fold of drapery has a precise meaning in icons. Icons do not merely depict a holy personage or event; they interpret them in a symbolic light, in accordance with the ideas of the Church Fathers. The very materials out of which the icons are made are important: a carved wood panel covered with layers of gesso, glue, and canvas; colors made of vegetable and mineral pigments; water and egg yolk; and gold leaf. They all appear as elements of the sacred ritual.

The twentieth century witnessed a remarkable renaissance of the Russian icon. Important restorations revealed their original colors; in-depth studies recount their history and meaning; the diaspora of intellectuals and iconographers from Soviet Russia spread Slavic art and culture around the world. The purpose of this Guide to Imagery is to try to catalogue this vast heritage of images according to iconographic type and subject, from the most ancient icons at the Monastery of Saint Catherine on Mount Sinai to those from Mount Athos, Constantinople, Crete, and the Balkans; from the schools of Pskov, Novgorod, and Moscow to those of the northern Russian monasteries; from the earliest monastic communities in the Egyptian desert near Thebes to the monasteries of the Solovetski islands in the White Sea. Behind them are fascinating stories of apostles, ascetic martyrs, and "fools for Christ," and the eyes of saints gazing through us, into the next world.

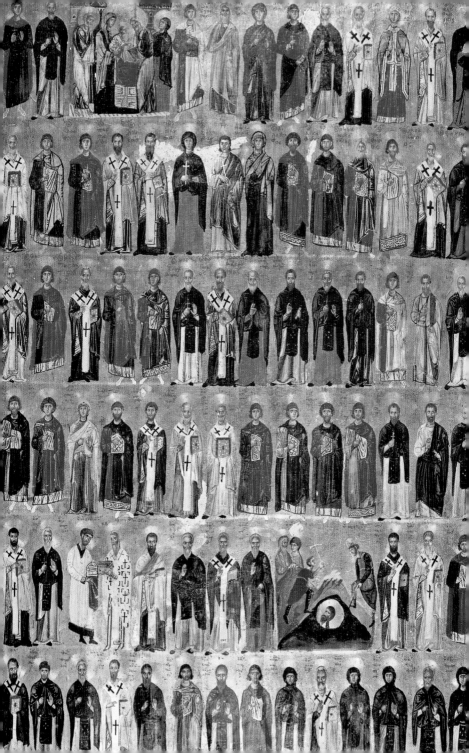

# THE ICONOSTASIS AND THE ORTHODOX CALENDAR

*The Iconostasis*
*The Royal Doors*
*The Feast Cycle*
*Calendar Icons*
*Processional Icons*
*Domestic Icons*
*Theological Icons*

◀ *Menologion* icon for the month of
February (detail), twelfth century. Mount
Sinai, Monastery of Saint Catherine.

*The wall of icons separating the sanctuary and nave represents, for Orthodox Christians, an extraordinary theological and visual synthesis of their faith and spirituality.*

# *The Iconostasis*

**Text**
"And the Word became flesh and dwelt among us, full of grace and truth; we have beheld his glory, glory as of the only Son from the Father." (John 1:14)

**Title**
Iconostasis

**Iconography**
Partition between the nave and the sanctuary, covered with several tiers of icons; it has a central entrance (the royal doors) and two side entrances (the deacons' doors)

In third-century churches in the East, the *templon* was an open wall separating the nave from the sanctuary (*bema*). Later, around the ninth century, images of the Virgin and Christ were added between its columns. In the fourteenth century, icons began to be arranged in tiers, according to strict iconographical and theological rules. At the bottom, directly accessible to the faithful, are icons of Christ, the Virgin, the archangel Michael, and the patron saint of the church. The second tier includes large-format individual icons, with Saint John the Baptist, the Virgin, and various saints, in a composition known as the *Deesis*, as intercessors on either side of the enthroned Christ. The third register features icons of the twelve great Byzantine liturgical feasts. This cycle is called the *Dodekaorton*; the more complex iconostases might include fourteen, sixteen, or even more feasts. The two upper registers are devoted to the patriarchs and prophets and are centered, respectively, on icons of the Trinity and of the Virgin. The iconostasis thus is read horizontally, but also vertically, along the symmetrical axis (from the Trinity above to the Annunciation below) created by the royal doors.

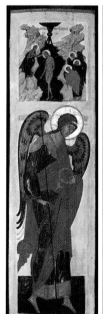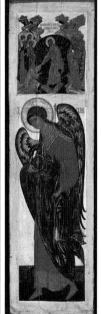

▶ Pskov school, *The Archangel Michael and Theophany (Baptism), the Archangel Gabriel, and the Harrowing of Hell (Resurrection)*, from the *Deesis* and festal tiers of an iconostasis, sixteenth century. Pskov (Russia), museum.

The domes of an imaginary temple crown the iconostasis and form lunettes containing scenes from the Passion of Christ.

The third tier from the bottom shows the enthroned Christ flanked by Mary, John the Baptist, the archangels Michael and Gabriel, and the apostles and martyrs. In the fourth tier, the Mother of God is enthroned among the prophets. In the fifth, the Trinity is surrounded by the Old Testament patriarchs.

The second tier is devoted to the cycle of the twelve great feast days. At its center is an image of the Harrowing of Hell.

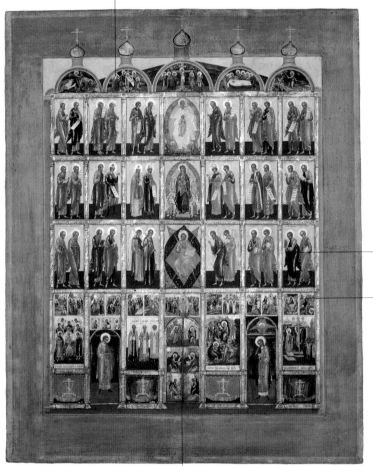

▲ Palech school, painted iconostasis, early nineteenth century. Collezione Bucceri–De Lotto.

The royal doors, featuring the Annunciation and the four evangelists. On the sides are two doors with images of deacons. Between the doors are, from the left, the Synaxis of the Archangels, the Three Hierarchs, the Nativity, and the Exaltation of the Cross.

In the upper order, the prophets Moses, Jeremiah, Daniel, and Isaiah are shown half length, holding scrolls.

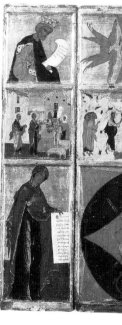

The central tier features the twelve great feasts: on the left side are the Trinity (Hospitality of Abraham), the Annunciation, the Nativity, and the Baptism. In the center are the Presentation in the Temple, the Raising of Lazarus, Christ's Entry into Jerusalem, and the Crucifixion. On the right, the Harrowing of Hell, the Ascension, the Transfiguration, and the Dormition of the Virgin.

The lower tier shows saints in intercessionary prayer; from the left, John Chrysostom, Basil the Great, the apostle Peter, and the archangel Michael.

▲ Portable iconostasis, ca. 1589.
Vologda (Russia), museum.

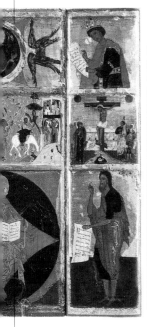

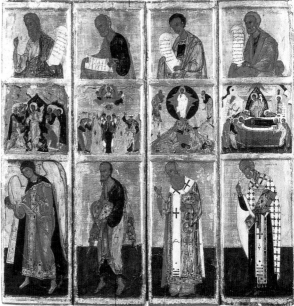

At the center, between the prophets David and Solomon, the Virgin of the Sign and Jesus are represented inside a circle flanked by two seraphim.

From left to right, the Deesis continues with Ezekiel, Gideon, Habakkuk, and Jacob.

Christ among the angelic powers, flanked by the Mother of God and John the Baptist.

From the left, the archangel Gabriel, Paul the Apostle, Gregory the Theologian, and Nicholas the Miracle-Worker.

*The central doors of the iconostasis, called the royal doors, lead into the altar sanctuary, while two side deacons' doors lead into sacristies where the Divine Liturgy is prepared.*

# The Royal Doors

**Text**
"Lift up your heads, O gates! and be lifted up, O ancient doors! that the King of glory may come in. Who is this King of glory? The Lord of hosts, he is the King of glory!" (Psalm 24:9–10)

**Title**
Royal doors; deacons' doors

**Iconography**
Royal doors with the Annunciation and the four evangelists; the deacon's doors with full-length images of deacons and scenes related to the Expulsion from Earthly Paradise, the Last Judgment, and the commemoration of the dead

The central doors of an iconostasis are called the royal doors. These doors are sacred and are kept closed. Only during the Divine Liturgy does the priest open them to gain access to the sanctuary (*bema*), where he consecrates the bread and wine. The wings of the royal doors bear an image of the Annunciation, sometimes placed above portraits of the four evangelists. In the lunette above the royal doors is the Communion of the Apostles in its dual aspects, bread and wine. In sixteenth-century Russian iconostases, the north side door appears, opening onto a chamber called the *prothesis*, where the holy gifts are prepared. The south side door leads to the *diakonikon*, a vestibule containing the liturgical vestments. The deacons' doors bear full-length images of deacons or of the Expulsion from Paradise, the Good Thief, the Last Judgment, or reminders of death. These eschatological subjects are depicted on the *prothesis* door because commemorative rites for the deceased take place in front of them. Inside, on the table of the *prothesis*, are special liturgical triptychs that list the benefactors to be prayed for during the Divine Liturgy.

▶ Cretan school, *Annunciation with Prophets David and Isaiah and Saints Andrew and Nicholas*, fifteenth century. Athens, Byzantine Museum.

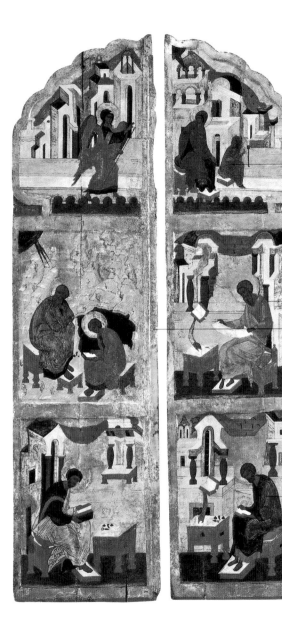

The Virgin and Gabriel are in a room hung with red drapery, which indicates the sacred nature of the event. Mary is represented twice: weaving the veil of the Temple and, on a smaller scale, meditating in prayer in the sanctuary.

The apostle Matthew opens a scroll; the book containing his Gospel rests on a small lectern.

John dictates his Gospel or the Apocalypse to Prochorus; the rocky landscape with a cave in the background recalls the island of Patmos, where John had the visions recorded in the book of Revelation.

The evangelists Luke and Mark are seated on royal thrones, with their feet on footstools. On their desks are writing implements, inkpots, scissors for cutting, and blades for scraping parchment. The perspective is reversed: the vanishing point toward which the perspective lines converge is where the observer stands.

▲ *The Annunciation and the Four Evangelists*, royal doors, first half of sixteenth century. Vologda (Russia), museum.

Christ, leaning out from the canopy over the altar (draped in red and gold and bearing the symbol of the cross), distributes Holy Communion to the apostles, in the form of bread (on the left) and wine (on the right).

The first to receive Holy Communion in the form of bread is Peter, followed by the apostles Andrew, Simon, Luke, John, and Philip.

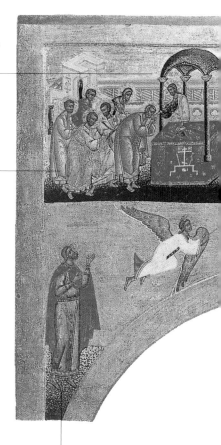

▲ *Communion of the Apostles, Trinity, Two Angels, the Martyr Nicetas, and the Virgin Eupraxia*, lunette over the royal doors, originally from Solvychegodsk, Cathedral of the Annunciation, late sixteenth century. Solvychegodsk (Russia), Museum of History and Art.

In the lowest part of the lunette frame, the two figures of the martyr Nicetas and the virgin Eupraxia have their hands raised in intercessory prayer.

In the center, the Old Testament Trinity is seated around an altarlike table. According to the interpretation of the Church Fathers, its image refers to the Eucharist, prefigured by the meal that Abraham offered to three mysterious pilgrims who visited him.

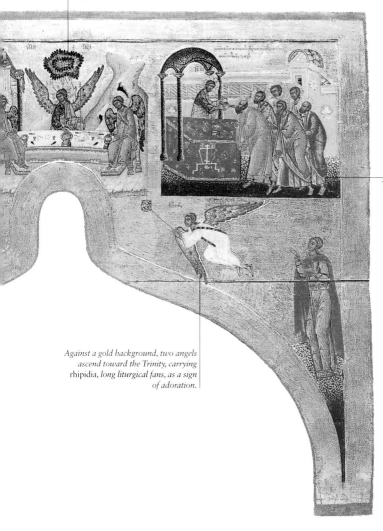

The Communion of the Apostles with wine. From left to right are Paul, Thomas, Mark, Matthew, James, and Bartholomew.

Against a gold background, two angels ascend toward the Trinity, carrying rhipidia, long liturgical fans, as a sign of adoration.

The door's border is adorned with four-petaled flowers inscribed in circles, an allusion to the cross.

Inside the circle, outlined by a green and blue frame with floral motifs, Abraham sits between Isaac and Jacob. In the background are paradisiacal trees, white like the robes of the three patriarchs, who hold the souls of the righteous in their bosoms.

Inside a red circle, Adam and Eve pluck the forbidden fruit and are banished from earthly paradise by an angel with a drawn sword. Behind them a fiery cherub guards the entrance to the garden.

Three monks and a woman pray in front of a skeleton disinterred from a grave. The man with the cross on his stole is an abbot. Through the use of reverse perspective, the image exhorts the faithful to pray for the soul of the deceased.

The names of the faithful commemorated during the liturgy are written in the spaces created by the arches and the plain or spiral colonettes with gilded capitals.

The upper lunette, carved and gilded, contains an image of Christ giving his blessing. When the doors are closed, the wings below him contain full-length figures of Saints Peter and Paul.

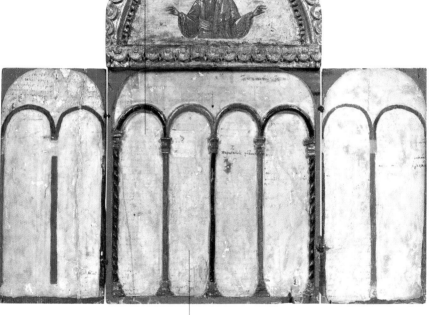

The names of the dead have crosses before them, to distinguish them from the living.

◄ *Bosom of Abraham, Expulsion from Eden, and Prayer for the Deceased*, *diakonikon* door, originally from the Church of the Resurrection in Zaozerie, late sixteenth–early seventeenth century. Vologda (Russia), museum.

▲ Liturgical triptych, sixteenth century. Athens, Byzantine Museum.

*The so-called* despotikai, *or first-rank icons, mark the most important moments of the Orthodox liturgical calendar, investing man's time on earth with a sacred meaning.*

# The Feast Cycle

**Text**
"Six days you shall labor … but the seventh day is a sabbath to the Lord your God." (Deuteronomy 5:13–14)

**Title**
Feast Cycle, composed of twelve (*Dodekaorton*), or sometimes fourteen, sixteen, or eighteen feasts

**Feast days**
Birth of the Virgin, September 8; Presentation of the Virgin, November 21; Conception of the Virgin, December 8; Nativity, December 25; Baptism, January 6; Presentation at the Temple, February 2; Annunciation, March 25; Resurrection of Lazarus, Saturday before Holy Week; Christ's Entry into Jerusalem, Palm Sunday; Harrowing of Hell, Easter; Thomas's Disbelief, first Sunday after Easter; the Holy (Myrrh-Bearing) Women, second Sunday after Easter; Ascension, forty days after Easter; Pentecost, fifty days after Easter; Holy Trinity, first Sunday after Pentecost; Transfiguration, August 6; Dormition, August 15; Exaltation of the Cross, September 14

The icons of the Feast Cycle (*Dodekaorton*), which celebrate the principal episodes of the life of Christ and the Mother of God, are aligned in the first tier of the iconostasis like pearls in a precious necklace. On a given day, the icon of the feast currently being celebrated will be exhibited on a lectern (*proskynetarion*) in front of the iconostasis. The subjects of these icons are derived from the canonical Gospels but are also enriched with details from the apocryphal Gospels and the prayers and hymns of the Divine Liturgy of John Chrysostom. The central theme, however, remains the Resurrection, the "feast of feasts," celebrated not only at Easter but every Sunday. Another important feast is Trinity Sunday. Eastern tradition, moreover, devotes every day of the week (to recall the cycle of the seven days of creation) to an event or character from the history of salvation:

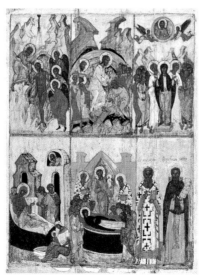

Sunday to the Resurrection, Monday to the Assembly (Synaxis) of the Archangels, Tuesday to John the Baptist, Wednesday to the Annunciation, Thursday to the Washing of the Feet, Friday to the Crucifixion, and Saturday to paradise and commemorating the dead. These themes inform the icon of the Days of the Week, which illustrates the *Hexameron*, the text recounting the Creation of the World.

Arranged clockwise around the Saturday of All Saints are
the Resurrection (Easter Sunday), the Assembly of the
Archangels (Monday), Christ's Baptism (Tuesday), the
Annunciation (Wednesday), the Washing of the Feet
(Maundy Thursday), and the Crucifixion (Good Friday).

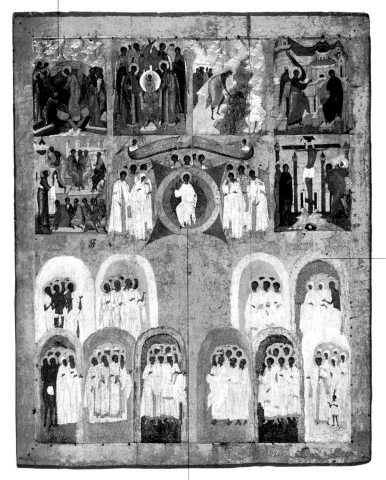

In the niches
of light are various categories
of saints:
prophets,
"fools for
Christ," hermits, bishops,
patriarchs,
apostles,
martyrs, holy
women, and,
last, sainted
physicians.

▲ School of Dionysius, *The Days of the
Week*, early sixteenth century. Moscow,
Tretyakov Gallery.

◄ *The Baptism, Resurrection, Ascension, Birth
of the Virgin, and Dormition of the Virgin, with
Saints Athanasius of Alexandria and Sergius of
Radonezh*, late fifteenth–early sixteenth century.
Vologda (Russia), museum.

The Saturday of All Saints, a luminous feast
that prepares the faithful for Christ's final
coming. Everyone is dressed in white robes:
Christ in Glory, his Mother, the angels, and
even John the Baptist, who is usually
depicted wearing camel hair.

Annunciation: The Virgin is weaving the veil of the Temple, the Holy of Holies shining at the top of a golden staircase. The veil symbolizes Jesus Christ, who will take human form in her womb. Gabriel appears with one wing open and the other folded, as if to halt his flight.

Nativity: Mary looks at Joseph, who has trouble believing in her virgin motherhood. On the lower left, the midwife Eve gives Jesus a bath, while Salome, paralyzed in the hand with which she tried to verify Mary's virginity, is cured by the Christ child.

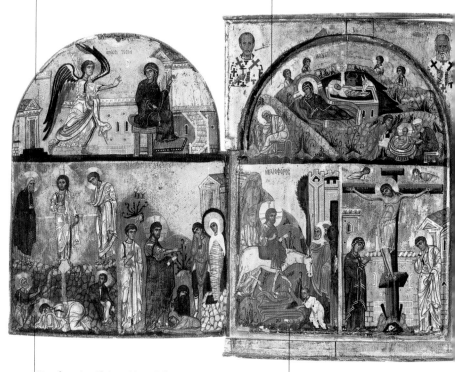

Transfiguration: Christ on Mount Tabor, with Elijah and Moses beside him, is transfigured in front of Peter, James, and John. At bottom center, John covers his face, dazzled by the brightness of the light. Raising of Lazarus: Christ resuscitates his friend in the presence of John, on the left, who is wearing the same clothes as in the previous scene.

Entry into Jerusalem: Christ comes down from the Mount of Olives to Jerusalem and is greeted by the crowd, who lay cloaks in his path and shake palm and olive branches. Crucifixion: blood and water pour out of the wound in Christ's side. He entrusts his mother to the care of John, his favorite apostle.

▲ *The Twelve Great Feasts*, tetraptych calendar icon, twelfth century. Mount Sinai, Monastery of Saint Catherine.

Presentation in the Temple: Simeon receives the Child in his arms; Joseph brings two doves as an offering; and eighty-four-year-old Anne unrolls a prophetic scroll.

Baptism: Jesus is immersed in the Jordan River, a symbol of the old natural world that he is renewing. On the left, John baptizes Jesus; behind him is a tree with an axe beside it: "Even now the axe is laid to the root of the trees" (Matthew 3:2–10; Luke 3:9). On the right are angels with their hands veiled, a sign of adoration.

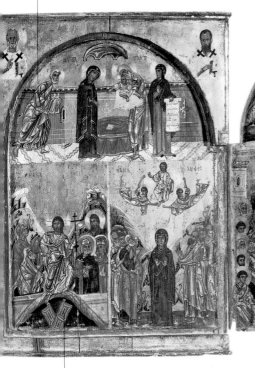

Harrowing of Hell: Christ breaks down the doors to the abyss and frees Adam, Eve, the Baptist, David, Solomon, the Queen of Sheba, and all the righteous who died before the Resurrection. Ascension: Christ rises up into heaven, borne by two angels, while the apostles gather around Mary, the pillar and foundation of the church.

Pentecost: Gathered around the door, which represents the world before Christ's coming, is the assembly of apostles, presided over by Peter and Paul, while the Holy Spirit descends from above. Dormition: The Virgin Mary's body is surrounded by the apostles, while a standing Christ raises Mary's soul to the heavens, where two angels welcome it.

*Rather like musical scores, these icons are veritable calendars of sainthood. They can be weekly, monthly, or yearly and are exhibited in churches on special lecterns.*

# Calendar Icons

**Text**
"I shall contemplate each day the faces of the saints to find rest in their words." (Antiphon of the liturgy of the hours)

**Title**
*Menologion; Synaxarion*

**Source**
Simeon Metaphrastes, *Lives of the Saints*

**Iconography**
Portraits of saints for each month, two months, three months, quarter, semester, or the entire liturgical year

These icons display the feast days of the saints in chronological order, in alternation with the movable liturgical feasts, as they are distributed in the Orthodox calendar, which begins on the first of September. Known as *menologia* (annual) or *synaxaria* (monthly), these panels are derived from the miniatures painted in manuscript collections of saints' lives. The most ancient icons of this sort are from the Monastery of Saint Catherine on Mount Sinai and date from the eleventh century. Sometimes saints celebrated on the same day are grouped together; other times only the first of them is represented. Whereas most saints are represented standing, martyrs are depicted at the moment of their martyrdom. In addition to the weekly and monthly icons, there are also diptychs covering four months, and even more complex panels that include the full cycle of twelve months. *Menologion* icons are exhibited in the church on a special lectern called the *analogion*. The background color chosen for the icon is very important, because it helps one to distinguish the various categories of saints and to read the more complex scenes, such as those from the Gospels, which are practically reduced to miniatures. The layout of these "calendars of sainthood" also plays a role in their legibility and practical use.

▶ *The Sun, the Moon,* details from the icon "*In Thee Rejoiceth,*" originally from Saint Alexander's Kushty Monastery, late eighteenth century. Vologda (Russia), museum.

*Second week of March: The Forty Martyrs of Sebaste, frozen to death on an icy lake. The last saint in this row is Benedict of Nursia, founder of Western monasticism.*

*First week of March: The movable feast of the Resurrection stands out from the rest. The images of saints and feasts with their ochre-colored frames contrast sharply with the dark green backgrounds.*

▲ *Calendar Icon for March*, nineteenth century, originally from northern Russia. Italy, private collection.

*Fourth week: Annunciation (March 25) and Synaxis (Assembly) of the Archangels around Christ Emmanuel.*

*Third week: The martyred monks of Saint Sabas, preceded by (from right to left) Chrysanthus and Daria, Cyril of Jerusalem, and Alexis the Man of God.*

# Calendar Icons

Surrounding the bust of Christ are the first six great movable feasts of the liturgical year: Annunciation, Nativity, Presentation in the Temple, Baptism, Transfiguration, and Raising of Lazarus.

The Exaltation of the Cross (September 14).

The liturgical year begins on September 1 with the feast of Symeon Stylites the Elder, shown atop his pillar surrounded by disciples. Further on is the Birth of the Virgin (September 8).

Saint Clement, martyr, first pope of Rome (November 23).

▲ Calendar Icon for the Liturgical Year, diptych, second half of the eleventh century. Mount Sinai, Monastery of Saint Catherine.

Presentation of the Virgin (November 21): Mary will remain in the Temple, according to an apocryphal text, from age three until age twelve.

Surrounding the bust of the Mother of God are the six great feasts that conclude the liturgical year: Entry into Jerusalem (Palm Sunday), Crucifixion, Harrowing of Hell (Easter), Ascension, Pentecost, and Dormition.

The forty martyrs of Sebaste, who died in a frozen lake for refusing to renounce the Christian faith.

The gaunt figure of a "fool for Christ" stands out in isolation, with sticklike legs and wearing only a rough loincloth.

Against the gold background, the red, blue, ochre, pink, and rare white tones, as well as the browns of the monks, martyrs, virgins, deacons, and bishops, form a chromatic tapestry in which no one color dominates over another, in a harmonious unity that visually echoes the joy of heaven.

Birth of John the Baptist (June 24): One can clearly see the shape of Elizabeth lying in her maternity bed. The last three rows show the saints of July and August.

*The cities of Constantinople, Vladimir, Novgorod, and Moscow were saved from their enemies thanks to the miraculous intervention of sacred icons.*

# Processional Icons

**Text**
"Today the glorious city of Moscow shines in beauty, welcoming your miraculous icon like the dawning sun, O sovereign lady." (Troparion [short hymn] of August 26, feast of the Vladimir Icon of the Virgin)

**Title**
Holy Face (*Mandylion*); Virgin of the Sign, Virgin of Vladimir

**Feast days**
Holy Face, August 16; Virgin of the Sign, November 27; Virgin of Vladimir, May 21, June 23, August 26

**Iconography**
Portable, two-sided icons on wood or cloth

Icons played a central role in both public and private devotion. Portable icons, painted on wood or embroidered on cloth, were carried in processions on special staffs alongside the imperial banners and episcopal symbols. Icons of Christ and the Virgin were taken on military campaigns, and during sieges were exhibited at the city gates or carried solemnly along the defensive walls. Christian emperors, both Byzantine and Slav, used to spend the night before battle praying to icons. The icon of the Virgin of the Sign defended the people of Novgorod from the attack that Prince Andrei Bogoliubskii of Suzdal launched against the city in 1170. Three feast days dedicated to the Virgin of Vladimir commemorate the three occasions on which she saved Russia from the Tatars. On August 26, 1395, a procession led by the metropolitan Cyprian and Prince Vasilii Dmitrievich carried this miraculous image along the city walls of Moscow. That same day Timur, known as Tamerlane, withdrew his attacking army. It is said that he had a vision of a luminous woman surrounded by warriors.

▶ *Virgin of the Sign, Exaltation of the Cross*, two-sided processional icon, sixteenth century. Novgorod (Russia), museum.

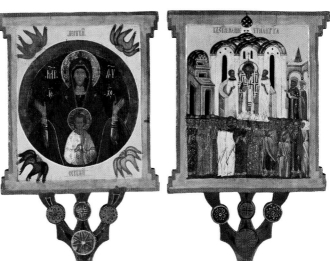

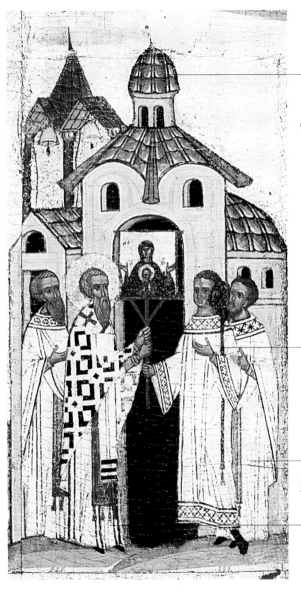

*The Church of the Transfiguration on Elijah Street: The central dome and the three sloping drainpipes on the roof characterize the centralized perspective, which highlights the image of the miraculous icon in the darkness of the entrance. To the left is a bell tower with typically stationary bells, which are rung by swinging the clappers. The tower's red tiles contrast with the emerald green roof of the dome.*

*The deacon is wearing a white* sticharion *adorned with simple geometric patterns repeated around the neck, along the broad sleeves, and along the lower edge. Under his arm he is carrying a metal* rhipidion *(prayer fan) with the head of a cherub carved on it.*

*The priests on both sides are distinguished by the gilded stoles that hang to their feet and by the white* phelonia *over their robes.*

*Archbishop John, wearing a* phelonion *adorned with white and black crosses, receives from the deacon the processional icon of the Virgin of the Sign.*

▲ *Battle of Novgorod and Suzdal* (detail), ca. 1460. Novgorod (Russia), museum.

The inhabitants of Novgorod come out to meet the procession with the bishop and the city rulers. From the Church of the Transfiguration in Elijah Street, the procession crosses the Volkhov River, carrying the icon of the Mother of God and the cross.

The envoys confer, but the Suzdal army is pressing at their heels. At the sound of the trumpet, the archers unleash a dense rain of arrows on Novgorod.

The city walls are defended by the icon, which, when displayed on the bastions, stops the enemy's arrows.

Saints Boris, Gleb, George, and Demetrius of Thessaloniki, and Michael the Archangel in the sky, lead the Novgorod armies to victory.

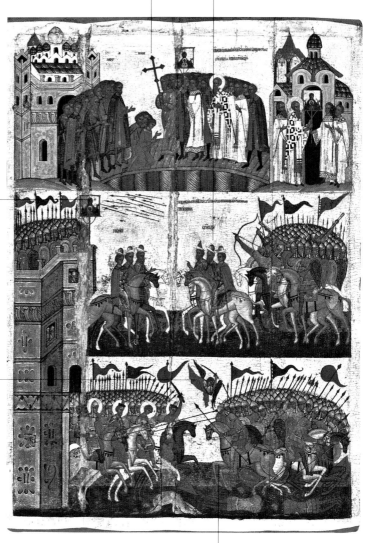

▲ *Battle of Novgorod and Suzdal*,
ca. 1460. Novgorod (Russia), museum.

The Suzdal army, led by their prince, withdraws. The first victims fall in the field, and some bow down, begging to surrender.

The Kremlin walls and the domes of the Cathedral of the Dormition.

Banners bearing images of the Virgin of the Sign and the Holy Face are raised.

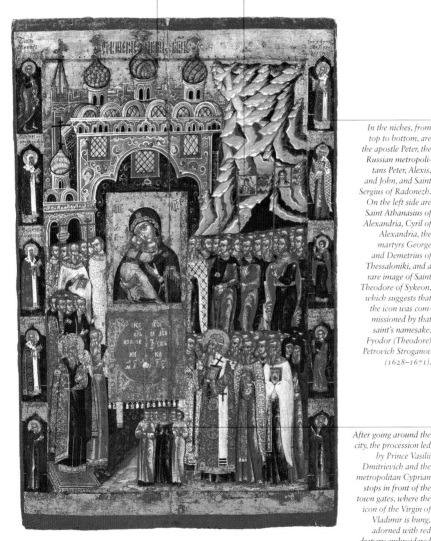

In the niches, from top to bottom, are the apostle Peter, the Russian metropolitans Peter, Alexis, and John, and Saint Sergius of Radonezh. On the left side are Saint Athanasius of Alexandria, Cyril of Alexandria, the martyrs George and Demetrius of Thessaloniki, and a rare image of Saint Theodore of Sykeon, which suggests that the icon was commissioned by that saint's namesake, Fyodor (Theodore) Petrovich Stroganov (1628–1671).

After going around the city, the procession led by Prince Vasilii Dmitrievich and the metropolitan Cyprian stops in front of the town gates, where the icon of the Virgin of Vladimir is hung, adorned with red drapery embroidered in gold.

▲ *Presentation of the Vladimir Icon of the Virgin*, first half of seventeenth century. Solvychegodsk, Museum of History and Art.

The walls of the Kremlin (citadel), built in white
stone in the fifteenth century, encircle the city with
their towers. We see the onion-domed churches
(such as the Cathedral of the Dormition) with three-
armed crosses and the bell towers, including the
towering Belfry of Ivan the Great.

A procession
with portable
crosses, a church
banner with the
Holy Face, and
the miraculous
icon of the Virgin
of Vladimir,
which would
save Moscow
from Timur's
army.

A bishop is
wearing the tra-
ditional phelo-
nion, *under
which we see the*
sticharion, *the
long purple
gown. The cuffs,
maniples, and
sleeves are made
of the same
material, and a
stole adorned
with crosses
hangs down the
middle.*

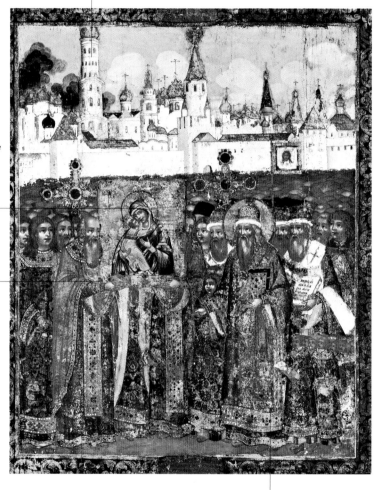

The bishops' miters are made of gold- and gem-
studded brocade with fur trimming. The metropoli-
tan Cyprian, with a golden halo, in a brocaded
sakkos, is holding a closed book and a small red
cloth with a gold hem. Behind him is a bishop
carrying an open missal and a white stole
adorned with crosses.

▲ Mikhail and Dmitri of Belozersk, *Pre-
sentation (Procession) of the Miraculous
Vladimir Icon of the Virgin in Moscow*,
1689–90. Vologda (Russia), museum.

*Icons are found in peasant homes as well as monks' cells; they are taken along on journeys and carried into battle; and they are precious possessions passed on from generation to generation.*

# Domestic Icons

Icons play a central role in both public and private devotion. In private homes, icons are hung in the best, most visible place in the house, which the Russians call the "beautiful corner" (*krasnyi ugol*). In monks' cells, icons are placed in front of the priedieu. When a child is born, an icon of his patron saint is painted the same height as the newborn. When an adult son or daughter leaves home, the mother blesses the child with an icon. The Orthodox faithful carry icons on journeys and into battle, as protection. In funeral processions, they accompany the bier and are placed on the grave. In Greece, one still sees icons housed in little chapel-shaped shrines. Folding-panel icons lend themselves well to private devotion and form little altars in the intimacy of the home. The largest collection of diptychs, triptychs, and polyptychs can be found in the Orthodox Monastery of Saint Catherine on Mount Sinai. In these works, minute scenes are usually developed around a larger central panel featuring an image of the Virgin or the Resurrection. The icon can sometimes be closed to form a small case or shrine containing a smaller image inside. The outside of the closing wings was often painted with images of holy warriors. One even finds domestic iconostases, on a small scale, with four or six panels.

**Text**
"Here's a holy icon to help you on your way; let it be a banner for your journey; pray it never leaves you."
(Russian lullaby)

**Title**
Family icon; beautiful corner (*krasnyi ugol*)

**Iconography**
Diptychs, triptychs, and polyptychs on a reduced scale; small domestic shrines; small churches in miniature erected at crossroads, containing icons; travel icons in special cases

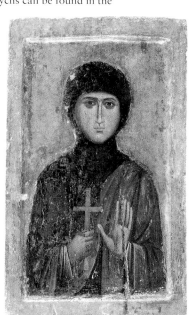

◄ *Saint Phebronia*, second half of thirteenth century. Mount Sinai, Monastery of Saint Catherine.

# Domestic Icons

*The birth of Cyril of Belozersk in the top part of the left panel displays the iconography used in the births of holy personages such as John the Baptist and the Virgin Mary.*

*The Virgin appears to Saint Cyril and orders him to found the Belozersk Monastery.*

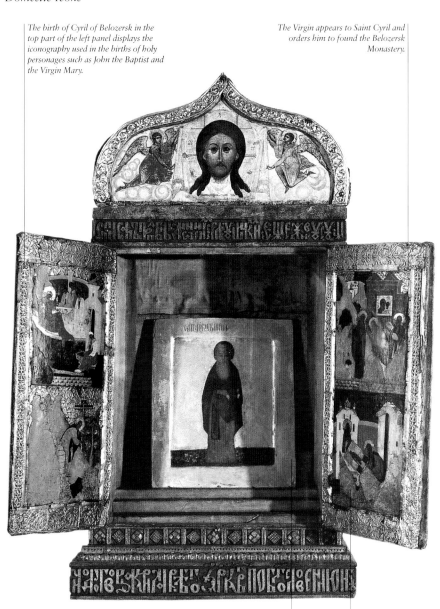

▲ Nikita Ermolov, wooden case, 1614; Dionysius of Glushitsa, *Saint Cyril of Belozersk*, 1424. Moscow, Tretyakov Gallery.

*This icon of Cyril of Belozersk is an actual portrait of the saint. On the side wings of its case are episodes from his life. In the gable, two angels hold up an image of the Holy Face.*

*Dionysius of Glushitsa executes the portrait of Saint Cyril of Belozersk.*

Bishop Nicholas, wearing a short, curly beard, carries the Gospel under his cloaked arm, in an image with a strongly reversed perspective.

Bishop Blaise, wearing a long, pointed beard, is wrapped in a white omophorion adorned with crosses. His orange gown harmonizes with the colors of the frame, which are accentuated by white outlines.

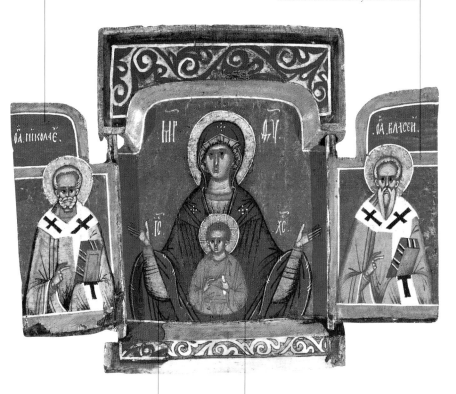

The carved, orange-painted edges and the brown carved ornament display an extremely lively and cheerful vernacular style. The wings, once closed, transform this icon into a small devotional object for use in the home.

Arms open, the Virgin of the Sign stands against a red background, typical of the Novgorod school of icon painting. Sprouting from her bosom like a flower is a Christ Emmanuel, blessing.

▲ Novgorod school, *Virgin of the Sign, with Saints Nicholas and Blaise*, triptych, late fifteenth–early sixteenth century. Moscow, State Historical Museum.

# Domestic Icons

Joachim and Anne's offering is rejected by the priest. The unhappy couple walks away.

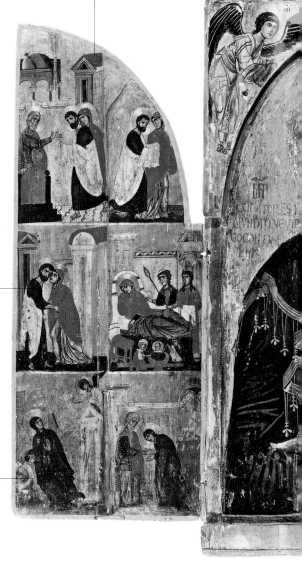

The conjugal embrace of Joachim and Anne. After giving birth, Anne receives gifts from her handmaidens while the ritual bathing of Mary takes place at her feet. On the facing wing: Joachim and Anne play with the young Mary; when the girl reaches the age of three, they take her to the Temple and dedicate her to the Lord.

Mary, by the well, receives the first annunciation from Gabriel; the priest gives her the skein to weave the Temple curtain. On the facing wing: Joseph is presented as the foreordained husband of Mary, and Mary receives the angel's second annunciation as she is weaving the Temple curtain.

▶ Virgin "Hodegetria Aristerokratousa" and Scenes from the Life of the Virgin, late thirteenth century. Mount Sinai, Monastery of Saint Catherine.

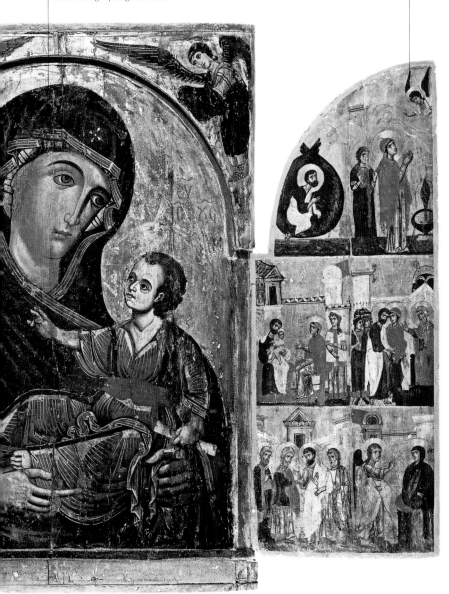

Mary's eyes are sad, in premonition of her
son's Passion. The infant Christ, wrapped in a
royal chiton and giving his blessing, looks sor-
rowfully at his mother. The Virgin's hands
clutch the edge of his golden robes.

Joachim goes into the desert, where, dur-
ing prayer, he is visited by an angel. The
same happens to Anne as she is walking
with a servant girl in the garden.

*They range from the primitive icons of Christ, the Virgin, and saints painted in the monasteries to the complicated allegories painted by artists working for the tsar's court.*

# Theological Icons

**Text**
"The image is not found in a part of man's nature; the nature of his wholeness is an icon of God." (Gregory of Nyssa)

**Title**
Bipartite or quadripartite theological icons

**Sources**
Documents of the Moscow Church Councils of 1551 and 1554

**Iconography**
Complex compositions combining several subjects in a single image

To paint icons is to reflect on the mysteries of God through the use of images. In sixteenth-century Russia, at the court of the tsars, icons were created to express lofty doctrinal concepts. Icons became veritable treatises of theology, and passionate debates and lively polemics sprang up around these images. The Council of Moscow (1553–54), for example, dealt with the famous *Quadripartite Icon* painted by the Pskov masters, who had been invited to Moscow by Ivan the Terrible after the fire of 1547. This icon is meant to illustrate, in four stages, the mystery of the divine economy, that is, God's plan for the salvation of humankind. The two upper panels—*"God Rested the Seventh Day"* (Hebrews 4:4) and *"Only Begotten Son and Word of God"*—develop the theme of the Father as Creator and the Son

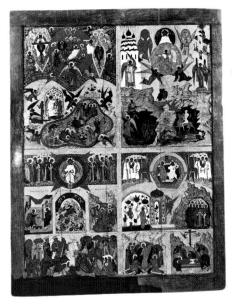

as Redeemer and Judge. The two lower panels—*"Come, People, Let Us Adore the Godhead in Three Hypostases"* and *"In the Grave Bodily"*—recapitulate the story of the incarnation and redemption. Another example of a didactic and theological icon takes its cue from the feast day, established in Byzantium, celebrating the renovation of the Holy Sepulchre in Jerusalem.

▶ Pskov masters, *Quadripartite Icon*, 1540–50. Moscow, Kremlin, Cathedral of the Annunciation.

38

Christ in the Father's arms as a crucified seraph; at the foot of the cross is an archangel with scepter and scroll.

The red circle of the angelic spheres is inscribed inside the star, whose four points contain symbols of the evangelists. At the center, the Ancient of Days (God the Father) rests and, on the right, pours the Spirit into Christ. Gabriel points to the Virgin of the Sign; Michael commands the angelic powers and watches over the world.

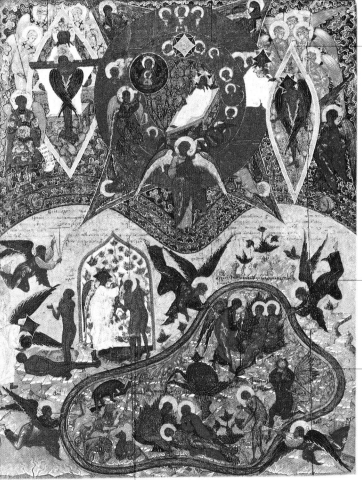

Here Christ is naked as the first man (Adam) and as the subject of the Baptism in the River Jordan (the New Adam). The wings indicate his angelic condition before incarnation.

The angel gives garments of animal skin to Adam and Eve, a sign of divine assistance.

Inside the world, enclosed by a sinuous line, we see the first homicide (on the right, Cain killing Abel) and the first funeral lament (on the left, Adam and Eve mourning over their son's dead body).

▲ Pskov masters, "*God Rested the Seventh Day*," detail of the *Quadripartite Icon*, 1540–50. Moscow, Kremlin, Cathedral of the Annunciation.

Under the undulant line of the heavens is the warm luminosity of earthly paradise. Eve is drawn out of Adam's rib; an angel appears with symbols of the Passion; Adam and Eve are driven from paradise through a small door. Behind them we can see a luxuriant garden.

# Theological Icons

Two angels hold the sun and the moon, symbols of the New and Old Testaments, respectively.

Christ Emmanuel in the sphere of cherubim and seraphim, borne by two angels; in the upper circle, the Ancient of Days in white robes with arms open.

Two symbolic buildings on the left and right, which represent the Church and the Cosmos, are presided over by two angels bearing a chalice and a sphere.

The dead Christ is borne up by Mary. The sepulchre spans the chasm between the two mountains like a dike.

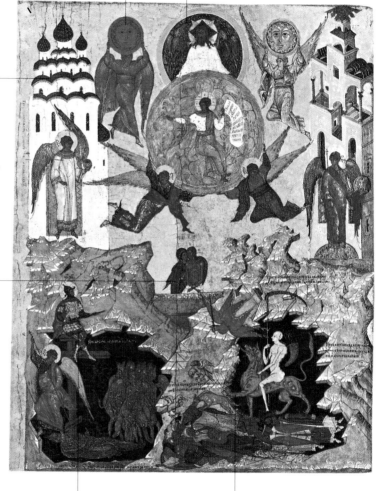

▲ Pskov masters, "Only Begotten Son and Word of God," detail of the Quadripartite Icon, 1540–50. Moscow, Kremlin, Cathedral of the Annunciation.

Christ as warrior sits victorious atop the cross as on a throne. Inside the cave, the archangel Michael runs Satan through with a lance as the souls of the damned look on in horror.

Death astride a monstrous beast tramples corpses mauled by animals. Defeated by Christ's power, he stops in front of a seraph with flaming wings and sword.

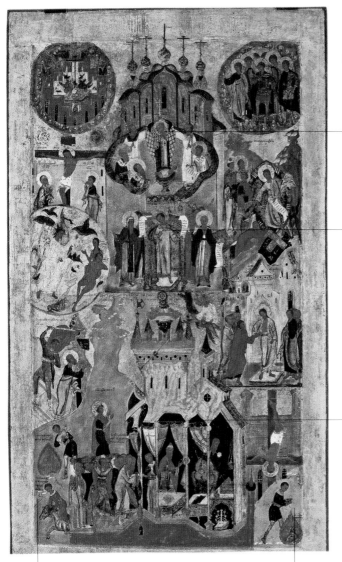

The Church of the Holy Sepulchre; below, inside the sanctuary, Saint James raises the cross with John Chrysostom, Basil the Great, and Gregory of Nazianzus.

From the pulpit, Romanos the Melodist sings the Divine Liturgy, with Dionysius the Areopagite and John of Damascus.

The Jewish Temple, with ark, censor, menorah, and animal sacrifice, which Christ overcomes by offering himself as a sacrifice.

From the top: The heavenly Jerusalem with the throne and symbols of the Passion; the Crucifixion; the Creation of Man; and the beheading of Saint Paul.

From the top: The archangels with Saint Michael; Christ breaks in the door of hell and frees Adam and Eve; Christ Resurrected appears to Thomas; Peter crucified upside down.

▲ Stroganov school, *Renovation of the Temple of the Resurrection in Jerusalem*, originally in the Cathedral of the Annunciation in Moscow, late sixteenth–early seventeenth century. Solvychegodsk, Museum of History and Art.

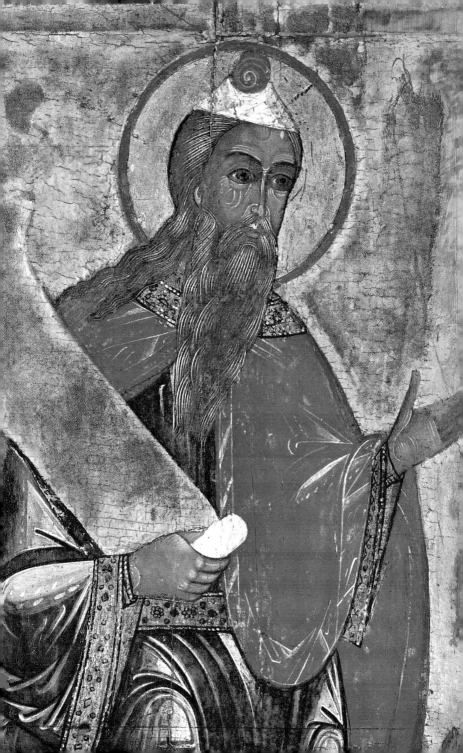

# THE OLD TESTAMENT

◄ Moscow school, *The Prophet Aaron*
(detail), sixteenth century. Reckling-
hausen (Germany), Icon Museum.

*The image of Sophia the Wisdom of God is of Greco-Eastern origin and has had a major influence on Russian philosophy and culture through literary and iconographical sources.*

# Sophia the Wisdom of God

**Text**
"[Wisdom] has slaughtered her beasts; she has mixed her wine; she has also set her table.
She has sent out her maids to call from the highest places in the town,
'Whoever is simple, let him turn in here!' To him who is without sense she says,
'Come, eat of my bread and drink of the wine I have mixed.'" (Proverbs 9:2–5)

**Title**
Sophia, the Wisdom of God (*Sofiia Premudrost Bozhiia*)

**Sources**
Proverbs 7:1, 8:30–31, 9:1; Ecclesiastes 24:3; Song of Solomon 2:6–7; Isaiah 6:6, 66:1; Ezekiel 1:8–14, 10:2; 1 Corinthians 1:24; Hebrews 12:29; Wisdom of Solomon 7:25–26; Dionysius the Areopagite; Anastasius of Sinai; John of Damascus

**Iconography**
Wisdom enthroned with wings and crown and surrounded by the Virgin, John the Baptist, Christ, the Ancient of Days, and the Throne of the Last Judgment (*Hetoimasia*)

▶ *Saint Sophia the Wisdom of God*, seventeenth century. Perm (Russia), Picture Gallery.

The quest for knowledge always fascinated ancient peoples. When Solomon succeeded David as king in 970 B.C., he asked God for wisdom, preferring it to all other things. In the book of Proverbs (9:1), wisdom is likened to a house built on "seven pillars." The Temple of Jerusalem—built under King Solomon, rebuilt by Herod the Great in 18 B.C., and finally destroyed by the Romans in A.D. 66–70—is an image of Wisdom, the house of God among men. In icons, Wisdom-Sophia is represented as a queen and angel seated on a throne. The architectural element of the throne recalls the Temple. Sophia's face, hands, and wings are bright red, indicating the fire of the Spirit. Her royal crown represents humility; the ribbons hanging from her hair symbolize chastity; and her clothing signifies age and royal priesthood. Sophia is immersed in the dark circle that evokes the impenetrable mystery of God. Beside the throne of Wisdom stand John

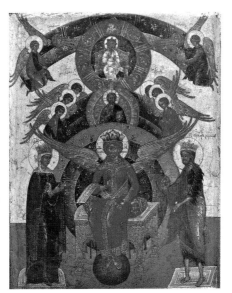

the Baptist and Mary, who is the "seat of Wisdom." Behind the throne, between the ranks of angels, are Christ and the Ancient of Days. Above, the angels roll up the heavens like a carpet and prepare the throne of the *Hetoimasia*, that is, the throne of Judgment at the end of time, on which Christ the Judge will sit.

*Wisdom in white robes sits enthroned in the circle of heaven. The circle is dark on the inside and unknowable, like the essence of God, and, on the outside, first red (the moving wheels and cherubim) and then greenish brown (angelic hierarchies), symbol of eternal energies.*

*The seven ecumenical councils (held at Nicea, Ephesus, and Constantinople between 325 and 787) are represented by seven domes; the seven angels in the circles are the gifts of the Holy Spirit.*

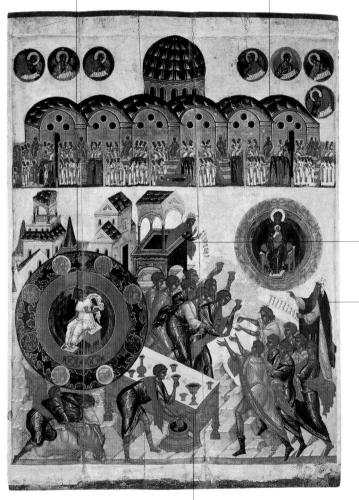

*From a balcony, Solomon unrolls a scroll containing the text of Proverbs 9:1: "Wisdom has built her house, she has set up her seven pillars." He points to the Virgin Mary, who, enthroned with the Child inside the circle, represents the new seat of Wisdom.*

*The hymnographer Cosmas of Maiuma, responding to Solomon's call, holds up a scroll with the beginning of his Canon for Holy Thursday: "Cause of all and bestower of life, the Wisdom of God has built her house [from a pure mother]."*

▲ *"Wisdom Has Built Her House,"* originally from the Church of Saints Athanasius and Cyril, Monastery of Saint Cyril, Novgorod, 1548. Moscow, Tretyakov Gallery.

*The devotees of Wisdom, the prophets and apostles, distribute wine to those thirsting for Wisdom; on the left, the slaughtered cows are an image of the eucharistic sacrifice.*

*Saint Michael, the supreme commander* (Archistrategos) *of the Heavenly Host, is the angel of light who watches over the world, opposes Lucifer, and weighs souls on his scale.*

# The Archangel Michael

**Text**
"The lightness of the angels' wings symbolizes the freedom from all worldly attraction, their pure and unimpeded uplifting towards the heights."
(Dionysius the Areopagite, *The Celestial Hierarchy*)

**Title**
Archangel Michael

**Feast days**
November 8; September 6
(Miracle at Chonae)

**Sources**
Daniel 10:13; Jude 1:9;
Revelation 12:7–9;
*Assumption of Moses*

**Iconography**
Standing armor clad and wielding a sword, or on horseback with lance, trumpet, censer, and scale, he leads the Heavenly Host and defeats Satan

His name means "He who is like God" and he is mentioned in the book of Daniel (10:13). According to an ancient Jewish tradition, in the Court of Heaven, the angels are represented presiding over the nations according to various hierarchies: Michael is one of the great princes and rules the kingdom of Israel. In an apocryphal Jewish text called the *Assumption of Moses* (cited in Jude 1:9), Michael fights Satan for the body of Moses, a scene also depicted in fresco by Raphael. The antithesis between Michael and the Prince of Darkness culminates in Revelation (12:7–9), where Michael and his Heavenly Host battle the dragon that is cast down to earth, with its rebel angels, and into the lake of fire. The cult of the archangel

Michael first developed around the fourth and fifth centuries. From Constantinople—where many sanctuaries are devoted to him—to Italy (Monte Sant'Angelo in Apulia, the Sacra di San Michele in Val di Susa) and France (Mont Saint-Michel, Lyon, Limoges, Le Mans), all of Christian Europe came under the protection of the Prince of Angels. In one iconographical tradition, Michael saves the church of Chonae in Phrygia from a flood.

▶ Andrei Rublev, *The Archangel Michael*, originally from the *Deesis* tier of the iconostasis, Zvenigorod Cathedral, ca. 1400–1410. Moscow, Tretyakov Gallery.

Two elegant wings with gold highlights graze the celestial vault and the rectangle of Earth, accentuating the calm majesty and strength emanating from the figure of Michael, leader of the Heavenly Host.

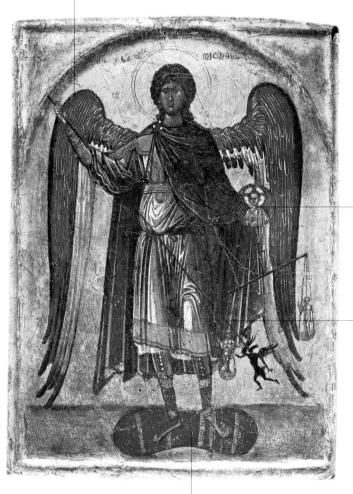

The archangel Michael, with left hand veiled out of respect, holds up a scale that hangs from a medallion of Christ Emmanuel; it is Christ who will judge the human souls, weighing them in the scale of his justice and mercy.

The archangel's scepter-lance fends off a devil who, as the souls are being weighed, is trying to tip the scale to a man's disadvantage, so he can then drag him into hell.

▲ *The Archangel Michael*,
Italo-Byzantine, late thirteenth century.
Pisa, Museo Civico.

The archangel Michael's feet, shod in small red boots, rest on a cushion that symbolizes the royalty invested in him.

# The Archangel Michael

Old Testament Trinity (Hospitality of Abraham); the Synaxis (Assembly) of the Angels; Ezekiel prophesies the destruction of Jerusalem; Vision of Daniel; Death of Moses with Michael and the devil disputing over his body.

The breastplate, wings, and ornamental band in the angel's hair sparkle with flashes of whitish blue striation (assist).

Jacob's Ladder; the Three Youths in the Fiery Furnace; Michael appears to Joshua; frees Peter from prison; appears to Saint Pachomius; destroys Sodom; and puts to flight the army of Assyrian king Sennacherib.

The Great Flood; King David sends Uriah off to his death in battle; he goes to Bathsheba, Uriah's wife; the king repents; the archangel Michael saves the church of Chonae from destruction.

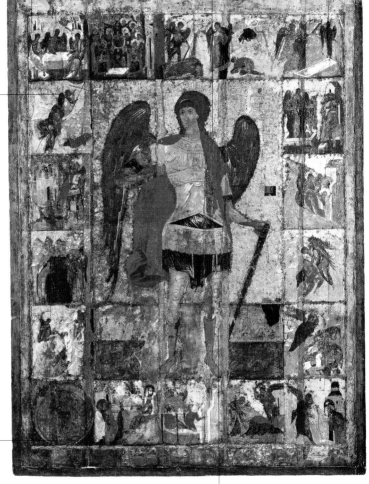

▲ The Archangel Michael and His Miracles, ca. 1400. Moscow, Kremlin, Cathedral of the Archangel Michael.

The rotation of the body is accentuated by the asymmetry of the wings and the diagonal of the sword's sheath.

► The Archangel Michael on Horseback, Russian, nineteenth century. Italy, private collection.

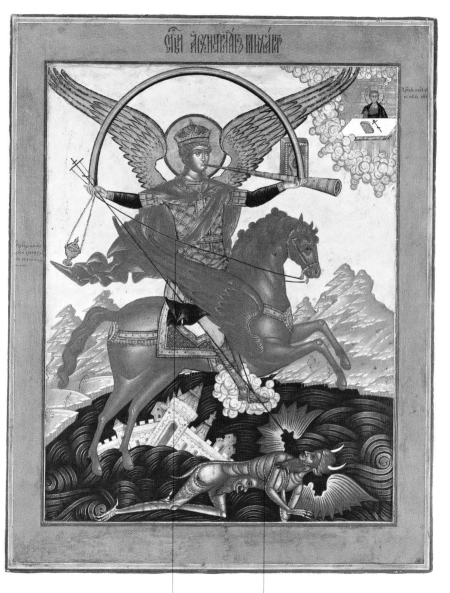

Face aglow with fire, Michael carries the book
and trumpet of Judgment in his left hand, the
censer and cross-shaped lance, with which he
conquers the demon, in his right. The rainbow
between his hands is a symbol of his covenant
with God.

Under the hooves of the winged horse
churn dark waters, symbolizing evil, in
which a city (Babylon) is drowning. The
demon, struck down by the lance and the
beams of light, crawls on his belly, which
takes the shape of a "grotesque" mask.

## The Archangel Michael

The high walls of Jerusalem are seen under a tricolor tent. A mountain with trees of paradise slopes down beneath it. The Child, held by the Virgin, gives celestial crowns to the angels, who coronate the just.

The archangel Michael points out Jerusalem to the standard-bearer at the head of the procession, who is carrying a red banner. Each army flies a similar standard; on the one at the bottom we can see the symbols of the Passion.

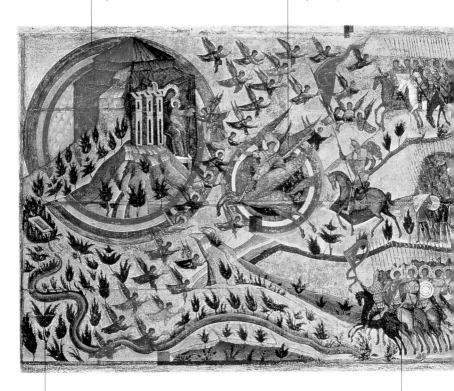

Vigorous saplings sprout along the river of Grace that springs from the fountain of the City of God, while a little font without water recalls the words of Jeremiah: "they have forsaken me, the fountain of living waters, and hewed out cisterns for themselves, broken cisterns, that can hold no water" (Jeremiah 2:13).

The sainted Russian prince Alexander Nevskii (1220–1263), in the red cape, is preceded by Saint George.

▲ "Blessed Is the Army of the Heavenly King," ca. 1552. Moscow, Tretyakov Gallery.

The two wings of the cavalry surround the central core of infantry flanking Emperor Constantine the Great, who carries the cross. The earthly host symbolizes the Heavenly Host riding toward Jerusalem.

Babylon, devoured by flames, is completely enclosed inside a circle, contrasting it with Jerusalem, toward which the procession is marching.

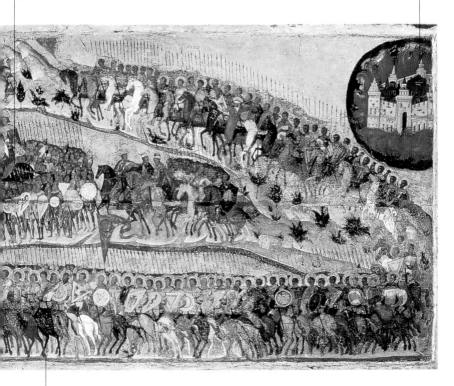

The three phalanxes represent the Russian troops who in 1551 defeated the Tatars and conquered the city of Kazan. The holy knights have haloes and shields of a great variety of geometric forms. Their lances form a dense texture of parallel lines.

# The Archangel Michael

The archangel Michael towers over the supplicating monk and intervenes with his scepter to prevent the water from devastating the church.

The holy monk is portrayed in an attitude of prayer; the blue tiles of the church dome of Chonae resemble the scales of a fish.

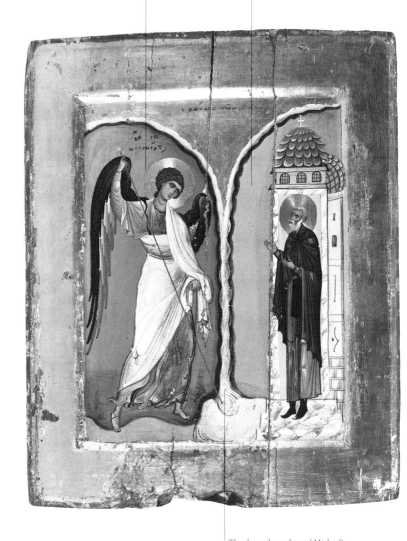

▲ *The Miracle at Chonae*, second half of the twelfth century. Mount Sinai, Monastery of Saint Catherine.

Thanks to the archangel Michael's intervention, the river water, diverted by the pagans to destroy the church of Chonae in Phrygia, converges into a single whirlpool that is swallowed up by the earth.

*Angels reflect in human events the beauty and eternal youth of God. They are his messengers and the executors of his will.*

# Archangels, Cherubim, and Seraphim

The heavenly powers are divided into nine choirs or ranks: angels, archangels, principalities, powers, virtues, dominions, thrones, cherubim, and seraphim. In Orthodox iconography, they are present at Christ's side during Creation. One cherub (from *karibu*, Babylonian sculptures) with flaming wings expels Adam and Eve from paradise, and two flank the Ark of the Covenant. In the Vision of Isaiah, a seraph (from the Hebrew *seraphim*, "to burn") purifies the prophet's lips with a burning firebrand (Isaiah 6:2–7). An angel wrestles with Jacob in Exodus (32:23–30). In Old Testament iconography, angels appear in such episodes as the Sacrifice of Abraham, Jacob's Ladder, the Three Youths in the Fiery Furnace, and Daniel in the Lions' Den. The archangel Raphael ("He that heals")

appears to Tobit and his son Tobias (Tobit 3:17). The archangel Gabriel explains to Daniel the meaning of his vision (Daniel 8:16–19). In the Gospel of Luke, Gabriel ("God is my strength") announces the births of John the Baptist and Jesus. In the Gospel of Matthew, the angel of the Lord speaks in a dream to Joseph (Matthew 1:20, 2:13–19). Finally, the archangel Michael ("He who is like God") fights the dragon (Revelation 12:7–9).

**Text**
"All the beauties of nature are ornaments of the angels' robes, the drapery of they who contemplate the face of the Eternal One." (Sacred author)

**Title**
Angels, archangels, principalities, powers, virtues, dominions, thrones, cherubim, seraphim

**Feast days**
Synaxis (Assembly) of All Heavenly Orders, November 8; Gabriel, March 26

**Sources**
Daniel 8:16–19; Isaiah 6:2–7; Matthew 1:20, 2:13–19; Revelation 12:7–9; Colossians 1:16; Dionysius the Areopagite, *The Celestial Hierarchy*

**Iconography**
Angels with scepter, sphere, and halo; seraphim are red, cherubim are darker

◀ *The Archangel with the Golden Hair*, late twelfth century. Saint Petersburg, Russian Museum.

53

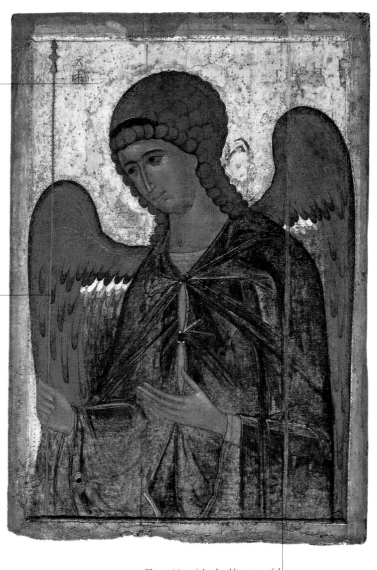

His face is turned toward Christ and illuminated by fine strokes of light (assist); the motif of the curls recalls Greek art, reworked into a Byzantine-Slavic spirituality.

The dark red wings become transparent at their center, assuming gradually lighter tones until they turn pale blue and then pure white.

The position of the shoulders, powerful beneath the blue mantle, is accentuated by the asymmetry of the wings, which creates a contained movement of great sweetness and majesty. The reflective luminosity of the mantle's folds and fastenings points to a spiritual energy, also expressed by the orange color of the undergarment.

▲ Constantinopolitan master, *The Archangel Gabriel*, 1387–95. Moscow, Tretyakov Gallery.

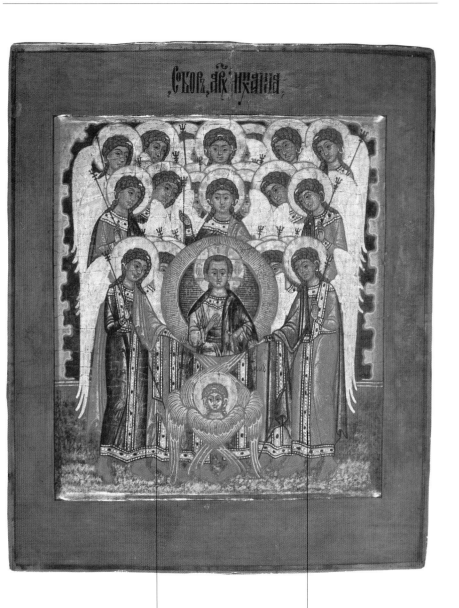

▲ *Synaxis (Assembly) of the Archangels around Christ Emmanuel*, Russian, eighteenth century. Paris, private collection.

*The luminous face of the seraph with flaming wings seems made of the same incandescent matter as the aura of Christ Emmanuel: red interwoven with gold assist.*

*The archangels are wearing red capes on their shoulders, over dark gowns (or vice versa, dark capes over red gowns); their scepters emphasize the triangular composition.*

Angels dressed in deliberately alternating colors roll up the sky like a tablecloth, while silence falls around them and the Last Judgment is prepared.

Christ in the golden circle bears up the green circle of the Sophia, while the throne of the Last Judgment is being readied above him.

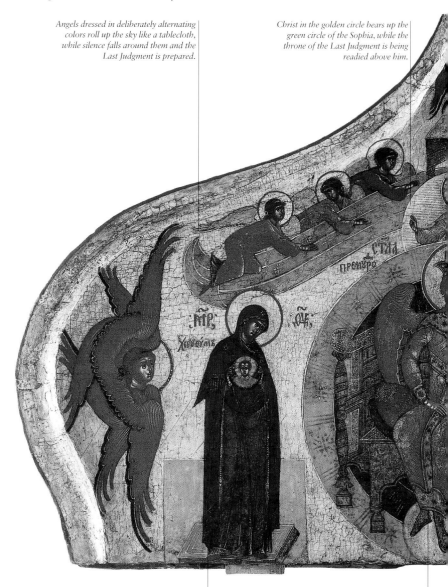

▲ Novgorod school, *Sophia the Wisdom of God*, upper portion of a *kibotos* (icon chest), seventeenth century. Moscow, Ecclesiastical Academy, Archaeological Cabinet.

The Virgin of the Sign worships Wisdom. On her breast she bears a disk with Christ Emmanuel.

Sophia the Wisdom of God, with her fiery wings and face. The throne is surrounded by a luminous green circle interwoven with golden stars.

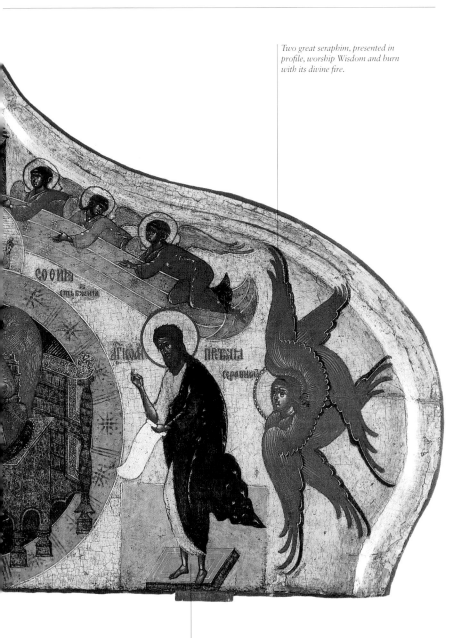

Two great seraphim, presented in profile, worship Wisdom and burn with its divine fire.

СОФНА
СТЬ БЖН

АГГ(Л) ПРТЧА
СЕРАФНМ

Saint John the Baptist on a pink footstool in reverse perspective holds out a scroll and forms the monogram of Christ with his fingers.

The cherub has six wings: with two it covers its head, with two its naked body; with the final pair it flies.

A seraph with light red wings, carrying a liturgical fan, or rhipidion, worships the cross.

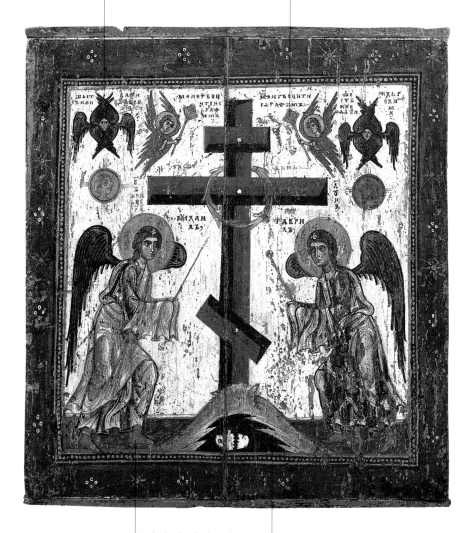

▲ Novgorod school, *Adoration of the Cross*, 1167. (The other side of this two-sided icon appears on page 238.) Moscow, Tretyakov Gallery.

Michael and Gabriel worship the cross and display the symbols of the Passion: the lance that pierced Christ's side and the sponge that quenched his thirst with vinegar.

The three-armed cross, with the crown of thorns hanging from it, rises up from the spot where Adam's skull was buried.

*Pure angelic beings, devoted to the beauty and glory of God,
they directly combat their enemies, the demons, and protect the
souls of men from diabolical snares and temptations.*

# Guardian Angels and Demons

In the phrase "deliver us from the Evil One," the Orthodox
*Our Father* underscores the personal nature of evil. The devil
never reveals himself directly; he acts under the guise of life's
opportune temptations, even convincing us that he doesn't
exist. In the Middle Ages, the devil was called "God's mon-
key": he imitates God's actions, but with opposite, negative
results. His shrewd intelligence derives from his origins as a
rebel angel, fallen from heaven for having disobeyed God and
wanting to be like him. The struggle between angels and
demons over human souls becomes a contest between luminous
beauty and horrifying ugliness. Sometimes the devil himself
appears; at other times, as in the temptations of Saint Anthony,
he assumes animal form. The Evil One can also be represented
as the dragon slain by Saint George, the Leviathan that swal-
lows up Jonah, or the beast into whose maw the damned souls
are cast. The soul of Judas is in hell, in Satan's arms, sur-
rounded by demons (who represent the
vices), each of whom is run through
by an angel's lance (representing
the corresponding virtues). Thus
demons and angels become
mirror images of
one another.

**Text**
"The guardian angels have
been given to us by God as
heavenly companions to
strengthen human nature
along the path of life, for
fear that she might stray
and succumb to the seduc-
tions of the spirit of evil."
(Sacred author)

**Title**
Guardian angel (*Aggelos
ho phylax, Angel khranitel*)

**Feast day**
Guardian angels,
October 2

**Sources**
Revelation 20:2;
apocryphal Apocalypse
of Saint Paul

**Iconography**
A guardian angel stands
watch over the sleeper and
keeps Satan at bay; angels
bind Satan in hell and run
the demons through; Satan
embraces the soul of Judas,
who clings to the purse
containing the thirty pieces
of silver

◀ Ermolai and Yakov Sergei,
Petr Savin, Semen Karpov,
*Angels Chaining Satan*, detail
of *The Harrowing of Hell*,
1692. Vologda (Russia),
museum.

The sleeper has his head turned toward the angel: his final prayer is directed to him. The Deesis icon over his bed symbolizes heavenly protection.

The luminous buildings represent the heavenly city, where "they need no light of lamp or sun, for the Lord God will be their light, and they shall reign for ever and ever" (Revelation 22:5).

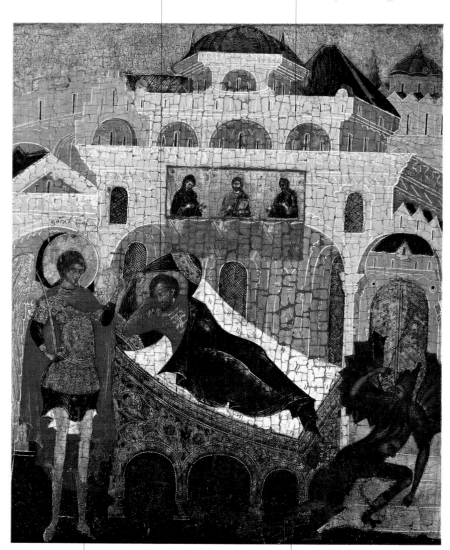

The guardian angel grips the sword of spiritual combat in one hand and with the other raises the cross.

The routed demon, powerless before the angel, turns toward him one last time.

The demons plummet downward, run through by the red tridents of the angels above. Each demon represents a deadly vice, which has its corresponding virtue represented among the angels in the upper portion of the icon, not visible here.

In the infernal darkness we see the bolts, hinges, and iron bars that had kept the gates of hell closed before Christ tore them away with the force of his resurrection.

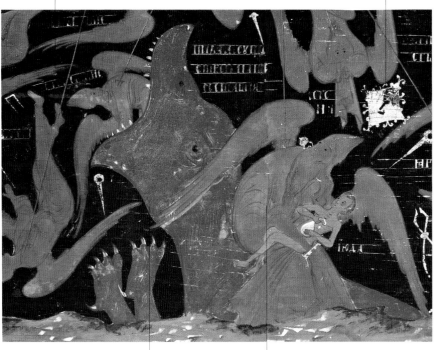

The fire red monster of hell is like the lake of fire mentioned in Revelation, which swallows up its own creatures, the demons.

Satan holds the apostle Judas like a son in his arms, the son of damnation. Judas clutches the pouch containing the thirty silver pieces he earned by betraying Christ. The gazes of Judas and Satan are similar, and both are fixed on the image of Christ the Judge, awaiting his irrevocable decision. Satan would like to keep Judas, but the painter seems to keep open the possibility that Judas might be saved.

◄ Nikifor Savin, *Angel Watching over the Soul and Body of a Sleeper*, early seventeenth century. Saint Petersburg, Russian Museum.

▲ *Among the Falling Demons Satan Holds Judas in His Arms*, detail of a Resurrection icon, late sixteenth century. Vologda (Russia), museum.

*In the iconography of the Creation, it is Christ himself who does the work. Indeed, he exists before everything else, and it is he who reveals to us the image of the Father.*

# The Creation and The Fall

**Text**
"Even as he chose us in him before the foundation of the world, that we should be holy and blame-less before him."
(Ephesians 1:4)

**Title**
Creation; Expulsion from Paradise

**Sources**
Genesis 1–4; Ephesians 1:4

**Iconography**
Christ shapes Adam and from his rib draws Eve; Adam and Eve eat the for-bidden fruit; an angel with a sword drives them out of earthly paradise, which is guarded by a cherub; Adam toils; Eve gives birth; Cain kills Abel

Byzantine iconography, following the Church Fathers, presents the biblical story of the Creation in the light of Christ. The second person of the Holy Trinity is present when God separates the heavens from the earth and the earth from the waters. After creating all the living beings, God shapes man in the image and likeness of his Son, who would save humankind by being sacrificed on the cross. God instills in Adam the spirit of life, and from Adam draws Eve, his companion; he then places the first humans in the Garden of Eden. However, tempted by Satan, man and woman disobey God and lose their royal rank (the splendid clothing in which they are dressed); they realize they are naked, that is, deprived of Grace, and are expelled from paradise. The gates close behind them, under the watchful gaze of a fiery cherub. All human history will be marked by the drama of this banishment and the promise of return. God does not abandon Adam and Eve but weaves rough tunics for them. The history of mankind will become the history of the salva-

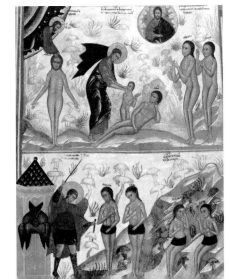

tion offered by God through the presence of men faithful to him: Noah, Abraham, Isaac, Jacob, Moses, David, and the prophets. In the fullness of time, Christ, made flesh in Mary's womb, comes to liberate Adam and Eve from hell, along with the souls of the righteous who died before his coming.

▶ Novgorod school, *The Creation of Adam and Eve and the Expulsion from Paradise*, fragment of an iconostasis deacon's door, mid-seventeenth century.

*Christ, seated on a throne, creates Adam (the small figure shaped by his hands) as an archangel looks on.*

*In royal vestments, as befits their rank, Adam and Eve are blessed by Christ on high.*

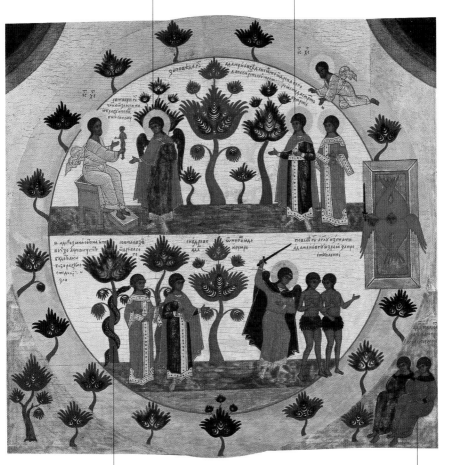

*In the tree, the snake whispers to Eve to pluck the forbidden fruit. Eve listens to him and implicates Adam as well.*

*The archangel with a sword drives Adam and Eve from the circle of paradise, whose gate is guarded by a cherub. The first progenitors are naked because they have lost their royal standing; outside the circle, we see them seated, wearing the tunics that God has sewn for them.*

▲ *The Creation of Man and Expulsion from Earthly Paradise*, detail of an iconostasis *prothesis* door, originally in Solvychegodsk Cathedral. Solvychegodsk (Russia), Museum of History and Art.

*The "bosom of Abraham" is the place of salvation and intimacy with God. Abraham is the father of the faith, Isaac the son of the covenant, and Jacob the one who wrestles with God.*

# Abraham, Isaac, and Jacob

**Text**
"The poor man died and was carried by the angels to Abraham's bosom. The rich man also died and was buried; and in Hades, being in torment, he lifted up his eyes, and saw Abraham far off and Lazarus in his bosom."
(Luke 16:22–23)

**Title**
Bosom of Abraham
(*Kolpos Abraam, Lono Avraamle*)

**Feast days**
Abraham: October 9;
Jacob: Sunday before
Christmas

**Sources**
Genesis 12–25; Luke
16:22–23

**Iconography**
Sitting in heaven,
Abraham, Isaac, and Jacob
hold the souls of the righteous in their bosoms

God commands Abraham to leave Ur of the Chaldees, the seat of his clan, and go on a long journey. Prepared to sacrifice his promised son, Isaac, on Mount Moria, Abraham (whose hand is stayed at the last moment by an angel) becomes the father of those who believe in God, thenceforth called the God "of Abraham, Isaac, and Jacob"—that is, of Abraham and his descendants (father, son, grandson). Abraham is also the father of the three great monotheistic religions: Judaism, Christianity, and Islam. Luke (16:22) writes that the beggar Lazarus "died and was carried by the angels to Abraham's bosom." The rich man, who had neglected to help Lazarus when alive, ends up in hell and amid his torments asks in vain for help from Abraham and Lazarus. The iconography of "Abraham's bosom" thus represents man's condition after death: to be in Abraham's bosom means to be saved. In the icon of the Last Judgment, the procession of the redeemed, led by the apostle Peter with the keys, passes through the gates of paradise and there meets the three patriarchs, Abraham, Isaac, and Jacob, who gather the souls of the righteous into the folds of their gowns, while the other souls teem behind them in the verdant garden.

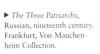
► *The Three Patriarchs*, Russian, nineteenth century. Frankfurt, Von Mauchenheim Collection.

*Christ is the image of the Father, who cannot be depicted in any way. The Ancient of Days represents the timelessness of Christ-God, who is simultaneously young and old.*

# God the Father

Christ has no age and lives in a timeless dimension that makes him at once the "Ancient of Days" described by Ezekiel (1:26–28) and Daniel (7:9–13) and the child Emmanuel, the "God with us" of Isaiah (7:14). The apostle Philip says to Jesus, "Lord, show us the Father, and we shall be satisfied," and Christ replies, "he who has seen me has seen the Father" (John 14:8–9). Christ unites all the attributes of God in himself: he is at once old and young—that is, he exists from the beginning and does not change with time, maintaining a state of eternal youth. While in 1551 the Moscow Church Council "of the Hundred Chapters" (*Stoglav*) recognized Rublev's icon (p. 70) as the canonical model of the Holy Trinity—and therefore as the sole manner in which the Godhead should be represented—in later centuries the image of the Father would spread throughout Russia as well as in the West. In this image, the issuance of the Son from the Father, and of the Holy Spirit from the Son, as described in the Nicene Creed, is visualized by the enthroned figure of God the Father (wearing a halo with an inscribed cross, attribute of Christ), holding Emmanuel the Judge on his knees, with the dove of the Holy Spirit.

**Text**
"As I looked, thrones were placed and one that was ancient of days took his seat; his raiment was white as snow, and the hair of his head like pure wool: his throne was fiery flames, its wheels were burning fire."
(Daniel 7:9–10)

**Title**
Lord *Sabaoth*; Ancient of Days (*Palaios ton hemeron, Vetkhii Denmi*); Paternity (*Otechestvo*)

**Sources**
Isaiah 7:14;
Ezekiel 1:26;
Daniel 7:9–13;
John 14:8–9

**Iconography**
The Ancient of Days enthroned with Christ Emmanuel and the dove of the Holy Spirit; Father and Son seated next to each other on the same throne

◄ Zhdan Dementiev, *God the Father*, detail of *The Ancient of Days*, 1630. Vologda (Russia), museum.

65

# God the Father

The two seraphim with flaming wings always hover near the throne of God.

The halo with inscribed cross around the heads of the Father and the Son is an attribute of Christ, who appears in the beginning as the Creator and in the future as the universal Judge.

Two stylites, or pillar saints, atop their columns, flank the throne. Their lives consisted of continuously climbing, like "angels on earth," to get closer to God.

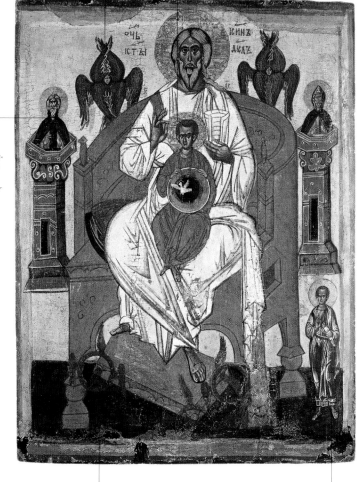

▲ Novgorod school, *Paternity*, ca. 1420. Moscow, Tretyakov Gallery.

The footstool of the throne, here presented in oblique perspective, suggests the dynamism of the divine energy: under God's feet turn the winged spheres of fire mentioned by the prophet Daniel.

A youthful apostle underscores the earthly dimension of the church, which carries the word of God to the world.

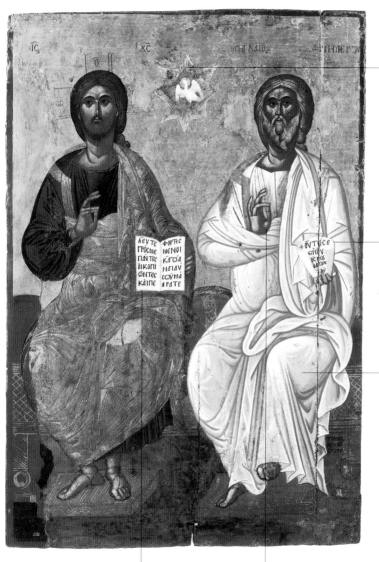

Inside a star formed by two rhombuses is the dove of the Holy Spirit.

The Ancient of Days (God the Father) with a scroll bearing the words "This is my beloved son" (Matthew 3:17).

The dazzling, iridescent robes that hide even his feet express unfathomable mystery.

▲ Thomas Bathas, *Holy Trinity*, second half of sixteenth century. Athens, Byzantine Museum.

The Son with the Gospel open to the passage "Come to me, all who labor and are heavy burdened, and I will give you rest" (Matthew 11:28). The colors of his robes, red and gold, reveal the unity of the two natures of God.

In Greek benediction, the thumb and ring finger are joined to form the initials IC, while the other fingers convey the initials XC: the Church Fathers saw in the form of the human hand the monogram of Christ.

*Following the Church Fathers, early Christian and Byzantine art saw the three pilgrims who appear to Abraham at Mamre as an image of the Holy Trinity.*

# The Hospitality of Abraham

**Text**
"The divinity I contemplate in the Father is the same in the Son, and that which I see in the Holy Spirit is the same as in the Son, and thus on our part there is one single worship and praise." (Basil the Great)

**Titles**
The Hospitality (*Phyloxenia*) of Abraham; Old Testament Trinity; Trinity

**Feast day**
Movable: the Monday after the Byzantine Pentecost, or the first Sunday after the Latin Pentecost

**Source**
Genesis 18:1–15

**Iconography**
Three angels seated around a table, served by Abraham and Sarah; a servant sacrifices a calf; in the background, the oak tree of Mamre, a building or tent, and a mountain

The three pilgrims who visit Abraham at the hottest hour of the day in Mamre, a village known for its oak trees, turn out to be messenger angels of God. In the iconographical tradition, the majestic open-winged angels always assume more importance than Abraham and Sarah, who serve them at table. Abraham's hospitable table becomes the altar of the holy council of the three persons of the Trinity. From Byzantium this tradition passed on to Russia. There, Saint Sergius of Radonezh (d. 1391) founded a Monastery of the Holy Trinity near Moscow. The monk-painter Andrei Rublev later translated Sergius's vision into the extraordinary masterpiece of theological balance and artistic and spiritual beauty that is the icon of the Trinity (ca. 1411). At the Moscow Church Council "of the Hundred Chapters" in 1551, the Russian Orthodox Church declared Rublev's icon (p. 70) the sole, insuperable model that every painter must follow when representing the mystery of the Trinity. Much has been written and theorized about the identities of the three figures—that is, which angel represents the Father, which the Son, which the Holy Spirit—but the mystery remains. Indeed, Abraham saw three persons and worshiped one unity (*Tres vidit, unum adoravit*).

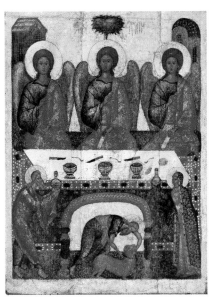

► *Old Testament Trinity,* sixteenth century. Moscow, Tretyakov Gallery.

The angel in the middle with flaming wings is Christ, as indicated by the letters in his halo. From the halo rises a stylized image of the oak of Mamre.

The open wings dominate the space, and their diagonals suggest that Sarah and Abraham's eyes are meeting those of the two respective angels, who form a square composition with the central angel.

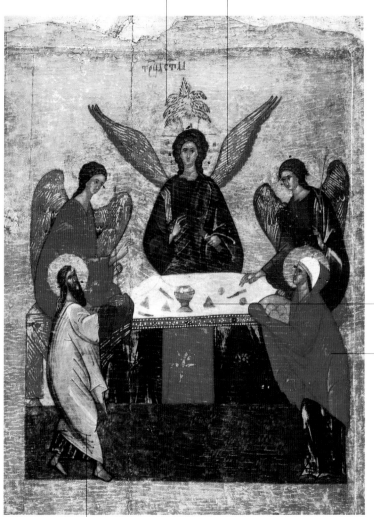

The white table, the knife-lance, the paten (diskos) with the loaf (which represents the Lamb), and the other pieces of bread cut up into triangles recall the typical elements of the Byzantine Divine Liturgy.

Sarah bears the bread fresh out of the oven, wearing a red cape that covers her hands. She directs her gaze at the angel on the upper left, who is announcing the birth of Isaac.

With hands covered, Abraham brings the sacrificial calf and speaks to the angel on the upper right.

▲ *Old Testament Trinity*, ca. 1420. Saint Petersburg, Russian Museum.

# The Hospitality of Abraham

The Temple stands behind the Father, mysterious and unknowable in his lilac-colored cloak; the blue robe glimpsed underneath represents the part of the heavens visible to man.

The mountain stands behind the Holy Spirit, the angel in the green cloak; some, however, identify this figure as the Son, because of his docile, obedient pose, and because he is looking at his reflection in the chalice of the sacrifice.

The profile of the thrones and footrests suggests an octagon (like a baptismal font), while all three figures are inscribed inside a circle, making this a perfect composition from a geometrical point of view.

The space between the two angels on the sides forms the outline of a chalice, holding the central figure.

▲ Andrei Rublev, *Old Testament Trinity*, ca. 1411. Moscow, Tretyakov Gallery.

The oak of Mamre (tree of life), whose roots plunge down into the chalice, stands behind the Son, in gold-banded red robes that billow out at the sleeve, representing the sacrifice. The splendid drapery of the lapis lazuli cape refers to the fullness of life.

Top row, left to right: The creation of the angels; creation of the heavens, earth, and waters; expulsion of the rebel angels; creation of the plants and animals; creation of man; original sin and banishment.

The angel announces to the incredulous Sarah, who is already elderly, that she will bear a son, Isaac.

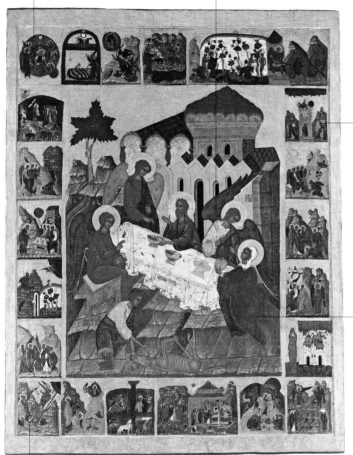

The scenes are read left to right down both sides: Noah's ark; the Tower of Babel; Abraham bows before the three guests; he washes their feet; serves them at table; and receives their blessing; the sacrifice of Isaac; the three angels visit Sodom; they rescue Lot; his wife turns into a pillar of salt.

Abraham offers food and receives the angels' blessing. The servant's slaughter of the animal foreshadows the sacrifice of Isaac. The diagonal table creates a rising movement from Sarah on the bottom right to the tree on the mountain on the upper left.

Bottom row, left to right: Jacob's Ladder; Moses and the burning bush; crossing the Red Sea; the Ark of the Covenant; Moses speaking with God; Saint Michael and Satan contending over Moses's body.

▲ Old Testament Trinity with Scenes from Genesis, ca. 1580–90. Solvychegodsk (Russia), Museum of History and Art.

# The Hospitality of Abraham

The inscription between the two oaks of Mamre reads: "The appearance of the life-principal Trinity in Abraham's tent."

The figure of the central angel dominates, and the use of black underscores God's unknowable nature.

Abraham and Sarah lean forward behind the two angels, their attitude expressing humility and servitude.

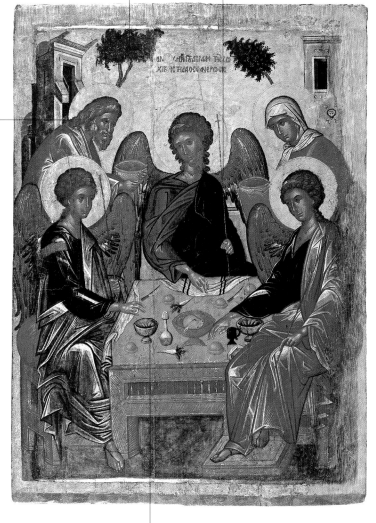

▲ *The Hospitality of Abraham*, fifteenth century. Athens, Byzantine Museum.

The table is richly set with loaves, root vegetables, and a calf's head in the dish. This icon is typical of the Cretan school, which was influenced by the late-Byzantine Palaiologan style.

*On Mount Horeb, the Lord reveals his presence to Moses in a bush that burns but is not consumed: a foreshadowing of Mary, who became a mother while remaining a virgin.*

# Moses and Aaron

God's friend and confidant, Moses leads the Jews out of Egypt. Despite the constant betrayal of his people, he never ceases to intercede on their behalf. Governor, prophet, and military leader, Moses ordains Aaron, his elder brother, as High Priest of Israel. As he is tending the flock of Jethro, his father-in-law, on the slopes of Mount Horeb, Moses has a strange vision of a bramble bush that burns without being consumed (Exodus 3:1–8). The episode of the burning bush received many interpretations, both iconographical and theological. The image already appears in its simplest form in Christian painting of the early centuries. From the fourth century on, it is endowed with a deeper significance by the Church Fathers and within the liturgical texts. Moses is often depicted removing his sandals, as a sign of respect for the holy place where God reveals himself. The presence of divinity, first suggested by the hand held up in benediction (*dextera Dei*), is indicated inside the bush itself: there the Virgin Mary appears together with an image of Christ Emmanuel, bearing in her bosom the flame of godliness, which burns within her but does not consume her. Moses, together with Christ and the prophet Elijah, also appears to the apostles in icons of the Transfiguration on Mount Tabor.

**Text**
"Put off your shoes from your feet; for the place on which you are standing is holy ground." (Exodus 3:1–8)

**Title**
Moses and Aaron

**Feast day**
September 4

**Source**
Exodus 3:1–8

**Iconography**
On the slopes of Mount Horeb, Moses removes his sandals before a vision of the bush that burns without being consumed; Aaron wears priestly vestments and headgear

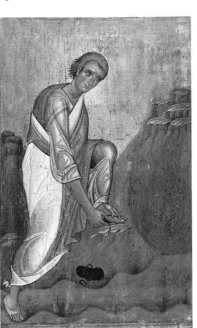

◀ *Moses before the Burning Bush*, late thirteenth century. Mount Sinai, Monastery of Saint Catherine.

73

## Moses and Aaron

On the gilt-edged, scarlet maphorion, the cross-shaped stars represent Mary's virginal motherhood. The blue color of her robes stands for her humanity.

Christ's red robes symbolize his divine nature, which, with his birth, took on our own human flesh, represented by the dark blue cloak.

John the Baptist points to the Christ child: "Behold the Lamb of God, who takes away the sin of the world!" (John 1:29).

A beardless Moses holds in his hand, covered by his scarlet cloak, a scroll bearing the word of the Law. He looks at Mary, a revelation of the mysterious bush he contemplated on Mount Horeb.

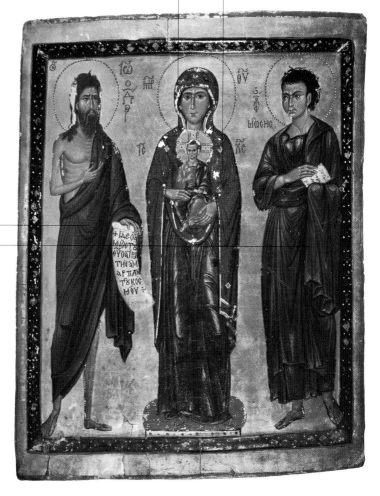

▲ The Virgin of the Burning Bush between Saint John the Baptist and Moses, ca. 1180. Mount Sinai, Monastery of Saint Catherine.

▶ Royal doors of the chapel of Saint John the Baptist, sixteenth century. Mount Sinai, Monastery of Saint Catherine.

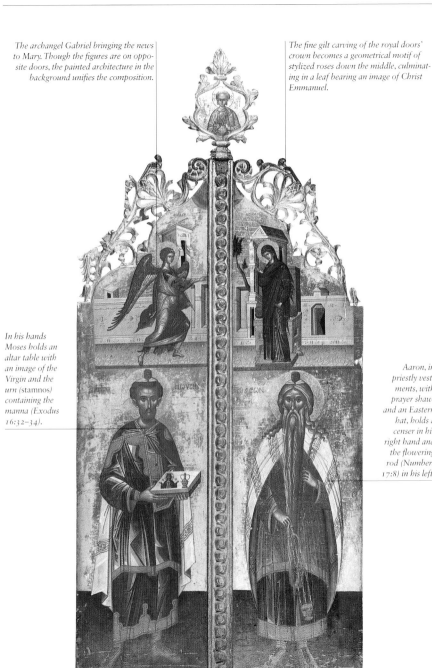

The archangel Gabriel bringing the news to Mary. Though the figures are on opposite doors, the painted architecture in the background unifies the composition.

The fine gilt carving of the royal doors' crown becomes a geometrical motif of stylized roses down the middle, culminating in a leaf bearing an image of Christ Emmanuel.

In his hands Moses holds an altar table with an image of the Virgin and the urn (stamnos) containing the manna (Exodus 16:32–34).

Aaron, in priestly vestments, with prayer shawl and an Eastern hat, holds a censer in his right hand and the flowering rod (Numbers 17:8) in his left.

*King David's song of penance, Solomon's love of wisdom, and Daniel's rescue from the lions' den are all images and prophecies of the coming of the Messiah.*

# David, Solomon, and Daniel

**Text**
"My God sent his angel and shut the lions' mouths, and they have not hurt me." (Daniel 6:22)

**Title**
David, Solomon, and Daniel

**Feast days**
David and Solomon, Sunday before Christmas; Daniel, December 17

**Sources**
2 Samuel 2; 1 Kings 3; Psalms 18, 51; Daniel 6; Sirach 47:2–11

**Iconography**
David, Solomon, and Daniel in prophets' robes, with royal crown and scrolls

In iconostases, at the center of the prophets' tier is always an icon of Mary, the Virgin who will bear the flower of Jesse's descendants (Isaiah 7:14). Yet it is not only the prophets' words but their very lives that anticipate and prophesy the fullness of the revelation that will occur in Christ. King David, Jesse's eighth son, prefigures the salvation the Messiah will bring: he defeats Goliath just as Christ will defeat Satan, and he shows mercy toward King Saul, his enemy. David is portrayed wearing a beard, and like Orpheus he is a singer and lyre player. He wrote numerous psalms, including the famous song of penance Psalm 51. Solomon, who became king of Israel around 970 B.C. (David died around 961), asks the Lord for the gift of wisdom and obtains it. The story of Daniel trapped in the lions' den and fed by the prophet Habakkuk is, according to the Church Fathers, a metaphor of the Eucharist. Daniel's emergence from the lions' den also prefigures Christ rising from the grave, as well as the early Christian martyrs.

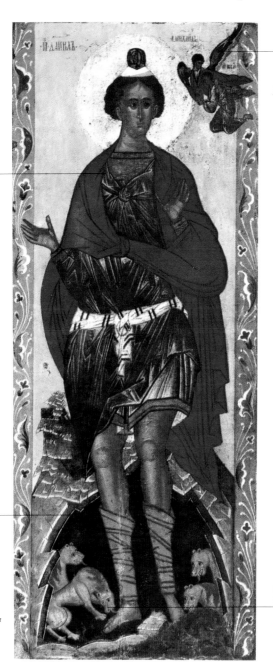

The prophet
Habakkuk, carried
through the air from
Judea to Babylonia by
the angel of the Lord,
feeds the hungry
Daniel.

The prophet Daniel
with spread hands, an
expression of prayer
and surprise at having
been saved by God's
intervention.

Wearing a short robe,
a broad cloak, and a
Phrygian hat, Daniel
rises up from the den
where he had been
imprisoned by King
Cyrus of Persia for
having killed a sacred
snake.

◄ Novgorod school,
*Daniel, David, and
Solomon*, 1497.
Moscow, Tretyakov
Gallery.

► *The Prophet Daniel in
the Lions' Den*,
sixteenth century.
Novgorod (Russia),
museum.

The ferocious lions,
rather than mauling
the prophet Daniel,
lick his feet affection-
ately; after seven days,
Daniel is found alive
inside the den in which
he had been locked up.

# David, Solomon, and Daniel

Moses and Jonah (far ends, opposite one another) carry accounts of the prophetic events that occurred in their lives. On Mount Horeb, Moses contemplated the bush that burned but was not consumed, a foreshadowing of the Virgin Mary, while Jonah, a recalcitrant prophet, spent three days inside the belly of the whale, prefiguring the three days Christ spent in the tomb.

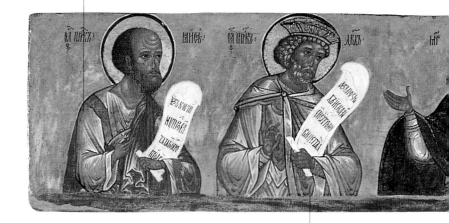

Beyond the confines of time and history, in a spiritual space emphasized by the green background, David and Solomon bend in prayer before the Mother of God and Christ Emmanuel, in whom their prophecies have been fulfilled.

▲ *Prophets' Tier*, first half of sixteenth century. Moscow, Tretyakov Gallery.

The image of the Mother of God of the Incarnation is a variant of the Virgin of the Sign. Here, instead of being inscribed inside a medallion, Christ Emmanuel appears between the folds of Mary's scarlet maphorion, *whose shape is reminiscent of a chalice.*

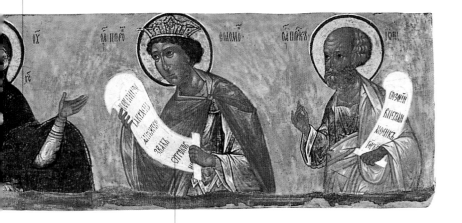

Inscriptions on the unfurled scrolls compare Mary to the burning bush. The crowns of David and Solomon indicate Christ's royal lineage, while their haloes represent his holiness.

*An angel saves Shadrach, Meshach, and Abednego from the fiery furnace of King Nebuchadnezzar. The three youths dance in the fire and praise the Lord.*

# The Three Youths in the Fiery Furnace

**Text**
"Then these three in the furnace with one voice sang, glorifying and blessing God: Blessed are you, O Lord, the God of our fathers." (Daniel 3:51, *New American Bible*)

**Title**
The Three Youths in the Fiery Furnace

**Feast day**
December 17

**Sources**
Genesis 1:8; Daniel 3

**Iconography**
Three youths dance amid the flames in a furnace, protected by an angel; three servants stoking the fire are struck down by the terrible blaze; from his throne King Nebuchadnezzar issues orders; beside him, atop a column, stands an idol

▶ Novgorod school, *The Three Youths in the Furnace*, late fifteenth century. Saint Petersburg, Russian Museum.

The book of Daniel tells the story of Shadrach, Meshach, and Abednego, who lived with the prophet in the court of King Nebuchadnezzar. When the three refuse to worship a pagan deity, the king punishes them by casting them into a fiery furnace, commanding that it be heated "seven times more than it was wont to be heated" (Daniel 3:19). While the executioners are snuffed out by the terrible blaze of heat, the angel of the Lord protects the three young Jews, who are "walking in the midst of the fire," as though they are strolling through earthly paradise (the same verb for "walking about" is used in Genesis 1:8, when the Lord "walks about" in the garden). Amid the flames, all three youths together praise and bless God. Nebuchadnezzar, seeing the men dancing in the flames, recognizes and blesses "the God of Shadrach, Meshach, and Abednego." The image of the three youths with arms raised in prayer amid the flames, protected by an angel, appears very early in Christian art. Early Christians interpreted the liberation of the three youths as an image of the resurrection of the dead.

80

*In Russia this prophet took the place of Perun, the Slavic god of thunder, who, like Elijah, rides into heaven on a chariot of fire drawn by celestial horses.*

# Elijah

A native of Galaad, in Transjordania, Elijah told his prophecies in the decade 860–850 B.C., during the reign of King Ahab and Queen Jezebel. The image of his ascent into heaven on a chariot of fire, under the terrified eyes of his disciple Elisha (Eliseus), appears in countless icons. In the frames of these icons we often find pictorial accounts of his story, as narrated in 1 Kings 17–19. After predicting a famine, Elijah takes refuge in a desert cave, where he is fed by a crow, a scene we see represented in many icons. Returning to the king's court, Elijah wins a challenge and puts to the sword the four hundred priests of Baal. Then he flees into the desert, where he prays for death. An angel appears, however, bringing him food. Strengthened by this bread, which the Church Fathers saw as prefiguring the Eucharist, Elijah walks for forty days, until he reaches God's mountain, Horeb. Here he has that extraordinary, ineffable experience of finding God, not in the wind or the earthquake or the fire, but in a "small voice." Elijah appears with Moses beside Christ on Mount Tabor in icons of the Transfiguration. He ranks among the great mystics of Israel. The Carmelite order, called "children of Elijah," considers the prophet their founder.

**Text**
"Then the prophet Elijah arose like a fire, and his words burned like a torch."
(Sirach 48:1)

**Title**
Prophet whose name in Hebrew means "Yahweh is God"

**Feast day**
July 20

**Sources**
1 Kings 17–19; 2 Kings 2:11, Sirach 48:1

**Iconography**
Elijah rises into the heavens on a chariot of fire in front of Elisha, who holds on to his cloak

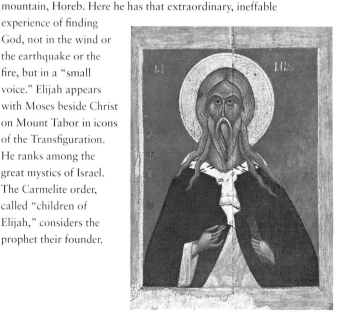

◀ *The Prophet Elijah*, late fourteenth–early fifteenth century. Moscow, Tretyakov Gallery.

81

# Elijah

The rocks mark the distance between earth and heaven, from which comes salvation.

By the order of the Lord, the crow brings Elijah bread in the morning and meat at night.

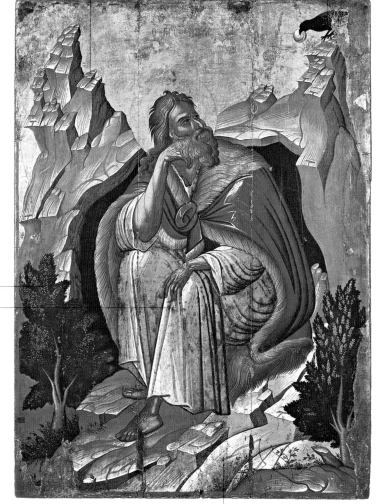

Two verdant trees suggest the lushness of the site. The flashes of light on the clothing, the rocks, and the trees' boughs indicate the presence of God.

Seated in contemplation, Elijah holds between his fingers the monastic rosary of the Jesus prayer, his shoulders wrapped in a fur cloak.

▲ The Prophet Elijah, early seventeenth century. Athens, Byzantine Museum.

The waters of the torrent Cherith slake Elijah's thirst. They are a gift from God and reflect his light.

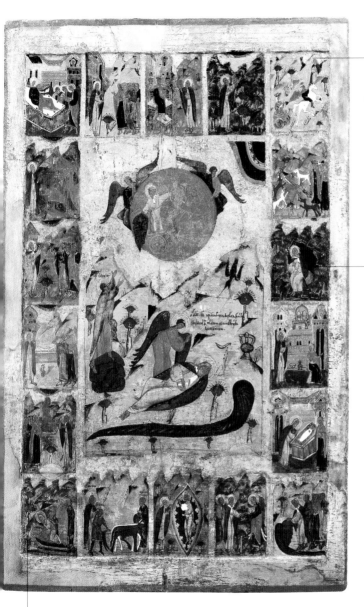

*Left to right across the top: Birth of Elijah; meeting with the priests; Elijah prophesies about Ahab; praying in the desert; meeting with Queen Jezebel. Just below the latter, wild beasts attack the queen.*

*Down the right side: Elijah in the desert; he asks the widow for help; resurrecting the widow's son.*

*Down the left side: Elijah with the king's messengers; he challenges the priests of Baal; he makes a sacrifice to God; fire descends from the heavens. Bottom row, left to right: Elijah slays the priests; Elijah calls Elisha; Christ appears to Elijah; an angel blesses him; Elijah separates the waters of the Jordan River.*

▲ *The Fiery Ascent of the Prophet Elijah, with Scenes from His Life,* first half of the seventeenth century. Arkhangelsk (Russia), Museum of Fine Arts.

# Elijah

In a quarter-circle, representing heaven, appears the blessing hand of God.

Standing on the chariot, Elijah reaches his hands toward God, and an angel behind him echoes the gesture.

The red circle inside which Elijah's chariot is inscribed is drawn by three winged horses.

An angel brings food and drink to Elijah in the desert.

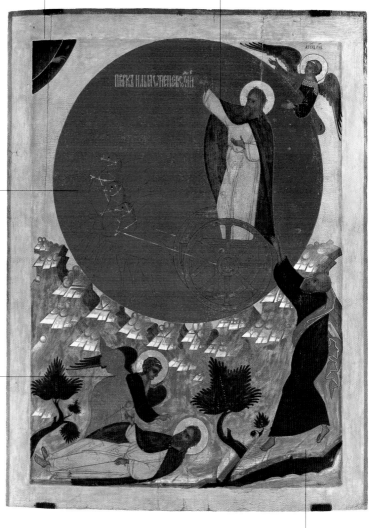

▲ *The Fiery Ascent of the Prophet Elijah*, ca. 1570, Solvychegodsk (Russia), Museum of History and Art.

Elisha grabs an end of Elijah's cloak as the prophet is about to be borne off into heaven; with it, Elisha will move the waters of the Jordan, which will open up under his feet.

Elijah towers majestically, his right hand raised in benediction, while the other holds a fluttering scroll that reads, "I have been very jealous for the Lord, the God of hosts" (1 Kings 19:10/14).

The four rearing horses around Elijah are an incandescent red. They will carry him off in a whirlwind into the sky.

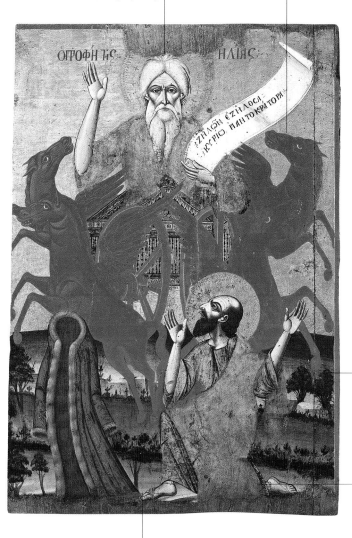

The waters of the Jordan, which Elisha will walk across, become dense and solid as though paved.

Elisha, kneeling in profile, raises his arms in prayer and receives the spirit of the prophet.

▲ Berat school, *Prophet Elijah on the Chariot of Fire*, eighteenth century. Tirana (Albania), Institute for Cultural Monuments.

Elijah's cloak, left behind with Elisha, stands by itself because it contains the spirit of the prophet.

*Isaiah's messianic prophecies are full of visions that have been captured in art: the Tree of Jesse, Emmanuel, the heavens rolled up like tents, the seraph with the live coal in his hand.*

# Isaiah

**Text**
"Therefore the Lord himself will give you a sign. Behold, a young woman shall conceive and bear a son, and shall call his name Immanuel." (Isaiah 7:14)

**Title**
Prophet whose name means "Yahweh saves"

**Feast day**
May 9

**Sources**
Isaiah 6, 7:14, 11:1

**Iconography**
Isaiah is represented with the scroll of his prophecy, and tongs holding the burning coal that the seraph used to cleanse his lips

Isaiah accomplished his prophetic and civic mission over a forty-year period under Kings Uzziah, Jotham, Ahaz, and Hezekiah. Through his interventions, Isaiah helped safeguard the peace and freedom of Jerusalem, which was besieged by the Assyrians. At the beginning of his mission, in the year King Uzziah died (740–739 B.C.), he has a direct, sensory experience of God. Isaiah sees the Lord sitting on a high throne inside the Temple and hears the voices of the seraphim. He speaks aloud, saying, "Woe is me! . . . I am a man of unclean lips!" but a seraph touches his lips with a burning coal, purifying him, and he responds to the Lord, who is calling him. He begins an intimate dialogue with God, a series of questions and answers. A constant in Isaiah's words is the prediction of Christ's coming, which the prophet announces to King Ahaz as Emmanuel, an infant named "God with us" who will save the people. The

▶ *The Prophet Isaiah*, ca. 1560. Novgorod (Russia), museum.

prophecy of a virgin who "shall conceive and bear a son" (Isaiah 7:14) forms the foundation of the iconography of Christ Emmanuel and the Virgin of the Sign. The image of Simeon welcoming Christ in his arms (Luke 2:28) is also a reference to Isaiah. Another image from Isaiah is that of the shoot that "shall come forth . . . from the stump of Jesse" (Isaiah 11:1), father of David and progenitor of Christ.

*From Abraham, father of the faith, will descend forty-two generations until the coming of the Messiah: patriarchs, kings, and prophets who make up the family tree of Jesus Christ.*

# The Tree of Jesse

The Gospel of Matthew recounts Christ's genealogy with precision: fourteen generations from Abraham to David; fourteen from David to the Babylonian captivity; and another fourteen to the birth of Jesus, son of Joseph and Mary. Seven hundred years before Christ, Isaiah (11:1) spoke of the Messiah as a "shoot" that "shall come forth . . . from the stump of Jesse." Jesse is the father of David and the forebear of the kings of Judea. The image of the "rod," "shoot," or "tree" is often used in the Bible to signify the birth of a new reality. The Tree of Jesse is a visualization of Christ's family tree, at whose root stands either Adam, Jesse, or King David himself. Inserted in the curling branches are the busts of the ancestors, kings, and prophets. The first generations of Christians, and later the Church Fathers, gave a Marian bent to the genealogy of Matthew, whose Gospel was read during the Christmas liturgy. The center of the composition thus becomes the Virgin enthroned with the Child. From this derives an iconographic composition called the Praise of the Mother of God, in which the prophets offer Mary symbols from the *Akathistos* hymn.

**Text**
"Rejoice, O rod, O divinely-planted branch! You alone are mother among all virgins. Without seed you sprouted from your bosom a Son who is God and Father of all creation." (Byzantine liturgy)

**Title**
Tree of Jesse (*Rhiza tou Iessai, Drevo Iesseevo*)

**Sources**
Isaiah 11:1; Matthew 1:1–17; Romanos the Melodist; Andrew of Crete; Germanus of Constantinople; Joseph the Hymnographer; Theodore the Studite; Irenaeus of Lyon; Hippolytus of Rome; Pseudo-Epiphanius

**Iconography**
From Jesse rises a tree trunk with seven branches on both sides, representing the forty-two generations from David to Jesus

◄ Antonios Sigalas, *The Tree of Jesse* (detail), 1786. Athens, Byzantine Museum.

87

# The Tree of Jesse

In the frame, Christian and pagan philosophers and wise men (Aristotle, Plato, and Pythagoras) form the Temple of Wisdom, crowned above by its seven domes.

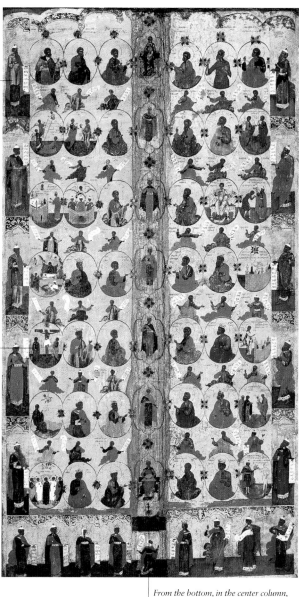

The half- and full-length figures above the medallions constitute fourteen rows of generations. Inside the circles are also some Gospel scenes.

▲ Workshop of the Moscow Kremlin Armory, *The Tree of Jesse*, 1660–70. Moscow, Tretyakov Gallery.

From the bottom, in the center column, are the prophet Balaam, kneeling; the recumbent Jesse inside the black rectangle; King David playing the psaltery; five kings of David's line; and, at the summit, the Virgin with the Christ child.

*The vision of Ezekiel, the ultimate direct experience of God in the Old Testament, prefigures the vision of the throne with the four living creatures, in Revelation.*

# The Vision of Ezekiel

The vision of the priest Ezekiel ("God is strong") foreshadows the vision of the Throne of God in the Apocalypse of John (Revelation 4:6–9), the source for the iconography of Christ in Majesty (*Maiestas Domini*) that appeared very early in Christian art. Among other things, Ezekiel's vision also justifies, from a theoretical point of view, the representability of God's glory. As the story goes, the prophet, finding himself among the exiles to Babylonia (593–592 B.C.) on the banks of the Chebar River (a canal of the Euphrates), sees four living creatures (man, lion, eagle, and bull) in a whirlwind of fire and, seated among the clouds, a human figure in brightness. Falling to the ground, Ezekiel hears a summons to eat a scroll containing bitter prophecies, which will taste "sweet as honey." In the vision, Christ Emmanuel sits atop a rainbow inside a round mandorla representing the depths of the heavens. In the Kremlin painting to the right, God's power is made manifest in a tempest that shakes the ground like an earthquake and sets the fish into panicked motion. Ezekiel is represented twice: on the left, he has his vision; and on the right, he eats the scroll.

**Text**
"And above the firmament over their heads there was the likeness of a throne, in appearance like sapphire; and seated above the likeness as it were of a throne was a likeness as it were of a human form." (Ezekiel 1:26)

**Title**
The Vision of Ezekiel

**Feast day**
July 23

**Sources**
Ezekiel 1, 2, 3:1–3;
Revelation 4:6–9

**Iconography**
Ezekiel eating the scroll while in heaven he sees a mandorla with four winged creatures (in the forms of a man, bull, eagle, and lion) and a human figure at the center, held up by flaming wheels and cherubs' wings

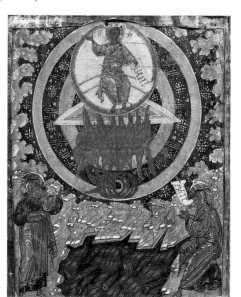

◀ *Vision of the Prophet Ezekiel on the Banks of the Chebar*, originally from the Solovki monastery, second half of sixteenth century. Moscow, Kremlin Museums.

# The Vision of Ezekiel

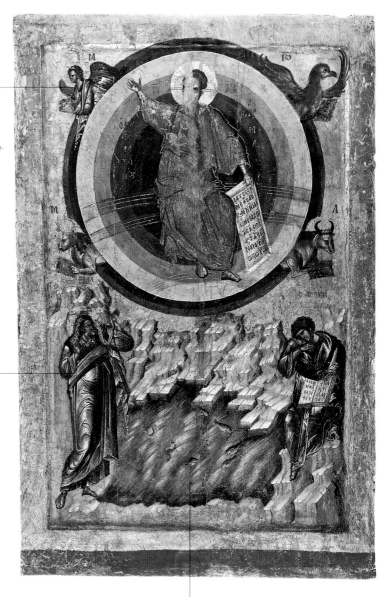

Christ
Emmanuel,
seated on the
rainbow, is sur-
rounded by the
four winged crea-
tures, reinter-
preted here as
symbols of the
four evangelists.
The mandorla
suggests the
impenetrable
darkness of the
heavens.

Ezekiel raises
his arms, over-
whelmed by
the vision. To
his right, the
prophet
Habakkuk
holds a book
with the words
"Son of man,
eat this scroll"
(Ezekiel 3:1).

▲ *Vision of the Prophets Ezekiel and
Habakkuk*, originally from the
Poganovo Monastery, ca. 1371–93. (The
other side of this two-sided icon appears
on page 209.) Sofia (Bulgaria), National
Art Gallery.

*The vision is so intense that the earth and
waters seem roiled by an earthquake.
Some of the fish are headless sirens, repre-
senting the end of the pagan world.*

90

*The "sign of Jonah" is that the prophet remained for three days inside the belly of the great whale, just as Christ would remain in the sepulchre three days before rising again.*

# *Jonah*

Little is known about this prophet who lived, according to the second book of Kings, in the eighth century B.C., at the time when Jeroboam II ruled over Samaria. He is simply called "son of Amittai, the prophet, who was from Gath-hepher" (2 Kings 14:25), a site in Palestine thought to be near Nazareth. Written centuries after his death, the book of Jonah does not present the prophet's utterances but rather tells his story in four brief chapters. Sent by the Lord to preach at Nineveh, Jonah escapes on a ship but ends up being swallowed by a great whale. Three days later it spits him back up on the shore. Jonah goes to Nineveh after all, and the city is converted. In the Gospel of Matthew (12:39–40), Jesus relates his own death and resurrection to the story of Jonah. Just as the prophet remained three days inside the belly of the whale, so Christ shall remain three days inside the sepulchre before rising again. The "sign of Jonah" will serve as a warning to unbelieving Israelites: while the pagans of Nineveh believed the words of Jonah, the scribes and Pharisees did not do the same for Christ. The image of Jonah being cast into the sea (a symbol of evil) also recalls icons of the Baptism: Jesus is immersed in the "liquid sepulchre" of the Jordan, and we, in the sacrament of baptism, are buried in his death (*kenosis*).

**Text**
"For thou didst cast me into the deep, into the heart of the seas; and the flood was round about me; all thy waves and thy billows passed over me." (Jonah 2:3)

**Title**
*Jonah* in Hebrew means "dove"

**Feast day**
September 21

**Sources**
Jonah; Matthew 12:39–40

**Iconography**
Jonah is cast into the sea from a ship, swallowed by a great whale, and spit back up on the shore. He rests in the shade of a gourd plant. In the background lies the city of Nineveh with its inhabitants

◀ *The Story of the Prophet Jonah* (detail), early seventeenth century. Saint Petersburg, Russian Museum.

91

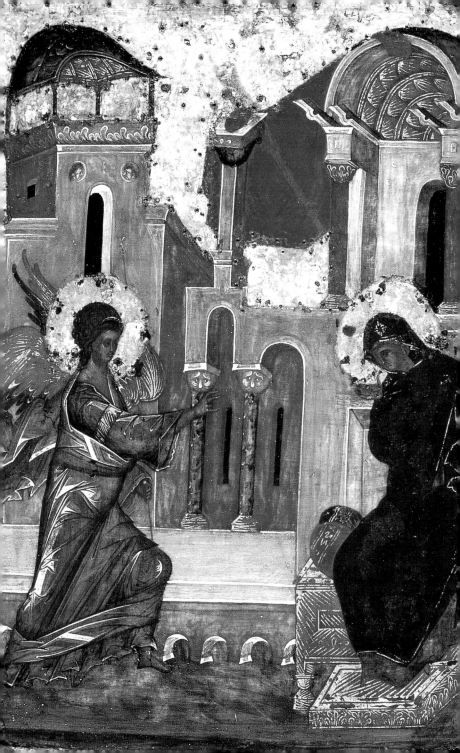

# GOSPEL EPISODES AND CHURCH FEASTS

*Joachim and Anne*
*The Birth of the Virgin*
*The Presentation of the Virgin*
*The Annunciation*
*The Visitation*
*The Nativity*
*The Presentation of Jesus*
*Simeon with the Christ Child*
*Christ in the Synagogue*
*John the Baptist*
*The Baptism of Christ*
*The Wedding Feast at Cana*
*The Transfiguration*
*Christ and the Samaritan Woman*
*The Raising of Lazarus*
*The Entry into Jerusalem*
*The Last Supper*
*The Passion of Christ*
*The Crucifixion*
*The Deposition and The Lamentation*
*The Harrowing of Hell*
*The Women at the Tomb*
*Doubting Thomas*
*The Ascension*
*Pentecost*
*The Dormition of the Virgin*
*The Exaltation of the Cross*
*The Last Judgment*

◄ Moscow school, *The Annunciation* (detail), ca. 1420. Moscow, Tretyakov Gallery.

*The childless old couple embrace in front of the Golden Gate at Jerusalem: in secular art, such an embrace signifies that an illustrious person has been conceived.*

# Joachim and Anne

**Text**
"The fruit of connubial relations between Joachim and Anne is the Virginity of Mary, following the path from the corporeal to the spiritual." (Vladimir Solovyov)

**Title**
The Conception of the Virgin

**Feast days**
Joachim and Anne, September 9; Conception of Anne, December 9

**Sources**
Protoevangelion (Infancy Gospel) of James; Maximus Confessor, *Life of the Virgin*; John of Damascus, *Homilies on the Birth of the Virgin*; Andrew of Crete, *Marian Homilies*

**Iconography**
Joachim in the desert and Anne in the garden receive the angel's announcement; the couple embrace before the Golden Gate

▶ *Joachim and Anne in the Desert*, scene from *The Intercession of the Virgin*, originally from Ustiug, Cathedral of the Nativity, mid-sixteenth century. Vologda (Russia), museum.

The names and stories of Mary's parents, the "grandparents" of Jesus Christ, do not appear in the canonical Gospels, but only in an apocryphal text, the Protoevangelion (Infancy Gospel) of James. It tells of one Joachim, a rich and pious Israelite, whose sacrificial offering is refused at the Temple because he has reached an advanced age without progeny and his wife Anne is no longer fertile. Sad and disconsolate, Joachim withdraws to the desert to fast and pray. Meanwhile, his wife, left alone, laments her sterility. Later, however, each is visited by an angel: they reunite and conceive Mary, the mother of Jesus, because "nothing is impossible for God." The figure of Anne echoes analogous sterile women in the Old Testament: Sarah, Abraham's wife, who conceives Isaac in old age; Hannah, wife of Samuel; and Elizabeth, wife of Zechariah, cousin to Mary, and mother of John the Baptist. The stories of

Joachim and Anne are depicted in the frames of many icons whose main subject is the Annunciation or the Presentation of the Virgin in the Temple. In the seventh century the emperor Justinian erected a church in Saint Anne's honor in Constantinople, thus promoting her cult. Many churches in Muscovite Russia were dedicated to the Conception of Anne.

The red cloth linking the two buildings indicates that the encounter is taking place indoors. The perspective of the buildings is reversed and converges on the two embracing bodies of the couple.

Anne runs into Joachim's arms; her fluttering cape underscores her rapture, while the symmetry of their arms and the sweet cheek-to-cheek embrace express union.

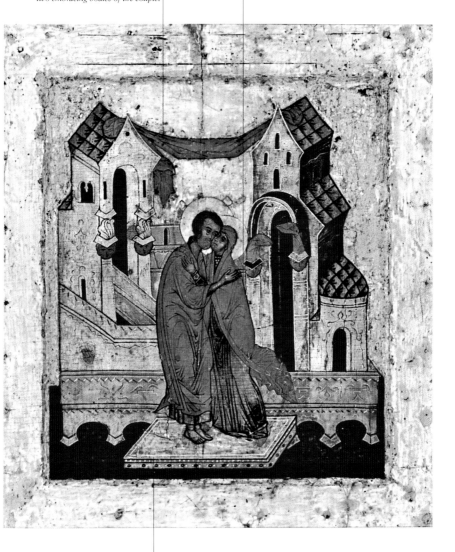

▲ Novgorod school, *The Conception of Saint Anne*, fifteenth century. Recklinghausen (Germany), Icon Museum.

The suspended platform situates the couple's embrace in an otherworldly dimension; the green represents the crystal sea mentioned in the Apocalypse and the meadow of paradise.

# Joachim and Anne

Between the multicolored houses blossoms a symbolic dome that towers over the Golden Gate of the city of Jerusalem. The scene derives from the secular iconography of the conception of illustrious people.

Angels tell Joachim in the desert (upper left) and Anne in the garden (right) that the time of their barrenness is over, and that soon they will conceive a daughter, Mary.

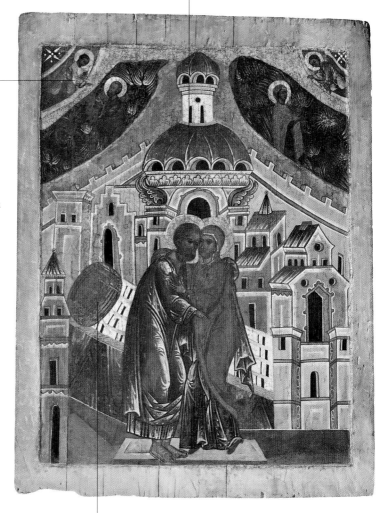

▲ *The Conception of Saint Anne*, originally from Lopasnia (now Chekhov), Church of the Conception, late sixteenth century. Moscow, Andrei Rublev Museum.

Behind the couple, the image of a white marriage bed with black bands and purple pillow has a number of meanings: it stands for conception pure and simple, but also for Mary as the "mystical ladder" down which the Lord will descend, and the altar of the eucharistic sacrifice.

*This feast day, a joyous occasion because through Mary the Savior came into the world, is celebrated on September 8, to signify the symbolic plenitude of the eighth day.*

# The Birth of the Virgin

This feast originated in fifth-century Jerusalem, where, according to tradition, the house in which Mary was born stood near the Pool of Bethesda, close to the present-day basilica of Saint Anne. The day, September 8, falls in the beginning of the Byzantine liturgical year and is considered the origin of all feast days, since, with the birth of the Virgin, the story of man's salvation begins. It also represents the plenitude of the eighth day, the day of resurrection, which follows the six days of creation and the seventh day of rest. The number 8 is also represented by the octagonal shape of baptismal fonts (and baptisteries), the place where the catechumen is reborn to a new life. Icons of Mary's birth represent the interior of Anne's home and a variety of situations: an anxious Anne contemplating the mystery that has taken place inside her; three handmaidens bringing her a cup, a fan, and some eggs, symbols of fertility and life; the midwife, aided by a servant girl, giving Mary her ritual bath. Joachim looking watchfully from a window; he and Anne coddling Mary. The Virgin is represented the size of a baby but with adult features, a halo, and the initials of her royal title: Mother of God.

**Text**
"Today Anne the barren gives birth to the Child of God, foreordained from all generations to be the habitation of the King of all." (Great Vespers for September 8)

**Title**
Birth of the Mother of God (*Genethlion tes Theotokou, Rozhdestvo Bogoroditsy*)

**Feast day**
September 8

**Sources**
Genesis 28:10–18; Proverbs 9:1–11; Ezekiel 43:27, 44:1–4; Matthew 1:20–25; Luke 1:26–39; Protoevangelion of James; John of Damascus, *Homilies on the Birth of the Virgin, Homilies on the Blessed Virgin*; Andrew of Crete, *Marian Homilies*; Photius, *Homilies on the Birth of the Virgin*; Romanos the Melodist, *Kontakion on the Birth of the Virgin*

**Iconography**
Anne on her bed, being served by three handmaidens, while two attendants bathe Mary; Joachim looks on

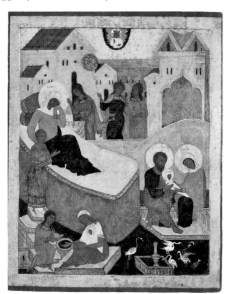

◀ *The Birth of the Virgin*, originally from the Simon Monastery, Church of the Nativity of the Virgin, early seventeenth century. Moscow, Kolomenskoe Museum.

*During an apprenticeship in the Temple lasting from age three to age twelve, Mary is prepared to become the Mother of God, the woman in whom the Holy Spirit will dwell.*

# The Presentation of the Virgin

**Text**
"Hear, O daughter, consider, and incline your ear; forget your people and your father's house; and the king will desire your beauty."
(Psalm 45:11)

**Title**
The Entry into the Temple
(*Eisodia tes Theotokou, Vvedenie vo Khram*)

**Feast day**
November 21

**Sources**
Protoevangelion (Infancy Gospel) of James; Maximus Confessor, *Life of the Virgin*; Tarasius of Constantinople; Peter of Argos; Germanus, *Homily for the Presentation*; George the Hymnographer, *Kontakion on the Presentation*

**Iconography**
Mary being presented to Zechariah; Mary in the sanctuary, nourished by an angel

▶ *The Presentation of the Virgin in the Temple*, detail of *The Annunciation, with Scenes from the Life of the Virgin*, ca. 1580–90. Solvychegodsk (Russia), Museum of History and Art.

Accompanied by a procession of virgins, Joachim and Anne present little Mary to the priest, who welcomes her into the Temple. There she will remain until adolescence. The icon of this scene represents the procession accompanying Mary and, in an upper room of the sanctuary—the heart of the Temple—the Virgin receiving the divine nourishment, the bread of contemplation, from an angel. The Virgin and the Temple become identified with one another: Mary lives inside the sanctuary just as Jesus will live inside her body; Christ's divinity is thus entirely hidden within his humanity, according to the logic of the incarnation. Likewise, the veil of the Holy of Holies that the Virgin is weaving when she receives the announcement from Gabriel represents Christ, who will be woven within her

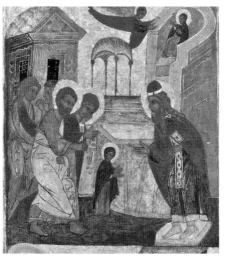

womb. The feast day of the Presentation of the Virgin corresponds to the dedication day of the New Church of Saint Mary in Jerusalem, built by Patriarch Elias and financed by the emperor Justinian, on November 21, 543. The holiday later spread to Constantinople, in the seventh and eighth centuries.

In the heart of the Temple, in the room at the top of the stairs, Mary receives a visit from the archangel Gabriel, who nourishes her with heavenly bread that foreshadows the Eucharist.

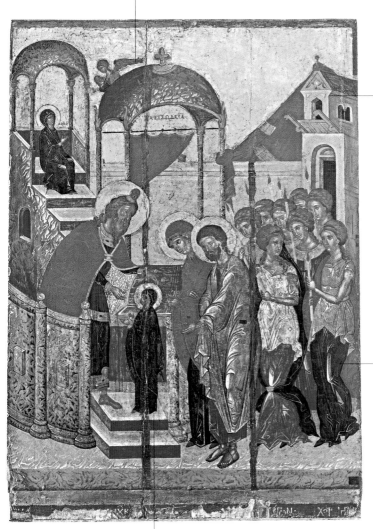

The red curtain stretching from the building roofs to the column of the baldachin represents the edge of the Lord's cloak in the vision of Isaiah. It indicates that the scene is taking place inside the Temple.

Joachim and Anne, followed by a procession of virgins holding lighted candles.

▲ Angelos, *The Presentation of the Virgin in the Temple*, mid-fifteenth century. Athens, Byzantine Museum.

Mary, who has a child's stature and the features of an adult, is represented standing on the steps of the Temple, opening her hands to the priest in a gesture of self-offering.

99

# The Presentation of the Virgin

Across the top: Joachim's sacrificial offering is refused; an angel speaks to Joachim among the shepherds; an angel speaks to Anne in her garden; the couple embrace and conceive; Mary's bath after her birth, in the presence of Joachim and the handmaidens.

The flight of the angel, perfectly horizontal and counterbalanced with the movement of the tree's foliage, harmonizes with the equilibrium of the whole composition.

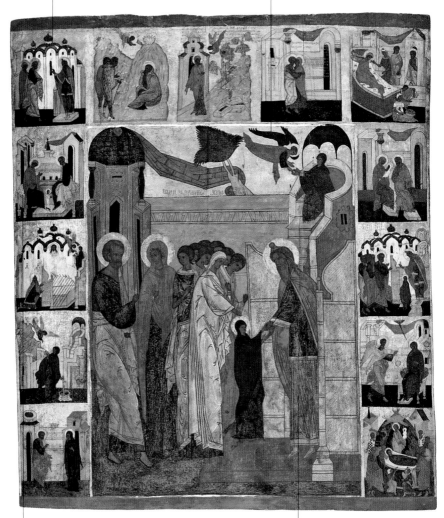

Left to right down both sides: Mary's first steps; her parents caressing her; Zechariah's prayer before the rods of her suitors; Mary being introduced to Joseph; an angel speaks to Mary at the well; the Annunciation; Joseph reproaches Mary; the Dormition.

The geometrical structure, the elongated figures, the warm tones, and the stories in the frame give this icon a special charm.

▲ Novgorod school, *The Presentation of the Virgin in the Temple with Scenes from Her Life*, sixteenth century. Moscow, Tretyakov Gallery.

*The feast day of March 25 coincides with the spring equinox, the time when, according to certain ancient beliefs, the first man was created. Mary is the new Eve, from whom Jesus will be born.*

# The Annunciation

Alongside the holy days of Easter and the Epiphany, dedicated solely to Christ, stands the feast of the Annunciation, which exalts the divine motherhood of Mary (proclaimed by the Council of Ephesus in 431). The date of the feast, March 25, falls exactly nine months before the Nativity (December 25). The earliest icons of the Annunciation present the Virgin and Gabriel standing and engaged in a silent dialogue of eyes and hands. If Mary's hand is open toward the archangel, as if signaling him to stop, it indicates reserve and detachment. If it is folded back onto her breast, it expresses consent and submission. Later on, the compositions acquire more movement, and the archangel is seen rushing up to the Virgin, who is seated on a throne. The iconography of the Annunciation, taking its cue from the Protoevangelion of James, is broken up into two different moments: the archangel appears first at the well, as Mary is drawing water; then he appears a second time, in her home, as Mary is weaving the purple veil for the Temple. This veil represents the body of Jesus, which has assumed human flesh inside her.

**Text**
"Today is the beginning of our salvation and the manifestation of the mystery which is from eternity. The Son of God becomes the Son of the Virgin, and Gabriel announces grace. So with him let us also cry to the Mother of God: Rejoice, thou who art full of grace. The Lord is with thee." (Troparion for March 25)

**Title**
Annunciation
(*Chairetismos*;
*Blagoveshchenie*)

**Feast day**
March 25

**Sources**
Luke 1:28–30;
Protoevangelion (Infancy Gospel) of James;
*Akathistos* hymn

**Iconography**
The archangel Gabriel with Mary; she is at the well or at home weaving the purple skein for the Temple and seated on a throne

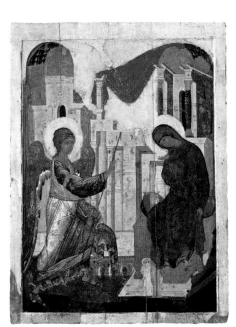

◄ Andrei Rublev and assistants, *The Annunciation*, from the Dormition Cathedral in Vladimir, 1408. Moscow, Tretyakov Gallery.

# The Annunciation

The Virgin's head is bowed as she listens to the angel. Her right hand echoes the angel's greeting, while Christ takes on human form in her bosom. Indeed, Jesus is represented symbolically between the folds of her cloak, as if he were being born from the purple skein Mary is holding in her other hand.

The archangel's archaic solemnity is expressed in the gentle firmness of his arm, which is raised in a gesture of benediction. The gilt background and haloes were lost in the sixteenth century, when the icon was transported from Novgorod to Moscow.

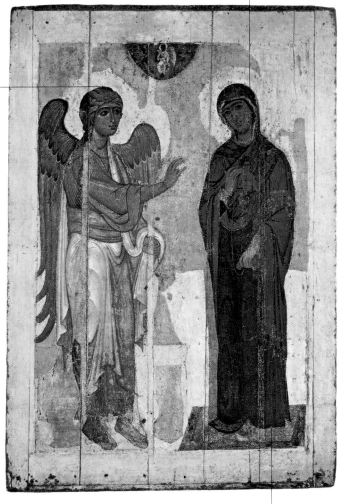

▲ *The Annunciation*, ca. 1120. Moscow, Tretyakov Gallery.

Mary's human nature is symbolized by her blue-green tunic, while the dark red cloak indicates that she has been invested with divine royalty. The footstool Mary is standing on places her in a sacred, regal dimension.

*Left to right and down both sides: Joachim and Anne present their offering; they are rejected for being barren; angels promise them a child; Conception of Anne; Birth of Mary; benediction of Mary; Mary caressed by her parents; her first steps; Presentation of Mary; the prayer before the rods left by Mary's suitors; marriage to Joseph; Annunciation at the well.*

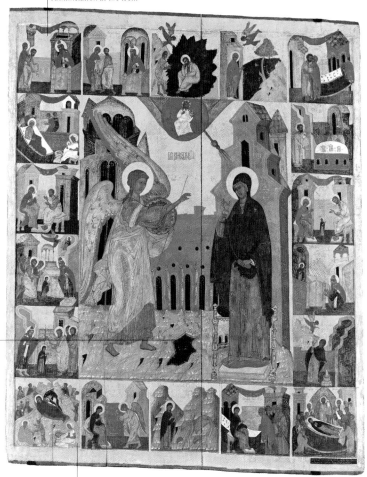

*The cave that opens up in the ground between the Virgin and Gabriel symbolizes death and hell and alludes to the birth of Christ. He would later enter that cave to redeem the world from death and sin.*

*Bottom row, left to right: Nativity of Christ; Gabriel announces to the Virgin her approaching death; Mary on the Mount of Olives; Mary taking her leave from the women of Jerusalem; Dormition.*

▲ *The Annunciation, with Scenes from the Life of the Virgin*, ca. 1580-90. Solvychegodsk (Russia), Museum of History and Art.

*Mary and Elizabeth embrace. The Baptist's future mother blesses Mary, who, overcome with joy, sings her Magnificat.*

# The Visitation

**Text**
"Carrying God in her womb, the Virgin hastened to Elizabeth, whose unborn babe straightaway perceiving her salutation rejoiced; and with leaps as it were with songs, he cried out to the Mother of God: Rejoice." (*Akathistos* hymn)

**Title**
The Embrace (*Aspasmos*) or Meeting (*Vstrecha*) of Mary and Elizabeth

**Feast day**
May 31

**Sources**
Luke 1; *Akathistos* hymn; Dionysios of Fourna, *Painter's Manual*

**Iconography**
Mary and Elizabeth embrace, sometimes in the presence of the conversing husbands, Joseph and Zechariah

The most ancient representations of this scene, which is mentioned only in the Gospel of Luke (1:39–56), date from the sixth century and are mostly wall paintings. Images on wood panel are much rarer because there is no corresponding celebration of the Visitation in the Byzantine liturgy. The episode is recalled, however, in the *Akathistos* hymn and in the iconographical cycles derived from it. At the Annunciation, Mary learns from the archangel that her elderly cousin Elizabeth, "who was called barren," is in her sixth month of pregnancy, "for with God nothing will be impossible." Mary sets out for the mountain village (today called Ein Karem), some hundred miles from Nazareth, where her cousin Elizabeth lives, so she can assist her in the final months of her pregnancy. In icons of the scene, the two women embrace and John leaps for joy in

Elizabeth's womb, because he "feels" the presence of Jesus inside Mary. In her haste, Elizabeth nearly stumbles, and Mary's hand grazes her cousin's womb; both women lean forward, their robes fluttering in the air. Each gesture expresses their deep emotion. The red cloth draped between the buildings means that their meeting is taking place under the merciful gaze of God.

▶ John of Stagnos, *The Visitation*, wall painting, 1637. Meteora (Greece), Barlaam Monastery.

*The ancient celebration of the full revelation of God's light is the Baptism in the Jordan River. Christmas icons show Jesus born in the shadows of an incredulous world.*

# The Nativity

Until the sixth century, the feast of Jesus' birth was celebrated on January 6, at the same time as the Adoration of the Magi (lesser Epiphany) and the Baptism of the Lord (greater Epiphany). Later, to underscore Christ's human nature, the feast of Christmas, December 25, was instituted. In the most ancient image of the Nativity, found in the basilica of Bethlehem, Mary is seated with the Child in her lap. After the Council of Ephesus, however, which established the dogma of divine maternity, the Virgin began to be represented lying down, a more natural posture for a woman who has just given birth. The icon of the Nativity is dominated by a mountain with a yawning cave, symbolizing hell, and many of its elements prefigure the Passion. Mary is the burning bush that has given birth to Christ, who is wrapped like a corpse and placed in the cradle-sepulchre. The donkey and ox represent the Jews and pagans; the star and the angels stand for the Trinity; the magi correspond to the women at Christ's tomb with their fragrances. Joseph being tempted by the shepherd-demon represents incredulous humanity, over which the vigilant Mary keeps watch.

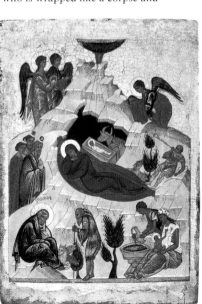

**Text**
"What shall we offer thee, O Christ, who for our sakes hast appeared on earth as man? Every creature made by thee offers thee thanks. The angels offer thee a hymn, the heavens, a star; the magi, gifts, the shepherds, their wonder; the earth, its cave; the wilderness, a manger; and we offer thee a Virgin Mother."
(Christmas Vespers)

**Title**
Nativity of Christ (*Genesis tou Christou, Rozhdestvo Khristovo*)

**Feast days**
December 25; Massacre of the Innocents, December 9

**Sources**
Gospel of Luke; Protoevangelion (Infancy Gospel) of James; Gregory of Nazianzus, *Homilies on the Nativity*; Romanos the Melodist, *Kontakion on the Nativity*; Ephraim the Syrian, *Hymns for Christmas*; James (Jacob) of Sarugh, *Christmas Homilies*

◀ Novgorod school, *The Nativity*, ca. 1475. Vicenza (Italy), Gallerie di Palazzo Leoni Montanari, Banca Intesa Collection.

# The Nativity

Eve pours the water for the ritual bathing of the Christ child; beside her, the midwife Salome, who had been paralyzed for trying to verify Mary's virginity, is miraculously cured.

Upper left, the Magi follow the star; just below, they adore the Christ child; upper right, forewarned by an angel, they take a different route back to their home countries.

From left to right: Joseph visited in a dream by the angel and then tempted by the shepherd-demon, who is driven away by a mysterious youth; the latter then accompanies Mary and Joseph on their flight into Egypt with the Child.

Elizabeth, with the young John the Baptist, takes refuge in a cave, escaping persecution by Herod.

King Herod hears of the prophecies of Christ's coming and gives the order for all newborns to be slaughtered.

Mothers grieve over the lifeless bodies of their children; to the side, Zechariah is murdered by soldiers in front of the altar for not revealing where John the Baptist is hidden.

▲ The Nativity of Jesus Christ, north-central Russia, early nineteenth century. Private collection.

*It celebrates Christ's encounter with humanity. Mary offers Jesus; Simeon and Anne, now old, are overjoyed to receive him; Joseph looks on, amazed and thoughtful.*

# The Presentation of Jesus

This feast falls forty days after the Nativity, since that was the prescribed interval for a woman to be purified after childbirth. During this period, mothers were not allowed near the sanctuary. The event was initially celebrated on February 14 (forty days after Epiphany) with a procession leading to the Church of the Resurrection in Jerusalem, as recounted by the fourth-century pilgrim Egeria. In the sixth century, the feast day was adopted in Constantinople, where it saved the city from the plague; in the seventh century, Pope Sergius I (r. 687–701) brought it to Rome. The scene takes place inside the sanctuary, where Simeon greets Mary, embraces the Child, and prophesies about both: Jesus will die on the cross, "a sign that is spoken against," and Mary, too, shall have her soul pierced by a sword (Luke 2:34–35). Two others take part, forming a small procession: the elderly prophetess Anna, and Joseph, who gives the ritual offering of two doves. Icons of the Presentation contain interesting parallels with other images: Simeon receives Jesus the same way Isaiah receives the burning coal on his lips (Isaiah 6:7) and the devout believer the Eucharist; Joseph, as in icons of the Nativity, represents humanity incredulous in the face of mystery; Simeon and Anna recall the figures of Adam and Eve in icons of the Resurrection.

**Text**
"The anxiety of your suffering will be a sword for you, but after it He will send quick healing for your heart." (Romanos the Melodist)

**Title**
The Meeting (*Hypapante*; *Sretenie*) of Christ

**Feast day**
February 2

**Sources**
Luke 2:22–39; Egeria, *Pilgrimage*; Nicephorus, *Church History*; Theophanes, *Chronicle*; Origen, *Commentary on the Gospel of Luke*; Romanos the Melodist, *Kontakia*; *Akathistos* hymn

**Iconography**
The Virgin hands the Child to Simeon; Joseph offers two doves; the prophetess Anna points to Jesus

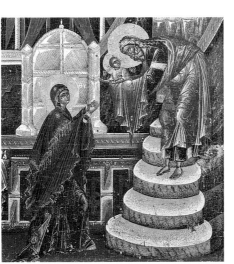

◄ Onufri, *The Presentation of Christ in the Temple* (detail), sixteenth century. Berat (Albania), Onufri Museum.

# The Presentation of Jesus

The curtain represents the veil of the Temple, but also the hems of the Lord's cloak, which fill the Temple, according to the vision described by the prophet Isaiah (6:1).

The little procession breaks up: Joseph offers two turtledoves; Anna points to Christ; Mary holds her arms out to the Child, while Simeon holds Jesus respectfully by the hems of his cloak, which gleams with splendid incandescence.

▲ Michael Damaskenos, *The Presentation of Christ in the Temple*, second half of sixteenth century. Mount Sinai, Monastery of Saint Catherine.

The doors to the sanctuary are closed, and Simeon descends the stairs of the ciborium, where the loaves of the Covenant are kept. The scene takes place inside the holy enclosure, even though the figures are conventionally represented outside of it.

*The iconography of the embrace between the elderly Simeon and the Child-Messiah is rare and suggestive and alludes to the icon of the Virgin of Tenderness (Eleousa).*

# Simeon with the Christ Child

The image of Simeon embracing Jesus derives from the iconography of the Presentation of Christ in the Temple, but it is also reminiscent of the icon of the Virgin *Eleousa* (of Tenderness). The elderly figure of Simeon stands for the people discovering salvation in Christ. His words form part of the Orthodox Vespers: "Lord, now lettest thou thy servant depart in peace, according to thy word: for mine eyes have seen thy salvation, which thou hast prepared in the presence of all peoples" (Luke 2:29–31). In the West, this hymn was inserted into the Compline liturgy in the fifth century under the title of *Nunc dimittis*. On icons, Simeon is named "God-Receiver." The image of Simeon embracing Jesus expresses an entirely spiritual fatherhood (or motherhood). And while icons of this type—in which Simeon is represented with the Child in his arms, in full or half length (recall Rembrandt's masterpiece on this subject)—are rare, even rarer are images of Simeon without the Child, which suggest the invisible presence of Christ in the pose of the hands, palms open on the chest. Simeon appears as an intercessor in certain *Deesis* compositions.

**Text**
"And there was a man in Jerusalem, whose name was Simeon, and the man was righteous and devout, looking for the consolation of Israel, and the Holy Spirit was upon him."
(Luke 2:25)

**Title**
Simeon the God-Receiver
(*Theodochos*;
*Bogopriimets*)

**Feast day**
February 3

**Sources**
Luke 2:25–32; Romanos the Melodist, *Kontakia*

**Iconography**
Simeon in an attitude of prayer and intercession, in full or half length, either alone or with Christ in his arms

◀ *Saint Simeon* (detail), originally from Moscow, mid-nineteenth century. Private collection.

The white striation (assist) accentuates the flowing and perfectly symmetrical movement of the beard and hair framing the face, and its intense, severe gaze.

The red Cyrillic characters read *"Simeon the God-Receiver."*

The real but hidden presence of Christ is suggested by the position of the hands, which are highlighted by fine brushstrokes of ceruse.

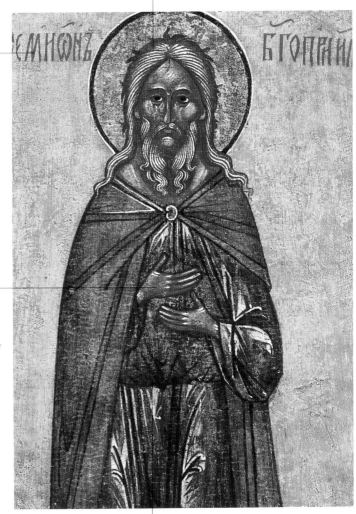

▲ Novgorod school, *Simeon the God-Receiver*, second half of fifteenth century. Vicenza (Italy), Gallerie di Palazzo Leoni Montanari, Banca Intesa Collection.

The folds in his robes are accentuated by highlights suggesting the presence of the supernatural; over his robes, Simeon is wearing a cloak fastened with a clasp.

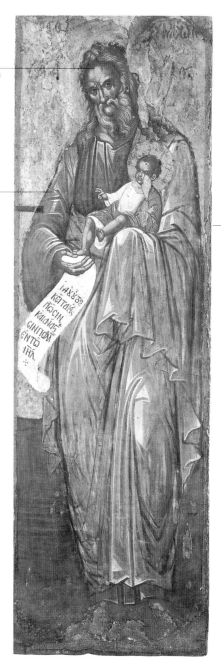

Simeon's gruff, austere gaze, framed by his dense hair and a gray, luminous beard, penetrates the viewer, inviting him to look at Jesus.

The azure blue robe is marked at the shoulders by a golden band (clavus) indicating royal stature. Simeon holds a scroll with the words "Behold, this child is set for the fall and rising of many in Israel" (Luke 2:24).

Cradled amid the rich folds of Simeon's aqua-colored cloak, Christ, in royal dress, gives benediction and kicks his legs.

▶ Michael Damaskenos, *Simeon the God-Receiver with Christ in His Arms*, sixteenth century. Iraklion (Crete), Church of Saint Matthew of Sinai.

*The image of the twelve-year-old Christ in the synagogue, surrounded by the Doctors, anticipates the icon of Pentecost, in which the apostles, gathered in prayer, receive the Holy Spirit.*

# Christ in the Synagogue

**Text**
"The Spirit of the Lord is upon me, because he has anointed me to preach good news to the poor. He has sent me to proclaim release to the captives, and recovering of sight to the blind, to set at liberty those who are oppressed, to proclaim the acceptable year of the Lord." (Luke 4:18–19)

**Title**
Mid-Pentecost
(*Mesopentekoste*, *Prepolovenie*)

**Feast day**
September 1; fourth Wednesday after Easter

**Sources**
Isaiah 61; Luke 4

**Iconography**
Proclamation of the New Year: Christ with book, the synagogue, the Jews, and the apostles; Mid-Pentecost: Christ Emmanuel enthroned, the Doctors of the Law, the semicircle and domes of the synagogue

▶ Semen (Semeiko) Borozdin, *Proclamation of the New Year*, late sixteenth–early seventeenth century. Saint Petersburg, Russian Museum.

When Jesus is twelve, his parents lose track of him. They later find him in the synagogue, listening to the Doctors of the Law and asking them questions. In Jewish tradition, a child comes of age at twelve or thirteen. The icon is connected to the feast of Mid-Pentecost, so called because it falls halfway between Easter and Pentecost. The image itself recalls the iconography of Pentecost, in which the apostles, seated in a semicircle, receive the Holy Spirit. The theme of the relationship between Jesus and the Jewish synagogue can be found in another icon, which depicts the moment when Christ, in Nazareth, reads the passage from Isaiah that speaks of him as the Messiah (Luke 4:14–19). Since Jesus represents the beginning of a new age—in Isaiah's words, "[He has anointed me] to proclaim the acceptable year of the Lord"—this icon celebrates the beginning of the Orthodox New Year, September 1. This theme, depicted here, is also tied to the polemics waged against the

introduction of the Western calendar in Russia, decreed by Peter the Great in 1699. According to an ancient legend, Adam was created on September 1, 5509 B.C.; dated inscriptions on ancient icons follow this chronology. Thus, the year 7179, before Peter the Great's reform, corresponds to 1671 in our calendar.

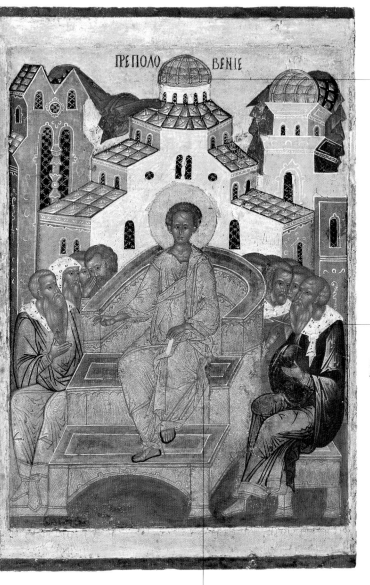

ПРЕПОЛО ВЕНІЕ

The symmetry of the buildings, the dome with sloping roofs, and the reverse perspective (lines converging toward the viewer) underscore the centrality of the figure of Christ Emmanuel.

Disconcerted and astonished, the scribes and Pharisees, seated in a semicircle in the restricted space around the throne, confer among themselves.

◣ Circle of Fedor Trofimov, *Mid-Pentecost*, originally from the Solovki Monastery, ca. 1590. Moscow, Kolomenskoe Museum.

The image of the Temple-throne, with steps and an apse that serves as a backrest, places the young Christ, giving benediction, inside the Ark of the Covenant, the dwelling-place of Divine Wisdom (whose presence is evoked by the red draperies over the roofs).

## Christ in the Synagogue

The two-tier triptych composition is more typical of Western than Eastern painting; particularly curious are the Muslim crescents atop the spires of the synagogue.

In the red breach of sky, surrounded by clouds, the Ancient of Days (God the Father) appears inside a golden circle, giving his blessing and sending the Holy Spirit, in the form of a dove, to Christ: "The Spirit of the Lord is upon me."

At the sides of the icon, the elongated figures of Saint Symeon the Stylite and his mother, Saint Martha (whose feast day also falls on September 1), emphasize the link between the Gospel event and the liturgical year.

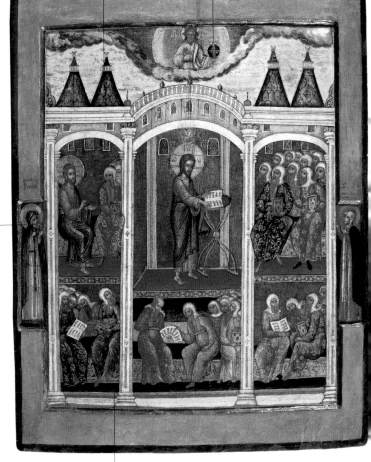

▲ Christ Preaching in the Synagogue, late seventeenth century. Moscow, Kolomenskoe Museum.

In the upper register, left, Christ explains the scriptures to a priestly official, while to the center and right, he reads and comments on the book of Isaiah before members of the synagogue. In the lower registers, the incredulous men search the scriptures for arguments with which to refute him.

*Angel of the Desert, forerunner of Christ, last of the prophets, and the first saint, the Baptist is one of the most fascinating and popular figures in Orthodox iconography.*

# John the Baptist

In Orthodox countries the figure of John the Baptist is very popular and much venerated and occupies a privileged position in the *Deesis* tier of the iconostasis, next to Christ and his Mother. He is the last and the greatest of the Old Testament prophets, and "yet he who is least in [Christ's] kingdom of heaven is greater than he" (Matthew 11:11). A hermit and preacher in the southern desert of Judea, John baptized his disciples in the waters of the Jordan, near its confluence with the Dead Sea. Though usually depicted wrapped in a camel-hair tunic, his iconography is rich and varied. We often see his severed head on a platter: King Herod beheaded him to please Salome, daughter of the king's lover Herodias (his brother's wife), whom the Baptist had reproached for her adultery. He is also represented with Jesus as the Lamb of God, in a chalice; or as an Angel of the Desert, messenger of the Lord according to the prophecy of Malachi (3:1). According to tradition, his head was discovered three times, giving rise to the iconography of the Finding of the Head of John the Baptist.

**Text**
"Having endured great suffering for the truth, thou didst rejoice to bring, even to those in Hell, the good tidings that God hath appeared in the flesh, taking away the sin of the world and granting us great mercy." (Troparion for August 29 and January 7)

**Title**
John the Baptist (*Baptistes, Krestitel*), Forerunner (*Prodromos, Predtecha*), or Angel of the Desert (*Aggelos tes heremou, Angel pustyni*); Birth (*Ivan Kupala*); Beheading (*Apotome tes kephales, Useknovenie glavy*)

**Feast days**
Birth, June 24; Beheading, August 29; Conception, September 23; Finding of the Head, February 24, May 25; Synaxis, January 7; weekly day of remembrance, Tuesday

◄ *John the Baptist in the Desert*, from the Cathedral of Saint Sophia in Novgorod, late fifteenth–early sixteenth century. Saint Petersburg, Russian Museum.

# John the Baptist

The severed head on the platter is shrunken in the sleep of death; on the scroll, one reads: "Behold, the Lamb of God, who takes away the sin of the world!" and "Repent, for the kingdom of heaven is at hand" (John 1:29, Matthew 3:2).

The wings take up a large part of the composition and give the Baptist's body a cosmic dimension. Interwoven with golden assist, they range in color from dark red to green to the bright orange of the lower edges, which are bordered in white.

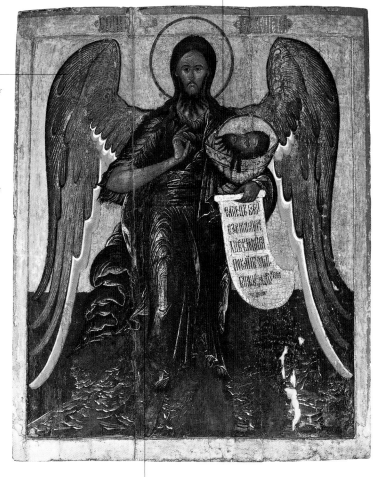

▲ *John the Baptist, Angel of the Desert*, originally from the Solovki Monastery, sixteenth century. Moscow, Kolomenskoe Museum.

John the Baptist is wearing a mantle (himation) over his ascetic penitential shirt of camel hair. The strokes of white light on his robes express the energy of the "uncreated" divine light.

116

A large halo encircles John's face, which is framed by the hair falling onto his shoulders and the long curls of his flowing beard.

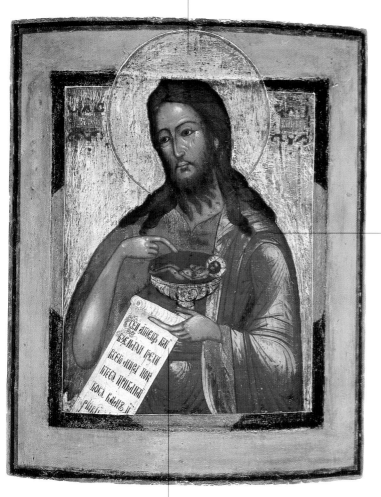

Over his camel-hair tunic, John is wearing a red himation, symbol of his preparation for divine life.

▲ *John the Baptist*, eighteenth century. Moscow, Ecclesiastical Academy, Archaeological Cabinet.

John is holding a scroll and a paten containing a small, naked Christ, who blesses with his right hand. The image suggests the bread of the Eucharist, called Lamb (amnos), and the words uttered by John himself by the river Jordan: "Behold, the Lamb of God, who takes away the sin of the world."

Upper register: Zechariah receives the angel's message in the Temple and is struck dumb because of his disbelief; he writes his son's name, "John," on a tablet; Elizabeth conceives; Visitation; birth of John. Left and right, down both sides: Murder of Zechariah; Elizabeth and the infant John flee Herod and take refuge in a cave; John is led into the desert by an angel; beginning his mission; Baptism of Christ in the Jordan River; John baptizes Jews in caves that may allude to those at Qumran.

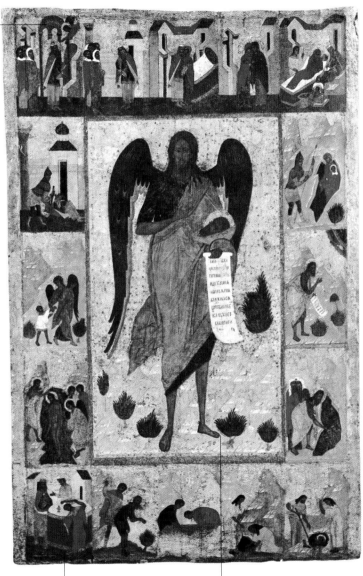

Lower register: Herod's feast; beheading of John; burial of his body; burial of his head; the head is found by John's disciples.

The flowering desert is a biblical image that alludes to the full blossoming of life when the Messiah announced by John comes into the world.

▲ *John the Baptist, with Scenes from His Life*, second half of sixteenth century. Yaroslavl (Russia), Museum of Art.

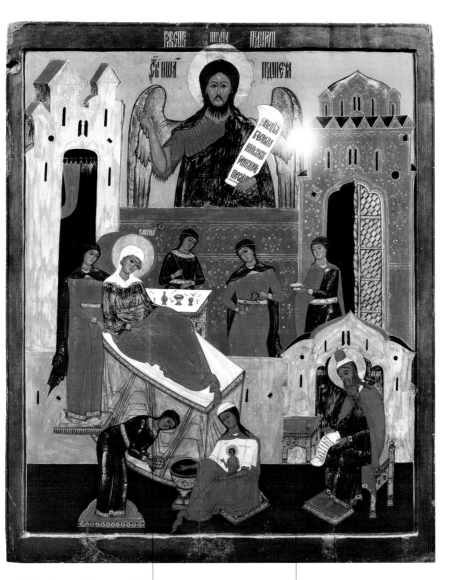

The Baptist towers between two buildings representing the Old and New Testaments, the Synagogue and the Church (on the left, the red and blue curtains symbolize the two natures of Christ). The house of Zechariah displays the comfortable living conditions of the priestly class.

Zechariah, sitting on a throne near a writing table, is busy writing. Behind him, depicted "in reverse," are the sanctuary he used to enter twice a year for the holy office and the Temple with the Golden Gate that leads into the Holy of Holies.

▲ The Birth of John the Baptist, from the region of Kargopol, sixteenth century. Arkhangelsk, Museum of Fine Arts.

# John the Baptist

The composition has a rhythm that ascends from right to left, underscored by the diagonal of the sword. John and his executioner are represented twice in sequence, first upon leaving the prison, and then at the moment of the beheading.

A sharp palisade surrounds John's prison; Christ is carried by an angel on a carpet of flaming clouds.

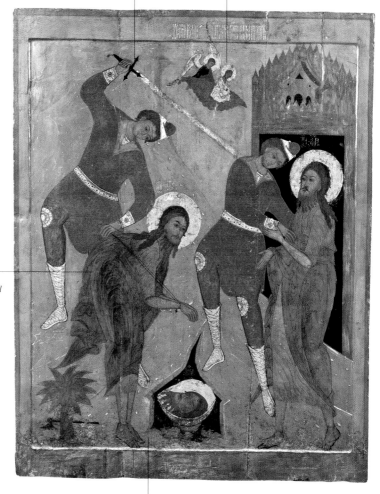

John bends under the mortal blow dealt by his tormentor, who holds him tethered by the wrists.

▲ *The Beheading of Saint John the Baptist*, from the northern Onega region, late seventeenth century. Arkhangelsk, Museum of Fine Arts.

The severed head is buried in a dark cave. To the left, a tree with an axe beside it recalls the words of John's own prophecy: "Even now the axe is laid to the root of the trees" (Luke 3:9).

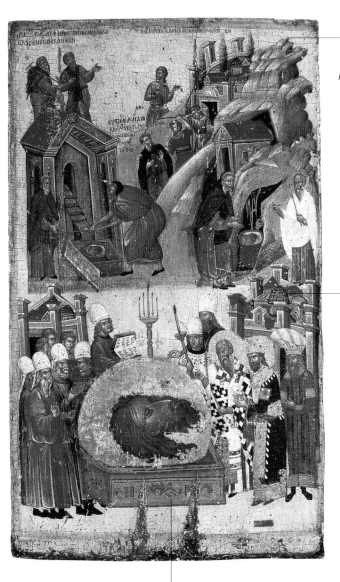

The head of the Baptist is found by Christians on the Mount of Olives, then it is hidden again during the persecution of Christians. It would be rediscovered in 452, near the city of Emesa (Homs) in Syria.

The Baptist's head is transported to Constantinople and hidden once again during the struggle with the Iconoclasts. In 850 it is discovered a third time.

▲ *The Three Discoveries of Saint John the Baptist's Head*, fourteenth century. Mount Athos, Monastery of the Great Lavra.

The relic is represented as a giant head in a sarcophagus (for John was a spiritual giant) and exhibited for veneration by the patriarch of Constantinople, the emperor, and other civic and religious authorities.

*Christ reveals himself on the banks of the Jordan, the river that descends from Mount Hermon and passes between Israel and Jordan before flowing into the great depression of the Dead Sea.*

# The Baptism of Christ

**Text**
"The waters saw you and were afraid. The Forerunner trembled and cried out, saying: How will the servant place his hand on the Master?" (Great Blessing of the Waters, January 6)

**Title**
Theophany (*Bogoiavlenie*); Epiphany; Feast of the Lights (*Ta Phota*)

**Feast day**
January 6

**Sources**
Matthew 3:1–17; Mark 1:1–11; Luke 3:1–18, 3:21–22; John 1:19–34

**Iconography**
Christ in the waters of the Jordan between two mountain peaks, flanked by the Baptist and three cloaked angels; on shore are an axe and a tree trunk

For Eastern Christians the feast of the Baptism is more important than the Nativity, in that it is a great theophany, a full manifestation of Christ's divinity. The iconography of the Baptism is simple and ancient, adhering closely to the Gospels.

The moment Christ abases himself (*kenosis*) by stepping into the river to be baptized, a voice from the heavens reveals him to be the Son of God. His descent into the "liquid sepulcher" of the Jordan foreshadows the Descent into Hell, and its meaning is the same: through death (*kenosis*) Christ will save man, and the nudity of his body reveals the new Adam. The rocky landscape (the Jordan valley) opens up into a whirlpool. John leans over Christ, who dominates the waters and blesses them. Next to the Baptist are a tree trunk and an axe (an image of Christ), in keeping with the prophecy of Isaiah: "Even now the axe is laid to the root of the trees" (Luke 3:9). Three angels (an image of the Trinity), with hands veiled as a sign of respect, are ready to receive the naked body of Christ, as if it were the Eucharist.

▶ Onufri, *Baptism of Christ* (detail), late sixteenth–early seventeenth century. Tirana (Albania), Institute for Cultural Monuments.

*The earth opens up as during the Descent into Hell: Christ immerses himself in the deadly abyss and reemerges victorious. Over him the dove of the Holy Spirit sheds the light of the Trinity and a voice from the heavens announces, "Thou art my beloved Son, with thee I am well pleased."*

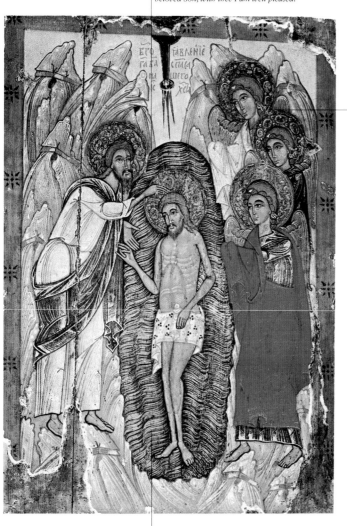

*With hands veiled, the angels are ready to receive Christ, the new Adam, the new man, naked as on the day of creation. With his baptism, he renewed in his own person the primordial image of man, and the beauty that man had lost through sin.*

▲ Ukranian school, *The Baptism of Christ*, sixteenth century. Kiev, National Art Museum of Ukraine.

*The waters of the Jordan, the "liquid sepulchre," begin to move upon contact with the body of Christ, who is girt around the hips with a loincloth reminiscent of funerary shrouds.*

*Unconnected with any particular church feast, Christ's first miracle is not often depicted on icons. When it is, it figures in the frame and is compositionally similar to the Last Supper.*

# The Wedding Feast at Cana

**Text**
"Every man serves the good wine first; and when men have drunk freely, then the poor wine; but you have kept the good wine until now."
(John 2:10)

**Title**
The Wedding Feast at Cana

**Feast day**
In ancient times, it was celebrated on January 6, along with the Baptism of Christ, the Nativity, and the Adoration of the Magi

**Source**
John 2:1–11

**Iconography**
Christ, the Virgin, disciples, newlyweds, servants, the ruler of the feast, the pots of water transformed into wine

The two great jugs still preserved at Kafr Kanna (which tradition claims are those used when Christ turned water into wine) appear, in fact, to be two ancient baptismal fonts. Also uncertain is whether the Gospel episode really took place in this village near Nazareth or at another place called Ain Kana, as some scholars propose. John alone tells of this miracle, which Christ performed at his mother's behest. The dialogue between the two is terse: Mary says: "They have no wine"; Jesus replies: "O woman, what have you to do with me? My hour has not yet come." But then he orders the servants to fill six purification jugs with water, and the ruler of the feast is pleased to find that the water has been turned into fine wine. In the language of John the Evangelist, Christ's actions are "signs": Christ is the new wine that will cheer the human marriage. Christ is also

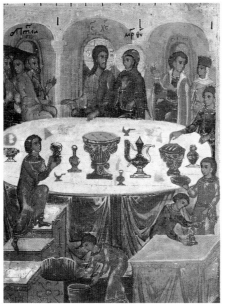

the true husband of humanity, represented by Mary. The icon presents them both seated at the wedding table. On the right, the newlyweds taste the wine, that is, the presence of Christ; on the left are the disciples, who that day "believed in him." In the foreground the servant-disciples prepare the wine, and one of them steps up to the wedding table, bearing a cup.

▶ *The Wedding Feast at Cana*, side scene from *The Harrowing of Hell*, sixteenth century. Vologda (Russia), museum.

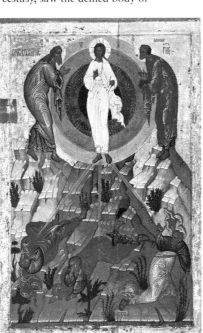

*According to tradition, every monk-painter is supposed to paint this icon at the start of his apprenticeship, so that he could paint his subsequent works in the light of Mount Tabor.*

# The Transfiguration

The spiritual teaching of Gregory Palamas (d. 1359), who saw light as the emanation of "uncreated" divine energy, is called Hesychasm, and it forms the foundation of subsequent icon painting. Since "no one has ever seen God," our knowledge of him can only come about negatively, through the dark luminosity of a cloud that reveals by hiding ("the cloud of unknowing"). At the Transfiguration, Christ, together with his disciples Peter, James, and John, climbs Mount Tabor, a small eminence in Galilee. Tabor has been considered a holy site since ancient times: at its summit, under the floor of the present-day Church of the Transfiguration, the rock still bears traces of ancient Canaanite cults. On this mountain one can encounter God and his revelation. It was atop Mount Tabor that the disciples, stunned and in a state of ecstasy, saw the deified body of Christ, standing on a cloud between Moses and Elijah (the two seers of the Old Testament): "his face shone like the sun, and his garments became white as light." At this point the disciples "fell on their faces," struck by the rays of "uncreated" light, which shone from the luminous aura enveloping the body of Christ.

**Text**
"Thou wast transfigured on the mountain, O Christ our Lord, and Thy disciples beheld Thy glory as far as they were capable, that when they should see Thee crucified, they might know that Thy suffering was voluntary and might proclaim to the world that Thou art indeed the reflection of the Father." (Troparion for August 6)

**Title**
The Transfiguration (*Metamorphosis, Preobrazhenie*)

**Feast day**
August 6

**Sources**
Matthew 17:1–8; Mark 9:2–13; Luke 9:28–36; Apocalypse of Peter; Gregory of Nyssa, *Life of Moses*; Romanos the Melodist, *Kontakia*

**Iconography**
Christ between Elijah and Moses, with Peter, James, and John

◀ *The Transfiguration*, second half of fifteenth century. Novgorod (Russia), museum.

# The Transfiguration

Elijah and Moses, conversing with Christ, are illuminated by the light of his glory. In the little clouds in the corners are two angels who guided the prophets from the heavens.

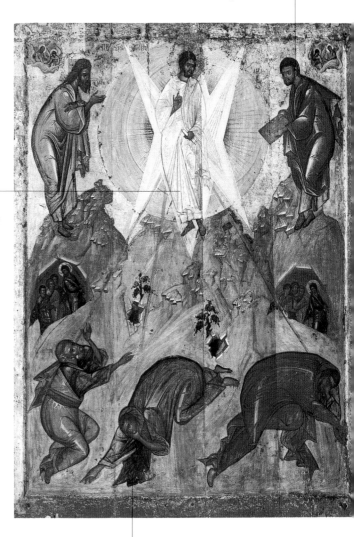

The body of Christ is transfigured in an incandescent light that is too much for the apostles to bear. Peter falls back, John feels short of breath, and James covers his bedazzled eyes.

▲ Theophanes the Greek, *The Transfiguration*, ca. 1403. Moscow, Tretyakov Gallery.

The disciples climb and then descend Mount Tabor in the company of Christ, who leads them to a luminous vision of his glory.

*This surprising encounter takes place beside a well dug by Jacob, near the city of Sychar in Samaria, one kilometer from the tomb of Joseph.*

# Christ and the Samaritan Woman

The exact location of the well is uncertain but is probably between the natural spring of the village of Askar (at the foot of Mount Ebal) and the well of the Arab village of Balata, near the ruins of Shekhem. The first Christian community considered this well sacred and used its waters for baptism. A small church was built on the site, and in the crypt one can still see the well of Sichem, fed by an active spring. As in the miracle at Cana, the Gospel of John speaks the language of "signs": the springwater is Christ, the true husband of humankind, which is here represented by the Samaritan woman. The conversation between the two is surprising, since speaking with a woman in public was cause for scandal at the time; the woman, moreover, is unfaithful and, worse, Samaritan. The Samaritans, in fact, were in open religious conflict with the Jews, maintaining that God should be worshiped atop Mount Gerizim and not on the Temple Mount in Jerusalem.

**Text**
"Having come to the well in faith, the Samaritan woman beheld Thee, the Water of Wisdom, of which she drank abundantly and inherited the kingdom on high, where her praises are sung eternally." (Troparion for the Sunday of the Samaritan Woman)

**Title**
Sunday of the Samaritan Woman

**Feast day**
Movable, fifth Sunday after Easter

**Source**
John 4:1–30

**Iconography**
Christ sits in front of the well; the Samaritan woman, who is drawing water, looks at him in surprise; a group of disciples gathers to the left, while on the right the Samaritans look on in curiosity from the city walls

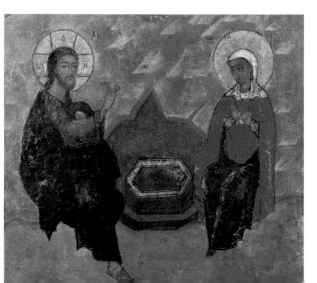

◀ *Christ and the Samaritan Woman*, originally from central Russia, seventeenth century. Lebanon, private collection.

*To strengthen his disciples' faith in him, Christ, before his Passion, raises his friend Lazarus from the dead. This unheard-of gesture brings the wrath of the Pharisees down upon him.*

# The Raising of Lazarus

**Text**
"Joining dust to spirit, O Word, by Thy word in the beginning Thou hast breathed into the clay a living soul. And now by Thy word Thou hast raised up Thy friend from corruption and from the depths of the earth." (Andrew of Crete)

**Title**
The Raising (*Egersis, Voskreshenie*) of Lazarus (*Eleazar*, meaning "God helps")

**Feast day**
Saturday of the sixth week of Lent, the eve of Palm Sunday

**Sources**
John 11; Andrew of Crete, *Canon for Lazarus Saturday*; apocryphal Gospel of Nicodemus; Egeria, *Pilgrimage*

**Iconography**
A mountain with two peaks; the Jews filing out of the city; the tomb; Lazarus, standing, wrapped in bandages; the apostles; Christ giving benediction; Martha and Mary at his feet

The tomb of Lazarus is in Bethany, today the Arab village of El-Azariye, on the eastern slopes of the Mount of Olives, just outside of Jerusalem. As early as the fourth century, the pilgrim woman Egeria told of the procession that the bishop of Jerusalem, together with monks and faithful, led from Bethany to the Church of the Resurrection in Jerusalem on the feast day of the Raising of Lazarus. The Orthodox Church celebrates this feast at the start of Holy Week. The Raising was first depicted in early Christian catacomb wall paintings. The dynamic center of the composition is Christ's imperious gesture as he commands: "Lazarus, come forth." While Christ's right hand is extended to call Lazarus back from the dead, his left holds the scroll with a list of the dead—that is, a list of sinners—thus "having canceled the bond which stood against us with its legal demands" (Colossians 2:14). The man holding the body by its wrapping and covering his face from the stench seems not to realize that Lazarus's eyes are already open. Christ bids him: "Loose him, and let him go."

▶ *The Raising of Lazarus*, twelfth century. Athens, Byzantine Museum.

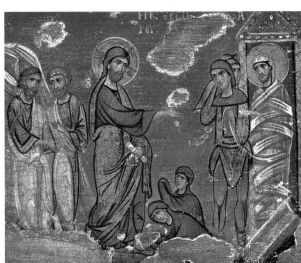

128

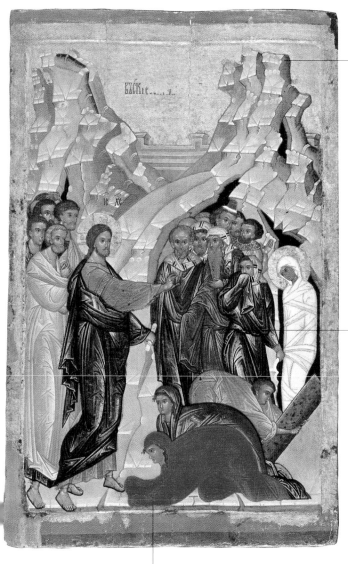

The three peaks allude to the Trinity. The pink one close to the walls of Bethany, in particular, refers to Christ, who, by assuming human form, will bring joy to the city of man.

The group of Jews inside the grotto with Lazarus represents humankind, dwelling in shadow and looking to Christ for their liberation.

▲ *The Raising of Lazarus*, fifteenth century. Novgorod (Russia), museum.

Mary (in red) prostrates herself in faith at Christ's feet. Behind her, Martha (in green) is uncertain and pensive: "Lord, by this time there will be an odor, for he has been dead four days." The two sisters' colors come together in the figure of Christ, in whom divinity (red) is dressed in humanity (green). Christ and Lazarus are the only two figures with the haloes of holiness over their heads.

*The Procession of the Palms is triumphal in character, but also paradoxical. Jesus sits astride a young ass; the people hail him as king, but soon he will be crucified.*

# The Entry into Jerusalem

**Text**
"Rejoice greatly, O daughter of Zion! Shout aloud, O daughter of Jerusalem! Lo, your king comes to you; triumphant and victorious is he, humble and riding on an ass, on a colt the foal of an ass." (Zechariah 9:9)

**Title**
Palm Sunday (*He Baiophoros*), Entry into Jerusalem (*Vkhod Gospoden*)

**Feast day**
Palm Sunday

**Sources**
Matthew 21:1–10; Mark 11:1–33; Luke 19–20; John 12:1–15; apocryphal Gospel of Nicodemus; Justin, *Dialogue with Trypho*

**Iconography**
Astride a donkey, Jesus descends the Mount of Olives with his apostles; before him are the city of Jerusalem, the crowd of Jews, and children gathering palm branches and laying out cloaks at his feet

Egeria describes in her pilgrimage account (ca. 381–84) a procession that began at the Mount of Olives, passed the shrine of the Ascension, and descended into Jerusalem to the Church of the Resurrection. The iconography of the feast goes back to the fourth century, and by the sixth century it had spread far in its definitive form. The village to the left of the Mount of Olives is Bethpage, between Bethany and Jerusalem, where the disciples untie the ass's colt, at Christ's command. The diagonal of the mountain-with-cave from which Christ descends with the apostles stands opposite the vertical line of the walled city. Christ is at the center of the two realities. By clambering up the Christ-tree to cut fronds, the children are lifted, as catechumens, from spiritual infancy to the maturity of faith. Christ is the branch of Jesse, the oak tree of Mamre, the tree of life that bridges the

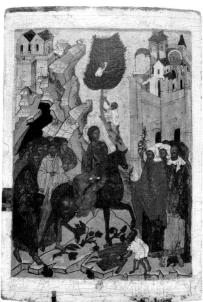

gap between the mountain of God and the city of man. Christ dominates matter (his mount) and enters his city in triumph, while feeling the hostility of those who hail him today and will crucify him tomorrow: "Now I enter in the city and, casting you out, I shall reject you—not that I hate you, but because I discovered that you hate me and mine" (Romanos the Melodist, *Kontakia*).

▶ The Entry into Jerusalem, first half of sixteenth century. Pskov (Russia), museum.

*The icons of the Washing of the Feet and the Last Supper lead us into the heart of Holy Week, to that dining table, or cenacle, at which Jesus gave of himself as food.*

# The Last Supper

The Byzantine liturgy of Holy Thursday commemorates the Washing of the Feet, the Last Supper, Christ's prayer in the garden, and Judas's betrayal. Before the Last Supper, Jesus washes the apostles' feet: "How beautiful are the feet of those who preach good news!" (Romans 10:15). Peter recoils in dismay, but Jesus says: "If I do not wash you, you have no part in me." The icon captures Peter's gesture: "Not my feet only, but also my hands and my head!" (John 13:9). Icons of the Last Supper show Christ telling his disciples: "One of you will betray me" (John 13:21). Peter invites John to ask Christ who the traitor is. Jesus replies: "It is he to whom I shall give this morsel." And Judas, "after receiving the morse¹, …immediately went out" (John 13:30). The Last Supper is repeated every day in the Byzantine liturgy. Hence, the icon of the Communion of the Apostles, situated in the lunette over the royal doors (through which the priest comes out with the holy gifts), shows Christ, the eternal priest, distributing the bread (on the left) and wine (on the right). In early icons, Christ is dressed in a simple red chiton and a blue himation. In more recent ones, he is dressed in the solemn vestments of the Byzantine liturgy.

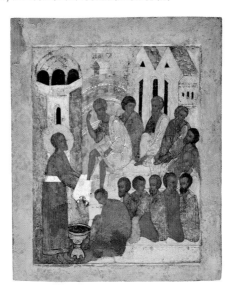

**Text**
"As we receive Communion with human body and blood, we receive God in our soul; the body and blood of God, the soul, mind, and will of God no less than of man." (Nicholas Kabasilas, *The Life in Christ*)

**Title**
The Washing of the Feet (*Nipter, Umovenie nog*); Last Supper (*Mystikos deipnos, Tainaia vecheria*); Communion (*Eucharistia, Prichastie*) of the Apostles

**Feast day**
Holy Thursday (Maundy Thursday)

**Sources**
Matthew 26:17–35; Mark 4:12–31; Luke 22:7–20; John 13

**Iconography**
The Washing of the Feet: Jesus washes the apostles' feet. Last Supper: Christ at table with the apostles. Communion of the Apostles: Christ gives out bread and wine to the apostles

◀ *The Washing of the Feet*, originally from the Church of the Ascension, Belozersk, first half of sixteenth century. Moscow, Tretyakov Gallery.

# The Last Supper

The architectural structure represents the room (cenacle) of the supper; but the apsidal form suggests an image of the early Church, convened around the sacrament of love.

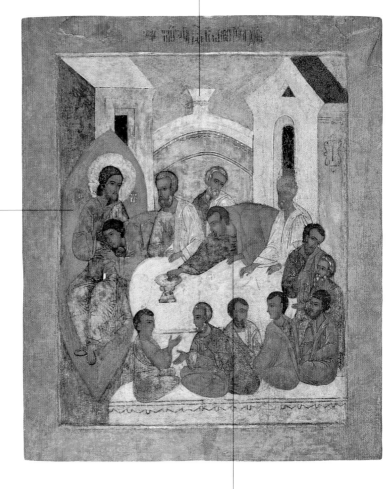

Inside a red mandorla that reveals him to be the Lord, Christ announces to Peter that the latter will become his successor as head of the Church.

▲ *The Last Supper*, originally from the Church of the Ascension, Belozersk, first half of sixteenth century. Moscow, Tretyakov Gallery.

John and Judas, with two apparently similar gestures, are actually performing two contrary acts: John is throwing himself on Jesus's breast to ask him, "Lord, who will betray you?"; Judas, meanwhile, grabs the morsel from the chalice, ready to betray him.

The lectern covered in red cloth, as well as the other architectural elements, indicates the interior of a Byzantine church.

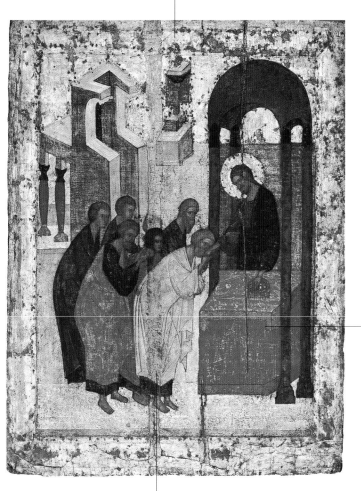

The altar covered in red cloth is a faithful reproduction of the kind used in the Byzantine liturgy. As in most early Christian churches, moreover, the altar is sheltered by a ciborium that, during the consecration of the host, was closed by drapery (as one might gather from the darker painted square behind it).

▲ Workshop of Andrei Rublev, *Communion of the Apostles*, ca. 1425–27. Sergiev Posad (Russia), Holy Trinity Cathedral.

Christ is the true priest, presiding over every celebration of the Eucharist. The first to receive Communion from him is Peter, followed by Andrew, Simon, Luke, John, and Philip.

*On the top tier of iconostases, called Golgotha or Calvary, a row of Passion icons unfolds on both sides of the crowning cross.*

# The Passion of Christ

**Text**
"He who in the Jordan set Adam free receives blows upon His face. The Bridegroom of the Church is transfixed with nails. The Son of the Virgin is pierced with a spear." (Antiphon for Good Friday Matins)

**Title**
The Way to Calvary (*Christos helkomenos, Shestvie na Golgofu*)

**Feast day**
Holy Friday (*Megale Paraskeve*)

**Sources**
Matthew 26–27; Mark 14–15; Luke 22–23; John 18–19; apocryphal Gospel of Nicodemus

**Iconography**
The cycle of the Passion comprises the agony in the garden, the betrayal by Judas, the arrest; the judgment of Annas, Caiaphas, and Pilate; and finally the Mocking of Christ, the Way to Calvary, and the Crucifixion

▶ *Christ Led to the Cross*, originally from Pelendri (Cyprus), Chapel of the Holy Cross, twelfth century. Limassol (Cyprus), Episcopal Palace.

In the eleventh century, the episodes of the Passion found their place in the "Golgotha" section at the crown of the iconostasis, around the great painted cross that towers over the screen. In single icons, the story of the Passion is told in the side frames. Some of the images of the Passion diverge from the Gospel story and include details taken from the apocrypha. In the Mocking of Christ, the group of mockers sometimes includes musicians, as in medieval mystery plays. While the episode of Simon of Cyrene helping Christ to carry the cross appears in the three synoptic Gospels but is not mentioned in John, the apocryphal Gospel of Nicodemus states that Christ carried the cross as far as the gates of Jerusalem, then was helped by the Cyrenean. To the image of Simon, Byzantine iconography adds

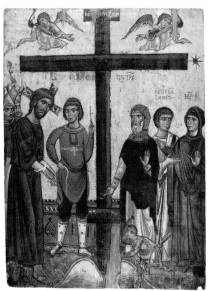

the two cross-bearing thieves, including the Good Thief, who on the cross "snatched" heaven from Christ. The Gospels do not specify how Christ, on Golgotha, was nailed to the cross. In fact, we know that once his hands were nailed to the horizontal arm of the cross (*patibulum*), Christ was hoisted up with ropes onto the vertical stem (*stipes*), which was already planted in the ground.

The diagonal of the mountain divides the composition into two triangles. On the left are the walls of Jerusalem with Jesus and the Holy Women; on the right, the rocks, the soldiers, Simon the Cyrenean, and the two thieves.

Simon of Cyrene joins the two thieves in symbolically bearing a processional three-armed Byzantine cross; the three figures look like they are faithfully performing a holy rite. The condemned man in the foreground, gazing up to the heavens, is the "theologian thief," to whom Jesus promised a place in heaven.

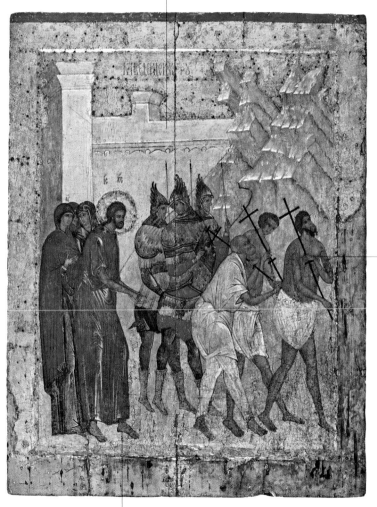

Christ seems to be emerging from the arms of his mother, who is accompanying him together with Mary Magdalen and Mary of Cleophas, while with hands bound and a sorrowful face he is dragged toward Golgotha by three armed soldiers.

▲ Moscow school, *The Way to Calvary*, originally from the iconostasis of the Dormition Cathedral in the Cyrillo-Belozersk Monastery, ca. 1497. Moscow, Andrei Rublev Museum.

Dressed like a king with a staff and red cape, Christ is mocked by the soldiers, who are urged on by the Pharisees. The presence of the two trumpet-players and a boy with a cymbal derives from classical mimes and mystery plays.

Christ is bound and scourged at the pillar, which stands like a cross on the rocks outside the walls of Jerusalem.

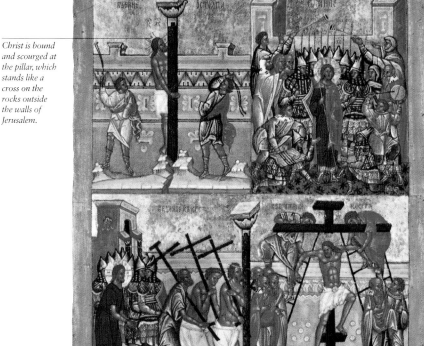

▲ Novgorod school, *The Flagellation; The Mocking of Christ; The Way to Calvary; The Mounting of the Cross*, originally from Novgorod, Cathedral of Saint Sophia, late fifteenth–early sixteenth century. Novgorod (Russia), museum.

The procession turns toward Golgotha. At the head are the two condemned men with their crosses, then Simon of Cyrene carrying the cross of Christ, who is behind the others and escorted by soldiers. In the next frame, Christ assumes gigantic proportions on the cross. He climbs up with the aid of two servants on ladders.

*In Orthodox churches, a cross rises up behind the altar and crowns the highest point of the iconostasis (the "Golgotha") as a painted crucifix flanked by Mary and John.*

# The Crucifixion

John Chrysostom sums up what it means to contemplate the Byzantine crucifix: "I see him crucified and I call him King." That suffering man who died on the cross is the creator of the world, the lord of all life. Why, then, was he put on the cross like a sinner? The answer: to free man from death. In the Church of the Holy Sepulchre in Jerusalem, under the Golgotha chapel, is the chapel of Adam. There one can see a split in the rock, which has, since the fourth century, been considered proof of the earthquake that the Gospel said was unleashed by Christ's death. On this spot, according to medieval legend, the skull of Adam was buried with three seeds of the tree of earthly paradise in its mouth; from these seeds would sprout the cross. "For as in Adam all die, so also in Christ shall all be made alive" (1 Corinthians 15:22). Christ is the new Adam and the cross is the tree of eternal life. The "Place of the Skull" (Golgotha) is represented as a crack in the rock with a skull inside, over which the cross is planted. The Crucifixion takes place before the walls of Jerusalem. Christ is born and dies outside the city, because "our commonwealth is in heaven" (Philippians 3:20).

**Text**
"He who hung the earth upon the waters is hung upon the Cross. He who is King of the angels is arrayed in a crown of thorns. He who wraps the heavens in clouds is wrapped in the purple of mockery." (Antiphon for Good Friday Matins)

**Title**
Crucifixion (*Staurosis, Raspiatie*)

**Feast day**
Good Friday

**Sources**
Matthew 27:45–66; Mark 15:33–40; Luke 23, 26–43; John 18:17–30; John Chrysostom; Nicholas Kabasilas; Athanasius of Alexandria; Basil the Great

**Iconography**
Christ on the cross, with Mary, John, the centurion, the Holy Women, and angels

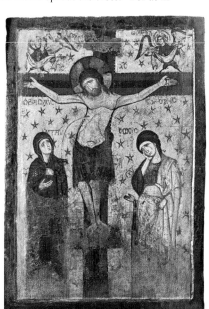

◀ *The Crucifixion*, verso of a two-sided icon, ninth–thirteenth centuries. Athens, Byzantine Museum.

137

# The Crucifixion

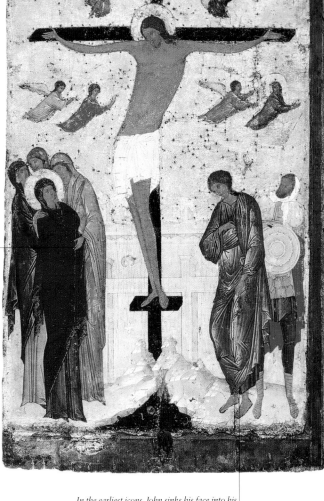

*Two angels descend above Christ, whose body on the cross looks as though rapt in a dance of victory. On the left, under his arm, an angel introduces an allegorical figure representing the New Testament, while on the right another angel is driving away an allegorical figure of the Old Testament.*

*Mary Magdalen, Mary of Cleophas, and Mary's sisters surround and support the grieving Virgin, forming a decorative motif similar to a bouquet of flowers in a spiritual garden; their slender, elongated figures are typical of the painting style introduced by Andrei Rublev.*

▲ Dionysius and workshop, *The Crucifixion*, originally from the Holy Trinity Cathedral of the Paulo-Obnorsk Monastery, ca. 1500. Moscow, Tretyakov Gallery.

*In the earliest icons, John sinks his face into his hand in horror; here he touches his heart instead. Behind him the centurion Longinus looks up toward Christ and recognizes him as the Son of God. The cross is planted in the "Place of the Skull," where Adam's cranium lies.*

*Christ's body is hastily prepared for burial, because the feast of Pesach (Passover) is near. Like the chorus in a Greek tragedy, art allows us to contemplate a cosmic grief.*

# The Deposition and The Lamentation

The canonical Gospels describe neither the Deposition nor the Lamentation. They only mention that Pilate allowed Joseph of Arimathea to collect the body. Icons of the Lamentation are inspired by the apocryphal Gospel of Nicodemus and by a sermon of George of Nicomedia. Mary kisses her son's wounds; Nicodemus removes the nails; Joseph of Arimathea lowers the lifeless body. Then Christ is laid on the stone used for preparing corpses. Here, too, apocryphal sources and traditions intertwine. The purple marble shown in the icons is the Stone of Unction, found at the entrance to the Church of the Holy Sepulcher. According to another tradition, this holy stone was moved from Ephesus to Constantinople in the late twelfth century. The Lamentation is also an important subject of icons: the Virgin kisses her son's face, John leans over the body, and Joseph of Arimathea kneels at Jesus's feet and worships him, while Nicodemus, overcome with grief, leans on a ladder. Mary Magdalen raises her hands to the heavens, surrounded by women.

**Text**
"After this Joseph of Arimathea, who was a disciple of Jesus ... asked Pilate that he might take away the body of Jesus ... They took the body of Jesus, and bound it in linen cloths with the spices, as the burial custom of the Jews." (John 19:38–39)

**Title**
Deposition from the Cross (*Apokathelosis, Sniatie so Kresta*); Lamentation (*Epitaphios threnos, Oplakivanie*); Burial of Christ (*Entaphiasmos, Polozhenie vo grob*)

**Feast day**
Good Friday

**Sources**
Matthew 27:57–61; Mark 15:42–47; Luke 23:50–56; John 19:38–42; apocryphal Gospel of Nicodemus; Romanos the Melodist, *Kontakia*; George of Nicomedia, *Homilies*

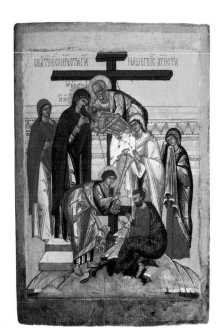

◀ Novgorod school, *The Deposition*, ca. 1480–90. Vicenza (Italy), Gallerie di Palazzo Leoni Montanari, Banca Intesa Collection.

139

# The Deposition and The Lamentation

The mountains embrace the scene, accentuating its drama and making it seem as if the arms of the cross, stretching into the triangle of the heavens, were embracing the cosmos and making it ring out with a silent cry of grief.

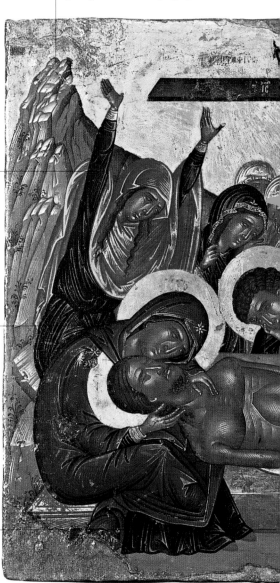

Mary Magdalen throws up her hands in a gesture of despair, as the other five women gather around her, bearing ointments and scents for burial.

The grieving Mother of God holds the dead Christ's head in her lap; John contemplates him sorrowfully; Joseph of Arimathea wraps him in the funeral shroud, which will later become the Holy Shroud.

The reddish purple marble of the tomb takes on a symbolic meaning, becoming the altar of the liturgy. The same is true of the little basket containing the tools for extracting the nails during the Deposition and the vase with scented oils used in burial.

▶ Emmanuel Lambardos, *The Lamentation of Christ*, early seventeenth century. Athens, Byzantine Museum.

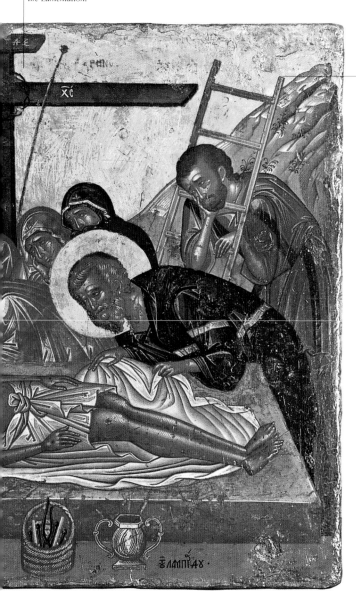

141

# The Deposition and The Lamentation

The mountains descend in regular intervals based on multiples of three. They act like a musical scale repeating the cry of grief expressed in the raised arms of the Magdalen, who is dressed in a bright red cloak.

The expression of grief rests on the ordered, geometrical structure of the composition, which is based on the repetition of the number three. Standing are Mary Magdalen, Mary of Cleophas, and Nicodemus. Below are the Virgin, John, and Joseph of Arimathea, who all have haloes around their heads and are closest to Christ.

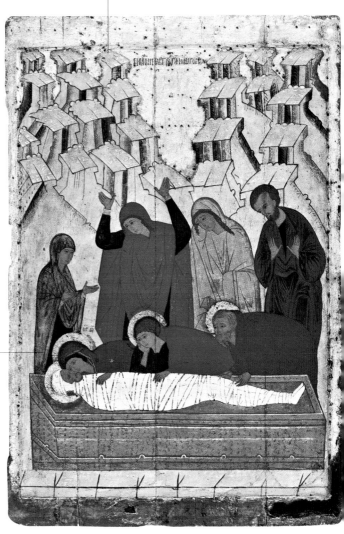

▲ *The Burial of Christ*, late fifteenth century. Moscow, Tretyakov Gallery.

*Orthodox iconography does not represent the moment when Christ emerges from the sepulchre; instead, he is shown already resurrected, breaking down the doors of hell.*

# The Harrowing of Hell

The Orthodox liturgy for Easter Sunday repeats the theme depicted on Easter icons: the church is closed, immersed in shadow, and the priest knocks three times with the cross from the outside, saying: "Open the doors to the Lord of the powers, the king of glory." Inside the church, the sacristan makes a great racket with bolts and chains, conveying a certain resistance, then finally opens up. The church is lit up and scented with incense. In the middle, on the lectern in front of the iconostasis, is an icon of the Harrowing of Hell, adorned with flowers. To the faithful gathered there in the Paschal night, the icon shows Christ gripping the cross, ripping the doors of hell from their hinges, and wresting from the shadows the first progenitors, Adam and Eve, as well as all the righteous of the Old Testament. In his hand Christ holds the "bond which stood against us" (Colossians 2:14). A chasm opens up in the earth, as in the landscape seen in the icon of Christ's baptism in the Jordan. The dark cavity recalls that in which the Christ child lies in his swaddling clothes in icons of the Nativity and is also reminiscent of Jonah, who spent three days inside the belly of the whale.

**Text**
"His flesh was as bait thrown into the arms of death, so that the dragon of hell, hoping to devour it, would instead vomit up those he had already devoured." (John of Damascus)

**Title**
The Resurrection (*Anastasis, Voskresenie*) or Descent into Hell (*Eis ton Haden kathodos, Soshestvie vo ad*)

**Feast day**
Easter Sunday

**Sources**
Apocryphal Gospel of Nicodemus; *Akathistos* hymn; Romanos the Melodist, *Kontakia*; John of Damascus, *Homilies*; Cyril of Jerusalem, *Catechesis*; Epiphanius of Cyprus and Eusebius of Caesarea, *Sermons on Christ's Descent into Hell*

**Iconography**
Christ with the cross, Adam and Eve, the souls of the righteous

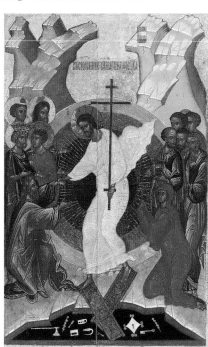

◄ *The Descent into Hell*, second half of fifteenth century. Novgorod (Russia), museum.

143

Three angels worshiping the Holy Cross, whose vertical element establishes the icon's symmetrical axis and the key to its interpretation: Christ's sacrifice has opened the gates of hell.

Christ rises victorious and resplendent over the unhinged doors of hell. Grabbing Adam and Eve by the wrists, he pulls them out of their tombs. Behind them follow the kings, the prophets, and the righteous. On the left one can see David and Solomon wearing crowns; on the right are John the Baptist with a scroll in hand and Noah with a small model of the ark.

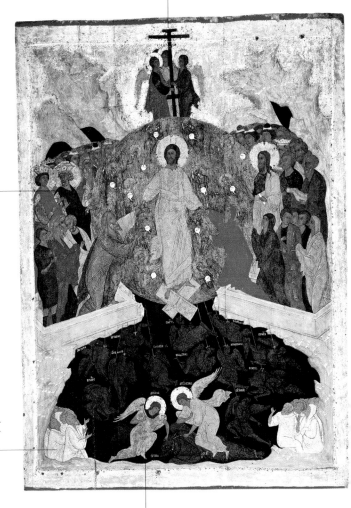

The souls of the righteous in limbo, wearing white robes, await liberation and hold out their hands in supplication.

▲ Workshop of Dionysius, *The Descent into Hell*, originally from the Nativity Church in the Therapon Monastery, 1502–3. Saint Petersburg, Russian Museum.

Two angels bind Satan. The demons in the background, each bearing the name of a vice, are run through by the lances of angels in the blue sphere above. Each angel has the name of a virtue written inside a small white circle. A few of the vice–virtue couplings include: rebellion and docility, humility and vainglory, purity and obscenity, joy and affliction.

*The sorrow of the women bringing scented oils turns to joy on being the first to witness and the first to announce the Resurrection.*

# The Women at the Tomb

On Easter Monday, the first working day after the Sabbath some women brought unguents to Christ's sepulcher (for this they are also called the Myrophorae, or Myrrh-Bearers). The theme, which appeared early in Christian art, became more iconographically precise in the eleventh and twelfth centuries. By the fifteenth century it had joined the festal tier in the iconostasis. The Gospels mention an unspecified number of women (including Mary Magdalen, Mary mother of James, Salome, and Johanna) who see, at the sepulchre, "two men … in dazzling apparel" (Luke 24:4), a "young man … in a white robe" (Mark 16:5), or "an angel of the Lord descended from heaven" (Matthew 28:2). The apparition of the angel, whose "appearance was like lightning, and his raiment white as snow," who sits upon the stone he has rolled back from the door, is a veritable manifestation of God, which, being pre-ceded by an earthquake, frightens the women and sends the soldiers fleeing. But the angel says: "Do not be amazed … He is risen, he is not here … he is going before you to Galilee" (Mark 16:6–7). John recounts the moving *Noli me tangere* ("Touch me not") episode (John 20:1–18): the meeting between Mary Magdalen and the resur-rected Christ, whom she ini-tially takes for the keeper of the sepulchre.

**Text**
"[T]hey have taken away my Lord, and I know not where they have laid him."
(John 20:13)

**Title**
Women at the Tomb (*Taphos*) or Myrrh-Bearing Women (*Myrophorai, Zheny mironositsy*)

**Feast day**
Second Sunday after Easter

**Sources**
Matthew 28:1–7; Mark 16:1–10; Luke 24:1–10; John 20:1–17

**Iconography**
The women bearing unguents (Mary Magdalen, Mary mother of James, Salome, and Johanna); the angel atop the stone he has rolled aside from the sepul-chre; resurrected Christ

◄ Workshop of Andrei Rublev, *The Women at the Tomb* (detail), ca. 1425–27. Sergiev Posad (Russia), Holy Trinity Cathedral.

145

Christ indicates to the Magdalen that he must go
up to the house of his Father, and, to the pious
women, that he will go before his disciples into
Galilee, "to the mountain to which Jesus had
directed them" (Matthew 28:16), where he will
institute baptism.

The group of six
women bearing
unguents, with,
off to the left,
Mary Magdalen,
who is speaking
to Christ. On
the left are the
walls of earthly
Jerusalem, while
on the upper
right, at the top
of the mountain,
is the heavenly
Jerusalem.

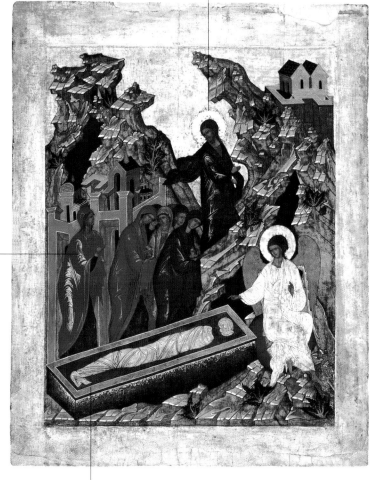

▲ Workshop of metropolitan Makar-
ios, *The Women at the Tomb*, sec-
ond half of sixteenth century.
Moscow, Tretyakov Gallery.

The angel points the women to the sepulchre,
whose mortuary wrappings are intact: the
body of Christ has emerged from them as a
butterfly from its cocoon, but without break-
ing it. It is proof of the Resurrection, as
confirmed by the tradition of the Holy
Shroud of Turin.

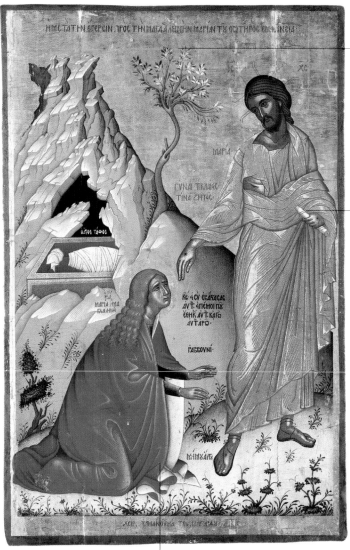

The olive tree growing over the empty tomb symbolizes the victory of life over death. The blooming meadow in which the kneeling Magdalen encounters Christ represents the garden of paradise.

Wrapped in its gleaming chiton, the body of the risen Christ, transfigured by the light of resurrection, bears the very luminous signs of the Passion: the wound in his side; the holes from the nails in the palms of his hands and on his feet. Christ shows his left hand to Mary Magdalen, while in his right he holds the list of human sins that he has redeemed by his death.

The beautiful and grieving Mary Magdalen, wrapped in her red cloak, recognizes her gardener as Jesus Christ, but the Lord quickly takes leave of her with the words "Do not hold me, for I have not yet ascended to the Father" (John 20:17).

▲ Emmanuel Lambardos, *Noli me tangere*, 1603. Dubrovnik (Croatia), Museum of Icons.

*Thomas's confession of faith, after moments of doubt and uncertainty, shines with an extraordinary light, which radiates out from the closed door that the risen Christ has passed through.*

# Doubting Thomas

**Text**
"Thomas's disbelief has been more advantageous for our faith than the faith of the disciples who believed." (Gregory the Great)

**Title**
Doubting Thomas (*Pselaphesis tou Thoma, Uverenie Fomy*)

**Feast day**
Thomas Sunday or *Antipascha* (First Sunday after Easter)

**Sources**
John 20:26–29; apocryphal Acts of Thomas

**Iconography**
The resurrected Christ shows his wounds to Thomas; the apostles are divided into two groups; the closed door through which Christ has passed shines with a brilliant, divine light

▶ Aleppo school, *The Virgin Handing Her Belt to Saint Thomas*, detail of *The Dormition of the Virgin*, eighteenth century. Balamand (Lebanon), Our Lady of Balamand Monastery.

On the very day of his resurrection ("the first after the Sabbath"), Christ enters a room when "the doors were shut." There his disciples have gathered. Thomas, who missed the event, does not believe the disciples' testimony: "Unless I see in his hands the print of the nails, and place my finger in the mark of the nails, and place my hand in his side, I will not believe" (John 20:25). Eight days later Jesus returns, again through closed doors, and Thomas receives the proof he had asked for from the resurrected Christ himself. Thomas's disbelief has had great importance in the theological debate over the authenticity of the Resurrection. The iconography of the episode has remained essentially unchanged since its earliest depictions. Christ at the center, in front of the closed doors of the building,

shows his wounds to Thomas, who approaches in fear. To the left and right, the apostles look on in admiration and astonishment. In the icon of the Dormition, Thomas is remembered as the one who, when summoned with the other apostles to witness the death of the Virgin, arrives late and is swept aloft by Mary, hanging from her belt. The Acts of Thomas, a third–fourth-century apocryphal text, tell of Thomas's evangelical work and martyrdom in India.

*The red drapery on the roofs indicates that the scene is taking place indoors; behind the marble exedra, the tops of the cypress trees bend in the same direction as the apostles below.*

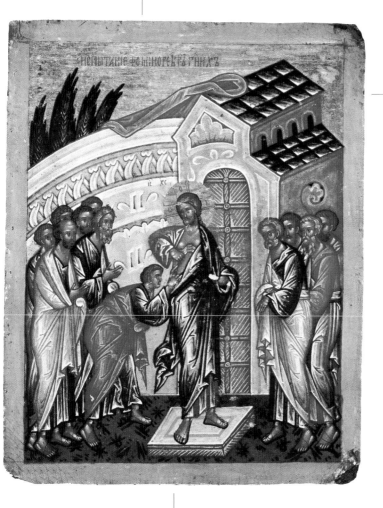

*The building in which the apostles are gathered suggests the form of a three-aisled early Christian basilica.*

▲ *Doubting Thomas*, originally from the Cathedral of Saint Sophia, Novgorod, late fifteenth–early sixteenth century. Novgorod (Russia), museum.

*Standing on a luminous platform, Christ bares his chest to allow Thomas to verify the wound in his side. Since he came in when "the doors were shut" (John 20:26), the door behind him, shining with the radiance of his gloriously resurrected body, is tightly closed.*

*This icon expresses the joy of creation as it witnesses the Creator's ascension into heaven. Humankind, as represented by the apostles, finds its center in the Virgin Mary.*

# The Ascension

**Text**
"Bowing down, the disciples did obeisance to God on high, and full of praise, they let their voices ring out to the mountain, as though shouting in honor of Eleona, since it was deemed worthy of so much." (Romanos the Melodist)

**Title**
The Ascension (*Analepsis; Voznesenie*) of Christ

**Feast day**
Forty days after Easter

**Sources**
Mark 16:19–20; Luke 24:50–63; Acts 1:6–14; apocryphal Gospel of Nicodemus; Romanos the Melodist, *Kontakia*; Cyril of Jerusalem, *Catachesis*; apocryphal Apocalypse of Peter

**Iconography**
Christ in glory with the Mother of God, the apostles, two angels in white robes, rocks, and olive trees

▶ *The Ascension*, mid-fifteenth century. Moscow, Tretyakov Gallery.

At the highest point of the Mount of Olives, above the grotto of the Eleona ("olive grove"), stands the Chapel of the Ascension (today a mosque), which marks the spot where Christ rose into the sky before the astonished eyes of his apostles. The memory of this great feast (which the Gospel places forty days after the Resurrection and fifty days before Pentecost) was at first celebrated on the same day as the Resurrection, then later at the same time as Pentecost, then finally, between the fifth and sixth centuries, as a separate feast. The iconographical schema, however, remains constant, with the apostles encircling the Mother of God. Icons place Mary at the very center of the composition, as the pillar and foundation of the Church, the axis linking earth with heaven, where Christ sits enthroned among the angelic powers. On earth, among the rocks and olive trees—which represent nature's joyous participation in the cosmic liturgy—the angels of the Resurrection reproach the agitated apostles: "Men of Galilee, why do you stand looking into heaven?" (Acts 1:11). Mary, the only person with the halo of sainthood, maintains an ineffable tranquility: in her the angelic and earthly worlds meet.

*The descent of the Holy Spirit is the definitive revelation of the Trinity, sparking the life of the Church like a fire and redeeming the ancient world from its prison of shadow.*

# Pentecost

The iconography of Pentecost presents the classic group portrait of the early Christian community: Mathias has taken the place of Judas, and Paul and the evangelists Mark and Luke appear together with the twelve apostles. The Mother of God, present at the Ascension, is absent in icons of Pentecost up until the seventeenth century. Bishop Innocent writes: "How could she not be present at the moment of the Spirit's arrival, she who conceived and gave birth by means of the Spirit?" The empty place between Peter and Paul evokes the presence of the Spirit of Christ. The composition of the icon, with the apostles seated in a horseshoe arrangement, recalls the icon of Christ teaching in the synagogue: he is the Consoler, or *Paraklete* (advocate, defender, and intercessor). Christ himself, before his ascension, says he is about to go up to his Father to send down the Spirit. The apostles represent the community of the faithful, open to the action of the Spirit. The later iconography of the ecumenical councils, expressed in the Russian concept of *sobornost* (commonality) will be the same. While the apostles are enflamed from above by the divine light, the old, imprisoned world below (the cosmos) awaits liberation from the shadows of evil through the effusion of the Holy Spirit.

**Text**
"Veni Sancte Spiritus,
Veni per Mariam."
(Ancient prayer)

**Title**
Pentecost (*Pentekoste,
Piatidesiatnitsa*) or Descent
of the Holy Spirit
(*Soshestvie Sviatogo
Dukha*)

**Feast day**
Fifty days after Easter

**Source**
Acts 2:1–2

**Iconography**
The apostles, the Virgin,
the house in Jerusalem in
the foreground, an allegory
of the cosmos, and luminous rays or flames
descending over them

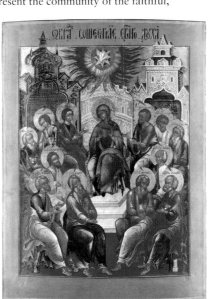

◄ *Pentecost*, from central Russia, mid-nineteenth century. Italy, private collection.

# Pentecost

Tongues of fire break away from the circle of heaven like jets of a spiritual fountain and come to rest over the head of each apostle. The personal and communal dimensions coexist, opening onto the old king languishing in his prison of darkness below.

The apostles gathered in the hemicycle are, on the left, Peter, Matthew, Luke, Simon, Bartholomew, and Philip; on the right, Paul, John, Mark, Andrew, James, and Thomas. The empty space in the middle evokes Christ, who is present through the mediation of the Spirit, a divine energy that marks, with subtle golden striation (assist), the horseshoe-shaped bench on which the apostles are seated.

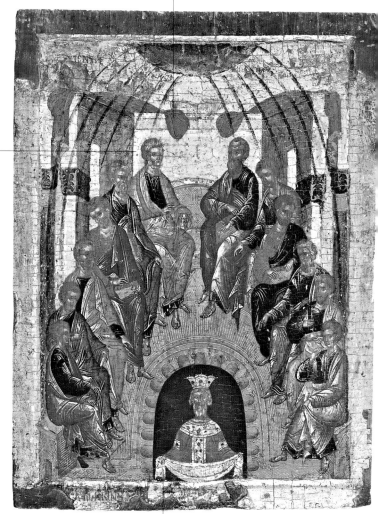

▲ Michael Damaskenos, *Pentecost*, second half of sixteenth century. Athens, Byzantine Museum.

The old king is the Cosmos, the world that lives in shadow, waiting to be revived by the Spirit. The twelve scrolls he holds on the spread cloth represent the preaching of the apostles.

*It is the most important Marian feast in all the Christian East and corresponds to the equally popular and celebrated Western feast of the Assumption in mid-August.*

# The Dormition of the Virgin

The belief that the body of Mary, which remained inviolate after she gave birth, never experienced decay in the tomb and was directly assumed into heaven was already prevalent in the early Christian community. Though lacking basis in the Gospels, it has a solid tradition and is upheld by both the Catholic and Orthodox Churches. The great feast of the Dormition was instituted by the Eastern Church in the sixth century. In the West we speak of Assumption, whereas the Orthodox underscore the fact that Mary went to sleep (*Dormitio*). The icon of the Dormition has its prologue in the side-frame stories of the Virgin (see the frame of the Annunciation icon on page 103): Gabriel announces to Mary that her death is near, and she asks to see the apostles again, prays on the Mount of Olives, and prepares her deathbed. This is when the apostles gather in Jerusalem to mourn. Behind the coffin, Christ appears with his mother's soul.

**Text**
"You fell asleep, yes, but not to die. You were assumed into heaven, but you never cease to protect humanity."
(Theodore the Studite)

**Title**
The Dormition (*Koimesis, Uspenie*) of the Virgin

**Feast day**
August 15

**Sources**
Apocryphal gospels; Theodore the Studite, *Panegyric on the Dormition*; John of Damascus, *Homilies on the Blessed Virgin*; Romanos the Melodist, *Kontakia*; John Mauropous, *Homily on the Dormition*; Epiphanius of Callistratus, *Life of the Blessed Virgin*

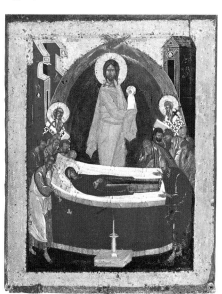

◄ *The Dormition of the Virgin*, originally from Moscow or Kolomna, late fourteenth century. (The other side of this two-sided icon appears on page 179.) Moscow, Tretyakov Gallery.

The gates of heaven open up, and
Mary ascends, borne by the
archangels; the twelve apostles
float on clouds in the sky toward
Jerusalem, where the Mother of
God has summoned them.

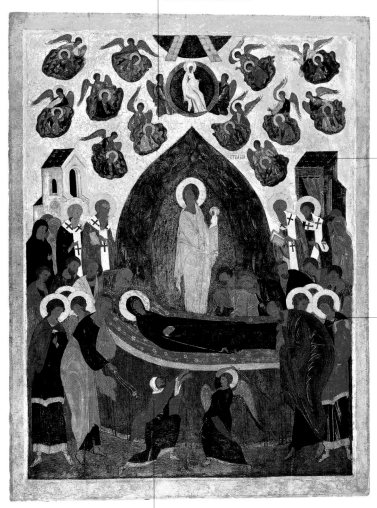

The buildings
represent Mary's
house and the
Temple of
Jerusalem, the
destination of
the procession.

Peter holds the
censer on the
left, while Paul
prays at the
foot of the bed
in the presence
of angels, apos-
tles, bishops,
Church Fathers,
and pious
women.

▲ Dionysius, *The Dormition of the
Virgin*, originally from the Cathedral
of the Dormition, Dmitrov, late
fifteenth century. Moscow, Andrei
Rublev Museum.

The structure of the composition is marked by the
strong horizontal of the Virgin's body, from which
arises the vertical line of Christ holding a small
Mary in swaddling clothes. In the foreground, an
angel cuts off the hands of the impious priest who
wants to upend the bier.

*One of the most important feasts of the Orthodox liturgical year was established around the relic of the True Cross, found by Saint Helen and kept in the Church of the Holy Sepulchre in Jerusalem.*

# The Exaltation of the Cross

To erase all memory of the places of Christ's Passion venerated by the first Christians, the Roman emperor Hadrian had a temple dedicated to Venus built upon Golgotha. The bishop of Jerusalem, Macarius, later asked Emperor Constantine—to whom the cross had appeared before the victorious battle of the Milvian Bridge in 312—to raze the temple so they could look for the sepulchre of Christ. Leading the excavations was Helen, Constantine's mother, who had granted the Christians freedom of worship. In 326, Helen found the Holy Sepulchre and, nearby, the remnants of the three crosses, the nails, and the inscription of the crucifix. On this site arose the Basilica of the Resurrection (or of the Holy Sepulchre), consecrated on September 13, 335. The following day, the feast of the Exaltation of the Cross was established, one of the twelve great feasts of the Orthodox calendar. The icon of the Exaltation of the Cross represents the moment when Bishop Macarius goes to the central point of the church and, aided by two deacons, elevates the cross a hundred or so times toward the four cardinal points as the faithful reply, "Lord have mercy on us" (*Kyrie eleison*). In some icons it is Saints Constantine and Helen who raise up the cross.

**Text**
"Rejoice, O Cross, thou guide of the blind and physician of the sick and resurrection of all the dead." (*Aposticha* for September 14)

**Title**
Exaltation (*Hypsosis*; *Vozdvizhenie*) of the Holy Cross

**Feast days**
Exaltation of the Cross, September 14; Adoration of the Cross, third Sunday of Lent; Appearance of the Sign of the Cross over Jerusalem, May 7; Procession of the Cross, August 1

**Sources**
Andrew of Crete, *Homilies on the Exaltation of the Cross*; Romanos the Melodist, *Kontakia*; Gregory of Nyssa, *Homily on the Resurrection*

◄ *The Cross of Golgotha*, back side of the closed wings of a triptych icon, sixteenth century. Moscow, Tretyakov Gallery.

# The Exaltation of the Cross

The Basilica of the Resurrection (Anastasis), also called the Church of the Holy Sepulchre, is crowned by five domes surmounted by Byzantine crosses and flanked by two other buildings.

The emperor Constantine and his mother, the empress Helen, enter through a door (or a side aisle) to worship the relic of the Holy Cross. A group of dignitaries approaches in solemn procession on the opposite side.

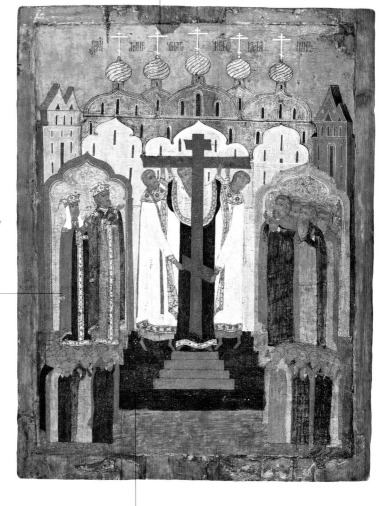

▲ *Exaltation of the Cross*, originally from northern Russia, 1580. Belgium, private collection.

Bishop Macarius, with the help of two deacons, raises the cross to the four cardinal points, represented by the four groups of the faithful to the left and right, above and below. The date of the icon, written in ink on the back, is July 2, 7088, from the creation of the world, that is, A.D. 1580.

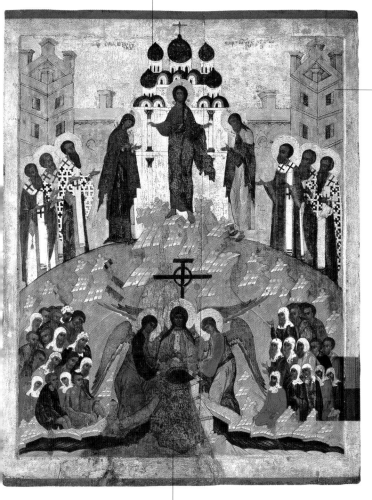

The elongated figure of Christ harmonizes perfectly with the white cathedral and its vertical domes in the background. Around him, in Deesis, are the Mother of God, John the Baptist, and holy bishops in procession.

While the upper part of the composition is dominated by holy buildings, the landscape below is characterized by rocks and a riverbed. The top of the mountain on which Christ's feet rest recalls Mount Tabor, where he was transfigured. Divine light shines on the facets of the rocks in the scene below.

The wood of the cross is immersed in the river's waters, which are thereby blessed and given new life, becoming a source of healing for the sick. The scene is reminiscent of the probatic pool of Siloam, scene of one of Christ's miracles.

▲ Procession of the Honorable Wood of the Cross, early fifteenth century. Suzdal (Russia), museum.

*This solemn, dramatic composition represents the final act of all human history when Christ, the righteous Judge, will take the throne and judge all the living.*

# The Last Judgment

**Text**
"And lo, a man climbed the clouds, a very tall man …He raised his arms to the East and shouted in a thundering voice: Lo, now the world shall be saved!" (Gregory of Nazianzus)

**Title**
The Second Coming (*Deutera parousia*) or Last Judgment (*Strashnyi sud*)

**Sources**
Genesis 3:15; Daniel 7:9–10; Matthew 25:31–46; Luke 16:20–26; Revelation 6:14, 20:13; Ephraim the Syrian, *On the Coming of the Lord* and *On the Judgment*

**Iconography**
Christ, Mary, John the Baptist, Saint Michael, the saints, Abraham, Lazarus, the Good Thief, Satan, Judas, angels, and demons

The first great frescoes of the Last Judgment would take up the entire western wall of the churches. This fascinating subject, which so inspired medieval man, is present from the very start of Byzantine iconography, and in Russia it took on increasingly elaborate forms of representation. The sources of inspiration—aside from the Revelation of John—are the book of Genesis, the visions of the prophet Daniel, the Gospel parable of Lazarus and the rich man, and Jesus's sermon on the chosen and the damned. Christ the Judge enthroned dominates on high, surrounded by Mary, John the Baptist, apostles, saints, and angelic ranks. At the center is the Prepared Throne (*Hetoimasia*), the supplicating Adam and Eve, and the hand weighing souls on the scale. On the lower left (Christ's right-

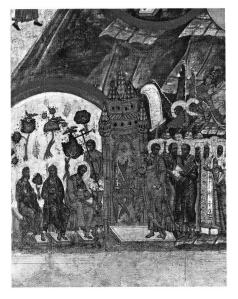

hand side), paradise is recognizable by the white background and lush garden. On the right is hell, a lake of fire fed by a river of incandescent lava flowing straight from God's throne. The procession of the righteous, led by Peter and Paul, is about to pass through the gates of heaven. Behind these gates are the bosom of Abraham, the Good Thief, and the enthroned Mother of God.

▶ *The Righteous Entering Paradise*, detail of *The Last Judgment*, 1580–90. Solvychegodsk (Russia), Museum of History and Art.

Christ is enthroned inside a golden mandorla and crowned by the choirs of angels. To his left and right are the Virgin and John the Baptist, and the twelve apostles holding open books, in which the acts of humankind are written.

The angel rolls up the sky like a parchment scroll. Beneath him, other angels drive the souls of the damned into the lake of fire, where Satan's beastly mount is chained.

The Hetoimasia, the throne prepared for the Judgment, on which Christ will sit, with the symbols of the Passion. At the foot of the throne are Adam and Eve, while beside it are the Old Testament patriarchs, prophets, and kings, as well as martyrs, bishops, and virgins.

▲ *The Last Judgment*, panel from a etraptych, twelfth century. Mount inai, Monastery of Saint Catherine.

The flaming cherub guards the gates of paradise, where the Mother of God sits enthroned with Abraham and Lazarus. Before the gate stand Peter and three Church Fathers.

# The Last Judgment

Left to right: Jerusalem; angels rolling up the sky over a red circle with God the Father inside; holy council of the Trinity, holding twelve open books. Below: Christ enthroned, surrounded by apostles and angelic ranks, holding a book that reads: "Do not judge by appearances" (John 7:24).

Monks and ascetics who lived angelic lives received flaming red wings for their ardor and rise up toward the throne of Christ; at the center, a hand emerges from the Throne of Judgment to weigh human souls on the scale; an angel lances the devils who try to tip the scale to the side of evil; further down, another angel drives sinners into the lake of fire.

▲ The Last Judgment, mid-sixteenth century. Saint Petersburg, Hermitage Museum.

The ten rectangles list the mortal sins and show the respective punishments of the damned, who are tortured by demons.

From the feet of the Trinity on high flows a stream of fire that forms a pool below. There Satan, in chains, holds the soul of Judas in his arms; inside the circle the earth and the seas give back their dead, to the sound of the angels' trumpets.

▲ *The Last Judgment, 1580–90.
Solvychegodsk (Russia), Museum
of History and Art.*

*One of the two mouths of the beast of hell (with
Satan on top) disgorges the serpent, who tries to
bite Adam's heel, but in vain: Adam is safe with
Eve under the throne of Christ. The serpent's
coils represent the trials (telonia, mytarstva) that
human souls must pass in order to redeem them-
selves from sin and ascend into heaven.*

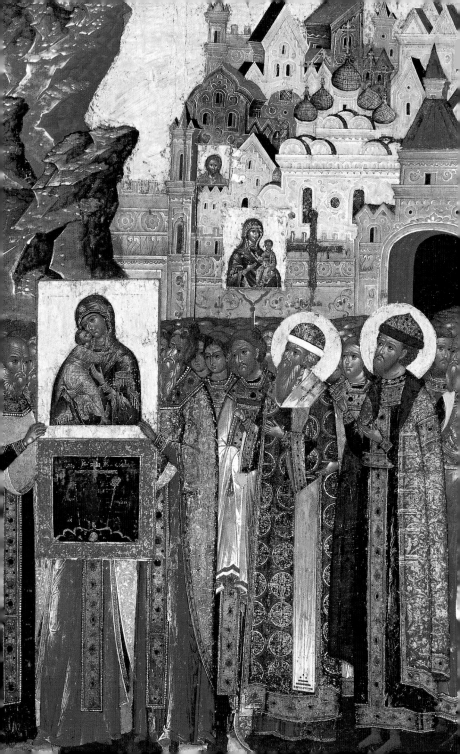

# THE MOTHER OF GOD

*The Virgin of the Burning Bush*
*The Virgin Enthroned*
*The Virgin* Hodegetria
*The Virgin* Orans
*The Protecting Veil of the Virgin*
*The Virgin* Eleousa
*The Virgin with the Playing Child*
*The Virgin Nursing*
*The Virgin of the Sweet Kiss*
*The Virgin of the Passion*
*Our Lady of the Kievan Caves*
*"It Is Truly Meet"*
*Life-Giving Source*
*Enclosed Garden*
*"Joy of All That Sorrow"*
*"In Thee Rejoiceth"*
*Praises to the Mother of God*
*Inviolate Mountain*
*Saint Anne with the Virgin*
*The Virgin of Intercession*
*Our Lady of Refuge*
*The Lamenting Virgin*
*"Soothe My Sorrows"*
*Deposition of the Virgin's Mantle and Belt*
*Unexpected Joy*
*The Conversing Virgin*
*The Three-Handed Virgin*
*Unfading Rose*

◄ *Presentation of the Vladimir Icon of the Virgin* (detail), originally from Moscow, Church of the Metropolitan Alexis at Glinishchi, ca. 1640. Moscow, Tretyakov Gallery.

*Becoming flesh in Mary's bosom, the Holy Spirit is kindled inside her but does not consume her, like a fire that does not burn its fuel. And thus she gives birth to God while remaining a virgin.*

# The Virgin of the Burning Bush

**Text**
"More honorable than the cherubim and incomparably more glorious than the seraphim." (Cosmas of Maiuma)

**Title**
The Virgin of the Burning Bush (*tes Batou, Neopalimaia kupina*); Jacob's Ladder (*Lestvitsa Iakovlia*)

**Feast day**
September 4 (feast day of the prophet Moses)

**Sources**
Genesis 28:12; Exodus 3:2–4; Isaiah 7:14, 11:1; Ezekiel 44:1–2; Revelation 4:6–8, 6, 8; *Akathistos* hymn; John Chrysostom, *Homily on the Annunciation*

**Iconography**
The Mother of God, the angelic powers, the symbols of the evangelists, the visions of Moses, Isaiah, Ezekiel, and Jacob

▶ *The Virgin of the Burning Bush*, detail of the fresco in the apse of the *bema*, second half of fifteenth century. Mount Sinai, Monastery of Saint Catherine, Chapel of Saint James.

Moses' burning bush was interpreted by the Church Fathers as an image of Mary giving birth to Christ, the divine fire, while remaining a virgin. A fourteenth-century manuscript kept at the Solovki Monastery in Russia describes Mary's powers: she can send lightning, frost, and earthquakes down to earth to punish the impious. These sources inspired the icon of the Virgin of the Burning Bush, which spread from Sinai to Russia in the fourteenth century. At the center of an eight-pointed star is the image of Mary the Rock, detached from the mountain by no human hand (Daniel 2:45). The green-blue rhombus represents the vegetable nature of the bush; the red rhombus the divine flames that do not burn it up. Inside the red points are four symbolic creatures: lion, ox, eagle, man; in the blue points, the angels of the Apocalypse. In the corners are visions of Moses, Isaiah, Ezekiel, and Jacob.

*In the four corners are the prophecies concerning the Mother of God: the burning bush of Moses; the seraph who purifies Isaiah's lips; the closed door of the Temple in Ezekiel, representing Mary's virginity; and Jacob's Ladder.*

*At the center of the rhombus, the image of the Virgin, the rock detached from the mountain, together with the ladder (uniting heaven and earth), and the Temple-Church, which, like Mary, contains Jesus.*

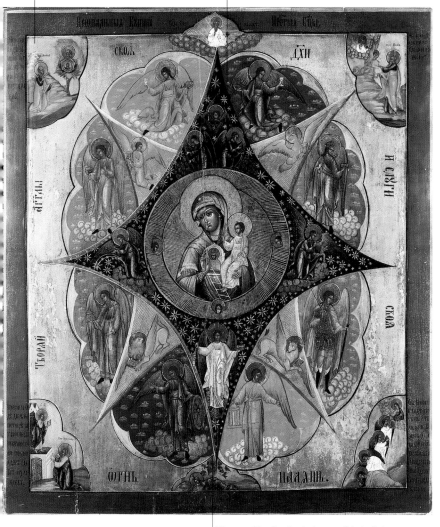

▲ *The Virgin of the Burning Bush,*
central Russia, late eighteenth century.
Private collection.

*The green-blue rhombus is the part of the bush that does not burn, whereas the red rhombus represents the flame and holds symbols of the four evangelists. Around them are the angelic powers, which Mary commands.*

*The magi adore Christ as a child-king seated in the lap of his mother, a queen on her throne. From this develops the theme of the Mother of God in majesty.*

# The Virgin Enthroned

**Text**
"Her hands carry the Eternal One, and her lap is a throne more sublime than the cherubim."
(John of Damascus)

**Title**
Mother of God
(*Theokotos*; *Meter Theou*; *Bogoroditsa*); *Kyriotissa* (standing, holding the Christ child to her breast, and showing him to the faithful

**Source**
Matthew 2:11

**Iconography**
The Virgin seated on a throne with Jesus in her lap and the saints beside her; when the throne is turned to the left or right, she is hearing the prayer of a supplicant kneeling at her feet

With its hieratic frontal pose, the image of the Virgin enthroned with her Son derives from ancient images of Egyptian, Greek, and Roman mother-goddesses. Its severe, majestic solemnity fits in well with the dogma of the Council of Ephesus, which in 431 established the divine maternity of Mary (*Theokotos*). The regal image of the Mother of God reached its peak at the imperial court of Byzantium. Surrounding her are the Christian emperors Constantine and Justinian, the Greek saints Theodore and Demetrius, and the archangels Michael and Gabriel. In Russia, on the other hand, the Virgin's throne is surrounded by the monastic saints Anthony of the Caves, Theodosius of the Caves, and Sergius of Radonezh. It was customary to represent, next to the Virgin's throne, a donor or religious founder seeking benediction for a new church or monastic community. The architectural throne suggests Mary as a metaphor for the living Temple, the ladder linking heaven and earth, the Inviolate Mountain. The subject—which is not connected with any particular canonical feast day—also gives rise to more complex iconographical compositions, such as the Synaxis (Assembly) of the Angels, "In Thee Rejoiceth," and the Praises of the Virgin derived from the *Akathistos* hymn.

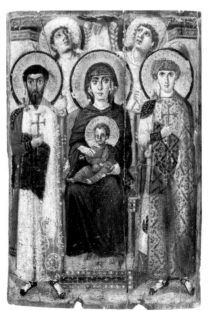

▶ *The Virgin Enthroned between Saints Theodore Strateletes and George,* sixth century. Mount Sinai, Monastery of Saint Catherine.

The heavenly sphere containing Gabriel (the angel of the Annunciation) gives a sense of rotation to the haloes and throne, free forms that seem to float harmoniously in the abstract gold of the background.

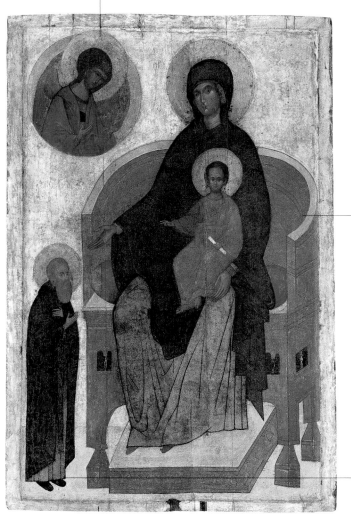

The throne resembles a temple, with its windows and columns, while the exedra of the back suggests the form of an apse. The throne thus becomes a metaphor of the Virgin herself, who is the true temple of the Holy Spirit, God's home. The reverse perspective of the throne and its semicircular form direct the composition to the left.

Mary's hand reaches out to touch Sergius of Radonezh, as if wanting to convey the grace of her blessing on him for founding the Monastery of the Annunciation at Kirzhach. This is one of the oldest known portraits of the saint. The footstool on which the Virgin's feet are resting "slides" out from the throne like a drawer.

▲ The Virgin Enthroned with Saint Sergius of Radonezh, early fifteenth century. Moscow, Historical Museum.

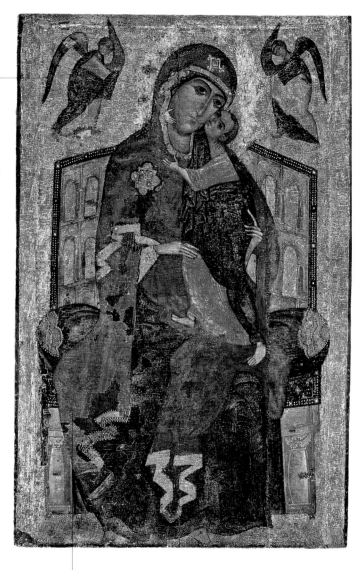

Two adoring angels
frozen in midair (each
with one wing open
and the other folded)
confer dynamism on
the composition and
precisely echo the
movement of Christ in
the Virgin's arms, as he
walks over her knees
and holds her lovingly
around the neck.

▲ *The Virgin Enthroned with Christ
Child*, originally from the Tolga
Monastery (near Yaroslavl), late
thirteenth century. Moscow,
Tretyakov Gallery.

*According to legend, this icon appeared
miraculously at the site near Yaroslavl
where the Tolga Monastery was later
erected in 1314. A marble relief reproduc-
ing this icon can be found in Venice, in the
Zen chapel of the Basilica of San Marco.*

*This very ancient icon has had an enormous influence on all Christian art. It conquered the medieval world from Greece and Russia to China and Ethiopia.*

# *The Virgin* Hodegetria

Like the icon of Christ, that of the Mother of God (*Theokotos*) is considered authentic, an object of worship, because it is a revealed truth. Tradition identifies the first portraitist of the Virgin and Child as the evangelist Luke, even though he did not meet Mary until after Christ's death when she was already elderly. The icon of the *Hodegetria* ("She who shows the way") arrived in Constantinople from Jerusalem, where it had been found in the fifth century by the sister-in-law of Emperor Theodosius II. Hidden from the Iconoclasts in a wall at the Hodegon Monastery, it was later carried to the city walls when Constantinople lay under siege and became, under the Palaiologan dynasty (1261–1453), a major *palladium* protecting the capital. Copies made their way to Rome, the Near East, the Balkans, and Russia. The fifth/sixth-century *Salus populi romani*, now in Santa Maria Maggiore in Rome and attributed to Luke, is supposed to be a copy of the Lydda icon of the Virgin, which miraculously traveled from Constantinople to Rome. The Kazan icon of the Mother of God, rediscovered in 1579, saved Moscow from Polish invasion. The Virgin of Tikhvin, originally from Constantinople, appeared on Lake Ladoga in northern Russia and warded off the invading Swedes.

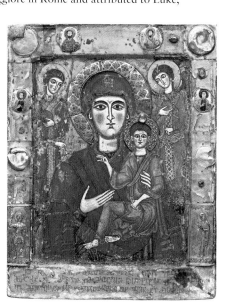

**Text**
"Painting your image most worthy of honor, Saint Luke, author of the Gospel of Christ, inspired by the voice of God, depicted the Creator of all things in your arms." (Troparion for the feast of the Vladimir icon of the Virgin)

**Title**
*Hodegetria* (*Odigitriia*); of the Door (*Portaitissa*, *Vratarnitsa*); Three-Handed (*Tricheirousa*, *Troeruchitsa*); and Soul-Saving (*Psychosostria*, *Dushespasitelnitsa*)

**Feast days**
Lydda icon, March 12; Kazan icon, July 8 and October 22; Pskov icon, July 16; Tikhvin icon, July 26; Smolensk icon, October 13, June 26, July 28

**Iconography**
The Mother of God holds the Christ child in one arm, as her other hand points at him

◀ *The Virgin of Cilkani*, thirteenth century. Tbilisi, Georgian State Museum of Art.

169

The border of Mary's richly embroidered mantle (maphorion) is an important decorative motif, framing her face and her big, asymmetrical eyes.

On her shoulders and head, Mary wears the triple, star-shaped cross, an ancient Syrian symbol of virginity (before, during, and after delivery).

▲ Timofei Rostovets, *The Virgin of Kazan*, 1649. Rostov (Russia), museum.

Because only her head and shoulders are portrayed, Mary invites the viewer to look at Christ with a mere inclination of the face, and especially with her large, expressive eyes. The Christ child is rigidly vertical and wearing regal dress highlighted by a subtle web of gold striation (assist).

Noble and serene, Mary's face displays a classic Byzantine splendor. Her complexion, transfigured by a soft play of shadow and light, reflects the "uncreated" luminosity of divine energy, in accordance with the Hesychast doctrine of Gregory Palamas.

The Mother of God holds the Child in her left hand and with her right points to him, drawing the attention of the faithful.

▲ *The Virgin* Hodegetria, from Byzantium, first half of fifteenth century. Moscow, Tretyakov Gallery.

Clothed in a splendid royal himation, giving benediction with one hand and in the other holding the scroll of the Law (which finds its fulfillment in him), Christ radiates the luminous splendor of his divine humanity.

*Standing with arms raised and the Christ child against her breast, she is the mediator between God and mankind. She also appears on coins minted by the Byzantine emperors.*

# *The Virgin* Orans

**Text**
"Your womb is vaster than the heavens, since in it you carried Him whom the heavens cannot contain, O Mother of God."
(Byzantine hymn)

**Title**
Virgin of the Sign
(*Bogomater Znamenie*);
Vaster than the Heavens
(*Platytera ton ouranon, Shirnaia nebes*); Great
*Panagia* (*Velikaia Panagiia*);
Virgin of the Blachernae
(*Blachernitissa*)

**Feast day**
Novgorod Virgin of the Sign, November 27

**Source**
Isaiah 7:14

**Iconography**
Virgin of the Sign: with arms raised and the Christ child against her breast; *Platytera*: with Jesus on her lap; *Panagia*: with angels or seraphim

A woman standing with arms raised and the palms of her hands turned heavenward was the simplest means by which early Christian art represented the soul of the deceased (often a martyr) awaiting eternal life in Christ. In the fourth and fifth centuries, this typology was transformed into the image of the Virgin Mary *Orans* or *Orant* (from *orare*, to pray). In this pose, which also recalls Christ on the cross, she sends her prayer heavenward. Over her heart appears an image of Christ Emmanuel, just as the empress and dignitaries of the Byzantine court wore medallions (*signum*) with an image of the emperor. Thus was born the iconographical typology of the Virgin of the Sign, derived from the prophecy of Isaiah (7:14). In her monumentality, the Virgin becomes the Great *Panagia* ("All Holy"), the icon that appeared for the first time in Constantinople in the ninth century, in the Church of the Blachernae, and became

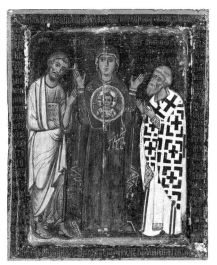

the symbol of the city itself. It was destroyed in a fire in 1434. In Russia, the image of the Mother of God *Blachernitissa* spread to Kiev in the twelfth century and later to Yaroslavl. The Novgorod Virgin of the Sign (*Znamenie*) intervened to save the city from attack by the soldiers of Suzdal in 1170. She rescued Novgorod again in 1352, this time from the plague.

▶ *Virgin Blachernitissa between Moses and Patriarch Euthymius of Jerusalem*, ca. 1224. Mount Sinai, Monastery of Saint Catherine.

The dark red, starred maphorion *encloses Mary's prayer-enraptured face and opens at her breast, revealing a royal blue gown bordered in gold around the neck and wrists.*

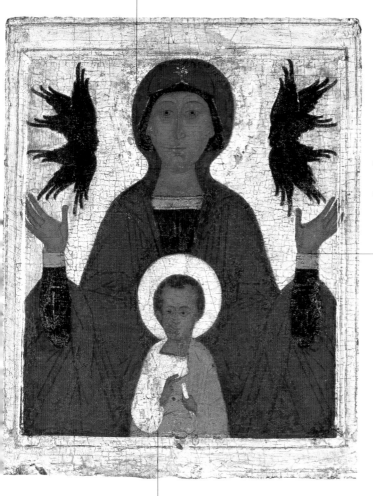

*Her arms emerge from her cloak in perfect vertical lines, while her fingers open in prayer like two wings, echoed here by those of the cherubim.*

The Virgin of the Sign, central ...ussia, two-sided processional ...on, mid-sixteenth century. ...oscow, Historical Museum.

*Jesus appears at the center of the Virgin's breast, as she raises her arms to the heavens, where two cherubim fly. Mary is a mediator between heaven and earth; the golden light comes down to earth in the Child enclosed in her bosom.*

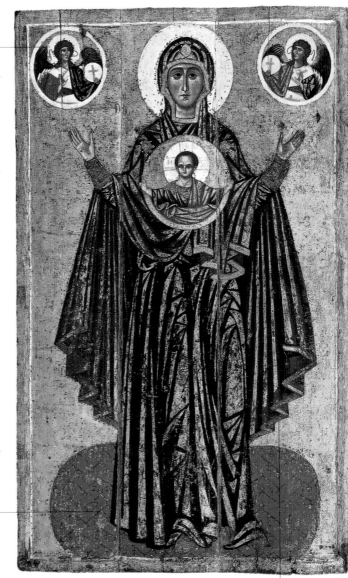

The four circles, together with Mary's raised arms, form a perfect inverted triangle. At the center of the halo is the Virgin's face, while on either side are the two archangels wearing priestly stoles (alluding to the Divine Liturgy). At the vertex is Christ Emmanuel, he who sacrifices and is being sacrificed, image of the Eucharist.

Rising up from the reddish purple royal cushion as from a fiery cloud, the figure of the Virgin, queen of the heavens and "All Holy," towers like a beacon of salvation.

▲ *Virgin Blachernitissa*, originally from Yaroslavl, Monastery of the Transfiguration, ca. 1224. Moscow, Tretyakov Gallery.

*The profusion of gold in the folds of her robe and royal mantle recalls the splendor and magnificence of ancient mosaics and gives the image a powerful monumentality. The fabric is reminiscent of the Virgin's mantle, kept as a relic in the Church of the Blachernae.*

*The feast day was established in 1160 by Andrei Bogoliubskii, grand prince of Vladimir. It spread in the principalities of Novgorod, Vladimir-Suzdal, and Kiev.*

# The Protecting Veil of the Virgin

The feast of the Protecting Veil (*Pokrov*) owes its origin in Russia to pilgrims who had visited the Constantinople Church of the Blachernae, where the mantle or veil (*maphorion*) of the Virgin, a relic brought over from Jerusalem, was kept. Especially during the weekly liturgical celebration of the feast (between Friday and Saturday), a cloth would be raised to reveal an image of the Virgin *Orans*. In this same Church of the Blachernae, Saint Andrew the Fool, a holy man, had a vision of Mary between John the Baptist and the saints, spreading her veil over those present. Icons depicting the episode show a church surmounted by domes, representing the Church of the Blachernae or perhaps Hagia Sophia. Inside, under an image of Christ Pantokrator, archangels open a veil (*pallium*) over the Virgin. Around her are gathered the apostles and Church Fathers, led by Peter, Paul, and John the Baptist. Below, the sixth-century hymnographer Romanos the Melodist holds the text of his hymn (*kontakion*) to the Virgin, while Andrew the Fool points out his vision to his disciple Epiphanius.

**Text**
"Under your protection we seek refuge, holy Mother of God." (Third-century Coptic papyrus)

**Title**
The Protecting Veil (*Pokrov*) of the Virgin

**Feast day**
October 1/14

**Sources**
*Life of Saint Andrew the Fool*; Russian icon-painters' manuals (*Podlinniki*); Pachomius the Serb

**Iconography**
The Virgin stands upon a cloud, either holding her veil or praying with arms open and surrounded by apostles and saints as the angels spread the veil over her head; below are Romanos the Melodist, Epiphanius, and Saint Andrew the Fool

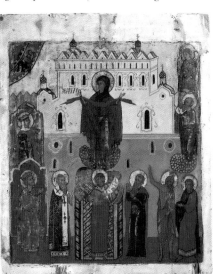

◀ Pskov school, *The Protecting Veil of the Virgin*, late sixteenth century. Collezione Bucceri–De Lotto.

# The Protecting Veil of the Virgin

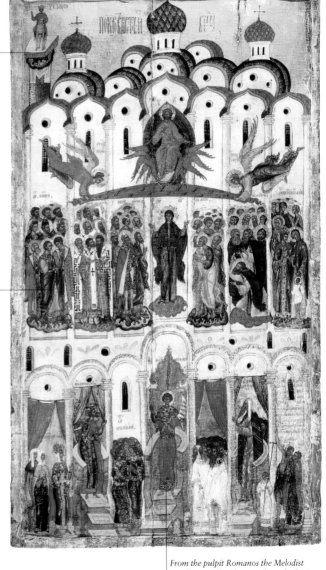

The equestrian statue of Emperor Justinian actually stood near Hagia Sophia in Constantinople, though the church in this icon, with six aisles and a central nave, symbolizes the Temple of Wisdom.

Two angels spread the veil over the Virgin Orans standing on a cloud of fire at the center, surrounded by six groups of saints: kings, prophets, bishops, apostles, monks, and pious women.

From the pulpit Romanos the Melodist unrolls a scroll with verses from the feast day's liturgy: "Today the Virgin stands before us in the church, and with the choirs of saints invisibly prays to God for us." On the right, Andrew the Fool shows Epiphanius his vision.

▲ Novgorod school, *The Protecting Veil of the Virgin*, mid-sixteenth century. Saint Petersburg, Russian Museum.

*It is one of the most popular and widespread images of Mary in both the West and the East, highlighting the affectionate intimacy that unites Virgin and Child.*

# The Virgin Eleousa

The Virgin of Mercy (*Eleousa*), a variant of the more ancient and solemn *Hodegetria*, expresses the intensity of the loving and affectionate relationship between the Mother and the Christ child. Mary hugs Jesus close to her, their faces no longer frozen and frontal, but turned toward one another, cheeks touching as the Son grabs her cloak. The *Eleousa* spread through Byzantium and Russia in the twelfth century. The most famous example of it is the Virgin of Vladimir, painted in Constantinople and brought to Kiev in 1130. After conquering the city on September 21, 1160, Prince Andrei Bogoliubskii took the icon to Vladimir, the city whose name it eventually took. On August 26, 1395, the Vladimir icon was brought in procession to Moscow to protect the city from Timur's hordes and placed in the Cathedral of the Dormition in the Kremlin. The icon of the Virgin of Vladimir—like the Virgin of the Don, which Prince Dmitri Ivanovich Donskoi used as a standard for his army at the battle of Kulikovo in 1380—became a symbol of the struggle against the invading Tatars. Even the great painters Theophanes the Greek and Andrei Rublev made copies of it.

**Text**
"Today the glorious city of Moscow shines in beauty, welcoming your miraculous icon like the dawning sun, O Sovereign Lady. Mother of God, save the land of Russia." (Troparion for August 26, feast of the Vladimir icon of the Virgin)

**Title**
The Virgin of Mercy or Tenderness (*Eleousa*; *Umilenie*); of the Sweet Kiss (*Glykophilousa*); of Vladimir (*Vladimirskaia*); of the Don (*Donskaia*); and of Saint Theodore (*Fedorovskaia*)

**Feast days**
*Vladimirskaia*, August 26, June 23, May 21; *Fedorovskaia*, March 14 and August 16; *Donskaia*, August 19

**Source**
*Povest' o Tamerlane* ("Story of Timur [Tamerlane]")

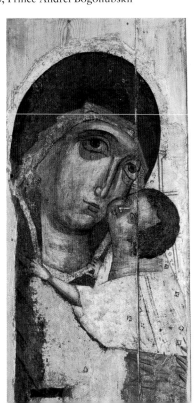

◀ *The Podkuben Virgin Eleousa*, first half of fourteenth century. Vologda (Russia), museum.

177

# The Virgin Eleousa

The tenderness of Mary's rapt expression, as she leans forward as if to receive a kiss from Jesus, expresses profound affection, veiled by the thought of the Child's future Passion.

The stylized forms, dark outlines, flat fields of color, and especially the red background, created from pure cinnabar, identify this icon as a work of the Novgorod school. The white inscriptions were apparently retraced in a later period.

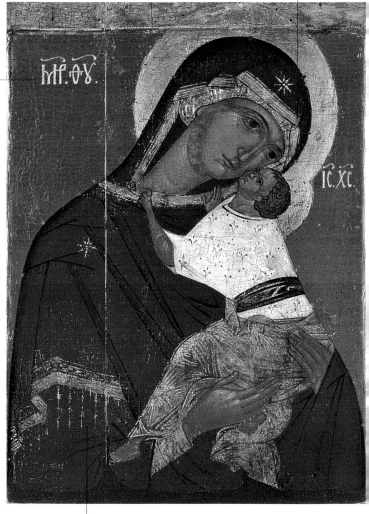

▲ Novgorod school, *Virgin Eleousa*, fifteenth century. Vicenza (Italy), Gallerie di Palazzo Leoni Montanari, Banca Intesa Collection.

Christ holds on to the hem of Mary's maphorion *with both hands. The implication is conjugal: that is, the love between Mary and Jesus symbolizes the mystical union between Christ and the church.*

The Mother's face, framed by the gold border of her maphorion, has an ineffable spiritual beauty, transformed as it is by a soft chiaroscuro and by a few bursts of light. The lobe of her ear is just barely visible under her head covering.

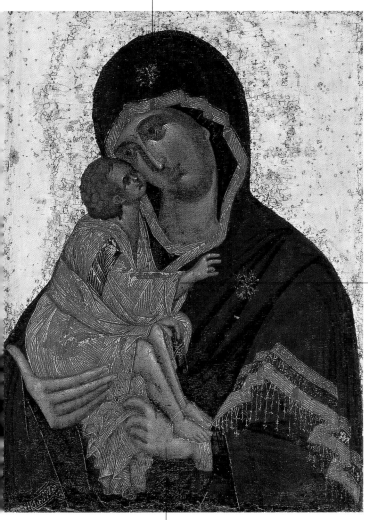

Christ's himation, rendered immaterial by the fine gold filigree, has a blue band at the shoulder. His right hand rests on Mary's shoulder, making the sign of benediction. His left, meanwhile, holds a scroll and rests on his knees, which here—unusually—are uncovered.

◣ Theophanes the Greek, *The Virgin of the Don*, originally from Moscow or Kolomna, late fourteenth century. (The other side of this two-sided icon appears on page 153.) Moscow, Tretyakov Gallery.

The Child's knees are bent, and he is gathered in Mary's arms. She is supporting him with her right forearm (dexiokratousa), while with her left hand she fingers the folds in Jesus's robe.

*This image departs from the normal solemnity of Byzantine icons. With an abrupt movement, the Child throws his head back, grabbing onto Mary.*

# The Virgin with the Playing Child

**Text**
"What, in short, is purity? It's a heart with compassion for all of creation. And what is a compassionate heart? It is a heart that burns for all of creation."
(Isaac of Nineveh)

**Title**
The Christ Child at Play (*Vzygranie Mladentsa*); *Pelagonitissa* (from Pelagonia, in Macedonia); *Kardiotissa*

**Feast days**
*Pelagonitissa*, November 7; Virgin of Shui and Smolensk, November 2, July 11, July 28

**Sources**
Cosmas of Maiuma, "*More Honorable than the Cherubim*"; Paterikon of Mount Athos

**Iconography**
The Christ Child grabbing onto his mother, with his head thrown backward

▶ Angelos, *Virgin Kardiotissa*, mid-fifteenth century. Athens, Byzantine Museum.

This variant of the Virgin *Eleousa* developed in the twelfth and thirteenth centuries at the borders of the Byzantine Empire, especially in Serbia and Macedonia. There the monumental, hieratic style that prevailed in the capital was being gradually replaced by a more expressive style marked by Western, especially Italian, influences, in which movement was more accentuated. In his mother's arms, Jesus stirs about, not out of childish restlessness, nor in whimsy or play: as in the garden of Gethsemane, he has a foreboding of the Passion and feels anxious and afraid. The inscription *Pelagonitissa*, which distinguishes such icons, refers to Pelagonia (now Bitolja), a city in Macedonia; but the origin and true meaning of this iconographical type remain uncertain. The icon of the Virgin with the Playing Child was replicated in Syria, Armenia, and Russia, where it found fertile ground in popular religiosity, which, at that time, put great emphasis on the theme of the Passion. In seventeenth-century Russia, a similar composition—the Virgin of Smolensk—appeared, working miracles against the plague.

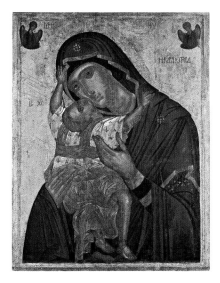

The Trinity is drawn in white on black in the semicircle behind Mary's halo. It is flanked by John the Evangelist and John the Baptist. The frame includes images of Saints Sergius of Radonezh and Cyril of Belozersk.

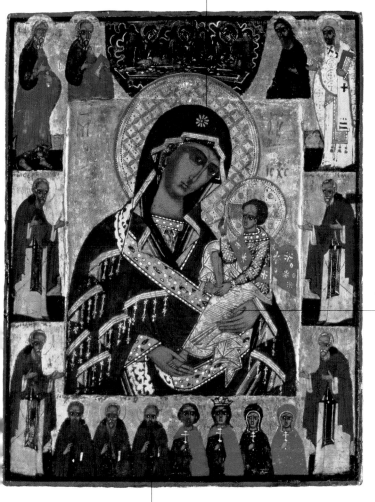

The Christ child's playful gesture of touching his foot actually presages the pain he will feel during the Passion, when nails will pierce the limbs that Mary is tenderly caressing.

▲ *Virgin of Shui with the Trinity and Saints*, originally from Yaroslavl, seventeenth century. Moscow, Historical Museum.

The incarnation planned by the Trinity and realized in the Virgin's womb is also realized in the communion of saints.

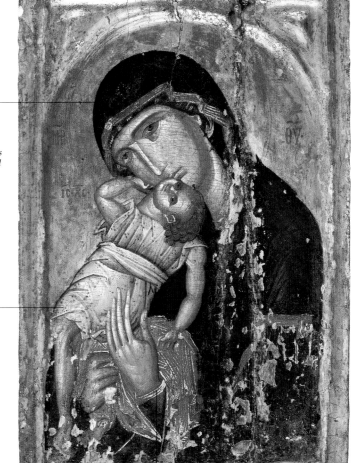

Mary's gaze expresses infinite sadness. Her mouth grazes the Child's cheek as Christ, in turn, caresses her face with one hand while the other seeks out his mother's hand to keep him from falling.

Jesus is wearing a short, light robe (chiton) that leaves his arms and legs uncovered. His body is turned toward his mother; with his head thrown back, his eyes, like Mary's, gaze out at us.

▲ *The Virgin* Pelagonitissa, *early fifteenth century. Mount Sinai, Monastery of Saint Catherine.*

In her closed right hand, Mary clutches Christ's royal himation, which is interwoven with gold assist, while her beautiful left hand, long and tapered, keeps the Child from falling.

*Images of Mary nursing the Child represent the idea that God is communicating with humanity through the Virgin's breast.*

# The Virgin Nursing

The earliest images of Mary nursing the Child are of Coptic and Palestinian origin: In Egypt this theme echoed images of Isis nursing her son Horus. From the Monastery of Saint Sabas in Palestine, the composition spread to Italy (Rome, Santa Maria in Trastevere) and, via Serbia, reached the monasteries of Mount Athos. In the seventh century, during the struggle with the Iconoclasts, Pope Gregory wrote to his adversary, Emperor Leo III the Isaurian: "Among the icons to be wor-shiped there is also an image of the Holy Mother holding our Lord and God in her arms and nursing him with her milk." The icons of Mary nursing the Child that have come down to us are, however, rare, since the subject was at odds with the solemnly hieratic character of Byzantine icons. Indeed, in the twelfth century, the Madonna *lactans* became more widespread in the Middle East, the Balkans, and Western Europe than in Constantinople and its environs. In the four-teenth and fifteenth cen-turies, in Greece and Russia, the subject broke away from Western natu-ralism and recovered its sacred meaning, wherein the Child is God communicat-ing with humanity. A typically Russian variant is called the Blessed Womb.

**Text**
"Blessed is the womb that bore you, and the breasts that you sucked."
(Luke 11:27)
"Blessed is the maiden's womb! Blessed is your breast, O Virgin! You have fed the flower that feeds all breath." (Hymn for the feast day)

**Title**
The Virgin Nursing (*Galaktotrophousa, Mlekopitatelnitsa*); Blessed Womb (*Blazhennoe Chrevo*) or Virgin of Barlovsk (*Barlovskaia*)

**Feast days**
July 3 and January 12; *Barlovskaia*, December 26

**Iconography**
Mary offering her breast to the baby Jesus

◀ *The Virgin of the Blessed Womb* (detail), south-central Russia, mid-nineteenth century. Collezione Bucceri–De Lotto.

183

*It is derived from a prototype believed to have been painted by Saint Luke at Ephesus. Tradition has it that this was the first icon of the Virgin brought to Kiev by Prince Vladimir in 988.*

# The Virgin of the Sweet Kiss

**Text**
"Rejoice, O volume wherein the Word was inscribed by the Father's hand, O pure one. O Mother of God, pray Him that thy servants be inscribed in the Book of Life." (Joseph the Hymnographer)

**Title**
The Virgin of the Sweet Kiss (*Glykophilousa, Sladkoe tselovanie*)

**Feast day**
*Korsunskaia*, October 9

**Iconography**
The Child holds on to the edge of the Mother's cloak and presses his cheek against hers as she embraces him

▶ Pskov school, *The Virgin of Liubiatovo* (detail), first half of fifteenth century. Moscow, Tretyakov Gallery.

The Cherson (Korsun) Mother of God is linked to the Greek prototype of the *Glykophilousa*, reduced to the faces of Mary and the baby Jesus close together, exchanging kisses and caresses. Cropping the image just under the shoulders heightens the intense emotion of their gazes and the loving bond between mother and son. Because the features in this icon are extremely human, as in the icon of the Virgin Nursing, it spread more easily in areas peripheral to the Byzantine Empire, such as Italy, the Balkans, and Russia. In the latter in particular, the Serb model, of Sienese derivation, became predominant in the sixteenth and seventeenth centuries. Unlike Italian icons, however, in which Mary holds the Child tightly to her breast with a single hand, in the Russian icons Mary embraces Jesus with both hands and total involvement. Other variants of the Virgin of the Sweet Kiss are the Virgin with the Playing Child (see pp. 180–82) and the Virgin of the Passion, in which Jesus holds tightly to Mary while two angels above them hold instruments of the Passion.

*The intense expressiveness of the two figures' eyes, their tight mouths, and the rigid geometrical synthesis of the drawing bring out all the drama and tension contained in Simeon's prophecy: "and a sword will pierce through your own soul also" (Luke 2:35).*

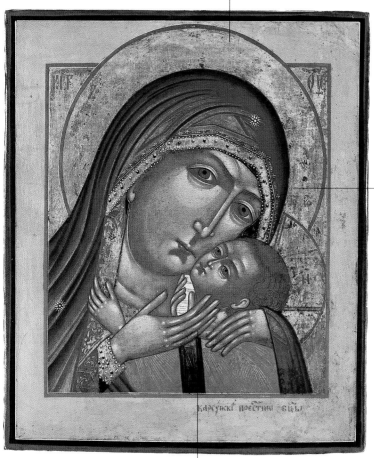

*The wrinkled brows, the earthen color of the faces, the ceruse highlights under and above the eyes express an awareness, at once sweet and painful, of the mystery of love that is realized in Mary.*

▲ *The Virgin of Cherson*, nineteenth century. Italy, private collection.

*The play of the hands, with their unnaturally elongated fingers highlighted by the light-colored brushstrokes, complements the facial expressions and lets us participate in the intense emotion of the image.*

# The Virgin of the Sweet Kiss

*The pleated, light blue bonnet holding back the hair, typical of Syrian married women, peeks out from under the elegant* maphorion *that seems to surround the Christ child the way the valves of a seashell surround a precious pearl.*

*The perfect ovals of the faces lightly touch each other, as with one hand Jesus grabs the edge of his mother's mantle, and with the other "clutches" her cheek. The Virgin holds the Child close with her left hand, as if to protect him, while supporting him with her right.*

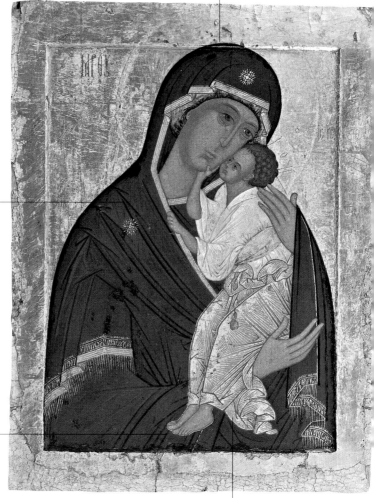

*Jesus's right foot is on top of his left, as on the cross. (The Holy Shroud shows that Christ's right leg was longer than his left.)*

▲ *The Virgin of Yaroslavl*, second half of fifteenth century. Moscow, Tretyakov Gallery.

*With his gilded himation tied around his waist, Christ, in his white chiton, looks as if Mary hasn't yet finished dressing him.*

The Child clutches Mary's chin, as if wanting to pinch her, to do anything he can to get her to kiss him. The Virgin's gaze is severe and maternal, conscious of the future Passion.

The placement of Mary's hands is exactly the same as in icons that show her lamenting the death of her son (see p. 210). Mary guards the Child in her heart.

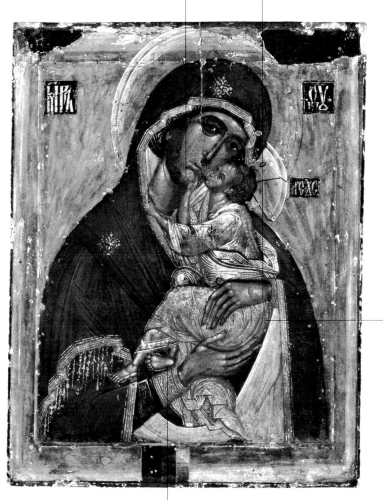

The Child, in his white chiton and a mantle entirely woven with gold assist, moves about inside the Virgin's dark maphorion, whose form recalls an inverted chalice.

▲ The Virgin of the Sweet Kiss, mid-sixteenth century. Moscow, State Historical Museum.

The Christ child's right foot, rotated with respect to the left one (since the right leg is longer than the other, as we know from the Holy Shroud), is supposed to point to Christ's dual nature, human and divine, in accordance with the canons of Byzantine iconography.

*Of Cretan origin, the Virgin of the Passion, known in the West as Our Lady of Perpetual Help, is a theological variant of the Hodegetria.*

# The Virgin of the Passion

**Text**
"He who once announced joy to the All-Pure, now shows her the signs of the future Passion. Christ, who has taken on mortal flesh, is frightened at their sight."
(Verses inscribed on icons of the Virgin of the Passion)

**Title**
Our Lady of the Passion (*tou Pathous, Strastnaia*), of the Thumb, or of Perpetual Help

**Feast day**
August 13

**Iconography**
The Child, in Mary's arms, clutches her hand and looks at the angels bearing the instruments of the Passion

An early example of this prototype was painted by the Cretan iconographer Andreas Ritsos in the fifteenth century. Compared to icons of the Virgin with the Playing Child, which allude to the Passion subtlely, this image is more explicit: two angels appear beside the Virgin's nimbus, showing the young Christ the cross, the lance, and the sponge. The angels thus reveal why the Child stirs in his mother's arms, and why her face becomes so tense. The child takes fright, and as he begins to move, one of his sandals comes loose. This prototype is also called the Virgin of the Thumb, since Jesus is sometimes shown grabbing Mary's thumb. The subject became very popular in fifteenth- and sixteenth-century Italy, especially in Rome, where the icon was venerated by the Augustinians and Redemptionists, who then spread the cult of Our Lady of Perpetual Help throughout the world. In Russia this theme appeared under the name of the Virgin of the Passion (*Strastnaia*) in the town of Nizhnii Novgorod, where the image once cured a woman. In 1641 it was transferred to Moscow, where the Monastery of the Passion (*Strastnoi*) was built in its honor.

▶ *The Virgin and Child*, iconostasis of the *katholikon* (main church), ca. 1350. Serbia, Dečani Monastery.

Mary is identified in the inscription as "the Mistress of Angels." Her gaze is mournful and weary, as if saying, "See if there is any sorrow like my sorrow" (Lamentations 1:12). She and the Child have metal haloes engraved with floral motifs. Intense light glows in the figures' faces and hands, painted with very fine lines of gold.

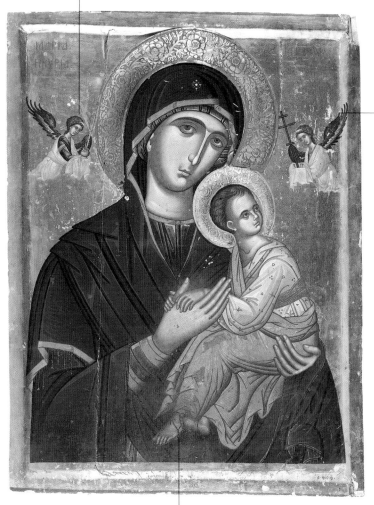

The archangels Michael and Gabriel bear the instruments of the Passion (sponge with vinegar, cane, lance, cross, and three nails) with their hands covered as a sign of respect. Similar angels will appear beside Christ on the cross. Seeing them, the Child grabs his Mother's thumb with his two little hands.

▲ *The Virgin of the Passion*, 1579. Mount Sinai, Monastery of Saint Catherine.

The emotional intensity is also manifest in the Child's right foot, which fidgets with the left and loses its sandal. The painter represents Jesus's right leg as longer than the left, as it was in the Holy Shroud that was on display at Constantinople until the eleventh century.

*The first Slavic center of monastic spirituality was the Caves Monastery in Kiev, the "Russian Bethlehem" founded by Anthony and Theodosius.*

# Our Lady of the Kievan Caves

**Text**
"You are indeed the royal throne. You have become the Paradise of the Spirit, more holy and more divine than the Paradise of old, home of Adam, made of clay. In you the Lord came down from Heaven." (John of Damascus)

**Title**
Virgin of the Kievan Caves (*Pecherskaia*), with replicas at Svensk (*Pecherskaia Svenskaia*); and at the Caves Monastery near Pskov (*Pskovo-Pecherskaia*)

**Feast days**
May 3; August 17

The Caves Monastery was founded in the eleventh century near Kiev, on the banks of the Dnieper River, by the saintly monk Anthony. A Russian pilgrim and later a monk at Mount Athos, Anthony was the first to bring Byzantine monasticism to Rus. His disciple Theodosius, who laid the foundations for the first monastic community (*laura* or *lavra*), is the model for all Russian monastic saints (called *prepodobnye*, "very similar" to Christ and the martyrs) from Sergius of Radonezh to Seraphim of Sarov. The founding of the Caves Monastery and its Church of the Dormition is attributed to the Virgin of the Blachernae

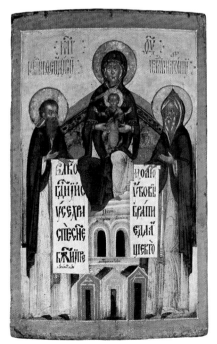

(Constantinople), who is said to have inspired four Greek architects to go to Anthony and Theodosius with her relics and a miraculously painted icon of her. The prototype of the Virgin of the Caves was painted by the monk Alimpii (Olympus) in the early eleventh century, and it derives from the Virgin *Orans*. Anthony and Theodosius are shown standing beside the monastery, which serves as the Virgin's throne.

► *The Virgin of the Kievan Caves*, originally from Kiev, second half of seventeenth century. Private collection.

*Using a typology similar to the composition "In Thee Rejoices," this icon translates the fundamental concepts contained in the ancient hymn* Axion Estin *into form and color.*

# "It Is Truly Meet"

Liturgical hymns, especially those devoted to the Mother of God such as the ancient *Akathistos*, were an inexhaustible source of inspiration for fourteenth-century icon painters. The iconography of "It is Truly Meet" derives from a tenth-century story from Mount Athos: while reciting nocturnal offices a monk receives a visit from a pilgrim asking for hospitality; at the moment of the night prayer, when one is supposed to sing the hymn of Cosmas of Maiuma "More Honorable (*Ten timioteran*) than the Cherubim," the guest—who later proves to be the angel Gabriel—begins to sing "It Is Truly Meet (*Axion estin*) to Call Thee Blessed." This variant was then introduced into the hymn "More Honorable" and is sung in the Byzantine liturgy after the consecration. The simpler iconographical version of the *Axion estin* shows Mary enthroned and surrounded by angels and prophets. In the lower section are Habakkuk and Moses, Saint Paul with the Church Fathers, Cyril of Alexandria, Gregory the Theologian, Basil the Great, and others. These figures are opening scrolls with words from prophecies and Revelation. A more complex version of the icon is divided into four scenes corresponding to the four verses of the hymn.

**Text**
"It is truly meet to call thee blessed, the Theotokos, the Ever-blessed, All-immaculate and Mother of our God. More honorable than the cherubim and incomparably more glorious than the seraphim..."
(Byzantine liturgy)

**Title**
"It Is Truly Meet" (*Axion estin*; *Dostoino est*)

**Feast day**
June 11

**Sources**
Genesis 2:3; Deuteronomy 18:15; Jeremiah 42:3; Lamentations 5:21; Habakkuk 3:2; Acts 3:22; Galatians 3:2; Cosmas of Maiuma, *Hymns*

**Iconography**
The Virgin enthroned with the angelic ranks, Habakkuk, David, Solomon, Paul, John Chrysostom, Cosmas of Maiuma, Cyril of Alexandria, Basil the Great, Gregory the Theologian

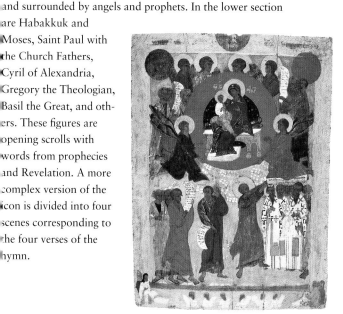

◄ *"It Is Truly Meet,"* northern Russia, second half of the sixteenth century. Moscow, Tretyakov Gallery.

# "It Is Truly Meet"

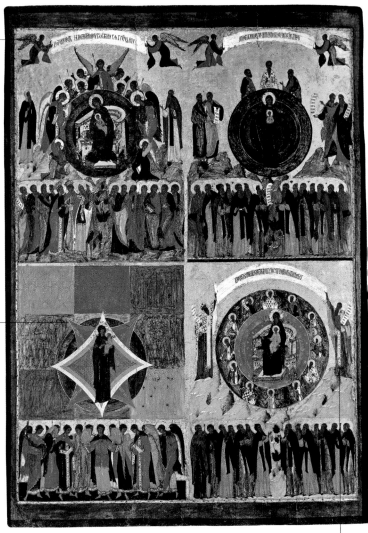

"It is truly meet to call thee blessed, the Theotokos." Angels, prophets, and saints surround the throne of the Mother of God and gather at her feet. In the panel to the right, John of Damascus and Cosmas of Maiuma lead the choir of monks and ascetics in praising Mary, who is seated in the heavenly spheres.

"More honorable than the cherubim and incomparably more glorious than the seraphim." In a star similar to that in the Burning Bush icon (two superimposed rhombuses and a circle), the Mother of God, standing with the Christ child in her arms, is surrounded by nine colored squares with mono-

"Thee who without corruption gavest birth to God the Word, the very Theotokos, thee do we magnify." The Mother of God enthroned with Christ in her lap, in a red circle inside a blue sphere with busts of bishops. On either side, Saints James of Jerusalem and Cyril of Alexandria open a scroll with the words of the hymn over the scene, while a crowd of monks gathers in prayer.

▲ Rostov master, "It Is Truly Meet to Call Thee Blessed," mid-sixteenth century. Moscow, Kremlin, Cathedral of the Dormition.

*The pagan cult of sacred springs, was transferred to a fountain at the gates of Constantinople, a symbol of Mary, the sealed fountain of life who offers the faithful the waters of salvation.*

# Life-Giving Source

The Sanctuary of the Source stands near the ancient Selimbria Gates of Constantinople at a spot now known as Balıklı. Tradition has it that in a vision, the Mother of God declared that its water was miraculous, and thus the sick flocked to it. In the icon born of this tradition, the faithful, gathered round the basin, laud the Mother of God as the inexhaustible source of life and health. In the Virgin's arms, the Savior holds up a scroll with the words "I am the living water." The Virgin *Orans* emerges in half length from a fountain shaped like a chalice or golden goblet. Drinking and bathing in the fountain's waters are the emperor, the patriarch, the poor, and the sick. A Thessalian is brought back to life when water is poured over his head, and a man possessed is freed of his demon. Sometimes fish, half red, half brown, are depicted in the basin, recalling the legend of a monk from the monastery that stood near the shrine. After roast-

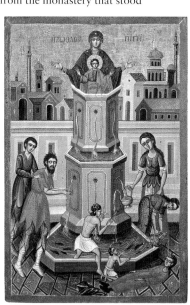

ing some fish, the monk, hearing that Constantinople had been taken by the Turks, said he would believe this only if the cooked fish came back to life and swam in the miraculous fountain, which promptly happened. The theme of the Virgin's fountain of life appeared in Russia in 1654 under Greek influence. A church service of the Life-Giving Source was written by Nicephorus Callistus.

**Text**
"Rejoice, inexhaustible source of life, shed thy grace, font of remedies that maketh the power of illness weak and vain." (Vespers for the Thursday after Easter)

**Title**
Life-Giving Source (*Zoodochos pege, Zhivonosnyi istochnik*)

**Feast days**
April 4; first Friday after Easter

**Sources**
Song of Solomon 4:12–15; John 7:37; Constantine VII Porphyrogenitus, *Book of Ceremonies*; Dionysios of Fourna, *Painter's Manual*; Joseph the Hymnographer, *Christmas Liturgy*; Nicephorus Callistus, *Tale and Church Service of the Life-Giving Source*

**Iconography**
Mother of God with Child and archangels; bishops, monks, rulers, the crippled, blind, lame, possessed drink from the miraculous fountain

◄ *The Virgin as Life-Giving Source*, eighteenth century. Berat (Albania), Onufri Museum.

The Virgin and Child stand in a goblet, a clear allusion to the eucharistic chalice. Around them the archangels Gabriel and Michael are holding, respectively, a slender rod called a merilo (measure) and a disk called a zertsalo (mirror).

On the left and right, bishops and rulers, monks and laity, men and women eagerly draw the waters of salvation.

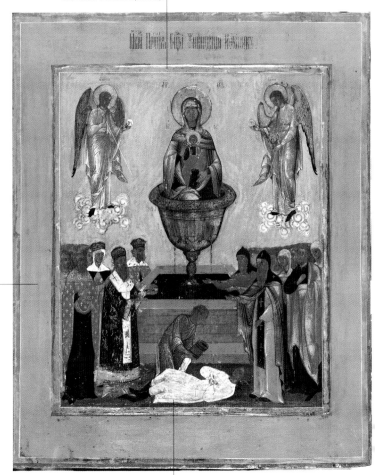

▲ *The Virgin as Life-Giving Source*, central Russia, nineteenth century.

The fountain's waters are poured over a dead man, bringing him back to life. Mary is the fountain of life and the water of salvation that obliterates all infirmity and can overcome even death.

*The allegory of Mary as a garden, aristocratic in nature and lacking any strictly liturgical reference, did not develop in the Christian East until the seventeenth century.*

# Enclosed Garden

Since antiquity, gardens have been considered spiritual places. In medieval monasteries, the cloister was a place for reading and meditation, an image of paradise. The Renaissance garden, sealed off by an enclosure wall (the *hortus conclusus*), was also a mystical image of Mary that, echoing the Church Fathers and the hymnographers, saw her as the "new Eve." In the *Lives* of the Russian saints, there is repeated mention of monastery gardens, such as that of the Holy Trinity Monastery, founded by Saint Sergius. In sixteenth-century Russia, the garden as a union of beauty and usefulness gave way to purely decorative and symbolic parks. This is reflected in legends about the Paradise estate of Andrei Bogoliubskii near Kiev and the "Red Garden" of Saint Hypatius of Gangra (in Old Russian, the word *krasnyi* meant both "red" and "beautiful"). The Russians then developed a taste for the Western Baroque garden, which the present icon reflects.

Its artist, who worked at the Kremlin Armory, depicts a balustrade giving onto the imperial park, and beyond it, a panorama of hills and villages. A profusion of gold dominates the crowns and clothing of the Christ child and Virgin, the vases in the corners, and the enclosure's barrier.

**Text**
"A garden locked is my sister, my bride; a garden locked, a fountain sealed."
(Song of Solomon 4:12)

**Title**
Enclosed garden
(*Hortus conclusus*;
*Vertograd zakliuchennyi*)

**Sources**
John the Exarch, *Prologue to the "Hexameron"*; Gregory of Nyssa, *On Virginity*; Nikon, *Life of Saint Sergius of Radonezh*; Chronicles of the Monastery of Saint Hypatius

**Iconography**
The Virgin, dressed like a queen and standing, with the Christ child in her arms, is crowned by the angels; in the background is a view of a courtly garden

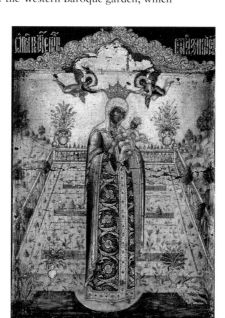

◀ Nikita Pavlovets, *The Virgin as Enclosed Garden*, 1660–70. Moscow, Tretyakov Gallery.

*In Tsarist Russia, Mary was the queen of all the afflicted, and the sick directed their pleas to her, so that she might intercede with Christ the King.*

# "Joy of All That Sorrow"

**Text**
"Joy to all the sorrow art thou, and of the oppressed protectress, and nurture of all the poor, comfort unto the estranged, a staff thou art of the blind, visitation of all the sick, a shelter and succor unto those brought down by pain, helper of orphaned ones."
(Troparion to the Virgin)

**Title**
The Virgin as Joy of All That Sorrow (*Vsekh skorbiashchikh radost*)

**Feast day**
October 24

**Iconography**
Mary stands before a throne, holding a scroll or the Christ child; angels with scrolls and different categories of sorrowing people presenting their pleas; on high, Christ the King or the Trinity

▶ *The Virgin as Joy to All That Sorrow*, central Russia, nineteenth century. Private collection.

Devotion to this image began in Russia after a woman was cured. The miracle occurred on October 24, 1688, in the Moscow Church of the Transfiguration, and the feast was instituted on that day. The icon became a destination for pilgrims and the sick seeking Mary's help with their troubles. In 1720, Tsar Peter the Great took a copy of it with him when he went to war against the Turks and later to his imperial residence in Saint Petersburg. In the icon, the Mother of God, standing before the throne, receives the entreaties of the faithful, which are written on scrolls and presented by guardian angels. Mary is crowned and dressed in regal raiment. In her right hand is a floral motif, as in the Unfading Rose icon (see pp. 221–23); in her left, a scroll with the prayer "O most clement Son, turn

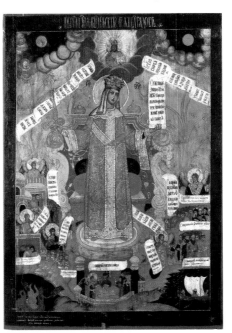

your gaze to your Mother and hear the prayers of your servants." Their written pleas say: "Visit us and help us in old age and sickness, O queen"; "Help those who suffer from frost and nakedness"; "Give nourishment to the hungry"; "Travel with us who travel." In Muscovite versions of the icon, Mary is holding Jesus in place of the scroll.

*This icon, which first appeared in Russia in the fifteenth century, takes its name from an ancient hymn of thanks in honor of the Mother of God, attributed to John of Damascus.*

# "In Thee Rejoiceth"

This icon celebrates Mary, Joy of All Creation, and derives from the feast of the Virgin's Protecting Veil. In the hymn, the Mother of God is compared to a throne in whose lap sits the Creator of the World. The Virgin, suspended in the heavenly sphere and surrounded by archangels, is inside a white circle containing two Marian images: paradise and the Temple. The vision looms over a mountain where the saints and blessed are gathered. Near the throne, Saint John of Damascus holds a scroll with the hymn's text. To the left are John the Baptist, Elijah, Moses, David, and the prophets. Below are monks, ascetics, the Desert Fathers, the "fools for Christ" (or "athletes for Christ") with long beards, the tsar and the metropolitan, and the Church Fathers and bishops, including Cyril of Alexandria, John Chrysostom, Basil the Great, and Gregory of Nazianzus. On the right are a group of virgin saints, Peter and Paul, Emperor Constantine and his mother, Helen, Vladimir, Boris, and Gleb, and martyrs. The Temple represents the Church of the Dormition in the Moscow Kremlin.

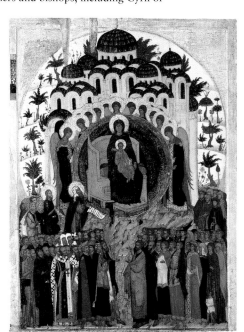

**Text**
"In Thee rejoiceth, O Full of Grace, all creation, the angelic hosts, and the race of men. O hallowed temple and spiritual paradise, glory of Virgins, of whom God was incarnate and became a little child, our God who is before all the ages." (Liturgy of Saint Basil)

**Title**
"In Thee Rejoiceth"
(*Epi soi chairei,*
*O tebe raduetsia*)

**Iconography**
The saints are gathered around a mountain on which the Mother of God sits enthroned, inside the white circle of paradise, and surrounded by the ranks of angels; in the background, an Orthodox church

◀ Circle of Dionysius, *"In Thee Rejoiceth,"* late fifteenth–early sixteenth century. Therapon Monastery near Vologda (Russia), Cathedral of the Nativity of the Virgin.

197

*The hymn called* Akathistos *(which means "not sitting") is one of the most widespread and most typical liturgical texts of Eastern Christendom.*

# Praises to the Mother of God

**Text**
"The wilderness and the dry land shall be glad, the desert shall rejoice and blossom; like the crocus it shall blossom abundantly, and rejoice even with joy and singing." (Isaiah 35:1–2)

**Title**
Praise to the Mother of God (*Pokhvala Bogomateri*); "The Prophets from Above" (*Anothen hoi prophetai, Svyshe prorotsi*); *Akathistos* to the Virgin

**Feast day**
Fifth Saturday of Lent (Saturday of the *Akathistos*)

**Sources**
Genesis 28:12; Exodus 3:2; Judges 6:36–37; Nehemiah 17:23, 24:17; Psalm 132:8; Song of Solomon 2:1; Isaiah, 6:6, 55:13; Jeremiah 31:32–33; Ezekiel 44:2; Daniel 2:34; Habakkuk 3:3; *Akathistos* hymn; Dionysios of Fourna, *Painter's Manual*

▶ *Praises to the Mother of God* (central detail), second half of fourteenth century. Moscow, Kremlin, Cathedral of the Dormition.

In the icon of the Praises to the Mother of God, the prophets celebrate Mary's greatness, surrounding her throne in festive prayer and holding up scrolls and Marian symbols as well as passages from the *Akathistos* hymn. This poetic composition— very popular among Orthodox Christians—is a Greek acrostic divided into twenty-four strophes, telling the story of the Virgin in a profusion of images. Composed by Romanos the Melodist in the sixth century, in 626 the hymn was given a twenty-fifth stanza of thanks to Mary for saving Constantinople from the Persians and Arabs. In the eleventh and twelfth centuries, the *Akathistos* was sung "while standing" in the Church of the Blachernae, and from there it spread to the Monastery of Saint Sabas and the Stoudios (or Studium) Monastery, and thence to Mount Athos, the Balkans, and

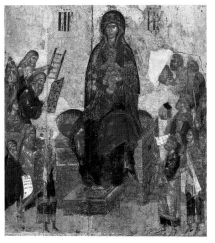

finally Russia. The most complete and original painting cycle illustrating the *Akathistos* was made for the Church of the Therapon Monastery between 1500 and 1502, by the Muscovite iconographer Dionysius and his two sons Theodore and Vladimir. Other versions are found in the external frescoes of churches in Romania and Moldavia.

*Clockwise (with the corresponding strophes of the Akathistos in parentheses): Annunciation (I, II, III, IV); Visitation (V); Joseph before Mary (VI); Nativity (VII); The Magi (VIII, IX, X); Flight into Egypt (XI); Simeon with the Christ child (XII); Christ teaching (XIII).*

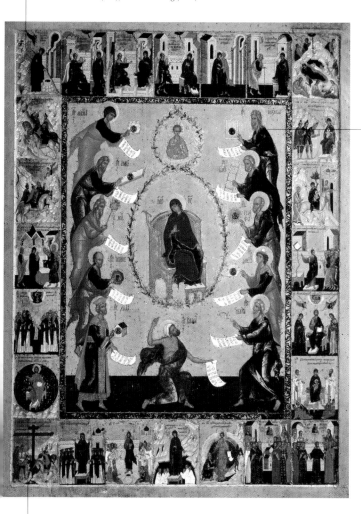

*Christ Emmanuel, the Mother of God, and the prophets holding scrolls and symbols of Mary. From the left, Habakkuk (shady Mount Paran); Ezekiel (shut gate); Jeremiah (tablet of the future covenant); Jacob (ladder); Aaron (flowering rod); Gideon (fleece); Moses (burning bush); Daniel (inviolate mountain), David (Ark of the Covenant); Balaam in the middle; Isaiah (tongs).*

*"Transporting our mind to heaven" (XIV); "The Uncircumscribed Word" (XV); "All Angel-Kind" (XVI); Mary, Divine Wisdom (XVII); "Wishing to save the world" (XVIII); "A rampart for virgins" (XIX); "Many compassions" (XX); "A brilliant beacon-light" (XXI); The Liberator and Redeemer (XXII); "A living temple" (XXIII); Thanksgiving and Praise (XXIV).*

▲ *Praises to the Mother of God with Akathistos of the Virgin*, originally from the Dormition Cathedral of the Cyrillo-Belozersk Monastery, mid-fifteenth century. Saint Petersburg, Russian Museum.

*Strophes I–IV: The angel's salutation;
Mary's surprise; the angel reassures her;
the power of the Almighty covers Mary
with his shadow (the red veil is often
found in icons, extended over the roofs
of buildings).*

*Strophes
XIII–XVIII:
Christ begins a
new Creation;
miracle of the
virgin birth; the
cloud of
unknowing
reveals and
conceals God;
the angels are
amazed by the
incarnation;
Mary, seat of
Divine
Wisdom; God
becomes man
"like unto us."*

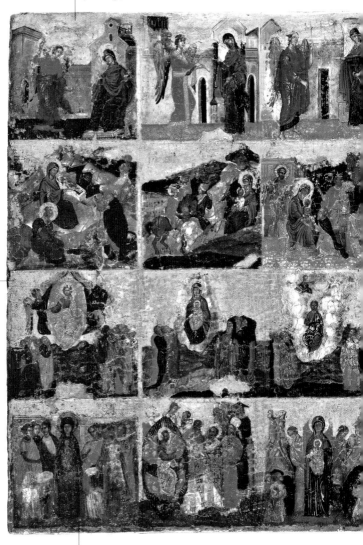

▲ *The* Akathistos *Hymn*, early sixteenth
century. Private collection.

*Strophes XIX–XXI: Mary as a "rampart for virgins";
hymns do not suffice to sing of Christ's compassions;
Mary as the beacon-light reflecting his glory.*

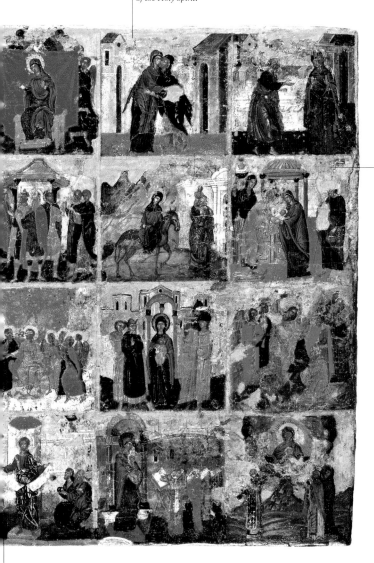

*Strophes V–VI: The greeting of Elizabeth; the "tempest of doubting thoughts" in Joseph's heart calms down when he learns that the Son is the work of the Holy Spirit.*

*Strophes VII–XII: The birth of Jesus; the magi follow the star; the magi adore Jesus; the magi announce the coming of Christ to the pagans; the flight into Egypt; the meeting with old Simeon.*

*Strophes XXII–XXIV: Christ tears up the promissory note of humankind's debts (sins); Mary the living temple; final prayer.*

*After the fifteenth century in Russia, the image of Mary as Jacob's Ladder is added to that of her as the inviolate mountain, giving rise to grand, complex compositions of the Virgin Enthroned.*

# Inviolate Mountain

**Text**
"Rejoice, heavenly Ladder whereby God came down. Rejoice, Bridge leading those of earth to heaven… Rejoice, Rock which refreshed those athirst for life." (*Akathistos* hymn)

**Title**
Mountain Uncut by Human Hands (*Gora nerukosechnaia*)

**Sources**
Genesis 28:12–16; Judges 6:36–38; Ezekiel 44:1–4; Daniel 2:27–45; 1 Corinthians 10:4; *Akathistos* hymn

**Iconography**
The Virgin *Hodegetria*, in half length or seated on the throne, with a ladder, mountain, and rainbow against her breast

This iconography derives from, and replaces, the more ancient prototype of Jacob's Ladder, mentioned in the second *oikos* (strophe) of the *Akathistos* hymn, in which Mary is called "heavenly Ladder whereby God came down." Icons of her as the "stone uncut by human hand" represent Daniel's great prophecy of the coming of Christ, which he made when he interpreted the dream of King Nebuchadnezzar: "As you looked, a stone was cut out by no human hand, and it smote the image on its feet of iron and clay, and broke them in pieces" (Daniel 2:34). The stone that shatters the image (idolatrous statue) is Christ; the mountain is Mary. The golden-headed, silver-breasted giant with bronze flanks and clay feet stands for the earthly reigns that will follow one upon the other until Mary, with her Virgin maternity, without human intervention, brings into the world the Messiah, who will then institute the reign of God. It is a typically Russian, especially Muscovite and Novgorodian, subject. The Virgin with the Child in her arms is displayed on her throne with the symbols of the *Akathistos* hymn relating to her miraculous maternity: the rainbow passing through her cape, the stone cut away from the mountain, Jacob's Ladder uniting earth and heaven.

► Moscow school, *The Virgin as Inviolate Mountain*, late sixteenth century. Private collection.

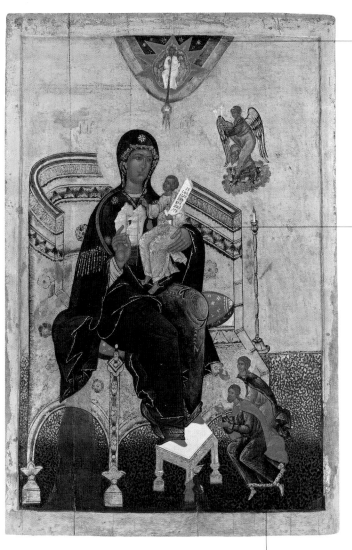

The heavens open over Christ as during the baptism in the Jordan. The ray of the Trinity beams down in the form of a dove from God the Father's mouth. An angel suspended on a cloud carries the cross, the lance, and the sponge, symbols of the Passion.

The holy inviolate mountain is Mary, who gave birth to Christ, the stone detached from the mountain without human intervention. The red ladder and the burning bush held by Mary are also symbols of the Virgin. The great golden throne stands for the greatness of Mary, who is "vaster than the heavens."

The holy warrior–martyr Nicetas and the virgin Eupraxia (patron saints of Nikita Gregorievich Stroganov, who commissioned the painting, and his wife, Evpraksia Federovna Kobeleva) are interceding with the Virgin on her throne.

▲ Stroganov school, *The Virgin as Inviolate Mountain*, late sixteenth century. Solvychegodsk (Russia), Museum of History and Art.

# Inviolate Mountain

Mary is wrapped in a flowing mantle that evokes the clouds in the sky (Gideon's fleece) and the smoke from fire, embodying a host of Marian themes (the burning bush, the column of fire, the luminous cloud) as well as her epithet, Vaster than the Heavens.

Christ is holding up an open scroll with the words "Before Abraham was, I am" (John 8:58). Beside him are the symbols of the stone, the ladder, and the rainbow passing through Mary's mantle.

From the throne, which is elaborately carved like fanciful religious architecture (an image of Mary as Temple-Church), sprout two green shoots and two lighted candlesticks, clear images of the bush that burns while remaining green (Mary the Virgin Mother).

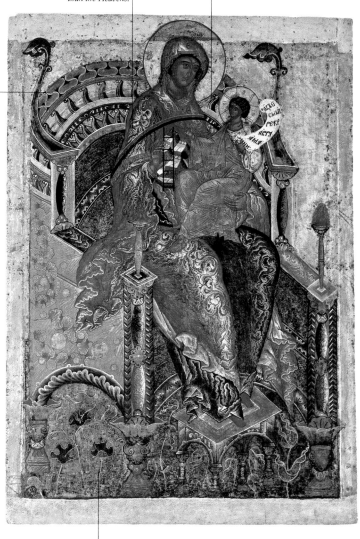

▲ The Virgin as Inviolate Mountain, ca. 1560. Moscow, Kolomenskoe Museum.

The throne's columns, finely carved and decorated with floral motifs, stand in the middle of a verdant garden (an image of Mary).

*The Gospels do not mention Anne, Mary's mother. In icons, she holds her daughter in her arms the same way Mary will later hold the baby Jesus.*

# Saint Anne with the Virgin

The icons of Mary in the arms of her mother, Anne, are rather rare and begin to appear only in the late thirteenth century. The iconography faithfully follows one of the most widespread themes of Byzantine painting—the Virgin and Child— replacing Mary with Anne and Jesus with Mary. As in the Virgin and Child icons (in both the *Hodegetria* and *Eleousa* types), Anne holds up and embraces, not just any little girl, but the Mother of God: she herself becomes the mother of the Mother of God. The icon is a symbolic rather than realistic representation, announcing "figuratively" what is supposed to happen, the "already but not yet befallen," and its every gesture is projected into the future. This is why Mary, though represented with the proportions of a small child, is dressed as her adult self, in the scarlet *maphorion* used by married women in Syria and the mantle marked on the shoulders and head by three star-crosses, a Syrian symbol of virginity (standing for her purity before, during, and after childbirth, unique among women). In the icon presented here, the dense weave of *assist* (light beams and gold threads) underscores Mary's royal standing.

**Text**
"A rampart art thou for virgins and all that have recourse to thee, O Mother of God; for the Maker of heaven and earth prepared thee, O Immaculate One, and dwelt in thy womb."
(*Akathistos* hymn)

**Title**
Saint Anne with the Virgin

**Feast day**
July 26

**Source**
Protoevangelion (Infancy Gospel) of James

**Iconography**
Mary in Saint Anne's arms

◄ Serbian artist, *Saint Anne with the Child Mary* (detail), second half of fourteenth century; silver gilt revetment from fifteenth–sixteenth century. Sergiev Posad (Russia), Holy Trinity– Saint Sergius Monastery.

205

# Saint Anne with the Virgin

Anne and Mary are dressed like married Syrian women: hair bonnet, dark robes, and red maphorion. Mary's is distinguished by its darker, more solemn color.

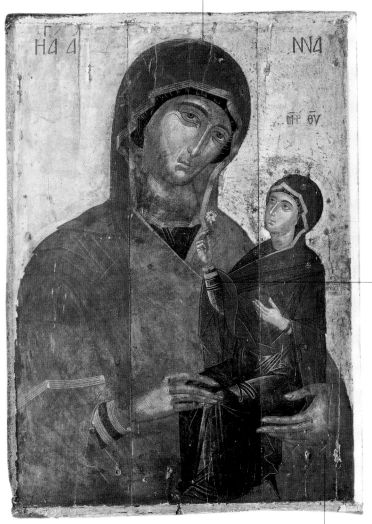

The letters MP ΘΥ (Meter Theou) above her head identify Mary as the Mother of God, who here is holding a lily, symbol of her purity.

▲ Emmanuel Tzanes, *Saint Anne with the Virgin*, 1637. Athens, Benaki Museum.

Anne's delicate, tapered hands carry Mary as if she were a sanctuary. The gold lines illuminating them indicate that they have been sanctified by their contact with the Mother of God.

*The image of the Virgin standing in three-quarter pose, interceding with God for the salvation of the faithful bowing at her feet, first arose in Constantinople and later spread to Russia.*

# The Virgin of Intercession

In fourth-century Constantinople the empress (later Saint) Pulcheria had a little church built at the *Chalkoprateia* (copper market), devoted to the worship of the Virgin's belt inside a holy chest, a relic brought from Jerusalem. The icon kept in this church had two titles: *Chalkopratissa*, from the location of the church, and *Hagiosoritissa*, that is "of the Holy Chest." Many icons of this type can be found in the churches of Rome. The Mother of God, usually standing full length, is turned to the left. With her right hand extended and the left held up, she intercedes on behalf of the sinners, pleading to heaven for their salvation. In Russia this iconographical type developed into the Virgin of Bogoliubovo, named after Prince Andrei Bogoliubskii. The Virgin appeared to him in a dream on July 18, 1157, making a gesture of supplication to Christ and opening a scroll with a prayer. The prince had an image of his vision painted and then had a monastery built on the site of the apparition: the monastery of Bogoliubovo. The theme was developed in subsequent centuries in Moscow, using other saints and holy monks prostrate at the Virgin's feet, from the metropolitans of Moscow (Peter, Alexis, Jonah, and Philip) and the bishops who evangelized the lands of Rostov, to the "fools for Christ" and Saints Zosimus and Sabatius of the Solovki Monastery on the White Sea.

**Text**
"All-pure lady and sovereign, Mother of God, accept this prayer from your servants and present it to your Son and our Savior, that he might save and take pity on this city and on all cities and lands." (Prayer to the Virgin of Bogoliubovo)

**Title**
The Virgin of Intercession (*Deesis*); of the Copper Market (*Chalkopratissa*); of the Holy Chest (*Hagiosoritissa*); of Bogoliubovo (*Bogoliubskaia*); Prayer of the All-Pure for the People (*Molenie Prechistoi o narode*)

**Feast day**
*Bogoliubskaia*, June 18

**Iconography**
Mother of God standing, raising her hands in supplication

◄ *The Virgin*, from the *Deesis* tier of the iconostasis, late fourteenth century. Moscow, Kremlin, Cathedral of the Annunciation.

The church of the Bogoliubovo
Monastery and the text of the
prayer recited on June 18, feast
day of the Virgin of Bogoliubovo.

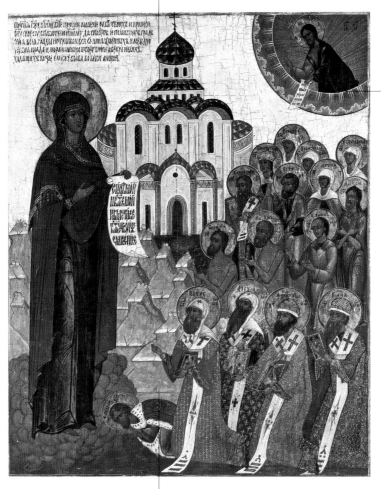

The Lord
answers "yes"
to the Virgin,
who has inter-
ceded with him
on his throne on
behalf of the
sinners. On the
scroll are the
words "O my
Mother and my
Creature, since
this is your
will…"

The Mother of God presents her plea:
"My Son and my God, uncontainable
Godhead who in humility…" At her feet
are Prince Andrei Bogoliubskii of Kiev,
the metropolitans Peter, Alexis, Philip,
and Jonah, the "fools for Christ," Peter
the Apostle, martyrs, and saints.

▲ *Virgin of Bogoliubovo*, Russian,
ca. 1700. Germany, private collection.

*This very rare iconography shows the Virgin being turned over to the care of Saint John the Evangelist, as it is told in the Gospels.*

# Our Lady of Refuge

The style and monumentality of the figures in this icon tell us that it belongs to the period of the Palaiologan dynasty, the last to rule Byzantium before the Ottoman conquest of 1453. Mary and John are represented as though still standing under the cross and listening to Christ's last words, his testament: "Woman, behold, your son!" and to John, "Behold, your mother!" Mary is wrapped in a precious blue *maphorion* and holds her bowed, sorrowful head with a covered hand. The stars of her virginity shine on her head and left shoulder; below, the hem of her mantle is embellished with a fine gold fringe. The Virgin's gaze, under her knit eyebrows, is turned to the disciple. John is wrapped in complex drapery reflecting an intense white light. His mantle (chlamys), knotted on one side, falls off his shoulder, uncov-ering the robe (chiton) underneath with its double orange band (clavus). John's face is inclined toward Mary but looks at the viewer, as if wanting to make him share in the great responsibility that weighs on him: taking in the *Theokotos*, the Mother of God, as his guest. The powerful play of shad-ows and light in the faces of Mary and John, who are called upon to become mother and son to one another, makes this icon a true masterpiece.

**Text**
"When Jesus saw his mother, and the disciple whom he loved standing near, he said to his mother, 'Woman, behold, your son!' Then he said to the disciple, 'Behold, your mother!' And from that hour the disciple took her to his own home." (John 19:26–27)

**Title**
The Virgin of Refuge (*Kataphyge*)

**Source**
John 19:26–27

**Iconography**
Mother of God, John the Evangelist

◀ *The Virgin of Refuge and Saint John the Theologian,* originally from the Poganovo Monastery, ca. 1371–95. (The other side of this two-sided icon appears on page 90.) Sofia (Bulgaria), National Art Gallery.

*In this image Mary's gesture ranges from the austere supplication of more ancient icons to the popular image of Our Lady of Sorrows.*

# The Lamenting Virgin

**Text**
"Behold, this child is set for the fall and rising again of many in Israel; and for a sign that is spoken against (and a sword will pierce through your own soul also)...his mother kept all these things in her heart." (Luke 2:34–35 and 51)

**Title**
Virgin of Sorrows, Great Humility

**Feast day**
Good Friday

**Sources**
Luke 2:34–35; John 19:25–27

**Iconography**
Bust of Mary with head inclined and hands gathered over her breast

This icon derives from the image of the Virgin in three-quarter pose, interceding for humanity with Christ on his throne (*Deesis*), her hands extended and palms turned heavenward. In the eleventh to fourteenth centuries, when the devotion to Christ's Passion increased, this image was transformed into the devotional image of Mary beside the lifeless body of Christ rising up from the tomb. What distinguishes this rare iconographic type is the unusual position of the hands, which seem to be holding something. In fact, Mary is re-enacting the gesture with which she held up the dead body of Christ in the sepulchre, supported his head in the Deposition and Lamentation, and sorrowfully embraced the vertical pole

(*stipes*) of the cross, leaning on it in exhaustion, as John stood witnessing the event. This icon of the Lamenting Virgin, also called the Mother of God of Great Humility, is thus linked to the Passion and contains, aside from the theme of prayer and intercession, a nuance of suffering. Through this gesture, the Virgin is reliving in her heart the Passion of Christ, in keeping with Simeon's prophecy: "a sword will pierce through your own soul also."

▶ Byzantine artist, *The Lamenting Virgin*, ca. 1280. Moscow, Tretyakov Gallery.

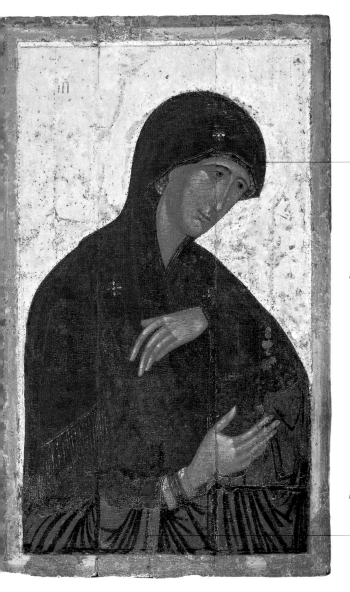

*The narrowed eyes accentuate the expression of sorrow, which is accompanied by a faith radiating from the face of the Virgin, the inexhaustible source of hope. A few subtle strokes of light are enough to lighten her gaze with an unexpected sweetness.*

*The palms of Mary's hands are not turned upward as in the prayer of intercession (Deesis). Instead they seem to be "cradling" a sorrow in her own heart, as though rocking her son in her arms or placing him in the sepulchre (see page 234).*

School of Constantinople, *Mother of God*, from the *Deesis* tier of the ...onostasis at the Monastery on ...e Hill (*Vysotskii*) in Serpukhov, ...387–95. Moscow, Tretyakov Gallery.

*Mary experienced the agonizing pain of separation from her only son, who was killed on the cross. She is the mother of sorrows, and all those who suffer are her favorite children.*

# "Soothe My Sorrows"

**Text**
"Soothe the pain of my much-sighing soul, O thou who hast wiped away every tear from the face of the earth. For thou dost drive away the sickness of men and quench the affliction of sinners." (Troparion for January 25)

**Title**
The Virgin of "Soothe My Sorrows" (*Utoli moi pechali*)

**Feast days**
January 25; October 9

**Sources**
Hymns and prayers to the Virgin

**Iconography**
A pensive Mother of God with her hand on her temple, Christ holding a scroll

This is a typically Russian icon that, according to tradition, was brought to Moscow by the Cossacks in 1640, at the time of Tsar Alexis I Mikhailovich. Placed in the Church of Saint Nicholas at Pupyshi in Moscow, it worked many miracles, especially during the plague of 1771. It was intensely worshiped, and a feast day was established for it after a miracle occurred around 1760. A number of copies were made of the image, one of which was brought to Saint Petersburg in 1765 and put in the Church of the Ascension. Many churches were dedicated to this icon. The image expresses the deep suffering felt by Mary when she saw her only son unjustly killed on Golgotha. The Virgin relived that sorrow during her long years of solitude, until she was assumed into heaven and received consolation, in the Dormition, for her pain. In the same way Mary takes the sorrows of all humanity upon herself. In the

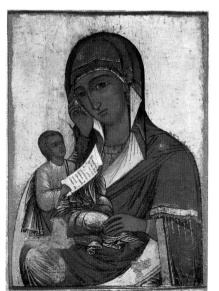

icon we see her holding her right hand to her temple, looking sad and pensive. Christ floats rather freely within her mantle, without the usual support of her arm, as though in a bodiless realm. He holds a scroll with the words "Judge righteous judgment, and act mercifully and magnanimously." The icon derives its name from a prayer to the Virgin: "Soothe the pain in my soul."

▶ *The Virgin of "Soothe My Sorrows,"* central Russia, mid-eighteenth century. Private collection.

*These two important relics, kept on display in Constantinople, were objects of veneration and frequent pilgrimage, thanks to their ability to perform miracles and promote inner healing.*

# Deposition of the Virgin's Mantle and Belt

The Church of the Blachernae in Constantinople, destroyed by fire in 1433, was the most important Marian sanctuary in the Byzantine Empire. In this church the mantle of the Mother of God, a precious relic that Emperor Leo I the Great had brought to Constantinople in 458, had been preserved in a transparent urn. This veil (*maphorion*) attracted throngs of pilgrims from all over Christendom. The Virgin's belt, on the other hand, had come with the other relics sent by Empress Pulcheria between 395 and 408. It was kept in the Chalkoprateia church, also in Constantinople. Both of these relics were lost when the Crusaders pillaged the city in 1204. At that time yet another relic preserved in the Blachernae, whose authenticity was decisive for Christianity, was lost: the Holy Shroud, now in Turin. Two distinct feast days were dedicated to the mantle and the belt.

The Virgin's belt was particularly miraculous, providing protection from demons and healing sickness. It was the "impregnable wall" defending the Church, the city of Constantinople, and all of humanity. A part of this relic is still preserved and worshiped today in the Vatopedi Monastery on Mount Athos.

**Text**
"O ever-virgin Mother of God, shelter of mankind, thou hast bestowed upon thy people a mighty investure, even thy immaculate body's raiment and sash, which by thy seedless childbirth have remained incorrupt." (Troparion for August 31)

**Title**
Deposition of the Virgin's Raiment (*Katathesis tes esthetos; Rizopolozhenie*)

**Feast days**
Deposition of the Virgin's mantle (*maphorion*), July 2; of the belt (*zone*), August 31

**Source**
Nicephorus Callistus

◀ Pervusha, *The Deposition of the Virgin's Belt*, early seventeenth century. Saint Petersburg, Russian Museum.

213

# Deposition of the Virgin's Mantle and Belt

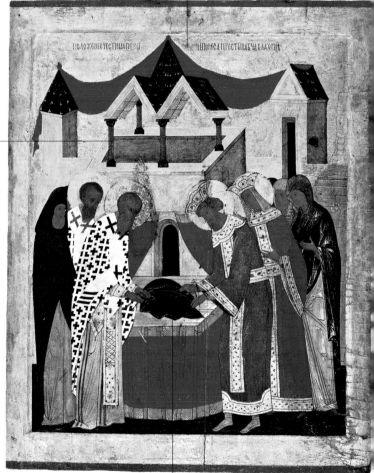

The cinnabar red veil, in addition to being a symbol of divine presence and an indication that the scene is occurring indoors, also alludes to the feast of the Protecting Veil of the Virgin (October 14), since under her veil, all of humanity is protected and saved.

The Marian Church of the Blachernae is stylized into highly geometric forms. At the center stands a canopy under which the scene is taking place. The painter, however, depicts the action as occurring outside, in front of the structure.

▲ *Deposition of the Mantle and Belt of the Virgin*, originally from Borodova (Vologda), Church of the Deposition of the Virgin's Mantle, ca. 1485. Moscow, Andrei Rublev Museum.

The two relics, the dark veil (maphorion) and the lighter-red belt, are laid down by Emperor Leo I and the patriarch Gennadius, as the empress, a bishop, a monk, and some women look on.

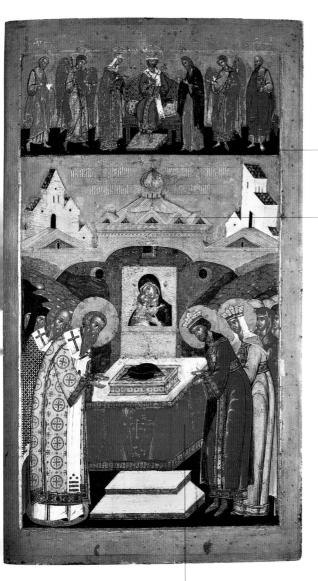

Deesis *with Christ, King of Kings, surrounded by the Virgin in regal raiment and crown, John the Baptist, archangels Michael and Gabriel, and Peter and Paul.*

The dome of the Church of the Blachernae, flanked by Constantinopolitan buildings, opens up to our view, revealing a three-aisled interior in which a great throng has gathered to participate in the extraordinary ceremony.

Before the icon of the Mother of God, adorned with a golden cloth, Emperor Leo I and the empress (on the right) and Patriarch Gennadius (on the left) place the Virgin's veil in a golden reliquary on the altar, as endless processions of faithful follow behind on either side.

▲ Deposition of the Virgin's Mantle in the Sanctuary of the Blachernae, 1627. Moscow, Kremlin, Church of the Deposition of the Virgin's Mantle.

*Also called the "icon of thieves," it shows the typically Russian scene of a repentant sinner on his knees before the icon of the Mother of God.*

# Unexpected Joy

**Text**
"[T]here will be more joy in heaven over one sinner that repents than over ninety-nine righteous persons who need no repentance." (Luke 15:7)

**Title**
Unexpected Joy
(*Nechaiannaia radost*)

**Feast day**
December 9

**Sources**
Luke 1:28–37; Demetrius of Rostov, *Runo Oroshennoe* ("The Dew-Covered Fleece")

**Iconography**
A sinner kneeling, reciting the words of the angelic salutation, in front of an icon of the Virgin *Hodegetria*

This icon emerged in eighteenth-century Russia, inspired by an edifying story written by Bishop Demetrius of Rostov, whom the Russian church venerates as a saint. The story tells of a sinner who, despite his crimes, never forgot to repeat, several times daily, the angel Gabriel's greeting to Mary in front of an icon of the Mother of God. One day, as he was contemplating committing a particularly wicked deed, the man saw the holy image come to life: he saw wounds open up in the Christ child, and blood began to pour out of his hands and side as on the cross. The man fell to his knees and said (we see the words coming out of his mouth like a ray): "O my Lady, who did this?" The Virgin's answer (written on the icon) came at once: "You and other sinners crucify my Son anew with your sins, just as the Jews did." The man remained praying a long time,

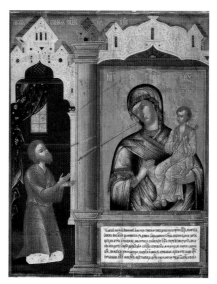

imploring Mary to intercede for him. After kissing Christ's bleeding wounds, he was granted not only forgiveness but also the unexpected joy of repentance and salvation. Under the icon, which appears inside a niche in a wall, is a plaque on which are written the opening words of Demetrius of Rostov's story.

▶ *The Virgin as Unexpected Joy*, north-central Russia, mid-nineteenth century. Private collection.

*The Mother of God appears, sitting on a tree, amicably conversing with the sacristan George in the presence of Saint Nicholas the Miracle-Worker.*

# The Conversing Virgin

The theme of this highly original and rare iconographic type can be read in its inscription, which specifies: "Apparition of the Most Holy Mother of God and Saint Nicholas to the sacristan George." It evokes the miracle connected with the icon of the Virgin of Tikhvin, a type of *Hodegetria* particularly popular and widespread in Russia, whose name is associated with the Monastery of the Dormition in Tikhvin. The Virgin is said to have appeared in a halo of light on June 26, 1383, indicating the site where a church should be built in her honor, a place other than the one where work had already begun. Before the church was consecrated, she made another appearance, to the sacristan George. This time she was sitting on a tree, with Saint Nicholas beside her, commanding a further change in the work: the church's cross must be made of wood, not of iron as the builders had planned, to recall the wood on which her son had been crucified. On the site of the apparition, a chapel in honor of Saint Nicholas was built, and a wooden cross was carved from the very tree on which the Virgin had appeared. In memory of the miracle, an icon was also executed, bearing the name of the Virgin *Besednaia*, "The Conversing One."

**Text**
"My Son and God was crucified on a Cross of wood, not of iron."
(Inscription on icons of the Virgin *Besednaia*)

**Title**
The Conversing (*Besednaia*) Virgin; Apparition of the Mother of God to the Sacristan George (or Iurysh)

**Feast day**
August 14

**Source**
Legend of the Virgin of Tikhvin

**Iconography**
The Virgin sitting on the trunk of a tree, Saint Nicholas, the sacristan George

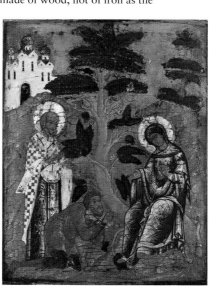

◄ *The Conversing Virgin*, central Russia, seventeenth century. Collezione Bucceri–De Lotto.

*Mary is sitting on the trunk of a tree just felled, whose splendid foliage, green and white, enlivens the background of the composition. The tree's bright buds are like those we see in spring.*

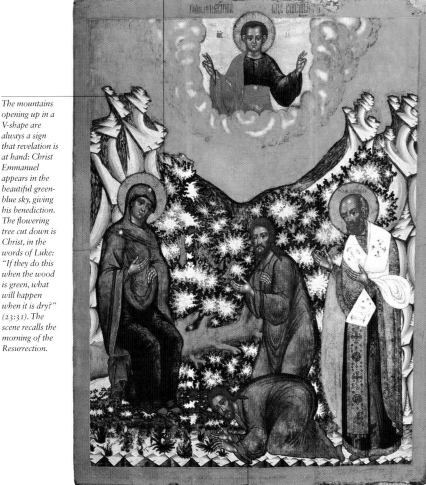

*The mountains opening up in a V-shape are always a sign that revelation is at hand: Christ Emmanuel appears in the beautiful green-blue sky, giving his benediction. The flowering tree cut down is Christ, in the words of Luke: "If they do this when the wood is green, what will happen when it is dry?" (23:31). The scene recalls the morning of the Resurrection.*

▲ *The Apparition of the Mother of God and Saint Nicholas to the Sacristan Iurysh*, originally from Rostov (Russia), Monastery of Saint Peter, 1705. Vicenza (Italy), Gallerie di Palazzo Leoni Montanari, Banca Intesa Collection.

*The sacristan George (Iurysh) appears twice: first bowing before the Virgin, then standing back up at Saint Nicholas's command. The position of the sacristan's hands echoes that of the Virgin and recalls her embrace of the dead Christ.*

*The first ex-voto in the history of the Christian faith, this image is connected to the story of the great Syrian theologian Saint John of Damascus, defender of the cult of images.*

# The Three-Handed Virgin

This image first appears in eighth-century Syria, during the struggle in defense of icons. The Iconoclast emperor Leo III the Isaurian, opposing John of Damascus, unjustly accused him before the caliph of Damascus and had his right hand cut off. John spent the night in prayer and promised God that if his hand were restored he would continue his struggle on behalf of the cult of icons. The Virgin spoke to him in a dream: "Your hand is healed. Now do what you promised to do." Waking up healed, John composed the hymn *In Thee Rejoiceth* and hung a silver hand, as an ex-voto, upon the icon of the Virgin. This story gave rise to the iconography of the three-handed Mother of God (with the third hand hanging around the Virgin's neck). John brought the icon with him to the Monastery of Saint Sabas in Palestine. From there, the icon was transferred by Archbishop Sabas to his homeland of Serbia, from whence it later passed on to the Chilandari Monastery on Mount Athos. This was where the version with the third hand emerging "nat-urally" from the

**Text**
"I have become the terror of demons, the city of refuge for those who turn to me. Come to me in faith, O people, and draw as from a river of grace. Come to me in faith, without doubt, and draw from the mighty, certain source of grace." (John of Damascus)

**Title**
The Three-Handed (*Tricheirousa*; *Troeruchitsa*) Virgin

**Feast day**
June 28 or (in Russia) July 12

**Iconography**
Virgin *Hodegetria* with three hands coming out of her veil, or with the third hand in gold or silver hung from her neck on a chain

urally" from the Virgin's veil, instead of being hung around her neck as an ex-voto, was born. In 1663, Patriarch Nikon of Moscow asked the Chilandari Monastery for a copy of the icon. The image then spread throughout Russia, like so many other Athos icons in the seventeenth century.

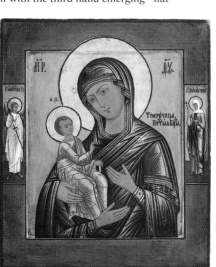

◀ *The Three-Handed Virgin*, central Russia, first half of nineteenth century. Collezione Bucceri–De Lotto.

219

# The Three-Handed Virgin

The gleaming gold lends an iridescence to the red tones of Mary's maphorion *and the Child's* himation. The clothing covers spiritualized bodies and radiates with divine energy, which in the icon is expressed as "uncreated" light.

The praying figures of Saint John and the prophetess Anna in the icon's frame probably represent the patron saints of the people who commissioned the painting.

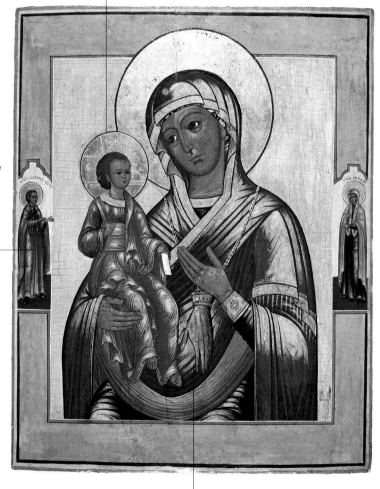

▲ *The Three-Handed Virgin*, central Russia, mid-nineteenth century.

The golden third hand, hung like an ex-voto on a chain around the Virgin's neck, recalls the episode when the caliph cut off the hand of John of Damascus, defender of the cult of images.

220

*Starting in the mid-seventeenth century, a refined, aristocratic iconography was used to consecrate the growing Muscovite state and adorn the four Kremlin churches dedicated to Mary.*

# Unfading Rose

In liturgical hymns, the virginity of Mary is compared to shoots and flowers that never wilt. This gives rise to an iconography combining sacred and secular symbols for Mary: throne, altar, dining table, heavenly palace, open book, red and gold curtain, heavenly garden, gate of paradise, the star that points to the sun, burning candle, bright lamp, prayer censer. In the icon on this page one finds all these images: Mary is holding a flowering rod, the Child the royal scepter, and both are wearing precious crowns and golden, brocaded vestments. In seventeenth-century Moscow, this image served to create a "visible" link connecting the four Kremlin churches dedicated to the Virgin—the churches of the Annunciation, Nativity, Dormition, and Deposition of the Virgin's Mantle. In 1668, the court painter Simon Ushakov painted the *Tree of the Muscovite State*, combining two compositions: the Praises to the Virgin and the Tree of Jesse. The rose garden sprouting from the walls of the Kremlin and the Cathedral of the Dormition represents the growth of the Christian Russian Empire around the effigy of the Virgin of Vladimir. A century later (1786), Antonios Sigalas, a priest from Santorini, combined the themes of the Tree of Jesse, the *Akathistos* hymn, and the Unfading Rose.

**Text**
"Rejoice, O thou only one who blossomed forth the unfading Rose." (Joseph the Hymnographer)

**Title**
Unfading Rose (*Rhodon to amaranton*); Unfading Flower (*Neuviadaemyi Tsvet*); Fragrant Flower (*Blagoukhannyi Tsvet*)

**Feast days**
Unfading Flower, April 3; Fragrant Flower, November 15

**Sources**
George of Pisidia, "*Akathistos*" of the Annunciation; Isidore Boucheir, "*Akathistos*" of the Dormition; Joseph the Hymnographer, *Canon of the Akathistos Hymn*

**Iconography**
Mary and Child with crowns and flowering scepters

◀ Tikhon Filatev, *The Virgin as Unfading Flower*, originally from the Church of the Nativity of the Virgin at Golutvin in Moscow, 1691. Moscow, Tretyakov Gallery.

Mary's veil and crown, symbols of protection, are spread over the city of Moscow by two angels sent by Christ.

In the delicately shaded, pastel-colored medallions, saints, princes, bishops, monks, and "fools for Christ" surround the image of the Virgin of Vladimir in the central oval. Her medallion, surrounded by roses, has the perfect shape of an egg, symbol of life and resurrection, and recalls Fabergé eggs, those handcrafted Russian jewels and masterpieces of goldsmithing.

▲ Simon Ushakov, *The Virgin of Vladimir as Tree of the Muscovite State*, originally from the Church of the Trinity at Nikitniki in Moscow, 1668. Moscow, Tretyakov Gallery.

The red walls of the Kremlin and the Cathedral of the Dormition behind it are bathed in a metaphysical light. From the cathedral sprouts the Tree of the Muscovite State, watered by the metropolitan Saint Peter and Prince Ivan Kalita, center. Their work is later carried on, in the seventeenth century, by Tsar Alexis Mikhailovich (left) and the tsarina with sons and crown princes Alexis and Feodor (right).

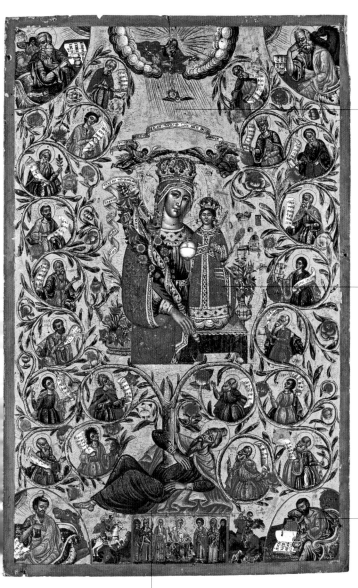

The heavens open and the Holy Spirit descends in the form of a dove, while two angels crown Mary and hold a scroll with the patron's dedication and the date: "Plea of the servant of God ... 1786"

Mary embraces Jesus, who is standing on an altar and holding a scepter and sphere. Both mother and child are wearing royal vestments and crowns. The two small vases of flowers and the golden objects are attributes of Mary from the Akathistos hymn.

In the four corners of the icon are the four evangelists. Near Saint Mark is the signature: "[By the] hand of Antonios Sigalas, priest from Santorini."

▲ Antonios Sigalas, *The Virgin as Unfading Rose with the Tree of Jesse*, 1786. Athens, Byzantine Museum.

At the root of the tree lies Jesse, father of David, sleeping the sleep of the dead. His line will give birth to Christ. Beneath him is a small Deesis of saints. The tree grows into ten branches with figures of the prophets.

# CHRIST THE SAVIOR

◀ School of Constantinople, *Christ
Pantokrator* (detail), originally from
the Pantokrator Monastery on Mount
Athos, 1363. Saint Petersburg,
Hermitage Museum.

*The scarce information for interpreting this icon only adds to its mysterious charm. Christ appears here as an angelic, ineffable, concealed embodiment of love.*

# Blessed Silence

**Text**
"Let it be the hidden person of the heart with the imperishable jewel of a gentle and quiet spirit."
(1 Peter 3:4)

**Title**
Angel of the Great Council (*Angel Velikogo Soveta*); Blessed Silence (*Blagoe molchanie*)

**Sources**
Isaiah 9:6, 16:10, 42:2, 53:5–7; Psalms 141, 142; Malachi 3:1; Matthew 3:1, 17:2–3; Philippians 2:8; 1 Peter 3:4; Revelation 7:9–17; Dionysius the Areopagite, *The Celestial Hierarchy*

**Iconography**
A beardless Christ in liturgical vestment, star-shaped halo, wings

This subject first appears in Russia in the fifteenth century, reviving the Byzantine iconography of the Angel of the Great Council. Christ is portrayed as the youthful Emmanuel, wearing a broad-sleeved *sticharion* embellished with pearls. The attributes of Christ, the Angel of Blessed Silence, are a beauty that is "the imperishable jewel of a gentle and quiet spirit" (1 Peter 3:4); a discreet presence who "will not cry or lift up his voice, or make it be heard in the street" (Isaiah 42:2); the docility of one "afflicted, yet he opened not his mouth; like a lamb that is led to the slaughter, and like a sheep that before its shearers is dumb" (Isaiah 53:7). The absence of any scroll or book, as well as the hands crossed over the chest (the pose that the Orthodox assume when receiving Communion), expresses the Savior's silence and his invitation to inner prayer, as inspired by David's invocation to "Set a guard over my mouth, O LORD" (Psalm 141:3). Later icons show

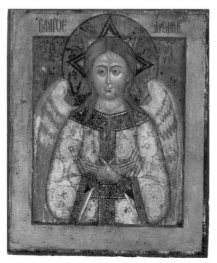

a star-shaped halo over the head, and wings, symbols of the energy that gives life to the cosmos. Both are attributes of Divine Wisdom. This image's appeal to silence and inner prayer expresses its links to the monastic milieu (the "angelic" order of life) and the sect of the Old Believers (*Raskolniki*).

► Moscow school, *Blessed Silence*, second half of eighteenth century. Collezione Bucceri–De Lotto.

*While this image may immediately evoke the child-God of Bethlehem or the twelve-year-old Jesus in the Temple, it actually represents the eternal Word that existed before time.*

# Christ Emmanuel

The prophet Isaiah is the first to use the term "Emmanuel" (7:14), which means "God is with us," and this sense of immediate presence is what the icon is supposed to represent. We see not a child before us, but the mysterious, unknowable face of God, who is eternally young and old at once, as emphasized by the Church Fathers. The figure's young age stands not for the Child but, rather, for the incorruptible, timeless youth of the sacrificial Lamb, daily renewed on the altar in the bloodless sacrifice of the Eucharist. At the Cathedral of the Dormition in Moscow, the placement of the Emmanuel icon in a *Deesis* over the northern doors of the iconostasis that lead to the *prothesis* (the room where the holy gifts are prepared) confirms this interpretation. For Russian culture, moreover, the Emmanuel represents the principle of Sophia, the Divine Wisdom of which John speaks in the prologue to his Gospel: "In the beginning was the Word, and the Word was with God, and the Word was God" (1:1). The smooth-faced Christ, in half length or, more rarely, full length, seated on his throne, is always inserted in an angelic *Deesis* between Gabriel and Michael (the archangels who stand guard over the Divine Liturgy). Sometimes an entire host of angels forms an assembly (synaxis) around him.

**Text**
"Young boy, eternal God, old boy who precedes the ages, coeval with the Father." (Anonymous Byzantine author)

**Title**
Christ Emmanuel

**Sources**
Isaiah 7:14; Matthew 1:23; Luke 2:46–47, 4:18–19; John 1:1

**Iconography**
The young Christ in half length, or seated in full length, with the archangels Gabriel and Michael

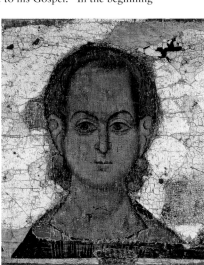

◄ *Christ Emmanuel*, detail from a *Deesis*, from the Cathedral of the Dormition in the Moscow Kremlin, second half of twelfth century. Moscow, Tretyakov Gallery.

# Christ Emmanuel

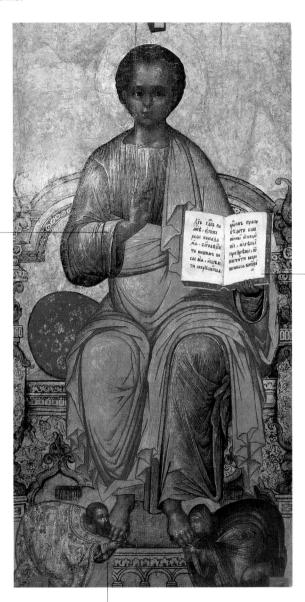

The royal vest-
ment is entirely
interwoven with
fine gold lines that
make the fabric
impalpable as
light. The orange
robe leaves the
left knee and the
right arm uncov-
ered, as the right
hand is raised in
benediction.

The book is open
to the passage of
Isaiah that Christ
read and com-
mented upon in
the synagogue of
Nazareth: "The
Spirit of the
Lord GOD is
upon me, because
the LORD has
anointed me to
preach good
tidings to the
afflicted" (61:1).

▲ Moscow school, *Christ Emmanuel*,
from a *Deesis*, ca. 1670. Moscow,
Kolomenskoe Museum.

The icon is from a palace built in Kolo-
menskoe by Tsar Alexis I Mikhailovich in
the seventeenth century. The two prostrate
figures have tentatively been identified as the
tsar's favorite boyar, Artamon Matveev, and
his wife.

*This is a rare subject that did not appear in Russia until the seventeenth century. Through a series of metaphors it explains why Christ died willingly on the cross.*

# Fruits of the Passion

Only thirty-seven known icons belong to this complex, allegorically rich typology, which seeks to express through images a variety of theological concepts concerning Christ's sacrifice. From the cross's horizontal element (*patibulum*) and lower cross-bar (*suppedaneum*) blossom flowers with angels on top, holding the symbols of the Passion in red globes. From the flowers at the extremities of the cross sprout four hands: the first (lower left) crowns a temple; the second (top center) unlocks the gates of heaven; the third (on the right) smites Death the Horseman with a sword; while the fourth (lower right) strikes the devil, chained to the foot of the cross, with a hammer. In the sky, dazzling as fire, appears the heavenly Jerusalem with the ranks of angels led by the Ancient of Days (God the Father). On the lower left is a white temple with five domes (the Church), in which the four evangelists stand between the columns. The *suppedaneum* of the cross, a symbol of the scale of divine judgment, tilts toward the damned (where Judas appears in Satan's arms, in Leviathan's maw), while it is raised on Christ's right-hand side, where souls are climbing out of their tombs to celebrate his victory.

**Text**
"He went to his Passion of his own accord, happy to perform so sublime a task, full of joy for the fruit it would bear, the salvation of mankind." (Cyril of Jerusalem)

**Title**
The Fruits of the Passion of Christ (*Plody stradanii Khristovykh*)

**Iconography**
Tree with flowering cross bearing the symbols (hammer, pincers, lantern, nails, lance, striking hand, silver coins, crown of thorns, tunic, shroud) and allegories of the Passion (flowering cross-tree, cross-ladder, cross-sword, cross-hammer, cross-key); from the flowers emerge hands that on one side crown the Church and open the gates of heaven, and on the other overcome Satan

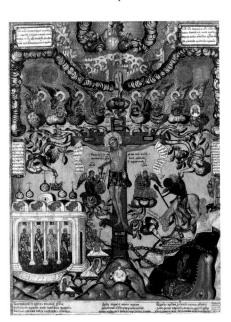

◄ *The Fruits of the Passion of Christ*, originally from the Solovki Monastery, 1689. Arkhangelsk (Russia), Museum of Fine Arts.

*Surrounded by the ranks of angels and the symbols of the four evangelists, the icon of Christ Enthroned, of early Christian origin, is the center of the* Deesis.

# Christ Enthroned

**Text**
"The keenest awareness of hidden things, leading the soul through visible things to the invisible reality, is like a cloud obscuring the entire sensible world and guiding the soul to an awareness of what is hidden." (Gregory of Nyssa)

**Title**
The Savior Enthroned (*Spas na prestole*) or in Majesty (*v silakh*)

**Sources**
Isaiah 6:1–4; Ezekiel 1:1–28; Revelation 4:1–9; Dionysius the Areopagite, *The Celestial Hierarchy*

**Iconography**
Christ enthroned with an open Gospel book, seraphim, and cherubim

The image of the Savior Enthroned is of Byzantine origin and dates from the centuries prior to the Iconoclast controversy. It came to Russia through Cappadocia in the twelfth and thirteenth centuries and there attained perfection in the main register of the iconostasis in the great icons of Theophanes the Greek and Andrei Rublev. The subject derives from a variety of sources: Isaiah's vision of the Lord enthroned among seraphim (6:1–4); the vision of Ezekiel where the Lord is surrounded by the four creatures (1:4–28); and the vision of John in which a rainbow of light surrounds Christ on his throne (Revelation 4:2–9). Variants of this typology include the one in which he holds the Gospel on his knees and another where the left foot and leg are rotated and asymmetrical, giving great dynamism to the composition. The four creatures of the Apocalypse (angel, eagle, lion, ox) are interpreted by the Church Fathers as symbols of the four evangelists. The mandorla of light contains faint monochromatic images of angels, creating the iconography of the Savior among the angelic powers, typical of the fifteenth century and the Muscovite tradition. Christ is enthroned inside a red rhombus inscribed within a blue oval, which is in turn inside a red square.

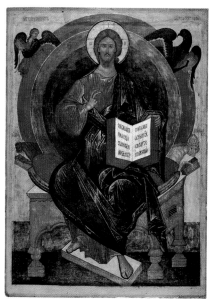

► Novgorod school, *Christ Enthroned*, originally from the former Old Believers' Monastery of Saint Nicholas in Moscow, sixteenth century. Moscow, Tretyakov Gallery.

The inscribed letters, IC XC, are the initials of Jesus Christ. The three Greek letters on the halo with cross stand for "I am that I am," the words with which God revealed himself to Moses on Mount Sinai (Exodus 3:14).

The filigree imagery of the throne and seraphim overlaps the red rhombus and the blue-green oval and is shot through with rays of light.

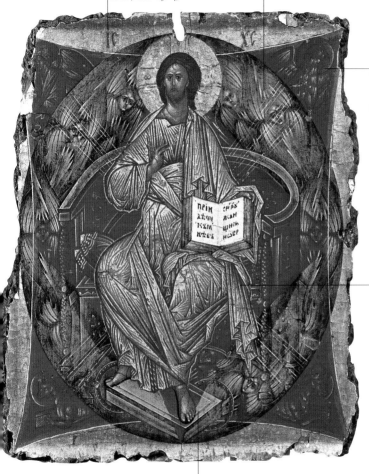

The four corners formed by the green oval's intersection with the red square (which represents the heavens spread out like a curtain) contain anthropomorphic images of the four evangelists.

The train of the Lord's robes that filled the Temple, according to the vision of Isaiah (6:1–4).

The wheels of fire with eyes and wings mentioned by Ezekiel (1:15–21) and the asymmetrical positioning of the Lord's feet produce an effect of rotating movement underscored by the curved line of the throne above.

▲ Andrei Rublev, *Christ in Majesty*, a. 1410. Moscow, Tretyakov Gallery.

*The pietà represents the culminating moment of despondency and death, for Jesus as well as for Mary, who holds her son, the bridegroom of mankind, after his deposition from the cross.*

# The Man of Sorrows

**Text**
"Mourn not for me, O mother, as you behold in the grave the Son, whom without seed you conceived in your womb. For I shall arise and be glorified, and as God I shall exalt in glory without end those who magnify you with faith and love." (Canon for Holy Saturday)

**Title**
The Utmost Humility (*Akra Tapeinosis*); The King of Glory (*Basileus tes doxes, Tsar slavy*); "Mourn Not for Me, O Mother" (*Ne rydai mene, mati*); Christ in the Tomb (*Khristos vo grobe*)

**Feast day**
Good Friday

**Source**
Philippians 2:5–11

**Iconography**
Christ in the Sepulchre, the Virgin Mary, John, Joseph of Arimathea, Nicodemus, Longinus the Centurion, disciples, and pious women

The iconography of the Man of Sorrows, featuring the dead Christ in the unnatural position of standing up in his tomb, first arises in Constantinople in the twelfth century, when the Holy Shroud was still on exhibit in Hagia Sophia. The shroud bearing the imprint of a partially bent Christ may have served as a model for iconographers. The rightward inclination of the head has, for example, been confirmed by recent studies of the Holy Shroud of Turin. In the icon, the dead Christ standing in the sepulchre is the bridegroom: the marriage of God and mankind has been consummated on the wood of the cross where Christ, through his blood, has engendered the new humanity, the Church, represented by Mary. Sometimes the image of the Holy Face (*Mandylion*), held up by two angels,

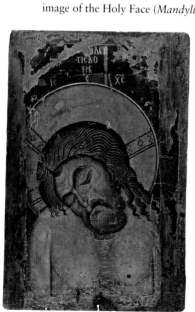

appears in the upper portion of the icon. The icon of the bridegroom is also called "Mourn Not for Me, O Mother." The Mother's tears are joined by those of the apostle John, the pious women, and the disciples. The full horizontal image of the dead Christ, whether painted or embroidered on the fabric of *epitaphioi*, related to the Lamentation and clearly derived from the Shroud. These images, painted or embroidered on cloth, are carried in procession on Good Friday.

▶ *The Man of Sorrows,* twelfth century. Kastoria (Greece), Byzantine Museum.

*The archangels Michael and Gabriel hold up the shroud with Christ's face for the veneration of the faithful, while two small seraphim in flight carry the instruments of the Passion.*

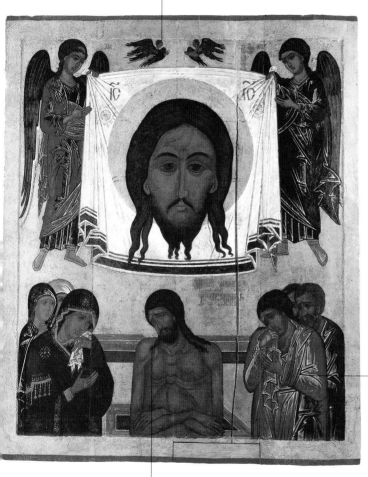

*A common sorrow unites Mary and John as they cry over the dead Christ. The disciples and pious women share not only their grief but also the light that shines on the robes of Mary and John. Though Christ's body appears here as an opaque, earthen shell devoid of light, they will all soon witness the Resurrection.*

▲ Moscow school, *The Holy Face and Man of Sorrows*, sixteenth–seventeenth century. Moscow, Kolomenskoe Museum.

*The dark mane of hair, divided into four strands, links the image of Jesus in the tomb to the one above, where the Christ of Mercy beams forth from the white cloth of the Mandylion.*

The cross from which Christ was taken down closes the composition above, with the words: "Mourn not for me, O Mother, seeing [me] in the Tomb."

The walls of Jerusalem in the background remind us that, like the prophets, Jesus was born and died outside the walls of his city.

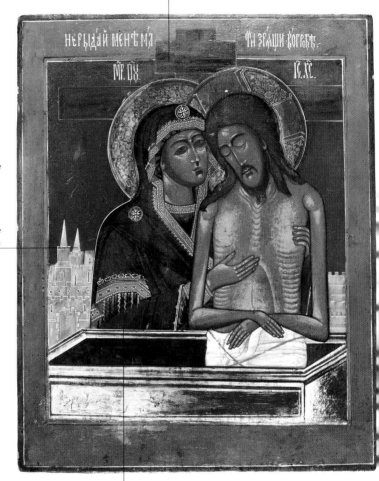

▲ "Mourn Not for Me, O Mother," north-central Russia, late eighteenth century. Private collection.

Mary embraces her dead son, who seems almost to be smiling in his mother's arms. This is the same Christ as in the Virgin Eleousa, pressed to her loving heart.

*The image of Christ cannot be the work of an artist but only a revelation from the Lord, who left the features of his Holy Face impressed on Veronica's veil.*

# The Holy Face

Western tradition identifies the "true" portrait of Christ as the one miraculously left by Jesus on the veil that Veronica used to wipe his face on Calvary. *The Golden Legend* recounts that the emperor Tiberius was cured by looking at this image, which Veronica herself brought to him in Rome. The relic, itself called "Veronica" (from *vera icon*, "true image"), was copied countless times before all trace of it was finally lost. Some identify its image with the icon of Manoppello (Chieti, Italy) or with the one in Genoa (San Bartolomeo degli Armeni). For Eastern Christendom, on the other hand, the true Holy Face is that of the *Mandylion*, the portrait that Christ sent to Edessa to cure King Abgar. This image was found hidden inside a wall in 545 and transferred to Constantinople in 944. Exhibited in the church of Hagia Sophia in Constantinople until 1204 (it disappeared at the time of the Fourth Crusade), it may in fact correspond to the folded Shroud of Turin itself. The tile (*keramion*) used to wall up the *Mandylion* during the persecutions preserved a reversed image of the Holy Face. There are currently three Holy Face icons deriving from the *Mandylion* of Constantinople: those of Novgorod, Laon (France), and Yaroslavl.

**Text**
"God became man to regenerate the image of man destroyed by sin, thus giving him back his original icon." (Church Fathers)

**Title**
The Image of Christ on the Cloth (*Mandylion*, *Ubrus*); on the Tile (*Keramion*, *Chrepie*); "Not made by human hands" (*Acheiropoietos*; *Nerukotvornyi*)

**Feast day**
Translation of the *Mandylion* to Constantinople, August 16

**Sources**
Jacobus de Voragine, *The Golden Legend*; John of Damascus, *On the Orthodox Faith*

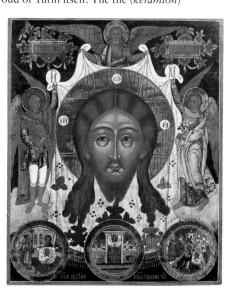

◄ Russian artist, *The Holy Face*, second half of nineteenth century.

Archangels Michael and Gabriel hold up the ends of Veronica's veil bearing the imprint of the Holy Face; the arch formed by the cloth recalls the vault of the heavens and their "bending" to reveal Christ, who "stretched out the heavens like a tent" (Psalm 104:2).

The face, with its ruddy complexion and typically Russian features, expresses the indissoluble link between death and resurrection and exalts Christ's divine humanity. The halo bears the mark of the cross and the words "I am that I am." The pointed beard emphasizes the oval of the face, shading it slightly.

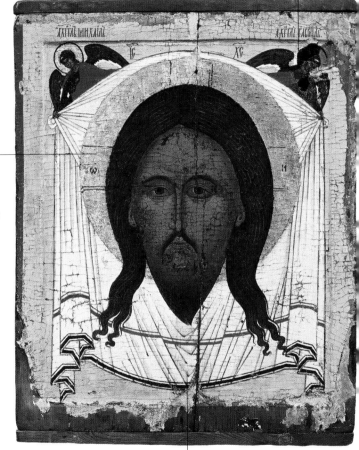

▲ *The Holy Face*, originally from Tikhvin, sixteenth century. Saint Petersburg, Russian Museum.

*The folds of the* Mandylion *create a decorative motif accentuated by the interplay of the red and white hem. The inner folds echo the shape of the beard, underscoring its rightward turn.*

Set on a golden background, the sacred cloth of Veronica appears as a holy object, imbued with divine energy. In the halo with superimposed cross the letters O, Ω, and N (omicron, omega, nu) stand for the holy name revealed to Moses on Mount Sinai; in the blue corners, the letters IC and XC are the initials of Jesus Christ.

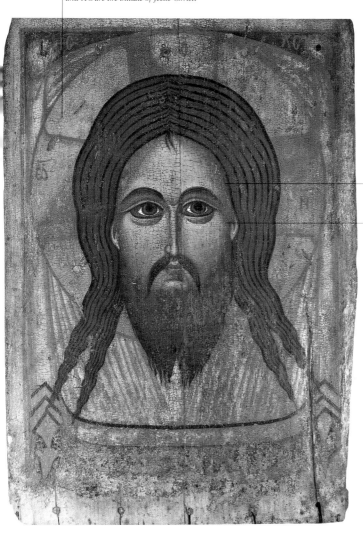

The large brown eyes give the face an intense magnetism. The long, narrow nose and small, closed mouth stand for silence and inner strength.

The full, flowing mane of hair forms a regular pattern of concentric grooves around the head, reminiscent of the rings of growth in a tree's trunk. The long, sloping moustache and thick, two-pointed beard complete the composition of the face.

▲ *Holy Face of Yaroslavl*, first half of thirteenth century. Moscow, Tretyakov Gallery.

The direction of the gaze and the shock of hair on the forehead, accentuated by the asymmetry of the eyebrows, preserve the "reverse" imprint of the Mandylion *found on the tile* (keramion) *under which it was hidden during the persecutions.*

Christ is at the center of the halo, which is itself inscribed inside the square of the icon: the circle symbolizes the heavens; the square, the earth. Similarly, in Orthodox churches, the dome of the heavens covers the cube representing the world.

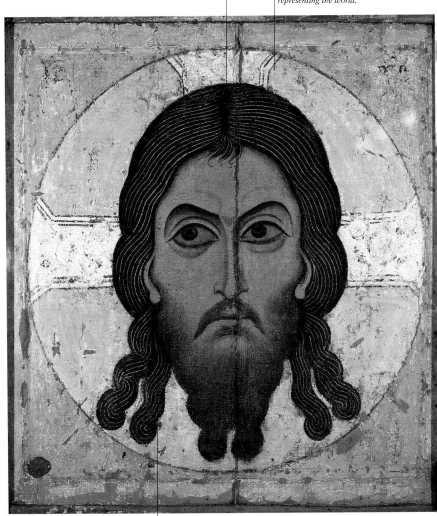

▲ Novgorod school, *The Holy Face*, ca. 1167. (The other side of this two-sided icon appears on page 58.) Moscow, Tretyakov Gallery.

The dark, wavy hair with its fine gold lines almost looks as if it has just had a comb passed through it, rendering it luminous. Under the ears, the hair is divided into braids that end in curls similar to the extremities of the beard.

The luminous, high forehead, with its unusual ogival shape, is enclosed by the thick hair and framed by a luminous halo.

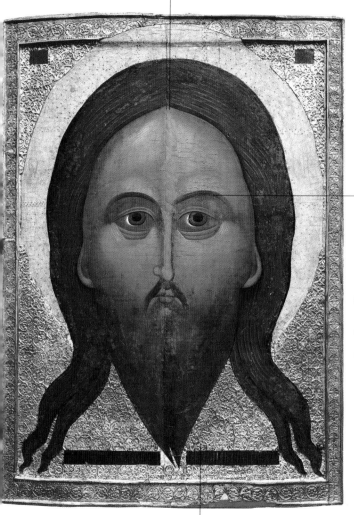

The eyebrows cast shadow on two large, dark eyes, deep and expressive, that look as though they were carved out of wood. The straight nose underscores a firmness of will and mind. The dense, soft beard ends in a double point, in keeping with an iconographic type known in Russia as the "Savior of the Wet Beard."

The Holy Face, mid-sixteenth century. ‹likii Ustiug (Russia), Ethnographic ‹useum.

Covered with a silver revetment (riza) with chased floral decorations, this image derives from the original of the Holy Face of Edessa. Numerous copies were made of the latter at Velikii Ustiug, in Russia, from 1447 onward.

*The image of the sleeping Emmanuel gives allegorical expression to a theological message: he who created the world never sleeps, but rather watches over it and saves it.*

# *Christ* Anapeson

**Text**
"Behold, he who keeps Israel will neither slumber nor sleep. The LORD is your keeper: the LORD is your shade on your right hand... The LORD will keep your going out and your coming in from this time forth and for evermore." (Psalm 121:4–8)

**Title**
Christ Reclining (*Anapeson*); Wakeful Eye (*Nedremannoe oko*)

**Sources**
Genesis 49; Psalms 110, 121; John 1

**Iconography**
Christ Emmanuel lying down, the archangel Gabriel, the Mother of God, the angels of the Passion, heaven, a sarcophagus, the Ancient of Days

Christ Emmanuel lies asleep on a sort of sarcophagus whose square form represents the earth. Watching over him is Gabriel, the angel who announced his incarnation. This composition first appeared on Mount Athos in the fourteenth century, then spread to Russia in the sixteenth century, with significant variants: the Child is lying not horizontally but diagonally, resting and meditating in the company of the Virgin *Orans*. His eyes are open—"Behold, he who keeps Israel will neither slumber nor sleep" (Psalm 121:4)—and his head rests on his arm. The scene, however, prefigures death: an angel appears holding the instruments of the Passion, then another holding a liturgical fan (*rhipidion*). Christ Emmanuel gazes into the distance, contemplating heaven and the future Passion. He rests under the tree of life, and in some icons swans and a small empty tomb appear at his feet. Scrolls bear the words spoken between mother and son: Mary says: "Almighty Lord, my Son and my God, incline your ear, hear the prayer of your Mother, who prays your holy name…" and Christ replies: "Why, O Mother, are you distressed, seeing me lying in bed crucified and laid into the tomb? I shall rise again in glory, and vanquish Hell."

▶ Russian artist, *The Sleep of the Just Man*, seventeenth century. Frankfurt, Von Mauchenheim Collection.

*The heavens open up and the Ancient of Days appears, giving benediction. Beneath him is the dove of the Holy Spirit in a red circle gleaming with gold striation. A seraph carries the cross, and an angel the instruments of the Passion.*

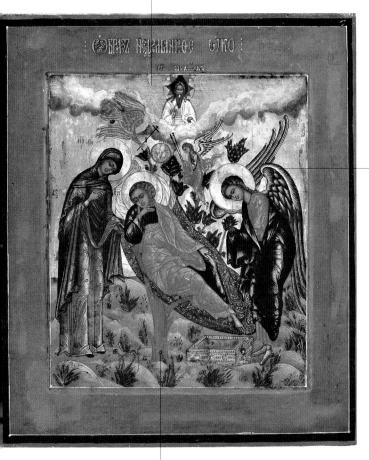

*The archangel Gabriel watches over the one who, upon his announcement, will become flesh in the bosom of the Virgin Mary.*

*"Wakeful Eye," originally from Moscow, first half of nineteenth century. Collezione Bucceri–De Lotto.*

*The verdant branches of the tree of life make shade for the reclining Emmanuel. Beside it, on the ground, is the sepulchre in which he will be laid.*

*The adult Christ giving benediction, holding an open or closed Gospel, is one of the most ancient iconographic types and is cited as proof of the historical authenticity of the incarnation.*

# Christ Pantokrator

**Text**
"The illuminated Word of the Father imposed a limit on itself in the incarnation; it restored the corrupted image of the primitive archetype, and filled it with divine beauty." (Byzantine liturgy)

**Title**
Christ the Ruler of All (*Pantokrator, Vsederzhitel*); The Savior with the Fearsome Eye (*Spas Iaroe oko*)

**Sources**
Acts of the Council of Nicaea; John of Damascus, *On the Divine Images*

**Iconography**
Christ is depicted waist length, holding an open or closed book or a scroll (with text from the Gospels or the Apocalypse), hand giving benediction, halo with cross

After the Council of Nicaea confirmed in 325 that Christ was the visible and perfect image of the Father, there followed three centuries of struggle against the heresies that denied either the divine nature of Christ (Arianism) or his human nature (Monophysitism). It was finally established that the person of Christ embodied the union of two natures, human and divine. The icon of the Pantokrator became the symbol of this dogma. Especially during the reign of the Iconoclast emperor Leo III the Isaurian (717–41), icons became targets of destruction, and their supporters were persecuted. In defending the image of Christ the man-God, they were defending the very principle of the incarnation and, by extension, the reality of salvation. The

Pantokrator icon became an important bulwark in defense of the true faith and had its share of martyrs, until the Seventh Ecumenical Council of Nicaea (787) and the Triumph of Orthodoxy (843) put an end to the strife. The icon of Christ Pantokrator, that is, Lord of the Universe, is the very image of the victory of the Orthodox faith over the heretics.

▶ *The Savior with the Fearsome Eye,* early fourteenth century. Moscow, Kremlin, Cathedral of the Dormition.

The great gilded nimbus contrasts with the dark hair, while the wide-open, asymmetrical eyes gaze beyond the confines of space and time. The graceful brushstroke rendering the flesh tone of the face draws its inspiration from classical antiquity. The result is a perfect balance between naturalism and mystical transfiguration.

The right hand holds a precious Gospel, bound with golden clasps and covered with precious white, red, and blue stones that form a cross in the center.

The fingers of the right hand, giving benediction, are gathered to form the initials of Christ's monogram, IC XC.

▲ *Christ Pantokrator*, sixth century. Mount Sinai, Monastery of Saint Catherine.

# Christel Pantokrator

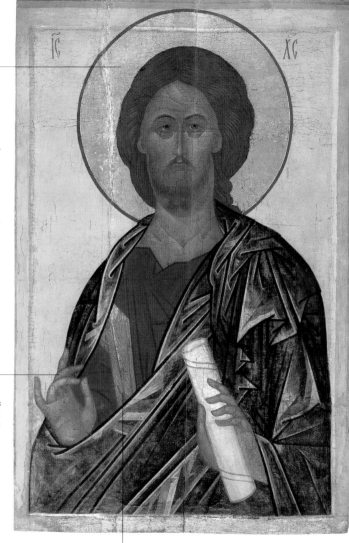

The thick, gathered hair frames the face, then falls in loose braids onto the left shoulder, suggesting a slight turn of the shoulders. The thick neck expresses the fullness of the breath of the Holy Spirit. The beard is a fine filigree shading the face. The expression derives from Andrei Rublev's Savior but differs in its aesthetic detachment.

The right hand gives benediction as the fingers form the initials IC XC, the monogram of Jesus Christ, written above in red on either side of the halo.

▲ *Christ Pantokrator*, originally from the *Deesis* of the Church of the Virgin's Protecting Veil in Gumenets, ca. 1530. Rostov (Russia), museum.

The dark red gown (chiton) with a golden band (stichos or clavus) around the shoulder indicates Christ's divine royalty. His human nature is symbolized by the blue-green color of the outer garment (himation), whose folds shine with gleams of light. His left hand holds the scroll closed, awaiting Judgment Day.

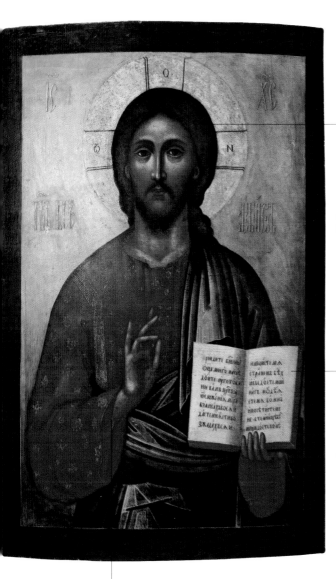

The shaded modeling of the face is derived from the painting of Simon Ushakov and displays elements of a refined, courtly art, executed by assistants. The halo with super-imposed cross, bearing the words "He that is" (O ΩN), surrounds the face in a mystical aura that shimmers when the icon is lit by the flickering light of an oil lamp or candles.

The choice of the text cited in the open book (Matthew 25:34–36: "Come, O blessed of my Father…") high-lights the patron's sen-sibilities. It reminds us that on Judgment Day, Christ will recognize us according to the love we have had for our neighbors.

The full sleeves and floral decoration of the tunic show the influence of Western Baroque art. The priestly benediction, with the hand forming Christ's mono-gram, was introduced in Russia by the patriarch Nikon.

▲ Workshop of the Moscow Krem-lin Armory, *Christ Pantokrator*, ca. 1670. Moscow, Kolomenskoe Museum.

*The Russian sensibility replaced the Byzantine Christ—the righteous, fearsome Judge—with the iconography of the* Spas *(Savior), a term whose very sound expresses infinite gentleness and mercy.*

# Our Savior

**Text**
"If you want to know who you are, look not to what you have been, but to the image that God had in creating you. In Him there is all His godliness, and all our humanity." (Pope Leo the Great)

**Title**
Savior (*Soter*; *Spas*); Christ the Merciful (*Eleimon*, *Vsemilostivyi*); Savior of Souls (*Psychosostes*, *Dushespasitel*)

**Sources**
Psalm 45; Acts of the Council of Nicaea; *Akathistos* hymn

**Iconography**
High forehead, uneven eyebrows, rounded right eyelid, flowing, evanescent beard, small, closed mouth, very deep eyes

▶ Moscow school, *Christ Pantokrator*, early eighteenth century.

All Christian iconography tries to answer one question: Who is Jesus of Nazareth? The icon of the Savior (the Russian *Spas*) shows Christ as the merciful face of the Father. Christ in fact says, "He that sees me, sees Him who sent me" (John 12:45). This image is a variant of the Pantokrator icon, in which the expression of strength and authority of the Byzantine Christ the Judge is tempered by the Savior's merciful face: "You are the fairest of the sons of men" (Psalm 45). In Christ, justice and mercy, truth and peace, are reconciled. This is the Russian Orthodox concept of divine humanity: Christ is at once lord of the universe and the prototype of a transfigured humanity. The Pantokrator's firmness of will and the incandescence of his eyes give way to a more intimate expression, a gaze that attracts. The Church Fathers recommended that one pray before an icon: "I saw the human face of God, and my soul was saved"

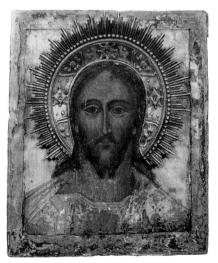

(John of Damascus). The Savior lets those who look upon him take part in the mystery of his incarnation. Andrei Rublev's icon of the *Spas*, found in 1918 (together with his *Archangel Michael* and *Saint Paul*) among the floorboards of a woodshed belonging to the Church of the Dormition in Zvenigorod, gives sublime expression to these ideas.

The convex shape of the face, accentuated by the mane of hair flowing down onto the left shoulder, suggests a slight turn in the pose and lets the spirit of the image move toward the onlooker.

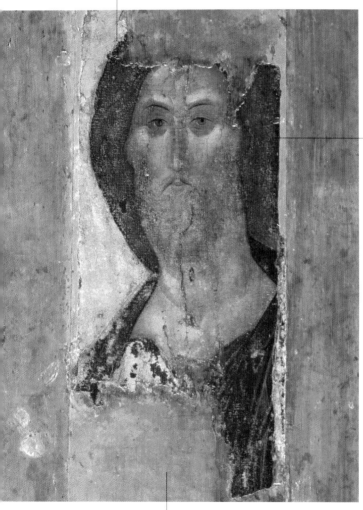

The thin, well-marked lines of the eyebrows, lashes, and moustache express a strong sense of pity and a loving judgment of the world. The puffiness of the eyelids, cheeks, and neck manifests the presence of the Spirit in the transfigured flesh of Him who suffered for us.

Andrei Rublev, *Christ the Savior*, from the *Deesis* of the Cathedral of Zvenigorod, ca. 1420. Moscow, Tretyakov Gallery.

The icon's poor state of conservation—it was used as a floorboard in a woodshed and rediscovered by chance in 1918—makes this precious fragment all the more sacred and suggestive.

*Just as the earthly court of the emperor or tsar gathered around its sovereign, the heavenly court gathers around Christ the Lord in the monumental icons of the main register of the iconostasis.*

# Deesis

**Text**
"If contemplation with the intellect had been sufficient, the Word need only have come among us intellectually." (Theodore the Studite)

**Title**
Intercession, Prayer, Supplication (*Deesis*)

**Feast day**
First Sunday of Lent (Sunday of the Last Judgment)

**Sources**
Matthew 17:1–9; Mark 9:2–13; Luke 9:28–36

**Iconography**
Christ enthroned, surrounded by Mary, John the Baptist, the archangels Michael and Gabriel, Peter and Paul, Elijah, and Nicholas the Miracle-Worker (or some other local saint), martyrs, monks, and the blessed

The Gospel episode of the Transfiguration can be considered an early form of *Deesis*: Christ appears to his disciples on Mount Tabor, between Moses and Elijah, who are praying. The simplest form of *Deesis*, with three figures (*trimorphon*), dates from the early centuries of Byzantine art: Christ is on his throne, with the Mother of God on the right and John the Baptist on the left. These two most powerful intercessors are represented in three-quarter poses, hands raised in supplication. Other "orants" are then added in hierarchical order on either side, extending the *Deesis* horizontally in a long procession of saints. They include the archangels Gabriel and Michael, the apostles Peter and Paul, Elijah, the patron saint of the church to which the icon belongs, the Church Fathers, martyrs, monks, and the blessed. The figures in the *Deesis* can be represented in full or half length, or even as faces, on one or more adjacent panels.

As the Russian iconostasis developed between the thirteenth and fifteenth centuries, the register devoted to the *Deesis* became the most important and imposing: tall icons with life-size images of Mary and the saints line up over the royal doors, inviting the faithful to raise their eyes and be filled with wonder.

► *Deesis* with Saints John the Almsgiver and John Climacus in the frame, eleventh century. Mount Sinai, Monastery of Saint Catherine.

To Christ's right, the Virgin Mary, the archangel Gabriel, the apostle Peter with keys and a folded scroll; to his left, John the Baptist, the archangel Michael with the sphere of the heavens, and the apostle Paul with a closed book.

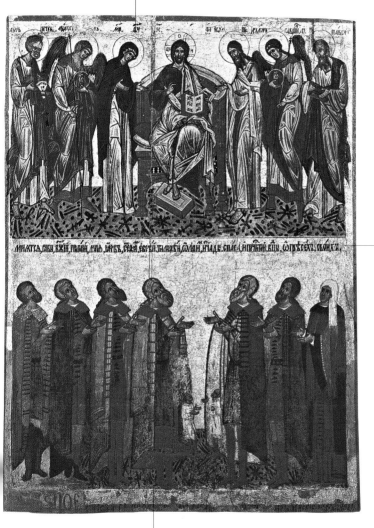

The inscription reads: "The servants of God, Gregory [far left], Mary [far right], Jacob [second on left], Stefan [second on right], Evsei [third on right], Timothy [center right], Olfim [center left], with their children [between Olfim and Timothy], pray to the Savior and the Most Pure Mother of God for [the forgiveness of] their sins."

▲ Deesis *with Novgorodians in Prayer*, 1467. Novgorod (Russia), museum.

The brightly dressed inhabitants of Novgorod in red-collared caftans (typical of fifteenth-century merchants) look up and raise their hands to Christ and the saints. Their feet rest on a "spiritual meadow" similar to the one in the upper register, to which their prayers will lift them.

# Deesis

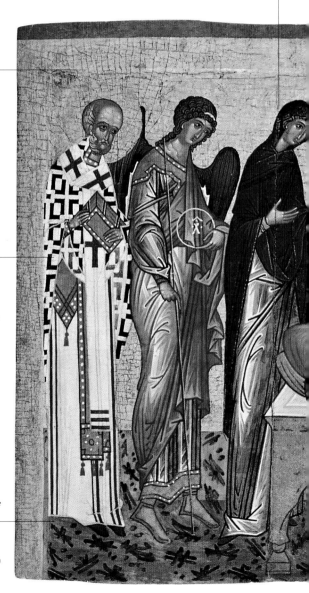

*The Mother of God, in a dark red maphorion typical of Eastern women, and John the Baptist, on the opposite side, wearing a camel hair tunic under his cloak (chlamys), are the most powerful intercessors at the throne of Christ.*

*The gold background represents the divine light that suffuses the transfigured bodies of Christ and his saints, who live in an eternal dimension outside space and time.*

*Saint Nicholas, wearing a priestly stole (omophorion) adorned with red crosses and fringes. His cloak (polystaurian) is also covered with crosses, in this case black and white. Together with Elijah (at the opposite end, wearing his characteristic red cloak lined with fur), they are the saints closest to the faithful, for whom they intercede, and to the commissioners of the work, who have chosen them as patron saints.*

*The green meadow recalls paradise and the crystal sea of the book of Revelation. Green, moreover, is the color of life and connotes the presence of the Spirit that renews the face of the earth.*

▶ Novgorod school, *Deesis*, from the Church of the Virgin's Protecting Veil in Borovsk, late fifteenth–early sixteenth century. Moscow, Tretyakov Gallery.

Christ sits on a double cushion painted in the same colors—red and blue-green—as his gown and cloak. The colors stand for his dual nature, human and divine, whose union is symbolized in the joining of the thumb and ring finger in a gesture of benediction.

The archangels Michael and, on the opposite side, Gabriel, bear symbols of their power: a long, slender staff and a heavenly sphere with the initials of Christ.

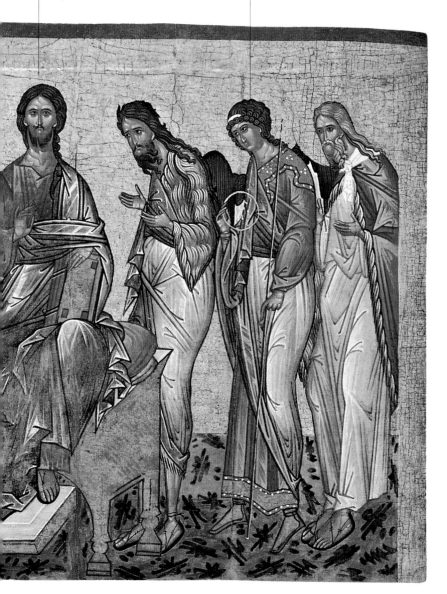

*The magnificence of the regal and priestly symbols of the Byzantine emperor and the Russian tsar stand for the grace and beauty of Christ, the true king and eternal priest.*

# The King of Kings

**Text**
"The princess is decked in her chamber with gold-woven robes; in many-colored robes she is led to see the king." (Psalm 45:13–14)

**Title**
King of Kings (*Basileus ton basileuonton, Tsar tsarem*); Great High Priest (*Megas Archiereus, Velikii Arkhierei*); "At your right hand stands the queen" (*Predsta Tsaritsa*)

**Sources**
Psalm 45:110; Matthew 21:5, 27:11; Mark 15:2; Luke 19:30; John 12:13–15, 18:36–37; 1 Corinthians 15:24; Nicolas Cabasilas, *Life in Christ*

**Iconography**
Christ in royal and priestly raiment with book and scepter, giving his blessing; the Mother of God dressed as a queen, John the Baptist with scroll

▶ Michael Damaskenos, *Christ the High Priest*, second half of sixteenth century. Athens, Byzantine Museum.

The mystical marriage between Christ and the Church is foreshadowed in Psalm 45: "at your right hand stands the queen in gold of Ophir." The Mother of Christ represents the Church/queen, and Christ is the bridegroom, king, and priest. The image of the Mother of God is presaged in the Old Testament by that of the Queen of Sheba, who, drawn by Solomon's wisdom, went to see him. Solomon's gold came from Ophir (1 Kings 9:28). Christ wears the vestments of royal and episcopal office, and his image is related, through the reference to Solomon, to another iconographical variant: the icon of Sophia the Wisdom of God enthroned between the Virgin and

the Baptist. Single icons are also devoted to the image of Christ the highest priest, and they echo the words of Psalm 110: "You are a priest forever after the order of Melchizedek." Christ's miter is adorned with pearls and red and blue pendants (*parapendoulia*). In the icon on this page, the open book reads: "My kingship is not of this world" (John 18:36) and "Take; eat; this is my body which is broken for you for the forgiveness [of sins]." Inscriptions name Christ the "King of Kings" and "Great High Priest."

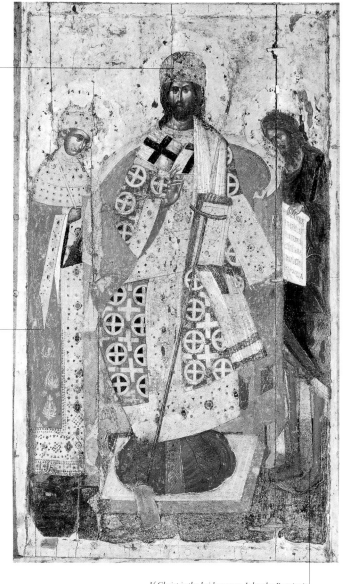

Christ's features are typical of a Russian tsar. Over his red episcopal sakkos, adorned with small white crosses on black, he is wearing a stole (omophorion), adorned with large black crosses, which hangs over his right shoulder, down to the edge of his episcopal vestment.

Dressed in royal raiment and adorned with pearls and gold embroidery like a Byzantine empress, Mary is also wearing a precious crown and holding a scepter in her hand. The scene is reminiscent of the Queen of Sheba's visit to Solomon.

▲ Serbian master working in Novgorod, "At Your Right Hand Stands the Queen," ca. 1380. Moscow, Kremlin, Cathedral of the Dormition.

If Christ is the bridegroom, John the Baptist is the bridegroom's friend who rejoices for him. The scroll that the prophet holds in his hand reads "He who has the bride is the bridegroom; the friend of the bridegroom, who stands and hears him, rejoices greatly" (John 3:29).

*During the Last Supper, after washing his apostles' feet, Jesus likens himself to a mystical grapevine, God the Father to the "vinedresser" who tends it, and his disciples to the branches.*

# The True Vine

**Text**
"The vine is silent when the grapes are gathered, just like our Lord when they judge him; the vine is silent when it is stripped, like our Lord when he is offended; the vine is silent when being trimmed, just like our Lord when he is being killed." (Cyrillona)

**Title**
The True Vine (*Ampelos*); "I am the vine"

**Feast day**
Holy Thursday

**Sources**
John 15:1–11; Cyrillona, *Discourse on the Last Supper*; Dionysios of Fourna, *Painter's Manual*

**Iconography**
Christ sitting in the middle of a tree giving benediction with an open Gospel; the twelve apostles, with scrolls or books, sitting on the branches giving benediction or talking; those closest to Christ are Peter and Paul

This typically eucharistic theme is drawn from the speech Christ made to his disciples after washing their feet: "I am the true vine, and my Father is the vinedresser. Every branch of mine that bears no fruit, he takes away, and every branch that does bear fruit he prunes, that it may bear more fruit" (John 15:1–2). The iconography of Christ the True Vine first appears in the fifteenth century on Crete and on Mount Athos, where many artists took refuge after the fall of Constantinople in 1453. The subject spread in the sixteenth and seventeenth centuries, finding a natural place on the liturgical vestments of priests and bishops. Christ sits as though enthroned at the bifurcation point of the vine's branches, an open Gospel on his knees, arms raised and giving benediction with both hands. Branching out from the trunk are twelve shoots with leaves and

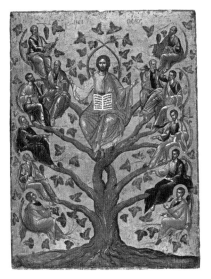

clusters of grapes. The apostles sit on the branches: Peter and Paul (right and left, respectively) are those closest to the Savior. The apostles hold either a book or a scroll and display their traditional attributes, enabling us to identify them even without reading their initials (near their respective haloes). In more complex versions, God the Father, and the dove of the Holy Spirit appear above the Son.

▶ *Christ the True Vine*, second half of sixteenth century. Athens, Byzantine Museum.

*The image of the empty throne, awaiting the Last Judgment, the final, concluding act of human history, intensely evokes the "already and not yet befallen."*

# The Prepared Throne

Few individual icons are devoted to this subject; it is more often inserted into complex compositions such as the Last Judgment and Sophia the Wisdom of God. The image of the Preparation of the Throne (*Hetoimasia*) is usually found on the backs of icons of other subjects, such as the famous icon of the Virgin of Vladimir. The throne being prepared is that on which Christ will sit during the Last Judgment. Lying upon the empty throne are the cloak of Christ the Judge and a closed book. In the icon on this page, however, the book is open to a passage in the Gospel: "Come, O blessed of my Father ... for I was hungry and you gave me food" (Matthew 25:34–35). Behind the throne stands a cross; the lance and the cane with the sponge drenched in vinegar lean against it, while the crown of thorns hangs from it. On the forestep of the throne stands a vase with the nails. Two cheru-bim hover beside the throne; in other instances, when the Gospel book is closed, they hold scrolls with the words "Come, O blessed of my Father, inherit the kingdom prepared for you from the founda-tion of the world" and "Depart from me, you cursed, into the eternal fire pre-pared for the devil and his angels" (Matthew 25:41).

**Text**
"Now is the time to open your ears, Satan. Now is the time to show you the power of the cross and the might of the Crucified One. For to you the cross is folly; to all creation it is considered a throne on which Jesus, nailed, is as though seated ... on a judge's bench." (Romanos the Melodist)

**Title**
Preparation of the Throne (*Hetoimasia tou Tronou*); The Prepared Throne (*Prestol ugotovannyi*)

**Sources**
Psalms 9:8, 110:1; Matthew 25:31–46; Acts 2:34; 1 Corinthians 15:25; Hebrews 10:13

**Iconography**
A throne with the cloak of Christ the Judge and the book of the Word; cheru-bim or seraphim surround-ing the throne; the cross with the crown of thorns and the symbols of the Passion

◀ *Hetoimasia*, back of a two-sided icon, second half of fourteenth century. Athens, Byzantine Museum.

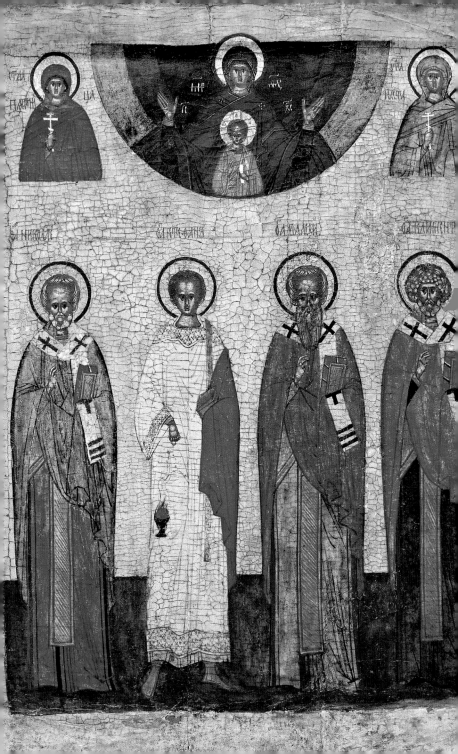

# APOSTLES AND MARTYRS

*The Evangelists Matthew and Mark*
*Luke the Painter*
*John the Theologian*
*Peter and Paul*
*Ignatius of Antioch*
*Stephen the First Martyr*
*Demetrius of Thessaloniki*
*George of Lydda*
*Mass Martyrdoms*
*Marina*
*Menas of Egypt*
*Paraskeve and Anastasia*
*Hypatius of Gangra*
*Florus and Laurus, Blaise and Spyridon*
*Nicetas*
*Cosmas and Damian*
*Catherine of Alexandria*

◀ Pskov school, *Saints Nicholas,*
*Stephen, Blaise, Clement, Paraskeve,*
*and Anastasia with the Virgin of the*
*Sign,* second half of fifteenth century.
Pskov (Russia), museum.

*Images of the evangelists at work in their scriptoria derive from the miniatures of illuminated Gospel books and Gospel lectionaries. They are painted on the outside of the royal doors.*

# The Evangelists Matthew and Mark

**Text**
"The Word of God made its home among men and became the Son of Man to accustom man to understanding God, and to accustom God to making His home among men." (Irenaeus of Lyon)

**Title**
Matthew the apostle and evangelist; Mark the evangelist

**Feast days**
Matthew, November 16; Mark, April 25

**Source**
Revelation 4:1–11

**Iconography**
Matthew and Mark with their respective symbols of the angel and the lion; an angel or an image of Sophia-Wisdom dictating to the evangelists what words to write; seat, lectern, writing table, quills, inks, eraser-knives, bookcases

Each evangelist is portrayed in his room, a veritable scriptorium furnished with shelves (*armaria*) for volumes and scrolls, lecterns, parchments, erasing-knives, quills (*calami*), and inks. The writings of Matthew, Mark, and Luke are shown to be inspired by an angel, or, after the fourteenth century, by Sophia-Wisdom herself, wearing a double-star halo formed by two superimposed rhombuses, red and blue, while John listens to a voice from the heavens and dictates to his disciple-scribe Prochorus. The Church Fathers assigned each of the evangelists one of the four living creatures of the Apocalypse. Matthew has the "son of man" as his symbol, since his account begins with the human genealogy of Christ. Mark is identified with the lion, because his Gospel begins with the figure of John the Baptist, man of the desert. Mark was an excellent witness and chronicler, and, knowing Latin well, accompanied the apostle Paul all the way to Rome, serving as his secretary and interpreter.

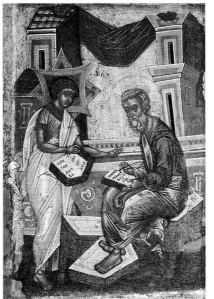

▶ *The Evangelist Matthew*, originally from Tver, second half of fifteenth century. Saint Petersburg, Russian Museum.

The ciborium on the right, enclosed by a red curtain, recalls the Holy of Holies; the basilica on the left, with its columned arcade, represents the house of Wisdom. The red cloth symbolizing the divine presence extends from the ciborium to a pillar that stands for Wisdom itself.

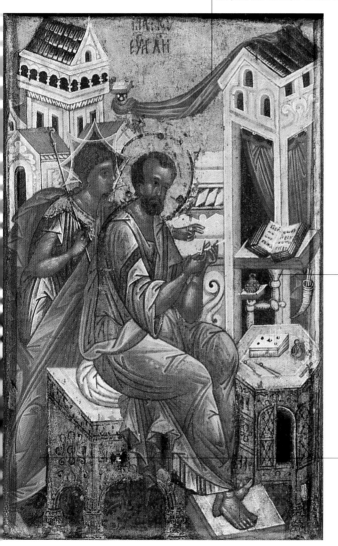

With a little knife Mark sharpens the point of his quill, which he will use for writing. In front of him are an open book on a lectern and a little cupboard-table with quills, styluses, inkpots, eraser-knives, and compasses. Behind is an armarium with books.

Sophia-Wisdom (the wingless female figure with scepter, crowned by a star-shaped halo) tells Mark what to write in the open book: "At that time Jesus was going on the Sabbath with his [disciples]…"

▲ The Evangelist Mark, from Novgorod, early sixteenth century. Moscow, Andrei Rublev Museum.

*The author of the "Gospel of Jesus's childhood" is also considered the first artist to portray Mary with the Christ child. Tradition attributes almost six hundred icons to him.*

# Luke the Painter

**Text**
"Every soul that believes conceives and engenders the Word of God." (Saint Ambrose)

**Title**
Luke the Painter

**Feast day**
October 18

**Sources**
Colossians 4:14; Gospel prefaces; Saint Jerome; Nicolas Maniacutius (1180)

**Iconography**
Luke at the easel, in front of Mary, who is holding Jesus; the evangelist is painting one of the two typical Marian icons, the *Hodegetria* or the *Eleousa*

A citizen of Antioch, Syria, Luke wrote the third Gospel and the Acts of the Apostles. Dead at age 84 in Boeotia, he was buried in Thebes, Greece. His bones were moved in the fourth century to Constantinople and later to Padua. In 1345, his skull was transferred to Prague. In 2000, the reliquary was reopened, and the skull was found to match the skeleton, while pollen testing proved the relic to be of Syrian origin. According to a fifth-century tradition and based on ancient icons from Antioch and Thebes attributed to the evangelist (icons later transferred to Constantinople and Russia), Luke was the first to paint the *Theotokos* (Mother of God). His icons include the *Hodegetria* of the Constantinople Church of the Blachernae, which restored the sight of two blind men (whence the name *Hodegetria*, "She who gives sight" or "shows the way"); and the Virgin of Smolensk, prototype of many Marian icons, which came to Russia in the twelfth century. Luke's symbol is the calf or ox, because his Gospel begins with a sacrifice made by Zechariah, John the Baptist's father.

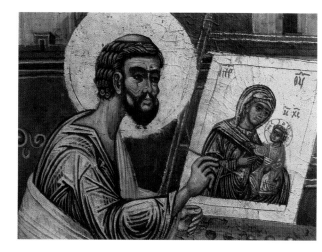

▶ Serbian painter, *Luke Painting the Icon of the Virgin* Hodegetria, 1672–73. Montenegro, Morača Monastery.

The two buildings are joined by a cloth, indicating that the scene is taking place indoors. At the bottom of the tower, a doorway covered by a red curtain leads down a stairway into a room with a table, pigments, and writing implements.

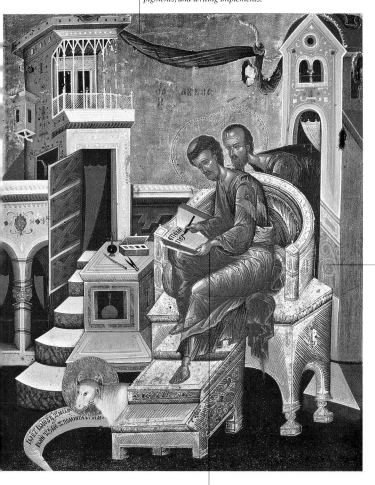

Behind Saint Luke, who is writing the Gospel, stands Paul, who is coming out of a small church.

▲ Onufri, *Luke the Evangelist*, detail from royal doors of an iconostasis, sixteenth century. Korçë (Albania), National Museum of Medieval Art.

Luke, whose symbol is the ox, sits on an imposing throne entirely hatched with gold lines. It also has three steps, or footstools, leading up to it.

*The author of the fourth Gospel lived exiled in a cave on the island of Patmos, where he dictated his extraordinary vision of the Apocalypse to his disciple Prochorus.*

# John the Theologian

**Text**
"John is the source of our loftiest spirituality. Like him, those who are silent know the mysterious confusion that can assail the heart; invoking the presence of John, their hearts catch fire." (Patriarch Athenagoras)

**Title**
John the Theologian; John the Theologian in Silence (*v molchanii*)

**Feast day**
September 26

**Sources**
*Acta Iohannis*; Irenaeus, *Against Heretics*; Gospel prefaces

**Iconography**
John in his cave, dictating the Gospel to Prochorus; or in half length, his fingers forming the monogram of Christ and sealing his lips, while an angel or Sophia whispers into his ear

One of the twelve apostles and the "disciple whom Jesus loved," John is the author of the "Gospel of love" or, as Origen calls it, the "flower of the Gospels." John also wrote three of the Catholic Epistles and the book of Revelation, the great vision he had on Patmos, where he was exiled by Emperor Trajan. There, to the deacon Prochorus, his constant companion, he dictated the terrible, disturbing vision of last days. According to Irenaeus, bishop of Lyon, John published his Gospel in Ephesus, where he spent the last years of his life, from A.D. 98 to 117. On icons, John is represented either as the beardless young disciple or as the bearded old man, like the Baptist, worthy of the epithet "son of thunder." Though one of the most charismatic figures of the early Church, in his texts John is always hiding behind the ordinary figure of the "disciple," becoming truly the "Theologian of Silence." And this is how he is depicted in the icon of the same name, with his forefinger pressed to his closed lips, as an angel whispers Divine Wisdom into his ear. John's symbol is the eagle, for the sublime manner in which he described the godliness of the Word: of all the evangelists, he flew highest.

► *Saint John the Theologian in Silence*, northern Russia, second half of sixteenth century. Moscow, Tretyakov Gallery.

Against the gold background of the sky, with the three rays of the Trinity beaming down on it, the mountain opens up to reveal a cave in the form of a round dome, with two rocky spurs on top.

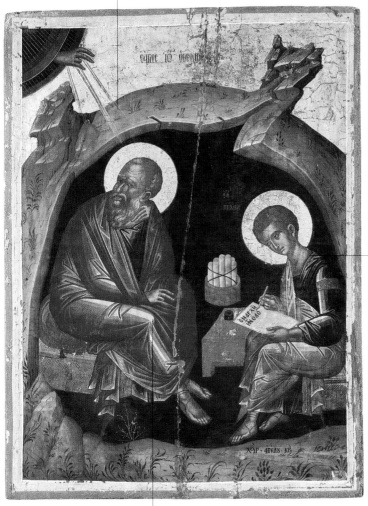

Prochorus writes John's words down on a parchment resting against his knees. Beside him is a red writing table. At the center of the cave are some scrolls, rolled up, tied, and collected in a basket.

▲ Angelos, *Saint John the Theologian Dictating His Gospel to Prochorus*, mid-fifteenth century. Mount Sinai, Monastery of Saint Catherine.

Wrapped in his gown, John crouches on a red cushion, leaning on his elbow, looking thoughtful as he listens to the Word of heaven, which he will then communicate directly to his disciple Prochorus.

# John the Theologian

At the baths, John resuscitates a boy who had been suffocated by a demon; his father thanks him; John baptizes the inhabitants of Ephesus; he denounces pagan feasts; Jesus appears to John; John heals a possessed man.

The apostles draw lots; John and Prochorus sail to Asia Minor; Prochorus helps John after a shipwreck; the two exiles work at the baths together; John is reproached for his indolence.

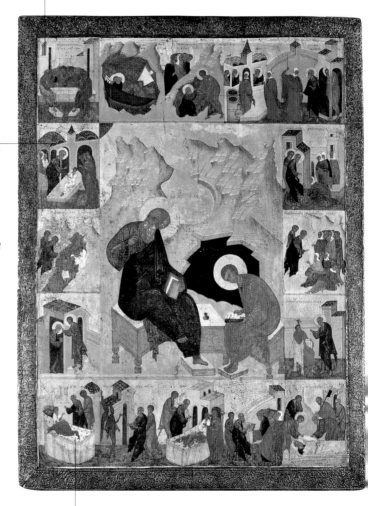

▲ Circle of Dionysius, *Saint John the Theologian on the Island of Patmos, with Scenes from His Life,* late fifteenth–early sixteenth century. Moscow, Tretyakov Gallery.

John heals a young man; performs an exorcism; heals a boy in front of his parents; gives his Gospel to the inhabitants of Ephesus; is buried by Prochorus and friends.

At the baths, where he works as an
attendant with his disciple Prochorus
(behind him), John revives a boy who
had been suffocated by a demon.

The scene takes place inside the baths,
as we can see by the water canals and
the circular building in the background.

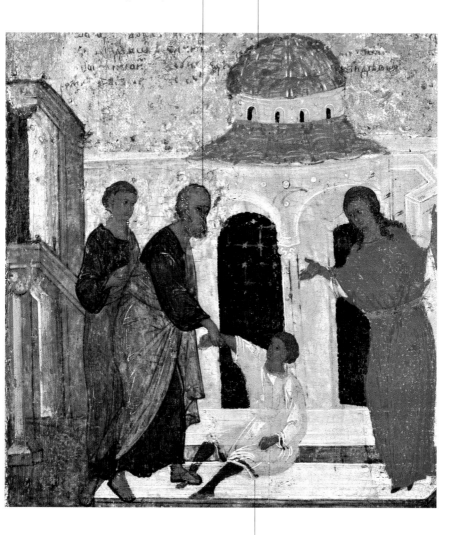

▲ *Saint John Resuscitates a Boy*, side
scene from the icon *Saint John Dictating
His Gospel to Prochorus*, early sixteenth
century, originally in the Church of
Tosninskoi. Vologda (Russia), museum.

As John seizes his wrist, the boy
gets back up, to the astonishment
of his mother.

# John the Theologian

The high, broad forehead, marked by luminous furrows, and the small, closed mouth, held shut by the fingers for emphasis, express the depth of the silence and contemplation in which John is immersed.

The angel with the double-star halo of Wisdom leans from behind John's shoulder to whisper the words of God in his ear.

In the frame, John the Baptist (the Forerunner), another great mystic of silence and asceticism.

▲ *Saint John the Theologian*, north-central Russia, early twentieth century. Private collection.

The slender, open book with ivory-colored pages and a gem-studded cover seems to float weightlessly under John's fingers, which are barely touching it.

*The kiss of the first pope and the "apostle of the people" symbolizes the unity of the Church, while that of Peter and Andrew stands for the union of the Western and Eastern Churches.*

# Peter and Paul

On gilt glass discovered in the Roman catacombs we find the earliest images of the *Concordia apostolorum*: Peter and Paul exchanging the kiss of peace. It was a peace they had managed to establish at the Council of Jerusalem in the year 48, even though the former represented the Church of the Law (circumcised Jews) and the latter the Church of Grace (uncircumcised pagans). Yet at Antioch, when Peter avoids the Gentiles, Paul reprimands him: "I opposed him to his face, because he stood condemned" (Galatians 2:11). Peter was the first whom Jesus called; his name was then Simon and he fished Lake Tiberias with his brother Andrew. Paul, by contrast, whose original name was Saul, was a fierce persecutor of Christians; indeed, Stephen, the first Christian martyr, was stoned to death in his presence. Saul converted around the year 31 or 32 in Damascus, under the guidance of one Ananias, after experiencing the blinding vision described by Luke (Acts 9:1–20). Peter and Paul both died martyrs' deaths in Nero's Rome, between A.D. 64 and 67: Peter was crucified upside down, and Paul, being a Roman citizen, was beheaded. They are both represented in all icons in which the apostles are gathered, even events at which Paul was not present.

**Text**
"Christ redeemed us from the curse of the law, having become a curse for us—for it is written, 'Cursed be every one who hangs on a tree.'" (Galatians 3:13)

**Title**
*Concordia apostolorum*; The Princes of the Apostles

**Feast day**
June 29

**Sources**
Acts of the Apostles; Galatians 2:11–21; apocryphal Apocalypse of Paul

**Iconography**
Peter and Paul embracing, in full or half length, sometimes in a circle; in *Deeses* they appear both in full and half length

◄ Cretan school, *The Apostles Peter and Paul*, mid-sixteenth century. Mount Athos, Monastery of the Great Lavra, Chapel of Saint Athanasius.

# Peter and Paul

The painting technique "by illumination," whereby one gradates the face from the darker to the brighter areas, embodies the spiritual renaissance expressed in the Hesychast doctrine of Gregory Palamas.

The unnaturally swollen neck indicates and emphasizes the presence of the breath of the Holy Spirit.

The high, luminous forehead and strong, intent features express the tension of a man seeking the face of Christ by all means.

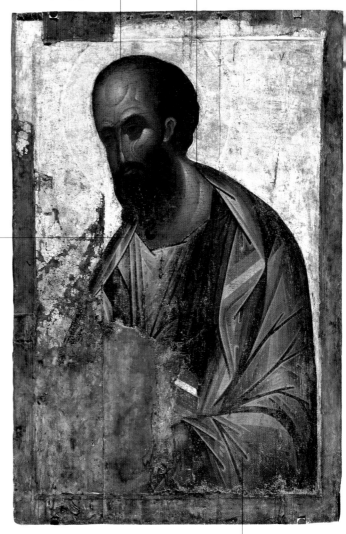

▲ Andrei Rublev, *Saint Paul*, originally from the *Deesis* of Zvenigorod Cathedral, ca. 1400. Moscow, Tretyakov Gallery.

The folds in the green gown are brighter than the rest, as though the light source came from the lapis lazuli blue tunic, the point where divine light is in highest concentration.

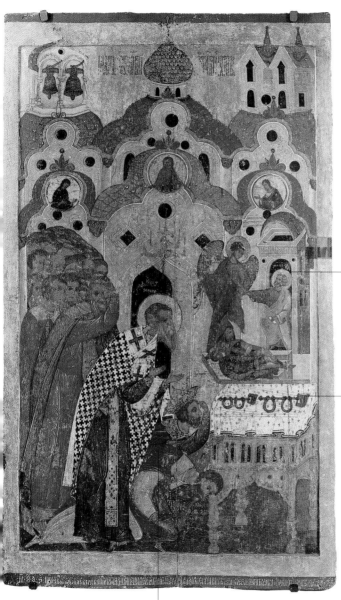

After putting the soldiers to sleep, the angel takes Peter by the hand and leads him out of the prison.

The architecture is typical of the churches of Novgorod and Pskov, with their domes, surrounding buildings, and bell towers. On the altar inside the sanctuary, we see the relics of the holy chains in which the saint was bound.

▲ Novgorod School, *Veneration of the Chains of Saint Peter the Apostle*, 1558. Novgorod (Russia), Museum.

The tsar and metropolitan, followed by the people of Novgorod, worship Peter's chains. The tsar (kneeling) crosses himself with the fingers joined, symbolizing the Trinity, according to Orthodox custom.

# Peter and Paul

The angels take haloes from inside the heavenly Jerusalem to give to the saints seated in hemicycles around Christ, the Virgin, and the Baptist (inside the sphere), all dressed in white, luminous robes.

The broad red and black onion domes, with their geometrically reflecting tiles, seem to lift the holy city up toward the golden realm of the heavens.

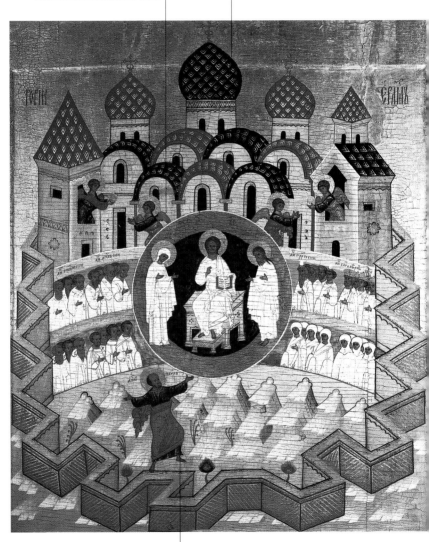

▲ *The Vision of Saint Paul*, detail of the north deacons' door, originally from the Cathedral of the Annunciation in Solvychegodsk, ca. 1579. Solvychegodsk (Russia), Museum of History and Art.

Heavenly Jerusalem, surrounded by walls, and Saint Paul gesturing toward his vision, which is described in an apocryphal text from which Dante Alighieri, among others, drew inspiration.

*The iconography of this saint, a bishop martyred when he was mauled by two lions, symbolizes the bread of the Eucharist, which is eaten by the faithful so that they may live.*

# Ignatius of Antioch

Arrested during the reign of Trajan, when Rome was persecuting the church of Antioch, Ignatius was transported from Syria to Rome to be martyred. Along the way to the imperial capital, he had a chance to visit the early Christian communities of Smyrna and to meet the bishop of that city, Polycarp. In Smyrna, Ignatius received delegations from a number of Asian Christian communities, to whom he later sent letters giving advice and recommendations. During his long stay in Smyrna, he also wrote to Rome to announce the end of the persecution of Christians in Antioch. Once in Rome, Ignatius was mauled to death by lions. As the Colosseum had just recently opened, we can only speculate as to whether Ignatius was martyred there, in Flavius's amphitheater, or in some other similar Roman arena. Neither is it certain whether any other Christians were actually martyred in the Colosseum. Indeed, Evagrius, who was the first to testify in this tradition, lived during the fourth century, by which time the persecutions had already ended. The relics of Saint Ignatius were taken from Rome to Antioch and back again before being scattered all over Europe.

**Text**
"I am God's wheat, and am ground by the teeth of beasts to become the pure bread of Christ. Allow me to imitate the Passion; when the world can no longer see my body, then shall I truly be his disciple."
(Ignatius of Antioch)

**Title**
Martyr, bishop, Doctor of the Church

**Feast day**
December 20

**Life**
Antioch ca. 50–ca. 107/118
Rome

**Sources**
Irenaeus; Origen; Polycarp; Eusebius of Caesarea; Simeon Metaphrastes

**Iconography**
Ignatius wearing the ancient *phelonion* and *omophorion*, between two lions

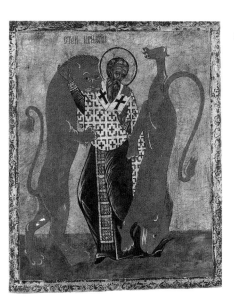

◀ *Saint Ignatius of Antioch, central Russia, seventeenth century. Damascus (Syria), Patriarchate of Antioch.*

*With the death of Stephen, the first martyr, a deacon unjustly accused of being a blasphemer, Christianity came out of the synagogues and spread into the pagan world.*

# Stephen the First Martyr

**Text**
"Behold, I see the heavens opened, and the Son of man standing at the right hand of God." (Acts 7:56)

**Title**
Deacon and First Martyr (*Protomartys, Pervomuchenik*)

**Feast day**
December 27

**Source**
Acts of the Apostles 6–7

**Iconography**
Stephen is wearing the deacon's tunic (*sticharion*) and stole (*orarion*), which hangs over his left shoulder, holding the chest of the Holy Gifts and a censer

In the spot where Saint Stephen was stoned outside the walls of Jerusalem, north of the Damascus Gate, Empress Eudoxia had a basilica built in 430–40. Stephen's name first appears in the list of the seven disciples chosen by the Christian community of Jerusalem to serve the poor at the refectory, thus relieving the apostles of this duty so they could devote themselves entirely to preaching the Word. In Acts 6:3, Luke calls these men "full of the Spirit and of wisdom." The definition of "deacons" as "servants" and "ministers" will only be used later, by Saul (later converted as Paul), who in Stephen's time was vigorously persecuting Christians. Saul was present when Stephen was stoned and approved of his killing (Acts 7:58). The iconography of Stephen shows him wearing a white deacon's *sticharion*, and an *orarion* of the same color over his left shoulder; the latter, a kind of stole, is held up with the left hand during prayer. In keeping with the iconography of sainted deacons, Stephen shakes a censer with his right hand, and in his left hand, which out of respect is covered by a red cloth, holds a casket with the Holy Gifts.

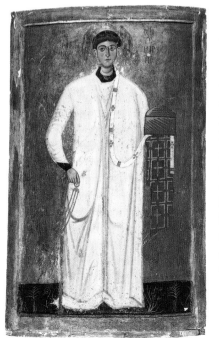

▶ *Saint Stephen the First Martyr*, early thirteenth century. Mount Sinai, Monastery of Saint Catherine.

*A martyr and warrior, his image in Greece, Russia, and the Balkans is almost as popular as that of Saint George. His biography is uncertain, and his iconography has fluctuated.*

# Demetrius of Thessaloniki

This deacon was martyred in 306, during Emperor Maximian's persecutions. His relics were translated in 418 to his basilica in Thessaloniki, Greece, which became a destination for pilgrims and processions throughout the early Middle Ages. In the basilica's mosaics (many of them destroyed by fire in 1917), Saint Demetrius was portrayed in a deacon's chlamys and with red hair, as he still appears in the images in Sant'Apollinare Nuovo in Ravenna and in Santa Maria Antiqua in Rome. Demetrius's icon is that of a holy warrior with sword, lance, arrows, and, sometimes, a shield embellished with a cross. Demetrius defended the city of Thessaloniki, and his fame as a warrior is surpassed only by that of Saint George. Crusaders chose him as a patron saint and brought some of his relics to France. The cult of Demetrius is very active in Greece and in Russia, where a cathedral was built in his honor in Vladimir. A miraculous icon of him (said to have been painted on a plank from the saint's coffin, brought over from Thessaloniki) was brought from Vladimir in 1380 by Dmitri Donskoi to protect Moscow on the eve of the battle of Kulikovo. This icon is now in the Cathedral of the Dormition in the Kremlin.

**Text**
"O Lord, do not let the city and its men perish. If you save the city and its people, I too shall be saved with them. If you let them perish, I too shall perish." (Sacred author)

**Title**
Martyr

**Feast day**
October 26

**Sources**
Greek and Latin *Passio* texts; *Menologium* of Simeon Metaphrastes; *Hieronymian Martyrology*; *Syriac Breviary*; Anastasius Bibliothecarius (the Librarian)

**Iconography**
The saint wearing cloak, with cross and shield, in half length, as is typical of martyrs; or else on horseback with flowing cloak and armor, running a pagan through with his lance

◄ *Saint Demetrius of Thessaloniki*, fifteenth century. Saint Petersburg, Russian Museum.

The flowing cape underscores the dynamism of the horse and the knight Demetrius, who is piercing the pagan king.

The lance ending in a three-armed Orthodox cross reminds us that, through his martyrdom, Saint Demetrius triumphed over paganism.

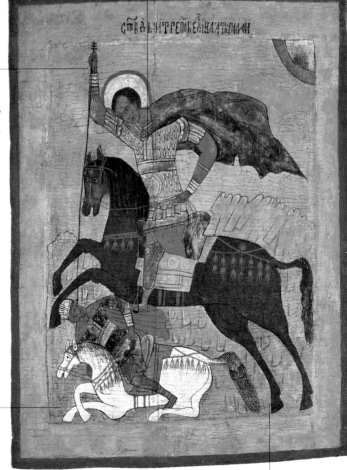

The pitiful horse, with its sad eyes and crumpled legs, expresses in a simple, direct visual language the defeated and humiliated pagan world.

▲ *Saint Demetrius of Thessaloniki,* late sixteenth century. Vologda (Russia), museum.

Just as Saint George lances the dragon, symbol of evil, so Saint Demetrius runs through the "king of the pagans," symbol of the enemies of the early Church.

The flying angel is carrying the martyr's crown to Saint Demetrius, while Christ, giving his benediction, looks out from the dome of the heavens.

The broad curve of the throne, covered with gold assist, the horizontal line of the sword being drawn from its sheath, the spread legs, the hastily knotted cape, and the saint's very gaze, expressing his readiness to fight pagans, make Demetrius look almost like a Japanese samurai.

The short black dashes on the white cloth draped across the seat of Demetrius's throne are similar to those on the Holy Shroud and create a parallel between the martyrdom of the saint and the death of Christ.

▲ *Saint Demetrius of Thessaloniki Enthroned*, originally from the Cathedral of the Dormition in Dmitrov (north of Moscow), ca. 1212. Moscow, Tretyakov Gallery.

*His biography is vague, and his feast day coincides with the beginning of spring. In his icon he is shown in triumph on a white horse, slaying a dragon with his lance.*

# George of Lydda

**Text**
"In the person of the martyrs, Christ himself is present; he who once triumphed over death triumphs over it forever in us." (Saint Cyprian of Carthage)

**Title**
Saint George the Victory-Bearer (*Tropaiophoros, Pobedonosets*)

**Feast day**
April 23

**Life**
Perhaps originally from Cappadocia, d. in Lydda mid- to late third century

**Sources**
*Passio*; Jacobus de Voragine, *The Golden Legend*; Venantius Fortunatus

**Iconography**
Dressed as an ancient knight, Saint George sits astride a white horse and runs his lance through a monstrous dragon that seems to have emerged from the bowels of the earth

The cult of Saint George has no precise historical references. It appears he was a tribune under Diocletian and suffered a terrible martyrdom lasting seven years, undergoing every manner of ordeal and performing great miracles until he was finally beheaded. *The Golden Legend* adds to this list the famous episode, captured in paintings and folktales, of Saint George killing the dragon, freeing the city, and saving the king's daughter. The cult of Saint George is very ancient: as early as the fourth century a tomb and sanctuary devoted to him are documented at Lydda, in Palestine. Churches and monasteries named after him began immediately to spread in the East. In Russia, the most beloved image of Saint George is not that of

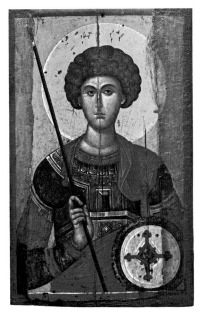

him as martyr (though the icons tell this story as well, in the frame), but that of the prince and Christian knight, symbol of grace and beauty triumphing over evil. The pagan image of the hero-horseman, adopted by early Byzantine culture, spread to the Russian principalities of Novgorod and Pskov, creating subjects of exquisite elegance and charm. Against the red backgrounds typical of the iconographic school of northern Russia, Saint George stands out proudly on his white steed.

▶ *Saint George*, first half of fourteenth century. Athens, Byzantine Museum.

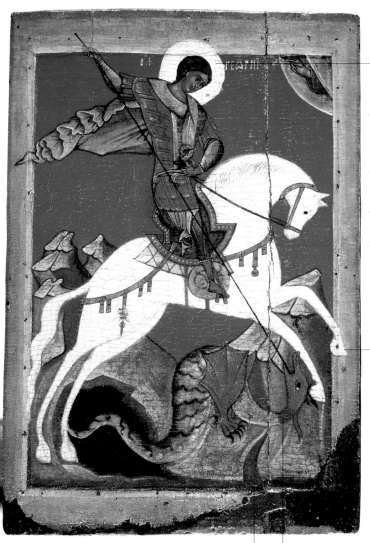

An idealized image of victory and the triumph over evil, Saint George dominates the scene, his face surrounded by a halo as white as his horse. The green cape, which represents the strength of the Holy Spirit, flows out from the diagonal of the lance, which joins it with its antithesis, the dragon.

The white arch of the horse's body spans the icon's space and juts out over the edge of the frame. The saint lightly and gracefully restrains his powerful white steed.

▲ Novgorod school, *The Miracle of Saint George and the Dragon*, fifteenth century. Saint Petersburg, Russian Museum.

The geometry of the composition (the intersecting diagonals of the horse's profile and the saint's lance) and the strong chromatic contrast make this icon a true masterpiece of simplicity and efficacy.

Coming out of its black cave, the dragon twists and turns in vain against the knight, who pierces its head with his sharp lance.

Left to right: George professes his faith to
Diocletian; strikes down pagan idols and
raises the dead; baptizes people in secret;
is put in prison.

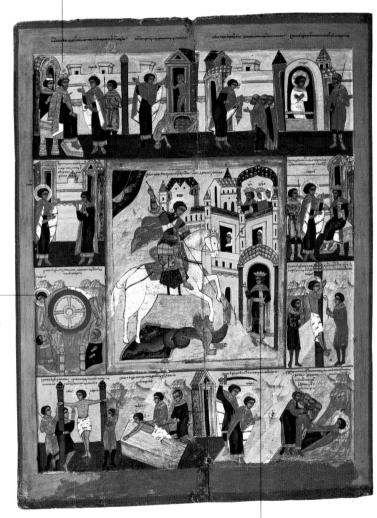

Seven years of
martyrdom: he
is broken over a
wheel; (right)
tortured with
prongs; (below)
burnt with live
coals; buried in
quicklime; and
finally
beheaded.

▲ *The Miracle of Saint George,
with Scenes from His Life*, late
sixteenth–early seventeenth century.
Vologda (Russia), museum.

Saint George binds the monster; turns it over
to the king's daughter; then kills it in front of
the king and his court, on the condition that
the entire pagan city convert to the true faith.

*They include Roman legionnaires martyred under Emperor
Licinius; monks of Sinai massacred by Arabs; and legendary
Christian officials of Ephesus, buried alive and resurrected.*

# Mass Martyrdoms

While there are many martyrdom scenes in the hagiographic
icons of individual saints, images of group martyrdom are rare.
The most famous of them is the icon of the Martyrs of Sebaste:
forty Roman legionnaires who, refusing to renounce their faith,
were ordered by Emperor Licinius to be exposed naked on a
frozen lake near Sebaste, where they froze to death. The icon of
the Seven Sleepers of Ephesus shows seven youths peacefully
sleeping in a cave. Their legend, written down by Bishop
Stephen in the fifth century, tells that in the year 250, during
the persecutions of Decius, seven Christian officials of Ephesus
were buried alive in a cave. Decades later, during the reign of
Emperor Theodosius II (408–50), the seven sleepers supposedly
reawakened, bearing witness to the resurrection of the body
and giving the lie to those who denied it. Finally there is the
dynamic, brightly col-
ored Russian icon
depicting the massacre
of monks in the caves of
the Sinai and the Raithu
desert, near the Red Sea,
when they were
assaulted in the fourth
century by nomadic
Arabs from across the
sea. Many were mar-
tyred, before the army of
the city of Farran (mod-
ern Feiran) intervened,
defeating the infidels.

**Text**
"Not letting oneself be
seduced by the visible rule
of evil and not denying the
love of the invisible good:
this is the heroic act of
faith." (Vladimir Solovyev)

**Title**
Seven Sleepers of Ephesus;
Forty Martyrs of Sebaste;
Massacre of the Holy
Fathers of Sinai and Raithu

**Feast days**
Forty Martyrs, March 9;
Sleepers of Ephesus,
October 25; Massacre of the
Holy Fathers, January 14

**Iconography**
Seven Sleepers: a cave with
the bodies of the seven
youths and the city of
Ephesus in the background;
the Forty Martyrs of
Sebaste: the icy lake on
which the half-naked mar-
tyrs froze to death; the
Massacre of the Holy
Fathers: the monks seeking
refuge inside their monaster-
ies

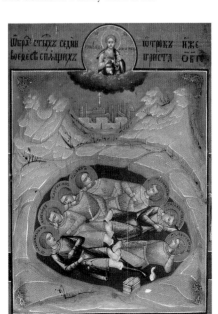

◀ *The Seven Sleepers of
Ephesus*, eighteenth century.
Private collection.

279

A mother loads her son's lifeless body onto the cart carrying the remains of the frozen martyrs to the bonfires where they will be burned.

Emperor Licinius orders his superintendent to have all the Christian soldiers killed by leaving them naked on the frozen lake.

On both sides of Christ are forty crowns of martyrdom, divided into groups of five.

The martyrs embrace and support one another, displaying the charity that unites them at the hour of their death.

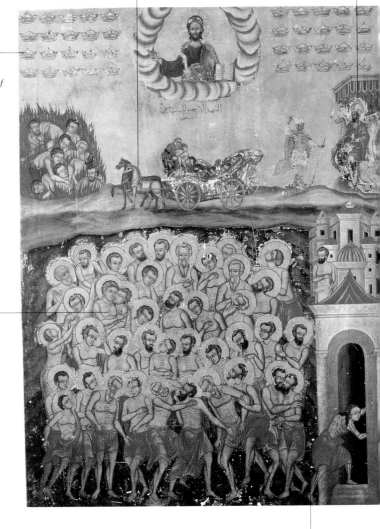

▲ Nemeh of Aleppo, *The Forty Martyrs of Sebaste*, 1701. Balamand (Lebanon), Our Lady of Balamand Monastery.

A frightened young legionnaire (who perhaps for this reason was whipped, as we can see from his wounds) flees into the city of Sebaste, while above him, a converted guard will die in his place.

The worn background shows traces of the crowns the martyrs will receive from Christ after their terrible ordeal.

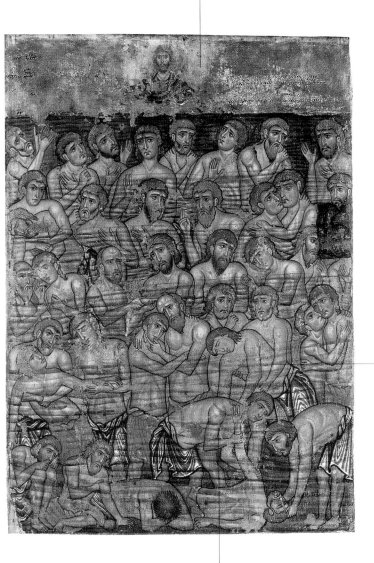

The older men support the youths, who collapse from cold and fear.

▲ *The Forty Martyrs of Sebaste*, twelfth century. Mestia (Georgia), State Museum of History and Ethnography of Svanetia.

The strongest carefully lay the bodies of the first victims onto the frozen surface of the lake.

The monks with golden haloes are those who have already been martyred, such as this abbot, who is blessing and encouraging his monks as he is being decapitated.

The spiritual beauty of the monastery where the frightened monks are gathered contrasts with the butchery breaking out in the desert: soldiers enter through the doors of the green side towers, sowing death everywhere.

▲ Stroganov school, *The Massacre of the Holy Fathers of Sinai and Raithu*, early seventeenth century. Saint Petersburg, Russian Museum.

Archers of the two armies confront one another. Meanwhile, the monks are pursued through the rocks in the desert and into their various monasteries, where they are killed by small groups of soldiers.

The boat in which the infidels arrived to carry out their slaughter.

*She has two names, one inspired by the sea (pelagus), the other by pearls (margaritae). She is the patron saint of Cyprus, from whose waters Aphrodite, goddess of love, was born, a marked contrast to this virgin saint.*

# Marina

The life of Marina (also known as Pelagia) derives from the legends that made her popular in both the East and the West, where she became known as Margaret. Daughter of a pagan priest, she was born at Antioch of Pisidia, raised by her wet nurse, baptized, and educated in the Christian faith. Banished for this reason by her father at the age of fourteen, she was tending her sheep one day when her beauty caught the eye of the prefect Oliarius, who declared his desire to marry her, if she were noble, or in any case to possess her as his concubine. Marina revealed her nobility, but also her Christian faith. For this reason she was imprisoned and martyred under Emperor Claudius II Gothicus (268–70). In prison she fought the devil, who manifested himself in the form of a dragon, chasing him away with the sign of the cross. In a more fantastic version of this story, Marina was swallowed by the demon and broke free by cutting his belly open with the cross. In the end she was martyred by beheading. She is represented in the manner canonical for the martyred saints, holding the cross in her right hand, with her left hand open and turned outward, in a sign of consecration and virginity. Her gold-bordered, red *maphorion* has a cross on top and the monogram XN ("Christ triumphs"). Icons of Marina are widespread in Bulgaria, Greece, and Crete.

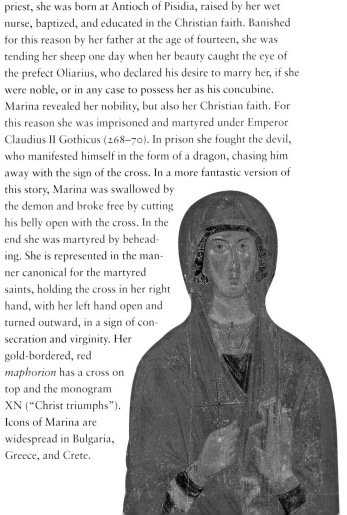

**Text**
"Christ came down to earth to let us be part of his blessed life; to give us the highest happiness in glorifying his name; and to live and suffer disinterestedly, wanting only his glory." (Anna Abrikosova, to her nuns in a Soviet camp)

**Title**
Marina virgin and martyr; Margaret (from the Latin *margarita*, meaning "pearl")

**Feast day**
July 17

**Life**
Antioch of Pisidia, fourth century

**Sources**
Timotheus, Greek *Passio* (fifth century); Jacobus de Voragine, *The Golden Legend*

**Iconography**
Wearing a *maphorion* and holding a Byzantine cross in the right hand; or struggling with the demon and striking it with a mallet

◀ *Saint Marina* (detail), fifteenth century. Athens, Byzantine Museum.

283

# Marina

Marina holds the demon tightly by a shock of hair, knocking him down with vigorous blows from the same hammer with which an executioner strikes the saint in the first small panel below.

An angel with the martyr's crown and a scroll with the words "Rejoice, champion of Christ who defeated the vile dragon."

The prison where Marina was confined and where the demon came to visit her.

The demon is portrayed in graphic detail, with horns and wings, a grotesque face, and a thin stream of hellfire issuing from his mouth and nose.

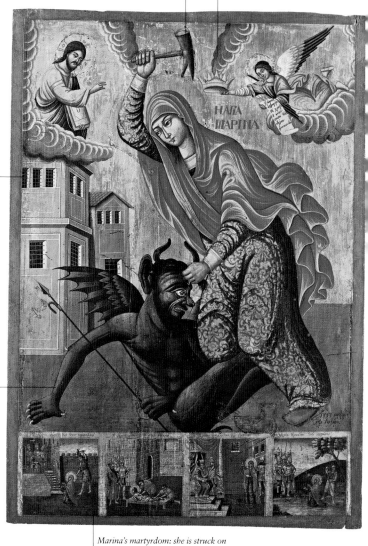

▲ Lazaros, *Saint Marina*, 1857. Athens, Byzantine Museum.

Marina's martyrdom: she is struck on the head and tortured but still refuses to give in. Finally the governor orders her to be beheaded.

*Ampullae (pilgrim's tokens) of Saint Menas spread from his native Egypt into Greece, Dalmatia, Italy, Gaul, and Africa. They show the sainted Egyptian martyr in prayer, between two camels.*

# Menas of Egypt

The term "Coptic" actually means "Egyptian" and is used to designate the Christians of the Egyptian Patriarchate, who formed a separate church in 451, after the Council of Chalcedon. The isolation of this church was deepened by the Arab-Muslim occupation of Egypt. In 722, the treasurer Obeid-Allah ibn al-Khattab ordered the destruction of all Christian images; the Coptic church rebelled and many were martyred. Their isolation is also reflected in their art, which, not having absorbed any Byzantine influence, preserves intact the style characteristic of ancient Egyptian and Syrian art. The frontal stiffness of the figures in Coptic icons, with their large, intense eyes, has been traced to the Fayum portraits. The Copt *abba* Menas (or Mena) is a national saint in Egypt. In Aramaic, *abba* means "father." A centurion in Emperor Maximian's army, Menas withdrew into the desert and preached the word of Christ to the idol-aters there; he was imprisoned, tortured, and beheaded. His tomb on the shores of Lake Maryut in Egypt, near Alexandria, was frequented by pilgrims as early as the fourth century. They came away with ampullae of oil from the lamps in his tomb.

**Text**
"For the great many miracles you always perform, you are called the physician who cures all illness. After your body was put in Egyptian earth, it worked miracles, prodigies, and marvels." (Doxology, Coptic liturgy)

**Title**
Holy Egyptian martyr and miracle-worker

**Feast days**
Martyrdom, November 11; Discovery of the Body, June 9

**Life**
Egypt, third century; died in 288

**Iconography**
On ancient ampullae, he is seen praying between two camels; Christ rests a hand on his shoulder, with natural ease; stories of his life and martyrdom

◄ *Christ the Savior and the Abba Menas*, early seventh century. Paris, Louvre.

285

The sun and the moon mark the alternation of day and night and represent the New and Old Testaments, respectively.

The heavens seen by men on earth are dark blue, whereas the other side of heaven, seen by God, is red. In Christ the heavens open and the Judge and Savior of the world appears between fiery clouds.

Across the top: in the desert, Menas prays and fasts; preaches against idolatry; is imprisoned; is condemned by Pyrrhus.

Left to right down both sides: on orders from Pyrrhus, Menas is stripped and beaten; tied to a post in the desert; tortured; then dragged over sharp iron prongs.

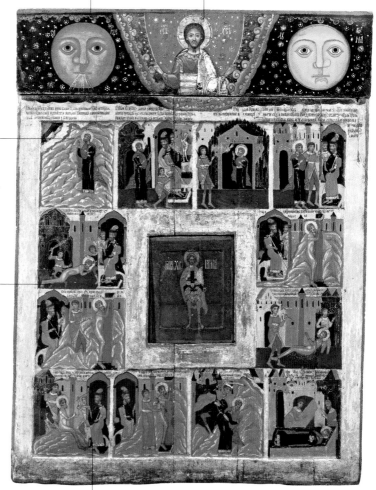

▲ *Saint Menas with Scenes from His Life*, originally from the Kargopol region, late sixteenth–early seventeenth century. Arkhangelsk (Russia), Museum of Fine Arts.

Across the bottom: Menas is struck in the face with clubs; beaten with rods; then, with his monk's habit back on, beheaded and then buried.

*Like so many other women martyrs of Byzantine Christendom, these two Greek saints became icon-symbols in Russia: Paraskeve symbolizing the Passion, Anastasia the Resurrection.*

# Paraskeve and Anastasia

Paraskeve was a third-century Greek martyr whose cult later spread into the Slavic lands. Her name in Greek means "preparation" (with specific reference to Easter) and "Friday." The saint thus became associated with Good Friday and the Passion of Christ, the "preparation" for the Resurrection. A Russian iconographic manual says that "she was close to the Lord's cross," as indicated by the red color of her *maphorion* and her headcovering, made from the holy linen on which Jesus left an imprint of his face. Anastasia was another Greek martyr, and her name means "resurrection," a fact symbolized by her green *maphorion*. She was also called *Pharmakolytria*, because of her intercessions as a healer: the phial she holds stands for the beneficent medicine of the Resurrection. Her relics are kept at the Gregoriou Monastery on Mount Athos, having been transferred there from Constantinople, where there was once a church dedicated to her. Thessaloniki—where the cult of Anastasia is very popular—also used to have a church dedicated to her. Paraskeve and Anastasia are associated with the two most important days of the week: the Friday of Christ's Passion, and the Sunday of the Resurrection.

**Text**
"I share everything with Christ, the spirit and the body, and the nails of the Resurrection."
(Gregory of Nazianzus)

**Title**
Paraskeve ("Friday"): *Piatnitsa*; Anastasia ("resurrection"): Curer (*Pharmakolytria*)

**Feast days**
Paraskeve, July 26; Anastasia, December 22

**Sources**
*Passio sanctae Anastasiae;*
*Menologium of Emperor Basil II*

**Iconography**
Paraskeve is represented standing, wearing a red *maphorion* and holding a small cross; Anastasia is also standing or in half length, wearing a green or blue *maphorion*, with a cross and a phial of medicine

◀ Novgorod school, *Saints Paraskeve and Anastasia* (detail), fifteenth century. Saint Petersburg, Russian Museum.

287

# Paraskeve and Anastasia

The crown of martyrdom being placed on Saint Paraskeve's head by two angels is inscribed perfectly inside the circle of the precious halo framing the saint's face.

The red cross symbolizes one's fidelity to the crucified Christ, to the point of undergoing martyrdom for him. The gold maniples around the wrists complete the saint's regal dress.

▲ Novgorod school, *Saint Paraskeve*, sixteenth century. Germany, private collection.

Paraskeve is wearing over her head the cloth on which Christ left an imprint of his Holy Face, and on her shoulders the red mantle of martyrdom. In her hand she holds a scroll with the beginning of the Nicene Creed: "I believe in one God, the Father almighty."

The elegant green maphorion, *symbol of life and resurrection,* covers the saint's head and body. Underneath one sees the bright red color of her bonnet and dress.

The phial of medicine sits in the saint's covered left hand; in her right hand she holds the cross of her martyrdom. The relationship between the two objects is clear: the greatest of all medicines is Christ's victory over death, the balm of his Resurrection.

Byzantine artist, *Saint Anastasia,* early fifteenth century. Saint Petersburg, Hermitage Museum.

The composition's perfect symmetry is dominated by the firm, severe gaze of Anastasia. Her great inner strength is magnified by the volume of her body, wrapped in the bright and orderly folds of her beautiful mantle.

*Rarely depicted in Russian iconography, Hypatius enjoys widespread veneration in the Byzantine church, where his intercession is considered particularly efficacious against sterility.*

# Hypatius of Gangra

**Text**
"Amid the fire he stood not like flesh burning but like bread that was baking." (Martyrdom of Polycarp of Smyrna)

**Title**
Bishop and martyr

**Feast day**
March 31

**Sources**
*Lives of the Saints* (Russia, seventeenth–eighteenth century)

**Iconography**
He is wearing an ancient *phelonion*, an *omophorion* adorned with crosses, and episcopal vestments; his right hand gives benediction, while his left holds up a closed Gospel; in the frame are scenes of his life and martyrdom

▶ *Saint Hypatius of Gangra with Scenes from His Life* (detail), first half of fifteenth century. Moscow, Tretyakov Gallery.

Hypatius was metropolitan of the city of Gangra, in the Roman province of Paphlagonia. What little we know about his life derives from a single account. After succeeding Athanasius as bishop, Hypatius apparently fulfilled his pastoral vows by battling paganism and building churches, hospices, and hermitages. He wrote a number of works, including a commentary on the Proverbs of Solomon, and took part in the Council of Nicaea. At the center of his icon he is represented in the orant pose, arms open, giving benediction and holding up the Gospel. A white *omophorion* with black crosses is wrapped around his shoulders and hangs down his left side over a red stole with white decorations. In the upper band of the icon are stories of his life as a bishop: he assembles the clergy and is brought under escort before the emperor, to whom he preaches the faith; he baptizes pagans and even resuscitates the emperor's wife. These are followed by the alleged episodes of

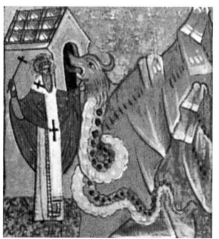

his martyrdom, after which Jesus appears and blesses him. In reality Hypatius died in an ambush set for him by some heretics, who attacked and stoned him to death.

Left to right: Hypatius instructs the clergy
of Gangra; soldiers escort the bishop to
see the emperor; he baptizes pagans; he
resuscitates the same emperor's wife.

Left to right
down both
sides: he is
roasted over the
fire; confronts a
sea serpent with
the cross; is
burned inside a
bronze statue of
an ox; is bound
to a horse and
dragged over
rocks; exorcises
a demon; is
buried alive and
has liquid mire
poured down
his throat.

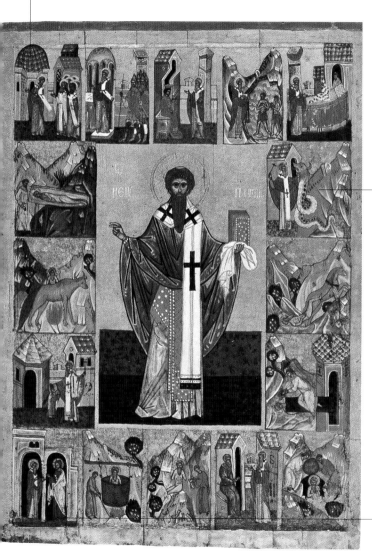

Left to right:
Christ visits him
in prison;
Hypatius is
boiled in a pot;
his feet and
hands are muti-
lated; he is
brought before
the emperor; he
is finally stoned
to death.

▲ *Saint Hypatius of Gangra with Scenes
from His Life*, first half of fifteenth
century. Moscow, Tretyakov Gallery.

*In ancient northern Russia, these four saints were among the most beloved and popular saints, seen as protectors of domestic animals and helpers in one's daily labors.*

# Florus and Laurus, Blaise and Spyridon

**Text**
"God is Spirit, for the breath of the wind passes through us all; nothing can contain it, nothing imprison it."
(Maximus Confessor)

**Title**
Martyrs and protectors of animals

**Feast days**
Florus and Laurus, August 18, "feast day of horses"; Spyridon, December 12; Blaise, February 11; Speusippus, Eleusippus, and Meleusippus, January 16

**Life**
Florus and Laurus, second century; Spyridon, d. 348; Blaise, d. ca. 316

**Iconography**
Florus and Laurus with Saint Michael, with their servants Speusippus, Eleusippus, and Meleusippus beneath them, tending the horses; Blaise and Spyridon with domestic animals

▶ Novgorod school, *Saints Blaise and Spyridon*, first half of fifteenth century. Moscow, State Historical Museum.

The brothers Florus and Laurus, stonecutters by trade and natives of Illyria, were martyred in the second century for having built a temple and dedicated it to Christ instead of the pagan deities. Because of the veneration they enjoyed in the early Church, they are represented in Russian icons in the company of Elijah, Nicholas, and James, bishop of Jerusalem and patron saint of Novgorod. Miraculous powers against epidemics were ascribed to Florus and Laurus, who were also protectors of domestic animals. In icons the archangel Michael entrusts a herd of horses to their care. Two other patron saints of animals were Blaise and Spyridon. Blaise, a martyred bishop of Sebaste (Armenia), lived in a cave with wild animals, practicing medicine on humans and animals alike. He and Bishop Spyridon of Tremithos (Cyprus) form a pair of miracle-working saints who replaced the pagan Dioscuri twins, protectors of livestock, in popular Byzantine iconography. In Russia, Spyridon supplanted Veles, the pagan Slavic god of livestock. Blaise is the patron saint of cows, Spyridon of goats and sheep.

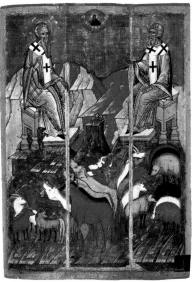

Florus and Laurus receive the bridles of
two horses from the archangel Michael.
The setting, atop a luminous mountain,
recalls the apparition of Christ between
Moses and Elijah on Mount Tabor.

Two elegant
horses, one white
and one black,
are docile with
the archangel
Michael, who
holds them by
the bridle and
turns them over
to Florus and
Laurus.

▲ *The Miracle of the Archangel Michael
with Saints Florus and Laurus*, sixteenth
century. Moscow, Tretyakov Gallery.

The servants of Florus and Laurus—the horsemen
Speusippus ("horse guardian"), Eleusippus
("horse herder"), and Meleusippus ("he who
catches black horses")—corral a herd of brightly
colored horses, having surprised them as they
were drinking at the river.

*His icons emphasize not so much the episodes of his life as the different stages of his martyrdom, enriching it with details not always confirmed by historical sources.*

# Nicetas

**Text**
"The truth of the God made man, that is the perfect unity of the absolute and the relative, of the infinite and the finite, of the Creator and the creature, reveals to us a universal principle that contains all the treasures of Wisdom and embraces everything in its unity." (Sacred author)

**Title**
Martyr and warrior, powerful foil against the demon

**Feast day**
September 15

**Life**
Fourth century

**Iconography**
Nicetas has a rich suit of armor, a cinnabar red cape, a curved sword, and a shield with concentric bands of different colors; in prison, he grapples with the demon and beats him with the same chains in which he is bound

Nicetas was a warrior-martyr who was burnt at the stake in 370 by Prince Athenarik for having preached the Christian faith to his fellow Goth warriors. His cult was quite developed in Constantinople, where there was a church devoted to him. In the fifteenth and sixteenth centuries in Russia, an apocryphal version of his martydom began to spread; it was rich in miraculous episodes, which were then illustrated in the frames of his icons. The central image presents him as a holy warrior: standing solidly on spread legs, sword drawn, gaze stern. At other times he is portrayed in prison, grappling with a demon trying to make him abjure his faith in exchange for his freedom. For this reason, Nicetas is often invoked in Russia to ward off the devil. In the icon on this page, all the images, starting with the half-figure of Christ and saints in the *Deesis* row, participate in Nicetas's struggle and triumph. In the side panels are Bishops Nicholas and Blaise, the Desert Fathers Onuphrius and Macarius, and defenders of the faith George and Elijah. In the bottom row are Saints Zosimus, Theodore, Demetrios, Stephen in the middle, and the women martyrs Anastasia, Juliana, and Paraskeve.

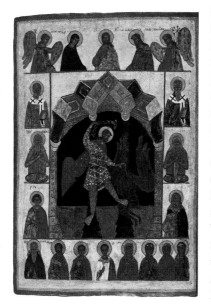

▶ Novgorod school, *Saint Nicetas Vanquishes the Demon*, late fifteenth century. Private collection.

*Left to right: An angel appears in a dream to Nicetas;*
*Juliana the Martyr appears with an icon of the*
*Virgin; Bishop Theophilus instructs Nicetas; he is*
*baptized; he preaches to the Goths; with prayers he*
*make the pagan idols fall.*

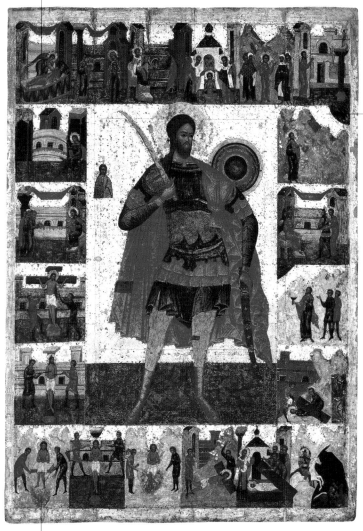

*Left to right*
*down both sides:*
*Nicetas strikes a*
*devil; sees*
*seraphim with*
*the crowns of*
*martyrdom;*
*preaches to the*
*people; professes*
*his faith before*
*the emperor; he is*
*crucified; trans-*
*forms poison into*
*the Eucharist; is*
*bound to a col-*
*umn and beaten;*
*is rolled down*
*from the top of a*
*mountain.*

*Bottom row: Red-hot splints are put on Nicetas's legs;*
*he is flayed with hooks; tortured with fire; beheaded;*
*and buried; Nicetas appears on a white horse and chases*
*unbelievers into hell.*

▲ *Saint Nicetas the Martyr with Scenes*
*from His Life,* second half of sixteenth
century. Yaroslavl (Russia), Museum of
History and Architecture.

*The two brothers combined their Christian faith with their profession as physicians, caring for the sick free of charge. For this they were called the* Anargyroi, *the "silverless ones."*

# Cosmas and Damian

**Text**
"The word of God made its home among men and became the Son of God to accustom man to understanding God, and to accustom God to making His home among men."
(Irenaeus of Lyon)

**Title**
The "silverless" physicians
(*Anargyroi, Bessrebreniki*)

**Feast days**
July 1, October 17, November 1

**Life**
Third century

**Source**
Procopius of Caesarea

**Iconography**
Cosmas, with beard, standing, wearing a red cloak and holding a phial of medicine and a scalpel; Damian holds similar instruments but is younger and beardless

A basilica dedicated to Saints Cosmas and Damian was built in the Syrian city of Cyrus as early as the fifth century. Their bodies were buried there, in a double tomb. According to Procopius of Caesarea, the building was later expanded at the behest of Emperor Justinian. Originally from Arabia, the two brothers lived in the third century, studied medicine in Syria, and practiced their art in Cilicia. Known for spreading the word of the Gospel through the exercise of their profession, for which they accepted no pay, Cosmas and Damian were apparently beheaded under the rule of Diocletian. By the fourth century, their cult had already spread throughout the Eastern Roman Empire, from Greece to Palestine, Cappadocia to Constantinople, from where it later passed into Russia. The iconography emphasizes their healing powers, showing them with medicines and surgical instruments. Byzantine iconography ignores the prodigious feats described in the rich hagiography of Cosmas and Damian, including the episode in which they extract a snake from a peasant's throat, or another in which they replace a patient's gangrenous leg with one from a dead man.

▶ *Saints Cosmas and Damian,* first half of fifteenth century. Moscow, Andrei Rublev Museum.

At the foot of Mount Sinai, the Orthodox monastery devoted to this saint contains the most ancient and precious icons of all of Eastern Christendom.

# Catherine of Alexandria

The most ancient source for the life of this wise and noble virgin, who lived in Alexandria, Egypt, in the third and fourth centuries, is a Greek *Passio*. It tells how Catherine refused to obey the emperor's order to sacrifice to the gods of the temple. She then converted the sages of the imperial court, who were promptly executed. Flogged and imprisoned, Catherine received a visit from the empress and the military officer Porphyrius and succeeded in converting the latter along with his two hundred soldiers. They too were killed. Catherine was then tortured on a toothed wheel, but the terrible machine broke, causing the death of many pagans. Finally, despite the empress's entreaties, Catherine's breasts were cut off and she was beheaded. The *Passio* recounts how her wounds shed milk instead of blood. Angels carried her body to Mount Sinai, and every year on her feast day, milk and miraculous healing oil would flow from her tomb. In 527, Justinian had the famous Monastery of Saint Catherine built at the foot of Mount Sinai, surrounded by high walls to protect it from the Saracens. Inside are the Church of the Transfiguration and an image of the Virgin of the Burning Bush (to whom the monastery was dedicated).

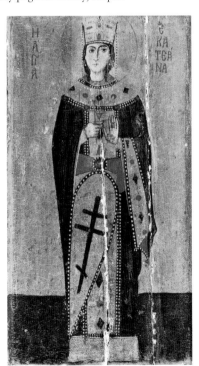

**Text**
"From the wound in Christ's side came the Church, and he made her his bride." (Origen)

**Title**
Martyr

**Feast day**
November 25

**Life**
Third–fourth century

**Sources**
Greek *Passio* (sixth–eighth centuries); Latin *Passio* (ninth century); Jacobus de Voragine, *The Golden Legend*; John Capgrave, *Life of Saint Katherine* (1445)

**Iconography**
Catherine in royal raiment wearing a precious crown, her right hand open and her left holding a cross, like all martyrs; she is often surrounded by episodes from her life, especially her long martyrdom

◄ *Saint Catherine with Scenes from Her Martyrdom* (detail), twelfth century. Mount Sinai, Monastery of Saint Catherine.

The central mountain, Gebel Musa
(2275 m), is where Moses received the
tablets of the Law. Here we see the four
thousand steps carved into the rock,
leading up to the mountaintop.

The chapel of Elijah, where
Moses (Exodus 24:9) and later
Elijah (1 Kings 19:8) had their
visions of God.

Moses removed his sandals as a
sign of respect when the burning
bush appeared before him.

The monastery is the custodian of
ancient revealed icons, "made not
by human hands," such as the
Virgin of the Burning Bush, here
carried or guarded by an angel.

▲ Ioannes Moschos, *The Monastery
of Saint Catherine on Mount Sinai*,
ca. 1720. Mount Sinai, Monastery of
Saint Catherine.

The highest peak of Sinai is the Gebel Katherin (2644 m), where Saint Catherine's mortal remains were taken by angels and where they were discovered in the eighth century, before being translated to the monastery.

ΓΟΝ

ΟΡѠϹϹΗΝ4

As recounted by Egeria in her pilgrimage account (A.D. 380), the whole Sinai area was dotted with small hermitages, churches, and monasteries.

A group of monks and priests in liturgical dress, carrying the Gospel and lighted candles, solemnly processes out of the monastery.

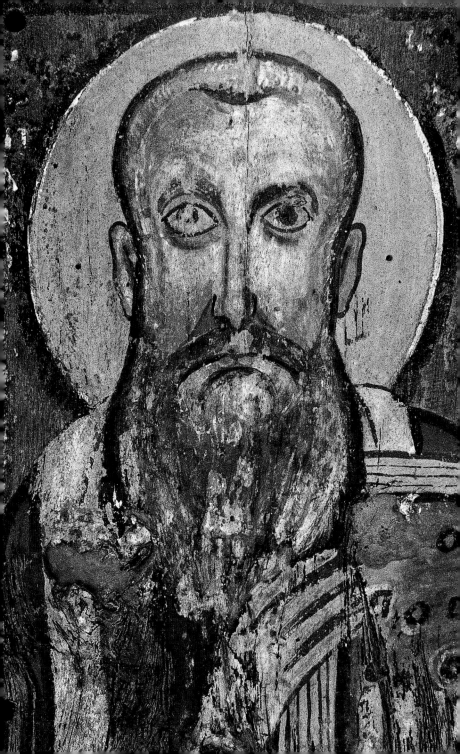

# FATHERS OF THE EASTERN CHURCH

◀ *The Bishop Apa Abraham* (detail),
Coptic, sixth–seventh century. Berlin,
Museum of Byzantine Art.

*James, Clement, Ignatius, Athanasius, and Cyril of Alexandria are the pillars of the temple of Orthodoxy, which they defended from heresies even at the cost of their lives.*

# Early Bishops

**Text**
"Let me have compassion every time I witness a sinner's downfall." (Ambrose of Milan)

**Feast days**
James of Jerusalem, October 23; Clement of Rome (Pope Clement I), November 24; Ignatius of Antioch, December 20 (East); Athanasius of Alexandria, January 18; Cyril of Alexandria, June 9

**Lives**
James, d. A.D. 62; Clement, d. 103; Ignatius, 50–107/118; Athanasius, 300–373; Cyril of Alexandria, d. 444

**Sources**
Protoevangelion of James; Irenaeus of Lyon; Origen; Clement; Athanasius

The iconography of the first bishops combines several different subjects to express the harmonious fusion of their testimonies. Through these images we know what sort of liturgical vestments were in use at the time of the early Church. At the Council of Nicaea, the Church triumphed over the heretic Arius, thanks in part to the presence of Nicholas of Myra. Ignatius of Antioch (who, according to tradition, was martyred in Rome, mauled by lions) and James of Jerusalem (whom the Eastern Church counts among the seventy earliest apostles) headed the two great sees of the first Church. Pope Clement I, who wrote a surviving letter to the Corinthian Church, was certainly a disciple of Peter and Paul (Origen, in fact, calls him the "third after the apostles") and died a martyr's death in the Tauric Chersonese (modern Crimea), where he had been banished by the emperor Trajan. Russian iconographic interest in scenes from the councils of the early Church can be explained by the presence, in the fifteenth century, of heretical movements that the Orthodox Church of Moscow was combating. It is in this context that we should situate the Russian representations of the early patriarchs of Alexandria Athanasius (defender of Orthodoxy at Ephesus) and Cyril (who opposed the heretical patriarch of Constantinople, Nestorius).

▶ *Saints Athanasius the Great, Cyril of Alexandria, and Ignatius of Antioch*, late fifteenth century. Novgorod (Russia), museum.

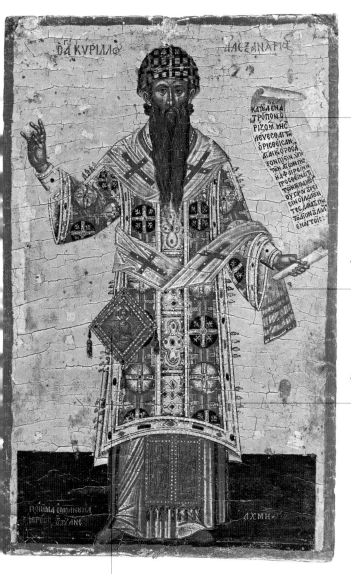

On the scroll are the words "We decree that the holy and orthodox faith established by the holy fathers be changed in no way…since not they spoke but the Holy Spirit spoke through them."

The bishop's attributes are the gilded miter on his head and the omophorion *with red crosses wrapped around his shoulders and folded over his left arm.*

Under the sumptuous sakkos, *which is closed by gold clasps, hangs a purple stole with figural embroideries and tassels.*

The epigonation *is a red silk square embroidered in gold, with an image of Christ Emmanuel.*

▲ Emmanuel Tzanes, *Saint Cyril of Alexandria*, 1648. Athens, Byzantine Museum.

Emperor Constantine, surrounded by bishops, presides over the Council of Nicaea.

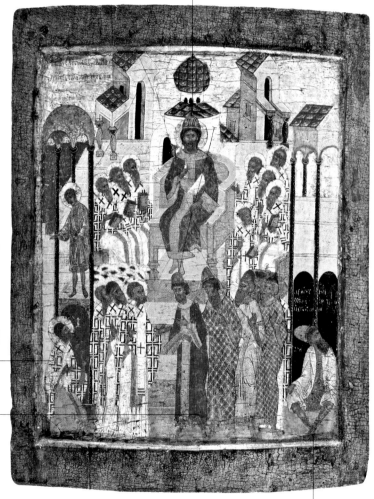

Peter of Alexandria has a vision of Christ Emmanuel (above him in the ciborium), who is showing him his torn tunic, symbolizing the sundering of the Church by the Arian heresy.

The emperor Constantine and court dignitaries welcome the bishops.

▲ Novgorod school, *The First Ecumenical Council at Nicaea*, late fifteenth century. Vicenza (Italy), Gallerie di Palazzo Leoni Montanari, Banca Intesa Collection.

The heretic Arius slumps, disemboweled and dead, in front of a dark doorway.

The inscription over James of Jerusalem calls him "brother of the Lord," since the Eastern Church counts him among the seventy earliest apostles.

The words over Ignatius of Antioch read "the God-Bearer" (Bogonosets, Theophoros), that is, one who carried the divine presence within himself.

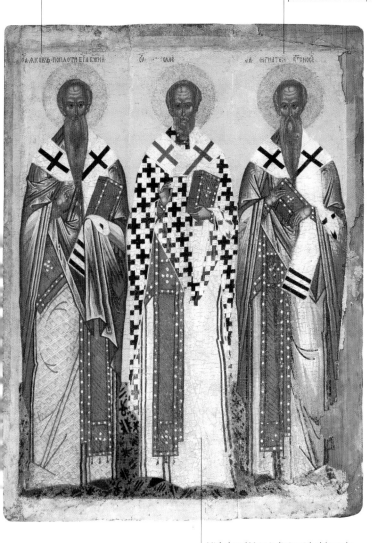

▲ Saints James of Jerusalem, Nicholas of Myra, Ignatius of Antioch (the God-Bearer), originally from the Murom Monastery on Lake Onega, late fifteenth century. Saint Petersburg, Russian Museum.

Nicholas of Myra is distinguished from the two bishops of Jerusalem and Antioch by his short beard, white phelonion covered with a grid of black crosses, and the red crosses on his omophorion.

*The three large haloes stand for the firm wills of the three defenders of the faith, which we see expressed in the intensity of their gazes.*

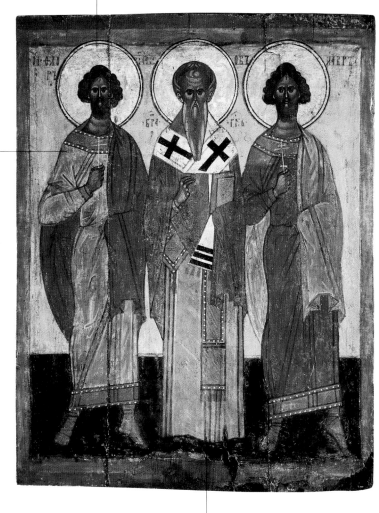

*Saint Florus in a light blue tunic and red mantle. On the right, Saint Laurus wears the opposite: a red tunic and light blue mantle. Each holds the cross of his martyrdom.*

▲ *Saints James of Jerusalem, Florus, and Laurus, second half of fifteenth century. Saint Petersburg, Russian Museum.*

*Behind Saint James, who is wearing the episcopal* omophorion *around his shoulders, are the words "brother of the Lord"; the two other saints stand close by his side.*

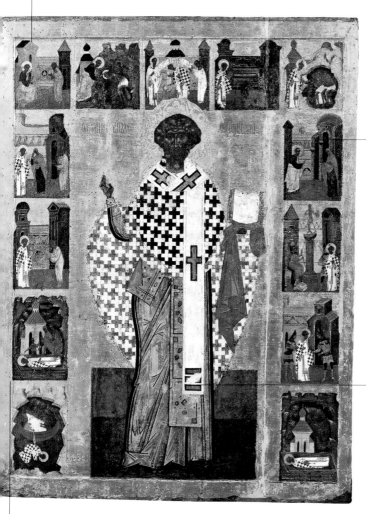

Across the top: Clement meets the apostle Peter; is baptized by him; is ordained bishop; preaches to the pagans kneeling before him; preaches to the Christians forced to work in rock quarries.

Left to right down both sides: Clement reunites with his father and mother; Peter speaks with the mother; Clement speaks with his father; Clement is condemned to death by the idolatrous king.

The bishop is wearing the ancient phelonion with alternating white and black crosses. Where it is open, the crosses appear transparent, forming an elegant ornamental play of inside and out.

Left and right down both sides: Clement's body is found alive in his parents' tomb; he is arrested; he is thrown into the sea; his body is found intact at the bottom of the sea, in an angelic church "not built by human hands."

▲ North-Russian school, *Saint Clement, Pope of Rome, with Scenes from His Life*, sixteenth century. Arkhangelsk (Russia), Museum of Fine Arts.

*He is one of the most venerated miracle-working saints in both Western and Eastern Christendom. Every city in Russia has a church dedicated to him, almost every house one of his icons.*

# Nicholas of Myra

**Text**
"The saints are the living, and the living are saints." (Origen)

**Title**
Saint Nicholas the Miracle-Worker (*Thaumatourgos, Chudotvorets*)

**Feast days**
December 6; Translation of his relics to Bari, May 9; weekly commemoration, Thursday

**Life**
Patara (Lycia), 280–345/352

**Sources**
Nicephorus, *Translatio*; John of Damascus, *Translatio*; *Adventus sancti Nicolai Beneventum*; Russian legend from Kiev (eleventh century)

**Iconography**
Broad, high forehead; short, gray beard; episcopal *omophorion*; right hand giving benediction, left hand, covered, holding up a closed Gospel.

The relics of this saint were spirited away from Myra and transferred to Italy, in 1087. Their dramatic voyage over the seas, and the reasons given for stealing them (to save them from the Turks) inspired at least four different texts. Born at Patara in Lycia (Asia Minor) in 280, Nicholas eventually became bishop of nearby Myra, where he died between 345 and 352. He was a vehement opponent of the heretical bishop Arius at the Council of Nicaea. After slapping Arius in the face, Nicholas was stripped of his holy insignia and thrown in jail; but Christ and the Virgin appeared to him and gave him back his freedom and his episcopal office, confirming him in the true faith. After the early Byzantine icons of him, dating from the tenth through the thirteenth centuries, his iconography grew more elaborate in Russia, with the addition of new episodes such as the Dnieper River rescue. He is shown in episcopal

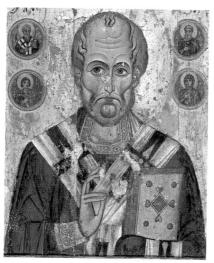

▶ *Saint Nicholas of Myra with Saints*, mid-thirteenth century. Saint Petersburg, Russian Museum.

vestments, wearing the cross-adorned *omophorion*, giving benediction and holding the Gospel. The firmness of the face, the high, furrowed forehead, the large, concentrating eyes accentuated by thick eyebrows, and the short beard represent Nicholas as a stout defender of the Christian faith against heresy, as well as an exorcist and healer.

*Top tier: Birth of Nicholas; his education; he becomes deacon; is ordained bishop; buys a rug from a poor man; gives it to the poor man's mother.*

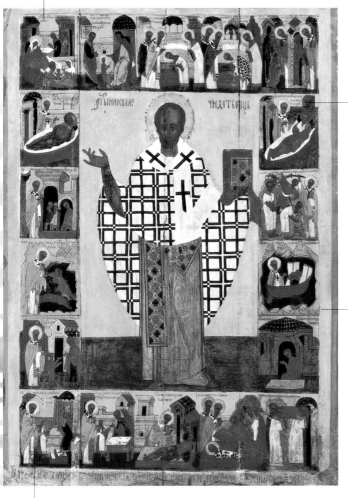

*Left to right down both sides: He appears before Emperor Constantine; appeals to the eparch Eulalius, asking for the liberation of three unjustly accused officials; visits the prisoners and comforts them; succeeds in preventing their execution.*

*Left to right: He saves the boy Dmitrii from the waters of the Dnieper River; on a boat, he calms a storm; he frees an adolescent from a demon; Dmitrii kneeling before a tabernacle.*

*Bottom tier: He frees a kidnapped child from Saracens; returns him to his parents; exorcises a man possessed; is buried; the translation of his relics.*

▲ *Saint Nicholas the Miracle-Worker with Scenes from His Life, 1540. Vologda (Russia), museum.*

*Three Cappadocian Fathers—Basil the Great, Gregory of Nyssa, and Gregory of Nazianzus—with John Chrysostom, dominate fourth-century Byzantine theology and culture.*

# Four Byzantine Hierarchs

**Text**
"Find a man who lives justly and I will pardon all the people." (Saint Epiphanius)

**Title**
The Three Hierarchs (*Treis hierarchai*, *Tri sviatitelia*): Chrysostom (*Zlatoust*); Gregory of Nazianzus, called the Theologian (*Bogoslov*); and Basil the Great

**Feast days**
Basil: January 1 (East), January 2 (West); Three Hierarchs, January 30; Gregory of Nyssa: October 16; John Chrysostom: January 27 (East), September 13 (West); Gregory of Nazianzus: January 25 (East), January 2 (West)

**Lives**
Basil, ca. 330–379; Gregory of Nazianzus, 330–390; Gregory of Nyssa, 335/340–394; John Chrysostom, 350–407

▶ *Saints John Chrysostom and Basil the Great, second half of fourteenth century. Moscow, Tretyakov Gallery.*

Saint Basil was born in Caesarea (Asia Minor) around the year 330 and studied at Constantinople and Athens, where he met Gregory of Nazianzus. Returning to Cappadocia in 356, Basil converted, was baptized, and went to live the monastic life in Egypt, Palestine, Syria, and Mesopotamia. In the mountains of Pontus, he and Gregory founded a monastic community. Here Basil wrote a monastic rule (the *Ascetikon*) on which all monasticism in Asia Minor would be based. Also with Gregory, he made an anthology of Origen's writings, the *Philokalia*. After becoming bishop of Cappadocia, he founded an "ideal city" called Basiliades, with churches, monasteries, and buildings dedicated to caring for the sick and housing pilgrims. John Chrysostom (called the "golden mouth" for his eloquence) was born at Antioch in 350 and, after a time as a hermit, became a priest, then bishop. In 398 he became patriarch of Constantinople. In a dispute with the emperor, he was exiled to Armenia, then to Pontus, on the Black Sea, where he died. His liturgy is still used in the Orthodox Church. Gregory of Nyssa was born in Cappadocia between 335 and 340. After studying philosophy, he was ordained bishop in 371–72.

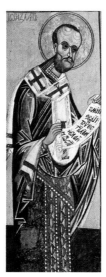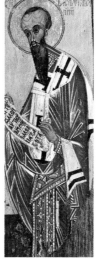

310

Left to right: Gregory the
Theologian, John Chrysostom, and
Basil are distinguishable from one
another by their facial features and
the shape or size of their beards.

The right hand is giving "Greek"
benediction, while the left hand is
veiled by the omophorion and
holding a holy book.

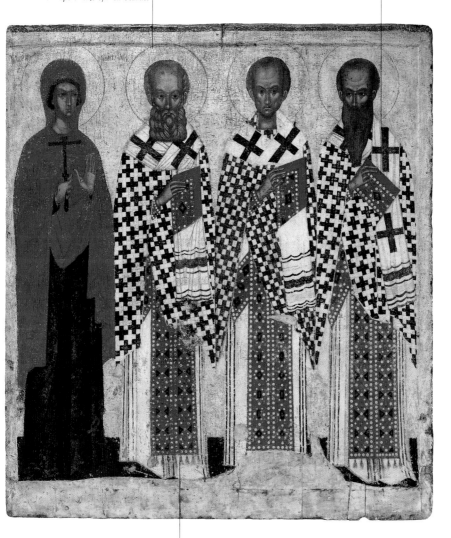

▲ Pskov school, *Saints Paraskeve, Gregory
the Theologian, John Chrysostom, and
Basil the Great*, fifteenth century. Moscow,
Tretyakov Gallery.

The phelonion *adorned with a grid of small
black-and-white crosses, the* omophorion
*with large crosses, and the red episcopal
stole with decorations and tassels are almost
identical for all three saints.*

The open arms accentuate the dynamic
symmetry of the composition. The image
of the saint suggests the form of a kite,
with its flowing tail of liturgical vestments.

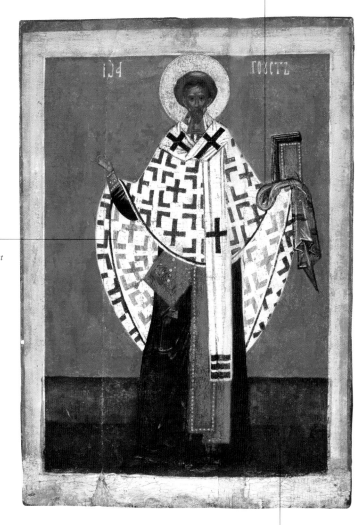

The white sakkos
opens elegantly against
the red background,
showing the trans-
parency of the cross
design on the reverse
side of the fabric.

▲ *Saint John Chrysostom*, from
Novgorod, second half of fifteenth
century. Arkhangelsk (Russia),
Museum of Fine Arts.

The emerald green and cinnabar red of
the background are typical of the
Novgorod painting style and create a
strong, eye-catching chromatic contrast
with the frame.

Basic the Great reads his text as his disciples enjoy the fruits of his teachings, their cups full of the water of Wisdom, and propose a spiritual toast.

John Chrysostom imparts his teaching to his disciples. The river of Wisdom spouts from a column behind his head and forms a pool in the shape of a leaf.

Gregory of Nazianzus lets the scroll containing his doctrine open freely into the hands of his listeners, as if it were growing directly out of the liturgical stole he is wearing. Behind the scene, other disciples quench their thirst with chalices of Wisdom.

▶ Semen Khromoi, *Sermon of the Three Hierarchs*, early sixteenth century. Perm (Russia), Picture Gallery.

*He dominated seventh-century theology and the Council of Constantinople of 608 and fought the Monothelite heresy, which claimed that Christ had a single, divine will.*

# Maximus Confessor

**Text**
"Like my nature He became, that I might understand Him. And like my form, that I might not turn away from Him."
(*Odes of Solomon* 7:6)

**Title**
Saint Maximus Confessor
(*Homologetes, Ispovednik*)

**Feast day**
August 13

**Life**
580–662

**Source**
*Syriac Life of Maximus*

**Iconography**
High, broad forehead, beard, wearing monastic robes and a great *schema* stole over his light tunic

He was called Confessor because he was tortured for his beliefs yet did not die as a martyr. He was born in Constantinople in 580 and, after serving as court secretary, entered monastic life around 613. The Persian invasion threatening Constantinople led him first to Crete, then to Cyprus, and finally to Africa (632). He intervened in the controversy on the dual nature of Christ, publicly debating the bishop of Constantinople, Pyrrhus, in 645. In Rome, with Pope Martin, he organized the Lateran Council of 649 to combat the Monothelite heresy; the two were arrested by the imperial army and transported to Constantinople. Martin was tried in 653 and died in exile in the Crimea two years later; Maximus was sent to Thrace, where he was retried, flogged, and deprived of his tongue and right hand. Deported finally to Lazica on the Black Sea, he died in 662, more than eighty years old. The Council of Constantinople of 680 solemnly rehabilitated Maximus and his doctrine. His thought was brought to light again in the twentieth century by the theologian Hans Urs von Balthasar.

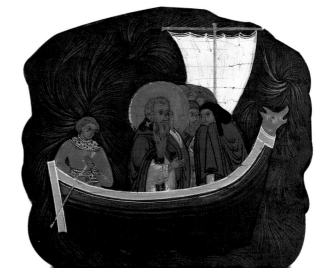

▶ Stroganov school, *Maximus and His Disciples Exiled to Lazica*, detail of *Maximus Confessor with Scenes from His Life*, late sixteenth–early seventeenth century. Solvychegodsk (Russia), Museum of History and Art.

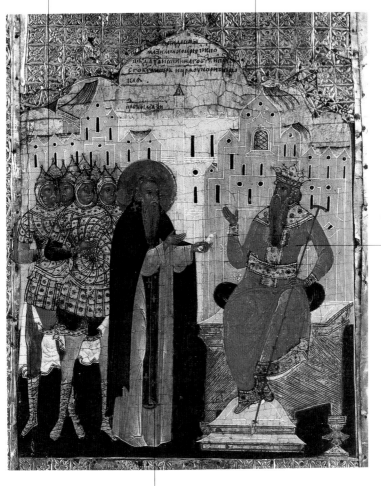

*Having arrested Maximus in Rome, the richly armored imperial guards drag him before the emperor.*

*The buildings of Constantinople are evocatively rendered with broad color fields and subtle geometric lines.*

*The emperor on his throne holds his scepter and listens indignantly to Maximus's words.*

▲ Stroganov school, *Maximus Confesses the Orthodoxy and Condemns Heresy before the Emperor*, detail of *Maximus Confessor with Scenes from His Life*, late sixteenth–early seventeenth century. Solvychegodsk (Russia), Museum of History and Art.

*Maximus confesses his orthodoxy before the emperor and condemns heresy, handing him a scroll containing his doctrine.*

315

*He is responsible for the fourteenth-century movement called Hesychasm, an ascetic practice based on silence, inner tranquility, and participation in the uncreated energy of divine light.*

# Gregory Palamas

**Text**
"In silence we learn the secrets of this shadow that shines brighter than the most brilliant light in the blackest darkness."
(Dionysius the Areopagite, *The Mystical Theology*)

**Title**
Byzantine theologian

**Life**
Died in 1359, canonized in 1368

**Iconography**
Half-length bust wearing the episcopal *phelonion* with ornamental motifs and a white stole adorned with crosses; in one hand he holds a closed Gospel, and with the other gives "Greek" benediction, forming the monogram of Jesus Christ, IC XC, with his fingers

After two decades on Mount Athos, Gregory Palamas became archbishop of Thessaloniki. His fascinating personality influenced the patriarch of Constantinople, Philotheus Coccinus, and even Emperor John VI Cantacuzenus. Together with Nicolas Cabasilas, Gregory Palamas dominated four-teenth-century Byzantine theology, with the support of the Councils of Constantinople (1341–51). Despite his popularity (he was canonized just nine years after his death), the icon published here is the only one known. He appears in episcopal vestments, holding the Gospel in one hand and giving "Greek" benediction, forming the monogram of Christ, IX XC, with the other. The doctrine founded by Gregory Palamas, Hesychasm ("quietism"), based on the "uncreated light" the apostles saw in the Transfiguration, influenced the aesthetic theology of iconography. According to Hesychast doctrine, God—indescribable, inaccessible, and unknowable—makes himself known through his energies. Hesychasm flourished on Mount Athos and in Russia, where, in *The Way of the Pilgrim*, the anonymous protagonist recites a prayer until his soul would repeat, even in sleep: "Lord Jesus Christ, son of David, have pity on me the sinner!"

▶ *Saint Gregory Palamas* (detail), fourteenth–fifteenth century. Moscow, Pushkin Museum of Fine Arts.

*During the ritual blessing of the bread at Saturday vespers, Saint Eulogius had a vision of angels rewarding the most conscientious monks with small gifts.*

# The Vision of Eulogius

According to an edifying text, the presbyter Eulogius, an Alexandrian, was clairvoyant: he knew the thoughts and intentions of the other monks. One day, during high vespers, he had a vision of angels who were bestowing gifts on the monks in accordance with their levels of asceticism. The theme of the vision derives from Eulogius's desire to give strength and support to the lazier and more distracted of the monks. In the icon, the angels give out coins (gold with the image of Christ, silver with the cross, or bronze) or a blessed loaf, then anoint them with myrrh and incense. The indolent monk receives nothing. At the center, over the altar, Sergius of Radonezh and Cyril of Belozersk worship the chalice with the bread (the *prosphora*); high above the chalice, and corresponding to it, is a medallion of the Virgin of the Sign, who carried Jesus inside her. The white, three-domed temple, a symbol of the Trinity, unites the scene. To the left of the temple, a monk rings the bells, while in the tower to the right, another monk strikes the *semantron*. On the lower left, Saint Eulogius holds up a scroll exhorting the monks to silence.

**Text**
"Let one remain useful to the soul in fasting and delightful to God, and not give in to sloth" (*Sayings of the Desert Fathers*)

**Feast day**
September 13

**Life**
Eulogius of Alexandria, Syrian abbot, d. 607

**Sources**
Palladius, Bishop of Aspuna, *Historia Lausiaca* (368–430); *Sayings of the Desert Fathers*; John Moschus, *Pratum Spirituale* (*The Spiritual Meadow*)

**Iconography**
Eulogius and escort: the most conscientious monks receive small gifts from the angels; Abbots Sergius of Radonezh and Cyril of Belozersk worship the eucharistic bread

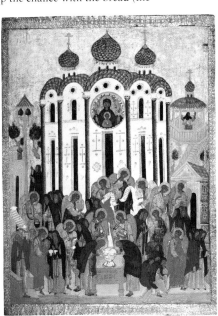

◀ *The Vision of Saint Eulogius*, originally from the Monastery of the Presentation in the Temple, Solvychegodsk, 1565–96. Moscow, Tretyakov Gallery.

*They converted the Slavic peoples thanks to the Cyrillic alphabet, which they invented. For this reason, Pope John Paul II declared them patron saints of all Europe in 1980.*

# Cyril and Methodius

**Text**
"What is knowledge? The sense of immortal life. And what is immortal life? Sensing everything in God. The knowledge that unites us in God reigns over all desires; and for those who receive it, it is the sweetest thing brimming up from the earth, for there is nothing like the sweetness of knowing God." (Isaac of Syria)

**Title**
Apostles of the Slavs; patron saints of Europe

**Feast days**
February 14 and May 11

**Lives**
Cyril, 827–869; Methodius, died 885

**Iconography**
Dressed in episcopal vestments, with books and scrolls with Cyrillic letters

Cyril was born in Thessaloniki in 837 and studied at Constantinople, where he became a sought-after teacher of philosophy. He preferred the monastic life, however, a choice he shared with his younger brother Methodius. At the emperor's behest, Cyril went with Methodius to the land of the Khazars, between the Don and the Caucasus, north of the Black Sea, where among other things he discovered the relics of Pope Clement I near Cherson. In the years 862–63, sent with his brother to visit the prince of Moravia, Cyril composed a new Glagolitic alphabet of thirty-two letters, which inaugurated the rise of Slavic literatures. With the help of Methodius, Cyril began to translate the Gospels, the Epistles of Paul, the Acts of the Apostles, and the liturgical texts into Cyrillic, the alphabet named after him. Pope Hadrian II received Cyril and Methodius in Rome with great honors (they brought the relics of Saint Clement with them) and authorized the use of Slavic tongues in the liturgy. After Cyril's death in Rome on February 14, 869, Methodius continued his brother's work in Moravia and Pannonia.

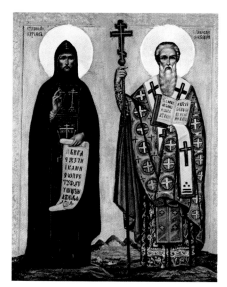

▶ *Saints Cyril and Methodius*, nineteenth century, Russia.

*A Doctor of the Church, during the iconoclastic persecutions he wrote three treatises defending sacred icons, justifying the representation of Christ through the doctrine of the incarnation.*

# John of Damascus

Born at Damascus in 650, John became a high functionary with the Omayyad caliphate in his Muslim native land, despite his Christian faith. He fell into disgrace, however, when the Iconoclast emperor Leo III the Isaurian denounced him to the caliph through a forged letter, supposedly in John's hand, advocating treason. Some accounts say that he had a hand chopped off in punishment. From this episode was born the iconography of the Three-Handed Virgin (see pages 219–20). In any event, John not only defended Orthodox Christianity against Islam but also the Orthodox cult of images and the theology of the Trinity, for which he composed hymns. Considering the icon an integral part of the Byzantine liturgy, John wrote three treatises defending holy images. He believed that the icon of Christ can be fully justified through the doctrine of the incarnation: one worships not the image but what it represents. And, after all, Christ, by assuming human form, assumed a concrete individuality. John ultimately withdrew to the Monastery of Saint Sabas in Jerusalem, where he continued his intense activity as a writer and orator concerned with doctrine, morality, exegesis, asceticism, and poetry. He died at age 100 at Saint Sabas.

**Text**
"I worship not the matter but the Creator of matter who became matter for me."
(John of Damascus)

**Title**
Doctor of the Church

**Feast day**
December 4

**Life**
650–ca. 750

**Sources**
John of Damascus, *In Defense of Holy Icons, On the Orthodox Faith, Homilies on the Nativity and the Dormition*

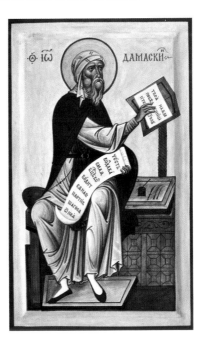

◄ Archimandrite Zinon, *John of Damascus, Defender of Holy Images*, second half of twentieth century.

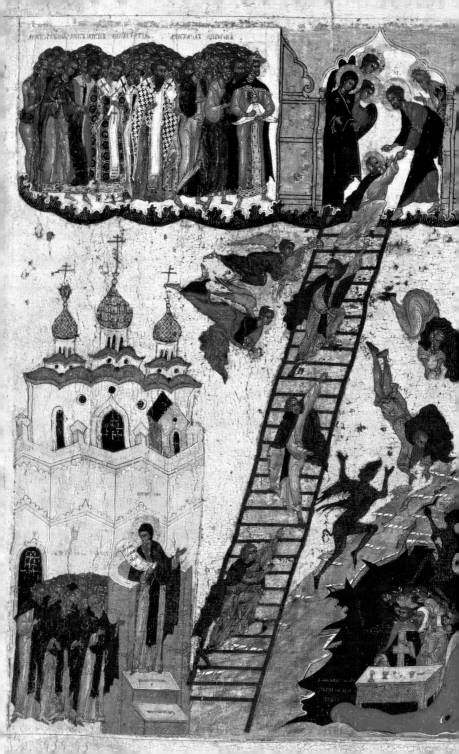

# MONASTIC SAINTS OF THE EAST

*Early Hermits*
*Mary of Egypt*
*Anthony the Great*
*Ephraim the Syrian*
*John Climacus*
*Stylites (Pillar Saints)*
*Theodore the Studite*
*John of Rila*

Novgorod school, *The Ladder of*
*Divine Ascent*, mid-sixteenth century.
Saint Petersburg, Russian Museum.

*In Cappadocia, Syria, and Egypt flourished the "Egyptian Thebaid," a primitive form of monastic life that would later develop in Greece, on Mount Athos, and in Russia.*

# Early Hermits

**Text**
"Granted freedom, the angels lift themselves up, while men hurl themselves into the abyss." (Origen)

**Feast days**
Pachomius, May 15; Macarius, January 19 or 21; Onuphrius, June 12; Anthony the Great, January 17; Ephraim the Syrian, January 28; Athanasius of Athos, July 5

**Lives**
Pachomius, 292/294–346; Macarius of Alexandria, fourth century; Anthony the Great, 251–356; Ephraim the Syrian, 306/307–373; Athanasius of Athos, 930–1001

**Sources**
Galatians 6:1; *Corpus Pachomianum*; *Sayings of the Desert Fathers*; John Climacus, *The Ladder of Divine Ascent*; *Philokalia*

▶ Novgorod school, *Saints Macarius the Egyptian, Onuphrius the Great, and Peter of Athos*, late fifteenth–early sixteenth century. Saint Petersburg, Russian Museum.

In Syria and upper Egypt, near Thebes, the first anchorites (from the Greek *anachorein*, "to withdraw") or hermits (*eremos*, "desert") lived in huts, following no specific rule, devoting themselves to prayer and penance. Thus arose the "Egyptian Thebaid," whose memorable inhabitants include Paul of Thebes (died 341), Onuphrius, Ephraim the Syrian, and especially Anthony the Great, founder of Egyptian monasticism. In the fourth century, with Pachomius, a transition occured from pure anchoritism to early forms of communal, cenobitic life. Basil the Great of Cappadocia (ca. 330–379) wrote the rule for Eastern cenobitic monasticism. Between the eighth and ninth centuries in Greece, on the slopes of Mount Athos, the "Athonite Thebaid" was born. The first to settle in the caves above the sea was the monk Peter, who took a vow of silence. In the tenth century, another great hermit, Athanasius, took refuge on Mount Athos, which was already inhabited by

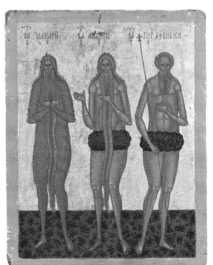

anchorites. His rule (*typikon*) became the model not only for all the monasteries of Athos, but also, later on, for the "Russian Thebaid." Today Mount Athos is a veritable monastic republic (two thousand monks, twenty monasteries), with a council of abbots (*hegoumenoi*) representing the Greek, Romanian, Bulgarian, Serbian, and Russian communities.

The saint's hermitage cave and death/dormition. Two angels guard the saint's body, while a third takes it up to heaven.

The vessel is shipwrecked on the island of Gaudos, and the hermit is asked to cross the sea to the isle of Crete.

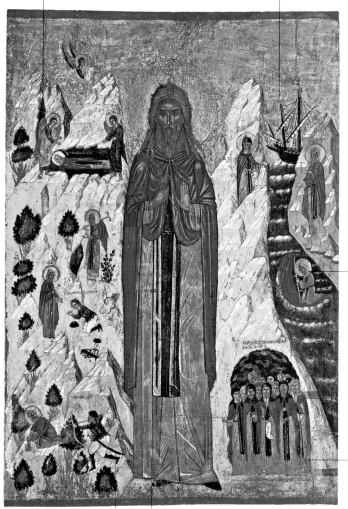

John the Hermit propels his boat by using his mantle as a sail and his staff as a mast.

After the shipwreck, John the Hermit's ninety-four companions find shelter in a cave on the shores of Crete.

John is wounded by a hunter's arrow and then (above) forgives him.

In a broad red mantle closed over his chest with a clasp, John is bareheaded and wearing a long blue stole over his monastic robes.

▲ *Saint John the Hermit, with Scenes from His Life*, late seventeenth century. Athens, Byzantine Museum.

323

The words "The Venerable Maximus" do not clarify whether they refer to Saint Maximus of Moscow (died 1434) or Saint Maximus of Totma (died 1650).

The two saints' hands lightly touch the clouds, which open onto a vision of the Mother of God enthroned with the Child and surrounded by angels.

Saint Maximus's long beard has partly faded but must originally have hung down to his feet.

The hilly landscape seems to float, while the hermits, on tiptoe, seem to want to touch the sky.

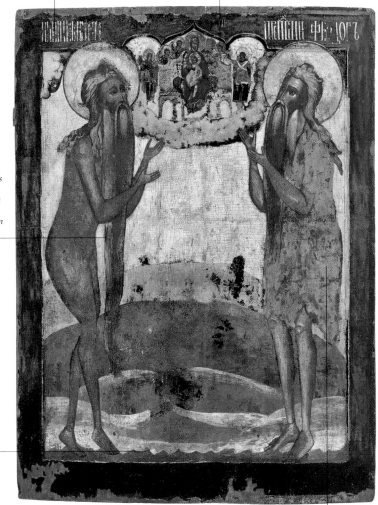

▲ *Saint Maximus and Saint Theodore Trichinas*, central Russia, late seventeenth century. Private collection.

Under his rough tunic we can imagine, tightly bound around his waist, the hair shirt that Theodore Trichinas (that is, "Theodore of the Hair Shirt") certainly wore, as we know from his name.

*Disfigured from fasting, parched by the sun, dressed in rags,
and protected only by her long hair, she lived for many years in
the desert of Jordan.*

# Mary of Egypt

She ran away from her parents at age twelve and lived for seventeen years in Alexandria, working as a prostitute. At the age of thirty-one, in the port of Alexandria, she embarked on a ship with pilgrims on their way to the Holy Land to celebrate the discovery of the Holy Cross, going along simply because she thought she could make easy money. Once in Jerusalem, however, she wanted to visit the Holy Sepulchre, but a mysterious force held her back. She withdrew to the desert to meditate, repenting her sins and asking God to show her where she could live in penance. A voice told her to cross the Jordan, and there, in the same desert where John the Baptist had lived (and where Jesus was baptized), she lived for forty-seven years, surviving, like the Baptist, on wild fruit. Her story comes down to us from the monk Zosimus, who spent every Lent in the Jordanian desert, in seclusion and prayer. There he met Mary of Egypt, who was disfigured from her hardships. The penitent woman made him promise that on Holy Thursday of the following year, he would bring her Holy Communion. Zosimus returned the following year, but the year after that he found the saint lying dead exactly where he had left her. According to tradition, Zosimus buried Mary with the help of a lion.

**Text**
"The soul attains perfection when the strength of its passion is entirely directed toward God." (Maximus Confessor)

**Title**
Her name is of Egyptian origin, related to the Latin *amare*, "to love"

**Feast Day**
April 1

**Life**
Egypt 354–431 Palestine

**Iconography**
Bare-breasted with a tunic belted around the waist, long, flowing hair, the nimbus of sainthood, emaciated face and body, receiving communion from the monk Zosimus in the desert landscape near the river Jordan

◄ *Saint Mary the Egyptian*, Syria, eighteenth century. Balamand (Lebanon), Our Lady of Balamand Monastery.

325

# Mary of Egypt

Zosimus the monk, wearing a red mantle and blue priestly stole, gives the saint Communion with the long "ladle-like" spoon typical of the Byzantine liturgy, where the bread is soaked in wine.

The saint, face gaunt from fasting, opens her mouth to receive the Holy Eucharist.

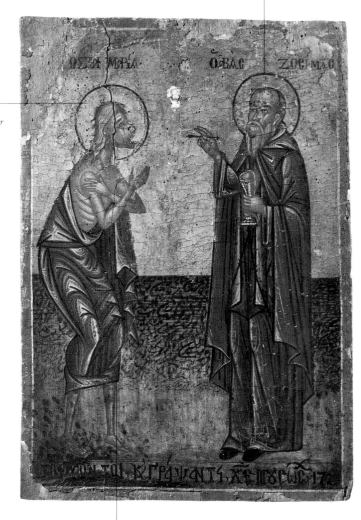

▲ The Communion of Saint Mary of Egypt, originally from Trebizond, 1723. Paris, private collection.

The ceruse marks on Saint Mary of Egypt's hair, skin, and clothing show that her being has been entirely transformed by the uncreated light of divine Grace.

*Father of monasticism, he is famous for his "temptations," which inspired many stories and works of art. His thoughts are collected in the* Sayings of the Desert Fathers.

# Anthony the Great

Born in 251 at Koma (today Memphis, Egypt), he was orphaned at the age of eighteen and retired to a hermitage for some twenty years. Here he suffered the famous temptations, near an ancient tomb in which he lived. Though the other hermits of the Thebaid saw him as their leader, he gave them no precise rules but only concrete advice. Anthony taught by example as a simple *abba*, a man of God. From his concise teachings were born the *Sayings (Apophtegmata) of the Desert Fathers*. Anthony left his isolation only twice: first, to help condemned prisoners in Alexandria during the persecutions of 311; and second, to fight the Arian heresy. He died in his retreat at age 105. Anthony's body was translated to Alexandria, then to Constantinople, and finally to Arles. The rule attributed to him was completed by his disciple Ammonas. The semi-anchoritic styles of living begun by Anthony were further developed by Pachomius and later on in Greek and Russian monasteries. A few years after his death, Saint Athanasius, patriarch of Alexandria, wrote a *Life* of Anthony in which we find the episode of the temptation: the demons in the form of animals represent the vices (fame, wealth, power, lust), which Anthony overcomes with the weapons of humility, sincerity, and brotherly charity.

**Texts**
"Associate yourself with a man who fears God, and if you stay close to him, you too will learn to fear God."
(*Sayings of the Desert Fathers*)

**Feast day**
January 17

**Life**
251–356

**Source**
Athanasius, *Life of Saint Anthony*

**Iconography**
Head covered by a simple monastic hood adorned with crosses, dark mantle, and lighter tunic, belted around the waist, with cross around the neck and staff; during the temptations, he is surrounded by wild, repulsive beasts representing demons

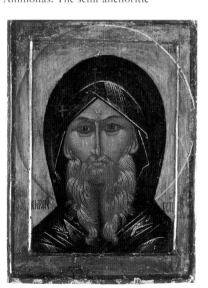

◄ *Saint Anthony the Great*, mid-sixteenth century. Moscow, State Historical Museum.

# Anthony the Great

Half-length Deesis of Saint Catherine, the Virgin, Christ the High Priest (center), John the Baptist, and Moses.

The vertical row features the priest Aron, followed by Melchisedek, Elijah, Elisha, and the hermit Onuphrius.

This vertical row includes Fathers of the Church and abbots of the Sinai Monastery. From the top: Basil the Great, John Chrysostom, Gregory of Nazianzus, John Climacus, and Anastasius of Sinai.

A horizontal row of martyred saints, all holding their crosses: Eustratius, Auxentius, Eugene, Mardarius, and Orestes.

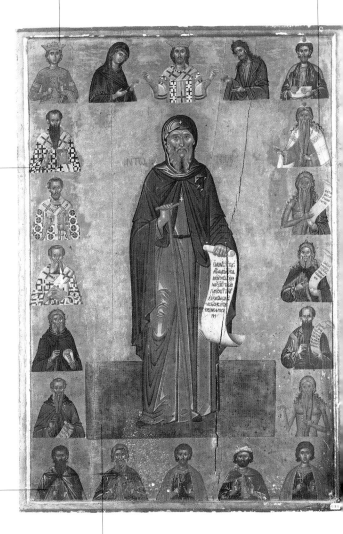

▲ Priest Demetrios, *Saint Anthony with Busts of Saints*, late fifteenth–early sixteenth century. Mount Sinai, Monastery of Saint Catherine.

The green rectangle represents the garden of paradise, on which Anthony's strong, serene figure stands, his head wrapped in his hood. In his hands are a scroll and a staff shaped like the Greek letter tau, a symbol of his monastic authority.

In red on gold, one reads, from left to right, the inscription: "Saint Anthony."

The short, prominent nose, serene, penetrating eyes, strong-willed features, and symmetrical beard accentuate the severe austerity of the abbot's face.

He is wearing a dark red mantle, brown sleeves, and lead-colored hood, whose ends fall onto his shoulder in a geometrical composition of drapery.

The scroll alludes to the famous temptations the saint overcame. It reads, "I saw the devil's traps laid out on the ground."

In white Greek lettering, we read the artist's signature: "[By the] hand of Michael Damaskenos."

▲ Michael Damaskenos, *Saint Anthony*, second half of sixteenth century. Athens, Byzantine Museum.

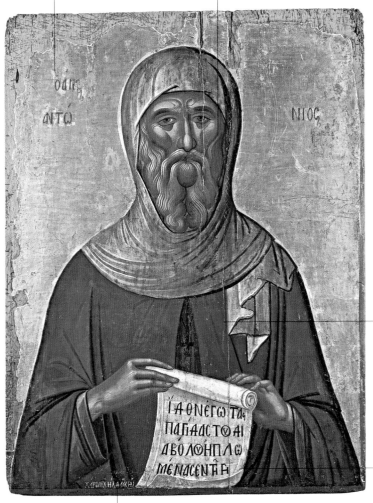

The demons tempting Anthony take on the forms of ferocious beasts, snakes, and even a scorpion menacing his life.

The temptations occur at night: the hills with their houses rest in green shadow, while the rocks of the desert in which Anthony lives are illuminated with the glow of his vision.

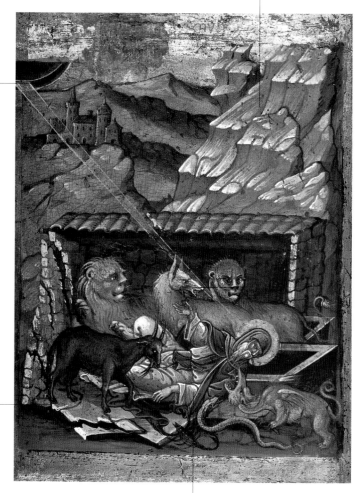

Prey to wrenching physical pain, Anthony lies contorted on the ground. But his spirit is sustained by a ray descending on him from heaven and he manages to master his fear and overcome the demons.

▲ Cretan painter, *The Temptation of Saint Anthony the Great*, fragment from *Saint Anthony with Scenes from His Life*, seventeenth century. Belgrade, National Museum.

The walls of Anthony's hut are falling apart, as though damaged by a strong earthquake.

*Called "God's Harp" for the suggestive beauty of his hymns, he*
*was the first to introduce female voices into the liturgy. He was*
*canonized in 1920 by the Catholic Church as well.*

# Ephraim the Syrian

The works of this Doctor of the Church and theologian-poet,
composed in Syriac, were quickly translated into many lan-
guages. Ephraim (or Ephrem) wrote prose commentaries on the
scriptures and composed hymns in verse to be sung by the
faithful. In particular, he wrote music for the female voice,
whose timbre is essential to the liturgical chanting of lauds.
Ephraim's teaching defended the virginity of Mary and the
veracity of Christ's dual nature, human and divine. He fought
the Gnostics and exalted freedom as the most precious gift God
gave to man. While emphasizing that an abyss separated the
Creator from the creature, Ephraim recalled that in the incar-
nation God assumed human flesh, voice, and appearance so
that we could see and hear him. In his hymns, he asserts that
God gave us three harps to let us hear his ineffable voice:
Moses, Christ, and
nature. People and
things, in short, bear the
imprint of the real but
hidden presence of the
Creator. For example, to
Ephraim a simple bird in
flight, with its open
wings, recalls the cross
and the power of its
sacred wood, the tree of
life: the bird flies because
it spreads its wings wide
open, like Jesus on the
cross. For these sublime
perceptions, Ephraim was
nicknamed "God's
Harp."

**Text**
"Truth is described in few
words; do not attempt any
great search for it. Take
refuge in silence!"
(Ephraim the Syrian)

**Title**
Deacon and Doctor of the
Church; "God's Harp"

**Feast day**
January 28

**Life**
Nisibis 306/307–373
Edessa

**Iconography**
Dormition of Saint
Ephraim: In the desert
grottoes near Thebes, the
monks hasten to the saint's
obsequies under a large
icon of the Virgin; a monk
feeds a stylite, handing him
food in a basket; around
the desert are trees such as
palms and cypresses, as
well as small wild animals.

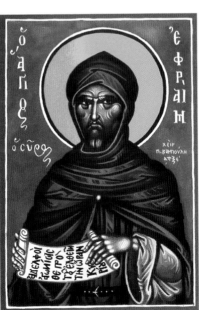

◄ Petros Vampoulis,
*Ephraim the Syrian*, 1965.

331

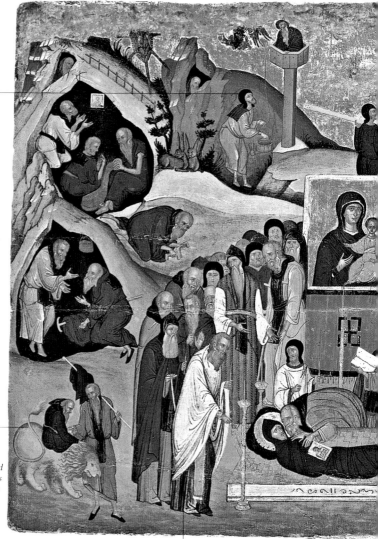

A monk offers food to a pillar saint (stylite) who, atop his column, sees an angel carrying the soul of Saint Ephraim to heaven. At the center, we see a monk carrying a wooden plank on his shoulder: this is the liturgical sematron, which is struck with a hammer like a bell, to announce the death of the saint.

A tame lion, two gray lynxes (above, resembling rabbits), and a few small palms and cypresses are the only signs of life in the desert.

▲ *The Dormition of Saint Ephraim the Syrian* (detail), 1457. Athens, Byzantine Museum.

The deacon censes the saint's body while the lector and cantor, kneeling under the icon of the Virgin, begin the funeral rite. Among the monks we see the hegoumenoi (abbots), distinguishable by their T-shaped staffs.

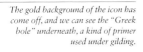

The gold background of the icon has come off, and we can see the "Greek bole" underneath, a kind of primer used under gilding.

In the grottoes of the Egyptian Thebaid, monks pray, write, and produce small wooden objects such as ladles and spoons.

Infirm monks are carried on litters, on muleback, or even on the backs of their fellow monks.

Laid out between four candlesticks and wrapped in funeral bands, Ephraim's body is kissed and venerated by his brother monks. On the saint's breast we see a small icon of the Man of Sorrows.

*The Ladder of Divine Ascent is an ascetic text that uses the biblical image of Jacob's Ladder. The thirty steps represent the different stages of monastic asceticism.*

# John Climacus

**Text**
"That all might attain complete detachment is impossible, but that all may be saved and reconciled with God is not impossible." (John Climacus)

**Title**
John of the Ladder (*Climacus, Klimakos, Lestvichnik*)

**Feast day**
March 30

**Life**
Seventh century

**Source**
John Climacus, *The Ladder of Divine Ascent*

**Iconography**
John Climacus in monastic robes, holding a scroll of his work, points his disciples to the ladder that leads to heaven

At age sixteen John Climacus (from *klimax*, "ladder" in Greek) entered the Monastery of Saint Catherine in Sinai, where he became a monk and then an abbot. At an advanced age he passed the leadership of the monastery on to his brother George and went back to living in solitude. He died sometime between 650 and 680. At the Sinai Monastery he wrote the mystical work for which he is famous, *The Ladder of Divine Ascent* (or *Heavenly Ladder*), taken from the biblical vision of Jacob, who saw a ladder come down from the heavens with angels on it. In this treatise, John Climacus describes a solid, sure path for his monks to follow, made up of thirty small treatises (*logoi*), later called steps, corresponding to the number of years that Christ lived on earth. By the eleventh century illuminated versions of *The Ladder of Divine Ascent* often showed not only monks making their way to the top and crowned by angels, but also others being dragged down to hell by demons. The theme of the spiritual ladder thus became contaminated by folk sources, which often emphazied the negative.

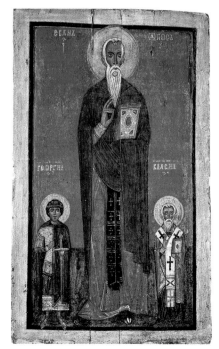

▶ Novgorod school, *Saints John Climacus, George, and Blaise of Sebaste*, second half of thirteenth century. Saint Petersburg, Russian Museum.

In the meadow of heaven, prophets, apostles, hermits, and Holy Fathers cheer on the climbing monks, while the angels fly down to crown them.

Mary, John the Baptist, and two angels look on as the gates of heaven open and Christ seizes the wrist of a monk who has reached the final rung.

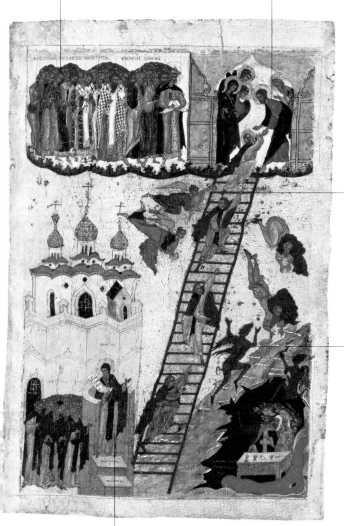

There are thirty rungs on the ladder.

Demons drag monks down into the pit, where they are swallowed up by the monster of hell.

Saint John Climacus at the pulpit, holding a scroll with the text of The Ladder of Divine Ascent, shows his monks the way. Behind him is an image of the Sinai Monastery.

▲ Novgorod school, *The Ladder of Divine Ascent*, mid-sixteenth century. Saint Petersburg, Russian Museum.

*Columns belong to pagan symbolism, since they used to have statues of idols at their summits. The stylites transformed them into places of Christian edification and sanctification.*

# Stylites (Pillar Saints)

**Text**
"Since God became man, man can become God. He lifts himself up with divine ascension in the same way that God humbled himself out of love for mankind." (Maximus Confessor)

**Title**
Pillar saints (*Stylitai, Stolpniki*)

**Feast days**
Symeon Stylite the Younger, May 24; Symeon Stylite the Elder, January 5, September 1

**Lives**
Symeon the Elder, Cilicia 390–459; Symeon the Younger, Antioch 521–592

**Sources**
Theodoretus of Cyrus; John of Damascus; Evagrius Scholasticus; John Moschus

Stylitism is one of the more extreme and original forms of Eastern Christian asceticism. The stylites' pillars stood near monasteries or villages, were usually ten to twenty meters high, and were equipped with a balcony, parapet, and roofing. Food was hoisted up to them. The stylite's relationship with society was an intense one: from atop his column, he would give advice, resolve disputes, preach, and celebrate mass. Stylitism spread from the fifth to the fourteenth centuries throughout the Byzantine Empire and into Russia. The most famous stylite, or pillar hermit, was Saint Symeon Stylite the Elder, who remained atop his column for twenty-seven years, performing miracles and conversions, especially among Arabs. His pillar stood at Qal'at Sim'an, near Antioch, in Syria. Another Stylite was Symeon the Younger, a native of Antioch. He founded a monastery near Antioch, at a place he called the Wondrous Mountain (*Thaumaston Oros*). He climbed the pillar at its center in 551 and became a priest in 554. Archaeologists have unearthed the remains of the monastery as well as the pillar atop which Symeon the Younger spent forty-four years.

► *Saint Daniel the Stylite* (detail), originally from the Therapon Monastery, iconostasis of the Cathedral of the Nativity of the Virgin, early sixteenth century. Kirillov (Russia), Cyrillo-Belozersk Monastery Museum.

Christ hands the Word of God, written on the scrolls in Arabic characters (the icon is Lebanese), to the two pillar saints, who in turn will communicate it to the people.

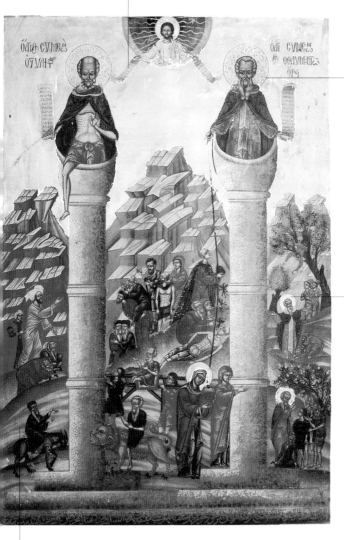

Atop his column, Simeon the Younger lowers his basket and receives food from a woman saint.

The stylite has descended from his pillar to heal and work miracles among the people.

Many sick people are being carried on people's backs or on litters; a hermit rides on the back of a lion; and there is an Arab with his servant. Symeon the Elder converted many pagan Arabs, and this icon's dedication is in Arabic.

▲ Nemeh of Aleppo, *Saint Symeon the Stylite and Saint Symeon of the Wondrous Mountain*, 1699. Balamand (Lebanon), Our Lady of Balamand Monastery.

# Stylites (Pillar Saints)

Top tier: Symeon is blessed in front of the icon; the stylite chains himself to a rock and climbs on top; performs acts of healing; presents himself in chains to the abbot.

The architecture of the column is complex, with an internal staircase, covered terrace and balconies, and ropes for hoisting food. The base of the upper balcony is enveloped by a dark cloud.

Left and right down the sides: He lives in a well with serpents; is put to the test; cures a possessed person from atop his column; blesses a dead mother; heals a woman bitten by a viper; heals a pregnant hind; the brigand Jonathan repents and dies under his pillar; the soldiers of Antioch claim his body.

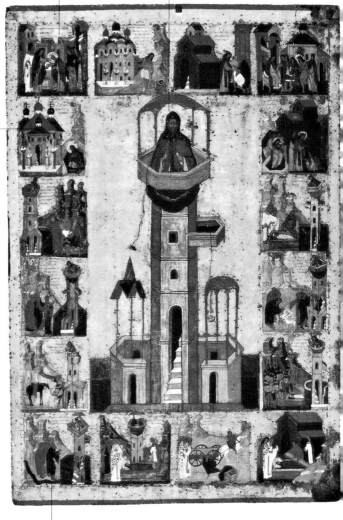

▲ *Saint Symeon the Stylite with Scenes from His Life*, from the local tier of the iconostasis, second half of fifteenth century. Ustiug (Russia), Church of Saint Symeon the Stylite.

Bottom tier: Symeon preaches from his pillar; his dead body is removed from the column in the presence of a bishop; a deaf-mute beside his funeral cart is healed; the translation of the saint's relics to the church of Antioch.

*He defended the orthodoxy of images against Emperor Leo III. Many monks persecuted by Arabs found refuge at his Studios Monastery in Constantinople.*

# Theodore the Studite

He and his entire family embraced the monastic life, following the example of his brother Plato: a measure of the passion that motivated defenders of the cult of icons and the Orthodox faith against Iconoclast attack. With the help of his brother Plato and Empress Irene, Theodore restored the famous Studios (or Studium) Monastery in Constantinople and instituted a monastic reform that would come to be called the Studite reform. Of particular interest at the Studios Monastery was the active school of calligraphy, which led to the transition from majuscule to minuscule script in book production. The Studios Monastery played an important role in the defense of icons during the Iconoclast struggle unleashed by Leo III the Isaurian. Theodore was arrested in 815 and exiled to Asia Minor. Together with his monks he founded many settlements on the Asian continent and the Princes' Islands (Kizil Adalar), near Constantinople, where he died in 826. His mortal remains were transferred to the Studios Monastery after the Council of Constantinople reestablished Orthodoxy and the cult of images in 843. In exile, Theodore wrote the famous *Treatise* in defense of holy images.

**Text**
"I do not worship the icon as God, but through the icon and the saints I offer God adoration and veneration, and as a result, piety, piety and honor to his friends as well." (Sacred author)

**Title**
The Studite, of Studios or Studium

**Feast day**
November 11

**Life**
Constantinople 759–826
Asia Minor

**Sources**
Theophanes the Confessor, *Chronicle*; Theodore the Studite, *On the Holy Icons*

**Iconography**
Theodore the Studite with monastic stole and scroll in front of the Studios Monastery

◄ Saints Theodore the Studite, Theodosius the Great(?), and Ephraim the Syrian, Velikij Novgorod, Icons Gallery, Novgorod State Musem Reservation.

Empress Theodora with her young son Michael.
On the other side are the patriarch Methodius
with icondule monks carrying the cross and books
of the true doctrine. In the middle, between two
angels, is the icon of the Mother of God.

The scene is
divided into two
registers and
represents the
Council of
Constantinople
of 843.

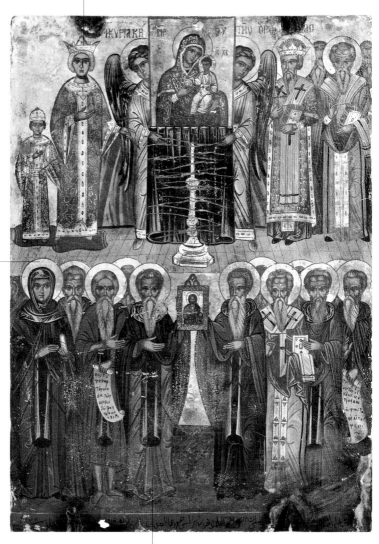

▲ Ananias of Aleppo, *The Triumph of
Orthodoxy*, 1772. Balamand (Lebanon),
Our Lady of Balamand Monastery.

Saints Theophanes and Theodore the
Studite, surrounded by other holy monks
and a bishop, hold up for the faithful an
icon of Christ Pantokrator.

*He is the patron saint of Bulgaria, where he founded monasteries independent of the centers of political and religious power.*

# John of Rila

Brought to Bulgaria by Clement and Naum, Christianity, officially recognized in 865, gave rise to the great monastic centers of Preslav (Bulgaria) and Ohrid (Macedonia), which had ties to the reigning dynasty. Meanwhile, in the wild Rila Mountains, a hermit named John (Ivan) was founding what would become the most important monastery in Bulgaria. His many miracles made him popular in his own lifetime. John of Rila was able to combine the ascetic principles of the early Christian era with a notion of poverty and self-denial similar to that of Saint Francis of Assisi. Soon other monasteries based on the Rila model were founded in uninhabited areas; some Bulgarian monks then moved on to Mount Athos, where the Zographou Monastery was founded. The icon of John still in the Rila Monastery is one of the most ancient portraits we have of its holy founder. Over his orange tunic, he is wearing a black *omophorion* adorned with crosses (the great *schema* of monastic seclusion) and a brown cloak. In one hand he holds a cross, and in the other, a scroll. John wrote *The Testament*, explaining his sense of spirituality. It would contribute to the rise, in the fourteenth century, of the Hesychasm of Gregory Palamas.

**Text**
"In the union with God, the heart absorbs the Lord, and the Lord the heart, and the two become one." (John Chrysostom)

**Feast day**
October 19

**Life**
876–946

**Source**
John of Rila, *The Testament*

**Iconography**
John of Rila wearing a broad stole called a *schema*, signifying withdrawal from the world; his hood is drawn back from his bare head, and he is holding a cross and scroll in his hands

◄ *Saint John of Rila* (detail), fourteenth century. Bulgaria, National Museum of the Rila Monastery.

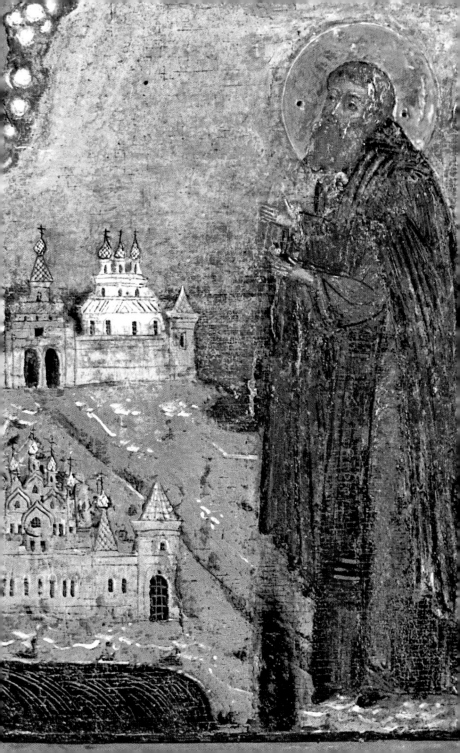

# RUSSIAN SAINTS

*Boris and Gleb*
*Princes and Metropolitans*
*Procopius of Ustiug*
*Anthony the Roman*
*Sergius of Radonezh*
*Blessed Iconographers*
*Hermits of the North*
*Basil the Blessed*
*Founders of Monasteries*
*Seraphim of Sarov*

◄ *The Blessed Paisius* (detail), Russian,
seventeenth century. Frankfurt, Von
Mauchenheim Collection.

*Portrayed on horseback or on foot, with swords and princely dress, they are considered the first Russian martyrs, having died to allow their elder brother to accede to the throne.*

# Boris and Gleb

**Text**
"Either man is the angel of light, the icon of God, his likeness, or he bears the image of the beast and becomes an ape." (Pavel Evdokimov)

**Title**
Passion-Bearers (*Strastoterptsy*)

**Feast days**
Boris, July 24; Gleb, September 25; translation of the relics, May 2 (1072)

**Source**
*Narration (Skazanie) about Boris and Gleb*

**Iconography**
They are standing full length, or often on horseback in profile, wearing their traditional princely garb; Boris has a beard, while Gleb, the younger, is beardless

They are known by their pagan names of Boris and Gleb, but their Christian names are Roman and David. The younger sons of Prince Vladimir of Kiev, who initiated the spread of Christianity among the East Slavs in 988, they were put to death by their elder brother Sviatopolk for having been appointed heirs to the throne by their father. In 1019, to avenge their death, Prince Yaroslav defeated Sviatopolk and recaptured Kiev; in 1020 he reunited the relics of Boris and Gleb in the church of Saint Basil at Vyshgorod. Boris and Gleb were canonized in 1051, and by the end of the eleventh century their cult had reached Constantinople, where an icon of the two brothers was exhibited in Hagia Sophia. Both were considered martyrs, not for being direct witnesses of the faith, but for submitting to their brother's violence, accepting death in order to respect the principle of seniority (which required that the younger brothers submit to the elder). In so doing, Boris and Gleb spared the nascent Russian state a civil war. If the baptism of the Slavic people in the waters of the Dnieper was bloodless, with Boris and Gleb, Russia was baptized in innocent blood.

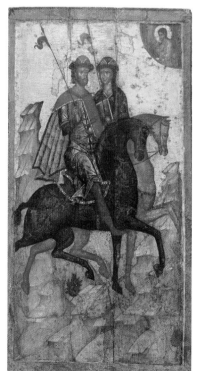

▶ *Saints Boris and Gleb on Horseback*, 1340. Moscow, Tretyakov Gallery.

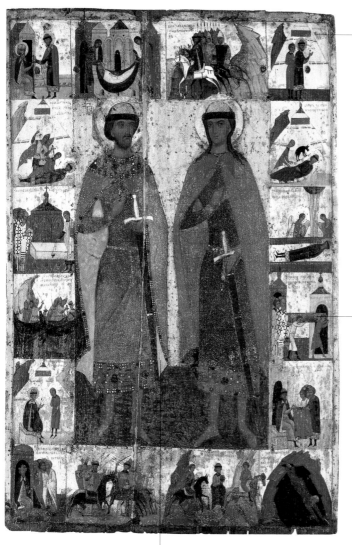

Top tier: *Prince
Vladimir sends Boris
to fight the Pechenegs;
Vladimir is buried;
Boris returns from the
war; Boris prays in his
tent. Right to left
down both sides:
Death appears to
Boris as a dog in a
dream; Boris is killed
in his tent; is laid out;
is buried.*

Left to right: *Gleb is
killed in a boat; transla-
tion of Gleb's mortal
remains. Bottom tier:
Battle between Yaroslav
and Sviatopolk;
Sviatopolk dies and is
cast into the abyss of
the earth.*

▲ *Saints Boris and Gleb with Scenes from
Their Lives*, second half of fourteenth
century. Moscow, Tretyakov Gallery.

*Dressed in fine clothing, the warrior-
princes Boris and Gleb hold their
swords with their left hands, while
their right hands hold the crosses of
martyrdom to their breasts.*

*In the Orthodox pantheon, there are four Muscovite saints corresponding to the four Byzantine hierarchs, and numerous princes and princesses, champions of lay holiness.*

# Princes and Metropolitans

**Text**
"Sovereign, I cannot obey
your command over that of
God. The earth belongs to
God, as does its fulfillment.
Like my predecessors, I too
am only a wayfarer and
pilgrim on this earth."
(Metropolitan Philip
Kolychev)

**Title**
*Blagovernye* ("of good
faith")

**Feast day**
Peter, Alexis, Jonah, and
Philip, October 5

**Terms as Metropolitan**
Peter 1308–26
Alexis 1354–78
Jonah 1449–61
Philip 1566–69

While the holiness of the Byzantine emperors was associated with the theocratic ideal, that of the Russian prince derived from his military prowess. First among the princes who fought for the freedom of Holy Russia was Alexander Nevskii (1220–1263), who battled the Tatars, the Swedes, and the Teutonic knights. Every bishop in the Eastern Church was also a monk, combining princely and ascetic qualities. The metropolitans of the pre-Mongolian period were strong enough to oppose secular power, but with the advent of the tsars, princely holiness went into decline. The four great Russian hierarchs, metropolitans of Moscow, were Saints Peter (metropolitan from 1308 to 1326), Alexis (1354–78), Jonah (1449–61), and Philip (1566–69), counterparts to the four Byzantine hierarchs (Basil, Gregory of Nyssa, Gregory of Nazianzus, and John Chrysostom). Alexis was active politically and diplomatically, excommunicating rebel princes and ensuring a Russian victory against the Tatars at Kulikovo. The most beloved Russian metropolitan was Philip Kolychev, but when he dared to defy Ivan the Terrible, he was deposed, exiled to the Otrok Monastery near Tver, and finally assassinated in 1569.

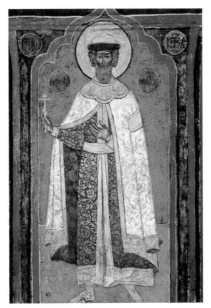

▶ *Prince Alexander Nevskii,* fresco, seventeenth century. Moscow, Kremlin, Cathedral of the Archangel Michael.

Wearing princely garb, Boris holds a
typical three-armed Byzantine cross,
symbol of his martyrdom.

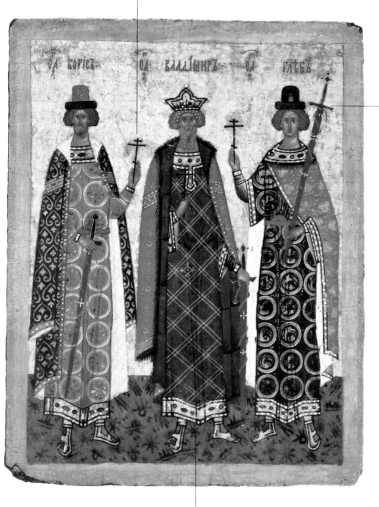

Gleb holds the
sword over his
head to indicate
his renunciation
of violence in
favor of the
cross.

▲ *Saint Vladimir between Saints
Boris and Gleb*, late fifteenth century.
Novgorod (Russia), museum.

*Vladimir, in royal raiment with fur cloak
and crown, is flanked by his two sons.
The grassy meadow they are standing in
represents heaven.*

# Princes and Metropolitans

Top tier: Alexis is born; is entrusted to a
tutor; has a vision of his vocation; enters
the monastery; is named bishop of
Vladimir; meets with the Tatar khan
(on the right, dressed in red).

Alexis wearing the white klobuk on his
head, and the cross-adorned omophorion
over his liturgical vestment.

Left to right
down both sides:
Alexis meets
Sergius of
Radonezh; he
blesses the abbot
Andronicus;
prays before
the tomb of
Metropolitan
Peter; meets with
the khan; cures
the khan's wife;
returns to
Moscow; names
Saint Sergius as
Andronicus's
successor; has his
tomb prepared.

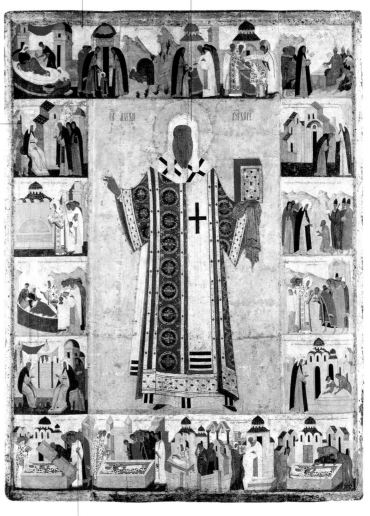

▲ Dionysius and assistants,
*Metropolitan Alexis with Scenes
from His Life*, late fifteenth century.
Moscow, Tretyakov Gallery.

Bottom tier: Alexis is buried; the body is disinterred; a
boy is brought back to life over his tomb; a woman
cured of her blindness donates an icon of Alexis to his
successor; the monk Naum is cured.

The Holy Face, "not made by human hands," on a cloth held up by an angel.

The words in cinnabar say: "Saint Peter the Metropolitan; Saint Alexis the Metropolitan; Saint Jonah of Moscow; Philip the Metropolitan."

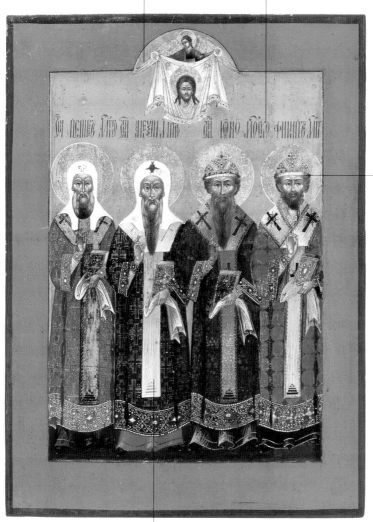

From the left: Peter and Alexis are wearing the klobuk, *the first with a cross on it, the second with a seraph; Jonah and Philip wear miters adorned with precious gems.*

▲ *The Sainted Metropolitans of Moscow, Intercessors for All of Russia*, originally from Saint Petersburg, early nineteenth century. Vicenza (Italy), Gallerie di Palazzo Leoni Montanari, Banca Intesa Collection.

Each of the brightly colored green, yellow, red, and violet stoles, all adorned with crosses, has three marks at the bottom, which stand for the office of bishop.

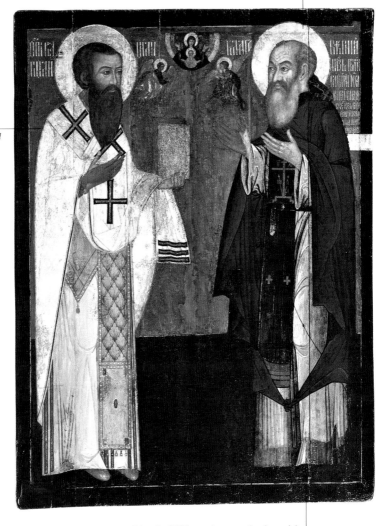

The face of Basil III, crowned with
a nimbus, is a faithful portrait of
the monk-prince.

*The bishop Basil
is wearing the
white episcopal*
sakkos, *along
with the typical*
omophorion
*with crosses,
folded over his
arm.*

Prince Basil III is wearing monastic robes and the
great schema *on his chest, which stands for the
sacred nature of imperial authority. With a saintly
halo around his head, the prince receives the
Gospel from Saint Basil.*

▲ *Saint Basil of Caesaria and Prince Basil-
Barlaam,* first half of sixteenth century.
Moscow, Kremlin, Cathedral of the
Archangel Michael.

*In Russia, the worship of princely saints was followed by the cult of "fools for Christ," a lay form of holiness among whose first adepts was a German merchant in Novgorod.*

# *Procopius of Ustiug*

The holiness of the "fools for Christ" derives from the words of Paul: "God chose what is foolish in the world to shame the wise" (1 Corinthians 1:27). The Greek Church worships six such *saloi*, including Simeon (died 550) and Andrew the Fool (880–946). Although his biography often spills over into legend, Procopius of Ustiug is considered the first "fool for Christ" in Slavic lands. A German merchant who spoke Latin, he brought this special form of asceticism, which fought spiritual pride by seeking the scorn of one's fellow man, to Russia in the thirteenth century. Feigned idiocy and madness were combined with a kind of preaching, conveyed more through actions than words, and accompanied often by a gift for prophecy. According to a *Life* of Procopius written in the sixteenth century, he converted to Orthodoxy from Catholicism, lived at the Khutyn Monastery founded by Saint Barlaam, then withdrew to the forests of Ustiug, despised by everyone. He famously prophesied that a meteor shower would threaten Ustiug. Procopius was buried, as he wished, on the banks of the Sukhona River. Decades after his death in 1302 a chapel was built on the spot, soon followed by a church, which was consecrated in 1461 after the saint miraculously intervened to save the Ustiug army from an epidemic.

**Text**
"Strange men who walk along the roads, hair scattered in the wind, iron chains around their necks, wearing no other clothing than a piece of sackcloth around the hips…"
(Sixteenth-century traveler to Russia)

**Title**
Fools for Christ (*Saloi, Iurodivye*)

**Feast days**
Procopius of Ustiug, July 8;
Barlaam of Khutyn,
November 6

**Lives**
Simeon the Fool, d. ca. 550; Andrew the Fool, 880–946; Procopius of Ustiug, d. 1302, canonized by Pius II in 1460 and by the Council of Moscow in 1547

**Sources**
1 Corinthians 1:18–31, 2:1–9; *Life* (sixteenth century)

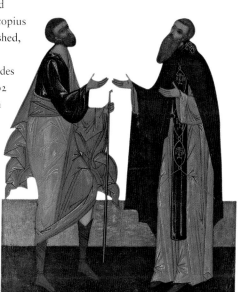

◄ *Saints Procopius of Ustiug and Barlaam of Khutyn* (detail), late sixteenth–early seventeenth century. Arkhangelsk (Russia), Museum of Fine Arts.

351

# Procopius of Ustiug

Top row: Procopius arrives in Ustiug; prays to the icon of the Virgin; preaches penance; is not heeded; a cloud of fire encircles the city; the inhabitants pray inside the cathedral; a light emanates from the icon of the Annunciation.

Left to right down both sides: A hail of meteorites over Ustiug; the icon cures some paralytics; Procopius prays outside the city; Procopius dies; he is buried; a rustic chapel is built for him; a paralytic is cured near his tomb; a man possessed is cured; an irreligious servant of the governor dies; a sumptuous tomb is built for him. Bottom row: the godless man's body is removed; the tomb of Saint Procopius replaces it; the governor prays over the saint's tomb.

Final panels: The paralyzed adolescent Pantaleimon is cured; the boy Fedor recovers his sight; Salome prays at the tomb; Domitian, a paralyzed priest, is cured.

▲ *Saint Procopius of Ustiug with Scenes from His Life*, 1602 (dated 7110, according to the Byzantine calendar). Velikii Ustiug (Russia), iconostasis of the Cathedral of Saint Procopius.

Two angels, their hands covered out of
respect, bend forward to receive
Procopius's soul and take it to heaven.

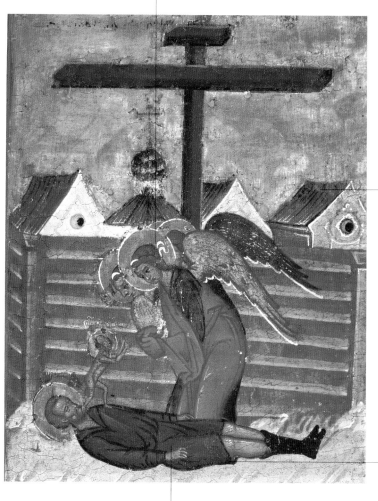

We see the
rooftops of the
city and the
dome of the
Monastery of
Saint Michael
with a small
cross on top.

Procopius
always wears a
simple tunic
and half-length
boots.

▲ *Death of Saint Procopius of Ustiug*,
scene from the icon on the facing page.

Outside the city, in front of the fence of
the Monastery of Saint Michael the
Archangel, Procopius was praying at the
foot of the cross before he lay down to
die in the snow.

*Born in Rome, he became one of the fathers of Russian monasticism. During the schism between East and West, he sought to preserve the true tradition of a single, undivided Church.*

# Anthony the Roman

**Text**
"The need to have icon before one's eyes arises from the concrete religious feeling that is not satisfied with only spiritual contemplation, but also seeks an immediate, sensory proximity, as is natural for man, who is made up of body and soul." (Sergei Bulgakov)

**Title**
Blessed Anthony the Roman, monk

**Feast day**
August 3

**Life**
Rome 1067–1147
Novgorod

**Iconography**
Anthony is wearing the great *schema*, which covers his head and hangs down to his knees; he is floating on a rock and holding a small model of the monastery he will found at Novgorod

The only account of his life says that Anthony was born in Rome in 1067 to a wealthy Greek Orthodox family. He became a monk at age 17 and remained faithful to the religion of his parents during the schism between the Catholic and Orthodox Churches, suffering numerous forms of persecution, including the destruction of his monastery. His legend tells that, when he withdrew to live in solitude on a ledge by the sea, the rock on which he was praying was torn away in a storm. But instead of sinking, it carried Anthony to shore near the Russian city of Novgorod, on the eve of the feast of the Virgin's Nativity in 1106. A few years later, in 1117, Anthony founded a monastery there. It still exists today and its codices and Latin inscriptions bear witness to the efforts this saintly monk made to keep the two traditions, Catholic and Orthodox, united. He died on

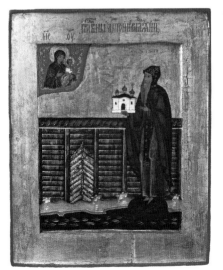

August 3, 1147, and the Russian Church, and especially that of Novgorod, set aside the day to honor his memory. His relics were rediscovered in 1597. In the icon reproduced on this page, Anthony, standing on a rock floating on the river, is about to arrive at the gates of Novgorod, under the beneficent gaze of the Virgin, to whom he presents a model of his church.

▶ *Saint Anthony the Roman,* seventeenth century. Saint Petersburg, Russian Museum.

*He is one of Russia's most popular and beloved saints. His vision of the Trinitarian mystery was translated into form and color by Andrei Rublev in his great* Trinity *icons.*

# Sergius of Radonezh

Sergius (Sergei) of Radonezh is the Saint Francis of the Russian people. He preached humility, penance, and brotherly love, performed miracles, and had mystical visions. Sergius was also the real architect of the spiritual and moral rebirth of the Russian people under the oppressive Tatar yoke. His support for Prince Dmitri Donskoi in the famous battle of Kulikovo was decisive. A worshiper of the mystery of the Trinity, whose cult he promoted, Sergius was also the first Russian saint to have a vision of the Mother of God, as we see in one of his icons. Sergius helped spread through Russia the Hesychast doctrine of Gregory Palamas, of fundamental importance in icon painting. Just a few years after his death, at the Lavra (Monastery) of the Trinity, under Sergius's successor, Nikon, the monk Andrei Rublev painted the icon of the Trinity (page 70), a theological and spiritual synthesis of Sergius's teachings, later held up as a model by the Church Council "of the Hundred Chapters" in Moscow. Since icon painting presupposes a profoundly spiritual, ascetic lifestyle, icons maintained a high level of visionary and contemplative mysticism as long as Sergius's influence prevailed. Once it waned, more allegorical and artificial representations became the norm.

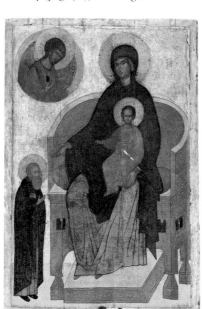

**Text**
"By contemplating the Holy Trinity we overcome the odious division of this world."
(Sergius of Radonezh)

**Title**
Abbot of the Holy Trinity Monastery near Moscow

**Feast day**
September 25

**Life**
1314–1392

**Source**
Epiphanius the Wise, *Life of Saint Sergius*

**Iconography**
Sergius of Radonezh is gripping an abbot's staff and wearing a brown monastic robe with hood, and a green stole, also with a hood (called the "great *schema*"); his face is framed by long, straight hair and a thick, rounded beard

◀ *The Virgin Enthroned with Saint Sergius of Radonezh*; early fifteenth century. Moscow, State Historical Museum.

Inside the green semicircle of the sky, the three angels of the Trinity appear in filigree. Underneath are the elegant buildings of Saint Sergius's Monastery of the Holy Trinity.

The red cloth joining the buildings indicates that the scene is taking place indoors, and that we are in the presence of God.

Accompanied by the apostles Peter and Paul, the Virgin appears in a vision to Saint Sergius and hands him the abbot's staff.

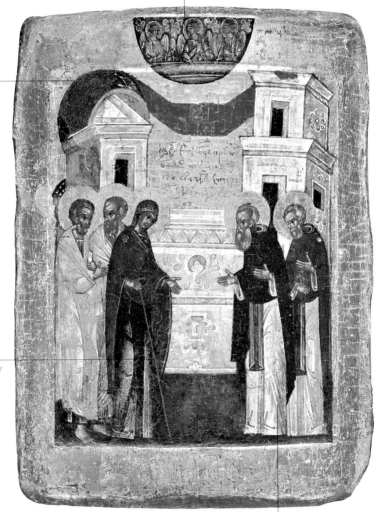

▲ *Apparition of the Virgin to Saint Sergius of Radonezh*, originally from Moscow or Pskov, sixteenth century. Vicenza (Italy), Gallerie di Palazzo Leoni Montanari, Banca Intesa Collection.

*Saint Sergius contemplates the vision, accompanied by the monk Nikon, who will become his successor, bowing humbly behind him.*

Top row: *Birth of Saint Sergius; the young Sergius is blessed; he is ordained a monk; he puts the demon to flight; is ordained deacon; is ordained abbot.*

*On the scroll are Saint Sergius's last words to his disciples: "Do not be sad, brothers, but rather preserve the purity of your bodies and souls, and love in a disinterested manner."*

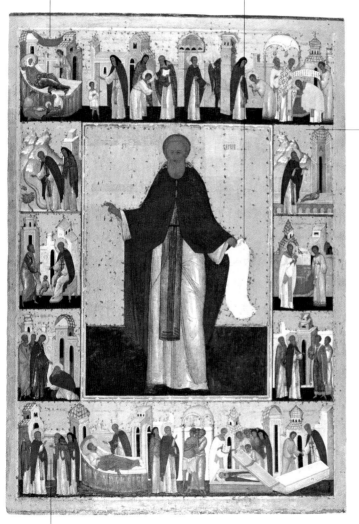

*Left to right down both sides: Saint Sergius makes a spring well up; he resuscitates a boy; gives him back to his father; has a vision of heavenly fire during the liturgy; has a vision of the Virgin; welcomes the messengers of patriarch Philotheus of Constantinople.*

*Bottom row: Saint Sergius heals an incredulous bishop; cures a sick man; and frees a man possessed by a demon; Saint Sergius is buried; a blind man recovers his sight near the saint's tomb.*

▲ Workshop of Theodosius, *Saint Sergius of Radonezh with Scenes from His Life*, ca. 1520. Moscow, Andrei Rublev Museum.

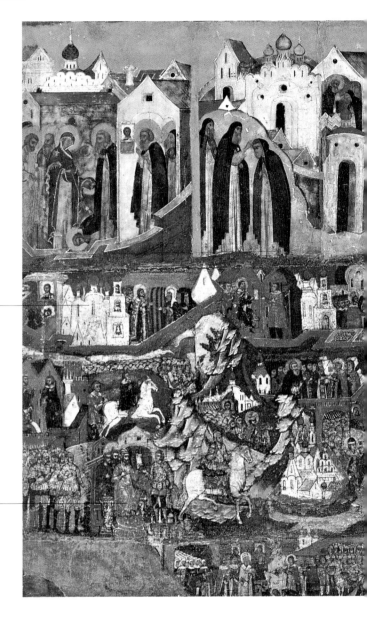

Monks in the monasteries pray for victory in the Battle of Kulikovo.

Prince Dmitri Donskoi sends and receives messages from allied cities.

▲ *Saint Sergius with Scenes from His Life, History, and the Battle of Kulikovo* (detail), first half of seventeenth century. Yaroslavl (Russia), Museum of Art.

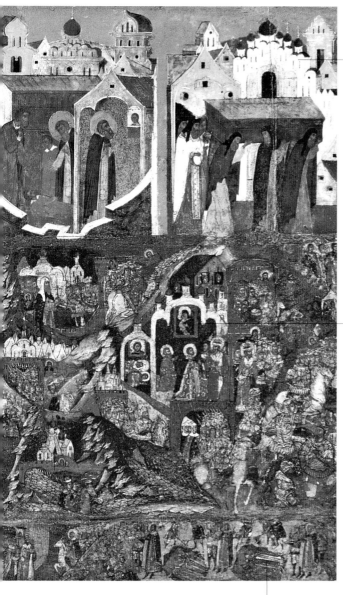

The large-format scenes present the last episodes in the life of Saint Sergius, from the vision of the Mother of God to his burial, set against picturesque architectural backgrounds. Below, in miniature, are the phases of the Battle of Kulikovo, in which the Tatars were defeated.

In the Russian towns, the field generals pray to icons for victory.

The armies of fortified towns ford rivers and unite on their march toward the Kulikovo (which means "Woodcock") camp, where they defeated the Tatars on September 8, 1380.

The battle dead are buried in common graves.

*Icon painting is a way to attain sainthood. Famous monk-painters include Theophanes the Greek and especially Andrei Rublev, who was canonized in 1988.*

# Blessed Iconographers

**Text**
"Through his great love for the ascetic and monastic life, Andrei Rublev was able to lift his mind and thought to the incorporeal, and to raise his sensible eye to the figures he painted."
(Joseph of Volokolamsk)

**Feast day**
July 4

**Life**
Andrei Rublev: died 1430, canonized 1988

**Sources**
Pachomius the Serb, *Life of Saint Nikon*; Joseph of Volokolamsk (the first collector of Rublev icons), *Responses (Otveshtanie)*; *Narration (Skazanie) about the Holy Icon-Painters* (seventeenth century)

Reviewing the history of icon painting, one finds few famous names among the artists. Indeed, icon painting is a religious gesture, a spiritual act entrusted to monks. Especially in the early centuries, there was no personal cult surrounding individual painters. Though not a sacrament in itself, the icon is considered a "sacramental" object, like the Gospels, the cross, and holy water, oil, and salt. The icon, moreover, is not painted but "written" (*zographos*, "icon painter," is related to *grapho*, "to write"), and the painter is considered an iconographer rather than an artist. However, though a monk, he often traveled for work and enjoyed a kind of "lay" autonomy. Some names therefore did emerge from the anonymity of the Church and the workshops, as a strong sense of personality emanated from certain styles, as in the case of the Blessed Theophanes the Greek and Andrei Rublev.

Theophanes worked at Novgorod and Moscow in the late fourteenth century, during the struggle against the Tatars. In 1405 (year 6913 "since the creation of the world," according to the Byzantine calendar), the abbot Nikon, successor of Saint Sergius, invited Danila Cherny and Andrei Rublev, two "masters inspired by God" (as sixteenth-century chroniclers called them), to paint icons and frescoes at the Holy Trinity Monastery. Russian director Andrei Tarkovskii's film *Andrei Rublev* recounts their life story.

► Gregory Krug, *Saint Gregory the Icon-Painter* (detail), twentieth century. Mesnil Saint-Denis (France), Ermitage du Saint-Esprit.

*In the vast, sparsely inhabited lands of the Volga, a great archipelago of monastic communities was born, the so-called Northern Thebaid.*

# Hermits of the North

The first hermit to evangelize the North of Russia was Demetrius of Prilutsk. He founded the monastery of Pereslavl and then that of Prilutsk, near Vologda, some five hundred miles from Moscow. Cyril (Kirill) of Belozersk, a disciple of Sergius of Radonezh, also founded a monastery in the Vologda region. His icon was painted in 1424 by another follower of Sergius, Dionysius of Glushitsa, who himself founded a monastery. The icon of Cyril, painted by Dionysius when the saint was still alive, portrays the saint's true features and gives us a sense of the charisma that his teacher, Saint Sergius, was also said to have: the attitude of goodness and understanding toward men that the Russians express in the term *sobornst* ("commonality"). Another hermit of the North, Stephen of Perm, a native of Velikii Ustiug, devoted himself to converting pagans, founding churches and monasteries, and painting icons. He was also a bishop. Paphnutius of Borovsk, from a converted Tatar family, became a monk under the guidance of Abbot Nicetas (another disciple of Saint Sergius) and, after a period of solitude in the forest, founded the Borovsk Monastery, where his relics now lie.

**Text**
"Like a sun your life has shone in the eyes of the faithless, and with the same light it illuminates us as we honor your memory."
(Troparion of the feast day)

**Feast day**
Paphnutius of Borovsk,
May 1

**Lives**
Demetrius of Prilutsk,
d. 1391; Cyril of Belozersk,
1337–1427; Stephen of
Perm, Velikii Ustiug
1340–1396 Moscow, canonized in 1547; Paphnutius
of Borovsk, d. 1477, canonized in 1540

**Source**
Macarius, *Life of Demetrius of Prilutsk*

**Iconography**
Stephen, Nicetas, and Paphnutius wear the great *schema*; Saint Cyril wears a simple monk's habit

◄ *Saint Stephen of Perm* (detail), Russian, second half of sixteenth century. Belgium, private collection.

*The oversized head stresses the importance of the face, which is a true portrait. The essential purity of the figure against the gold background expresses the glorious poverty of the monastic life.*

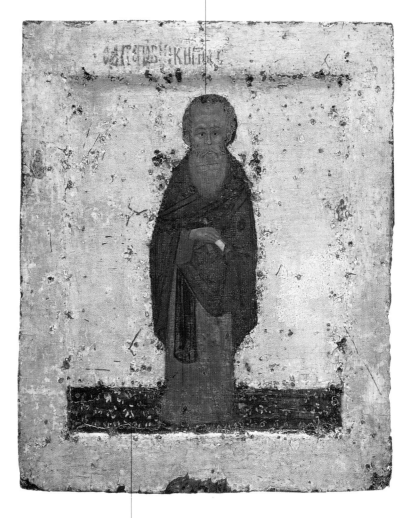

▲ Dionysius of Glushitsa, *Saint Cyril of Belozersk*, 1424. Moscow, Tretyakov Gallery.

*The inner dimension of the carved-out panel, the so-called cradle of the icon, is created by a simple horizontal rectangle, long and straight, the "spiritual meadow" on which the saint's feet rest.*

Top tier: Demetrius's monastic tonsure; his ordination as priest; he founds a monastery; converses with Sergius of Radonezh; meets with the grand prince Dmitri Donskoi.

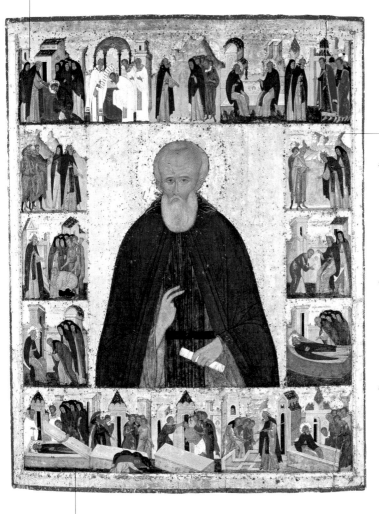

Left to right down both sides: Demetrius and his disciple Pachomius set out; peasants chase them away from the river Lezha; Demetrius prophesies Prince Dmitri Donskoi's death; he blesses his brother, a merchant dressed in red, who sets off to trade with the northern tribes; sensing his impending death, he designates Pachomius his successor; he dies.

Bottom tier: Saint Demetrius is buried; the archangel punishes thieves who robbed the monastery; a man possessed by the demon is healed near the tomb; the miraculous construction of the cathedral; healing beside the tomb.

▲ Dionysius, *Saint Demetrius of Prilutsk with Scenes from His Life*, early sixteenth century. Vologda (Russia), museum.

The monastery founded by Cyril is in the secluded region of Vologda, five hundred kilometers north of Moscow.

The white-stone Belfry of Ivan the Great, along with the architecture and wall of the Kremlin, appears transformed in the bright red light of the setting sun.

The Virgin appears to the sixty-year-old Cyril, predicting his death and showing him where he will be buried, near the White Lake (Beloe ozero). The dark cave in the rocky mountainside represents death.

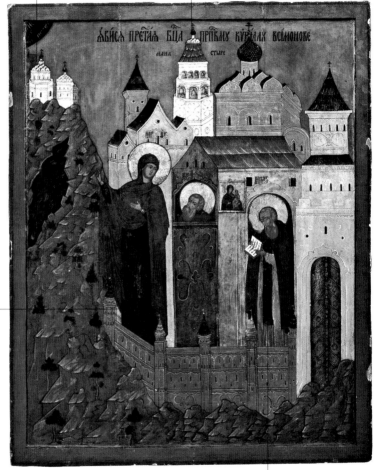

▲ *The Virgin Appears to Saint Cyril of Belozersk at the Simon Monastery,* originally from the Cyrillo-Belozersk Monastery, late eighteenth century. Vologda (Russia), museum.

At the Simon Monastery in Moscow, Cyril reads a sacred text and prays before an icon of the Virgin Hodegetria.

The monk's hood, with cross on top and glimmers of divine light in the folds, helps to highlight the deep, devout eyes, gazing into eternity.

The hollow cheeks, the result of long nocturnal vigils and fasting, are emphasized by the light strokes, which also highlight the long beard.

▲ *Saint Nicetas of Pereslavl*, seventeenth century. Moscow, Ecclesiastical Academy, Archaeological Cabinet.

Under his cloak, Saint Nicetas is wearing the great schema, *a black stole with crosses, indicating a vow of complete withdrawal from the world.*

This is probably a monastic icon destined for personal prayer; it is marked by a simple but intensely spiritual style.

Paphnutius is wearing the great schema, indicating the observance of strict monastic vows.

With his right hand, Paphnutius gives benediction, while in his left he holds a scroll with the last words he addresses to his brethren, "Do not grieve about this…"

▲ *Saint Paphnutius of Borovsk*, nineteenth century. Italy, private collection.

*The figure of the "fool for Christ," the holy vagabond who
wandered the country repeating the Jesus Prayer, was
immortalized by Pushkin and Tolstoy.*

# Basil the Blessed

The monastic experience in Russia took a peculiar form of holiness in the "fools for Christ," men who embraced the "folly" of the cross by leading lives of privation and prayer, seeking the disdain of their fellow men in a kind of voluntary, bloodless martyrdom. One of them, Basil the Blessed, became one of Moscow's most beloved saints. His mortal remains rest in the church in Red Square that bears his name, Saint Basil (though it is actually dedicated to the Protecting Veil of the Virgin). After leaving his father's home, Basil lived in the streets and city squares, often attending the liturgy, spending nights out in the open, in constant prayer, "without clothes or footwear, like the first man in Earthly Paradise, before original sin" (*Life*). The utter freedom of his way of life put him in contact with everyone, from the humblest of peasants to Tsar Ivan the Terrible himself, whom Basil accused of cruelty. To better understand this form of Russian sainthood, one must read *The Way of a Pilgrim*, the diary of a "fool for Christ" (*iuridovyi*) who, living on alms, traveled both cities and countryside, helping anyone he came across, forever repeating, under his breath, the Jesus Prayer. This anonymous text, published for the first time in 1870, has become a classic of modern spirituality.

**Text**
"Those who humbly choose what to the world looks like madness are clearly contemplating the wisdom of God himself."
(Gregory the Great)

**Title**
Basil the Blessed (*Vasilii Blazhennyi*)

**Life**
1464–1552, canonized in 1588

**Sources**
Russian *Menaia*

**Iconography**
Naked, with emaciated body, bristly hair, eyes and hands turned upward in a gesture of endless supplication, toward the Trinity or the Virgin, who appear in the open sky between clouds

◀ *Saint Basil the Blessed* (detail), late sixteenth century. Solvychegodsk (Russia), Museum of History and Art.

*The shading of the body brings out the luminous spirituality of Basil's transfigured flesh, while the whiteness of the Trinity's altar is reflected in his bristly hair.*

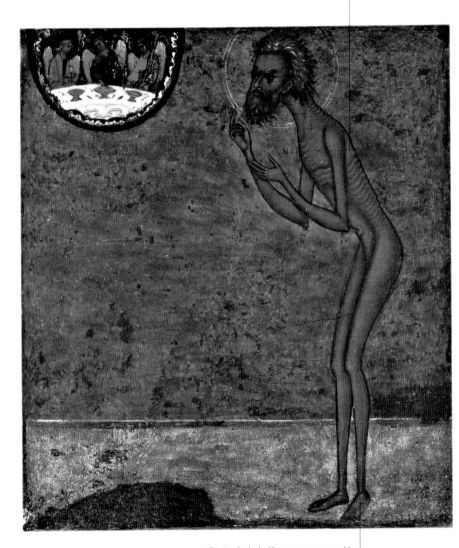

▲ Stroganov School, *Saint Basil the Blessed*, 1600. Moscow, Tretyakov Gallery.

*The Greek ideal of beauty seems negated by this rail-thin body, which makes the figure look more like an earthworm than a man. And yet this man touches heaven and sees the Trinity.*

*One of the most important events of Russian monasticism was the foundation of the Solovki Monastery in an archipelago on the White Sea.*

# Founders of Monasteries

Though they lie a mere 165 kilometers from the Arctic Circle, peculiar environmental conditions give the Solovetski islands a temperate climate that made it possible for monks to inhabit them and cultivate the land. The monk Sabbatius (Savvatii), originally from Cyril's Belozersk Monastery, was the first to inhabit one of these islands. After his death, he was succeeded by the hermit Zosimus, from the Barlaam Monastery, and the first monastic community sprang up around him. Considered the holy founders of the Solovki, on the largest island in the archipelago, Zosimus and Sabbatius are portrayed against the striking landscape around the monastic complex on the Holy Lake. The Solovki Monastery was rich and powerful under the abbot Philip, who later became metropolitan of Moscow and was killed by Ivan the Terrible. Transformed into a concentration camp by Stalin, it is now undergoing a religious renaissance. Another northern anchorite was Nilus, who, after taking his monastic vows in 1505 at Pskov, withdrew to the island of Stolbensk, on Lake Seliger (near Ostashkov, in Tver Province), where he lived for twenty-six years in solitude. The Stolbensk Monastery became a flourishing center of agriculture and fishing.

**Text**
"One must not doubt that the whole world owes the fact that it still exists to the prayers of monks."
(Rufinus of Aquileia)

**Feast days**
Sabbatius of Solovki, March 2; Nilus of Stolbensk, May 27

**Lives**
Sabbatius, died 1434; Zosimus, died 1478; Nilus of Stolbensk, took monastic vows at Pskov in 1505

**Iconography**
Zosimus and Sabbatius standing and interceding with the Virgin of Bogoliubovo, surrounded by monks from the Solovki Monastery, which appears in the background; they are also sometimes portrayed one in front of the other, offering the Virgin the monastery

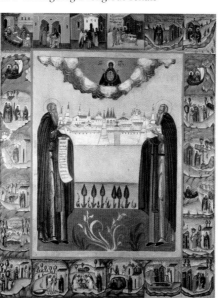

◀ Trans-Onega school, *Saints Zosimus and Sabbatius*, ca. 1759. Kizhi (Karelia, Russia), Church of the Transfiguration.

*Wearing the great schema of perpetual monastic asceticism, Saint Nilus offers his work up to Christ, who blesses it from the heavens.*

*Between the bell tower and sanctuary (both red, because they are sacred), and under the icon of Christ Emmanuel, lies the saint's lifeless body.*

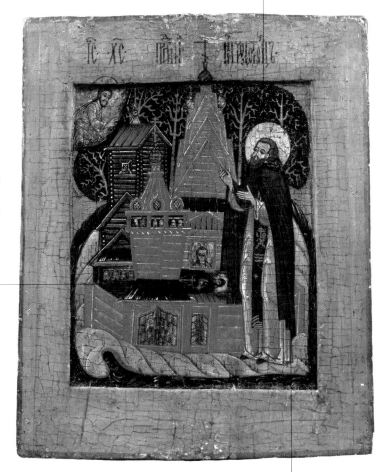

▲ *Saint Nilus of Stolbensk,* seventeenth century. Moscow, Kolomenskoe Museum.

*The icon shows in sketchy but realistic form the early monastery complex of Stolbensk, with its characteristic wooden architecture and towers. The site is surrounded by the waters of Lake Seliger and crowned by trees.*

*The writing on the icon says: "The blessed monk Sabbatius prays to the vision of the venerable and live-giving Cross of the Lord that appeared to him at the mountain named Orshina, [site of] the Monastery of the Holy Cross that is called now after his name Desert of Sabbatius."*

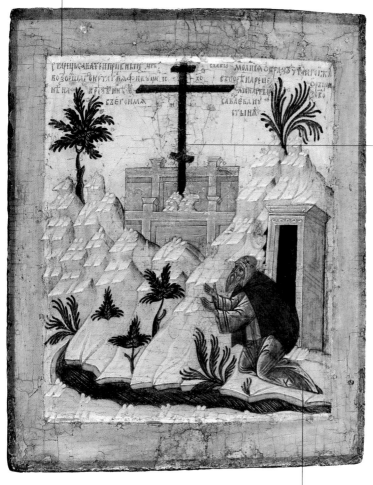

*The three-armed cross rises up from the stone of Calvary, between two walls that, like a dam, enclose the space between two mountains crowned by symbolic green trees. The abbreviated inscriptions next to the cross read "King of Glory" and "Jesus Christ Conquers."*

*The monk prays in front of his cell. The shrubs flourishing along the river and on the rocks show the fertility of the site, which by definition would be arid, were it not irrigated by the waters of Divine Grace.*

▲ Moscow school, *Saint Sabbatius of Tver*, mid-sixteenth century. Moscow, Andrei Rublev Museum.

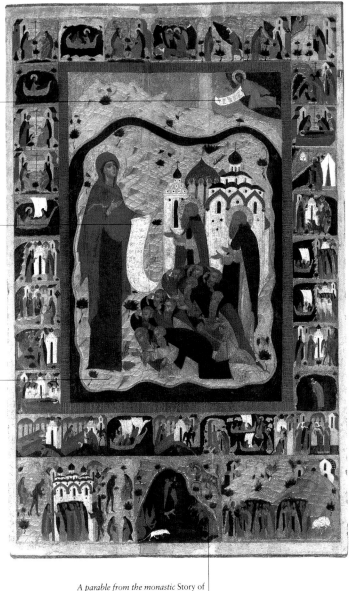

Christ receives the scroll from his mother's hands.

The Virgin of Bogoliubovo appears to Zosimus and Sabbatius, holding a scroll with a plea written on it.

The Solovki Monastery stands on an island surrounded by the waters of the White Sea.

▲ The Virgin of Bogoliubovo with Scenes from the Lives of Saints Zosimus and Sabbatius of Solovki, 1545. Moscow, Kremlin Museums.

A parable from the monastic Story of Barlaam and Joasaph illustrates the vanity of human life: Chased by a unicorn, a symbol of death, a man falls into an abyss, while a white rat gnaws at the roots of the tree from which he hangs.

The outer walls of the monastery are red, while the inner walls are white and hung with numerous icons. Here the Virgin of Bogoliubovo appears to Zosimus and Sabbatius, who are surrounded by praying monks.

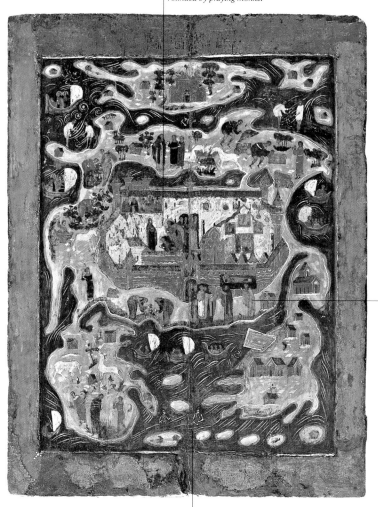

Scenes of everyday life around the monastery: harvesting vegetables, building walls, raising horses, and also carrying a coffin.

▲ *Saints Zosimus and Sabbatius of Solovki with the Mother of God*, originally from the Solovki Monastery, mid-seventeenth century. Moscow, Kolomenskoe Museum.

This icon is a veritable *map* of the Solovetski archipelago. In the waters of the Holy Lake are ships and boats, and even sea-gods.

*The most popular Russian spiritual father (starets) of the nineteenth century, Seraphim possessed the gift of healing and cardiognosis: the ability to "read" hearts.*

# Seraphim of Sarov

**Text**
"Only the pure of heart can see the Lord, who, being made of light, lives inside them and reveals Him to those who love Him and are loved by Him."
(Gregory Palamas)

**Title**
Spiritual father (*starets*)

**Feast days**
Canonization, July 19; feast day, January 2

**Life**
1759–1833, canonized in 1903

**Sources**
Sergius, monk of Sarov, *Life of Seraphim*; N. Motovilov, *The Spiritual Instructions of Saint Seraphim of Sarov*

**Iconography**
Kneeling in his cell wearing a simple white tunic, birch-bark clogs, a wooden cross around his neck and the rosary of the "Jesus Prayer" around his wrist; or standing, wearing the great *schema* and holding the rosary in front of the monastery he had built, with an icon of Mary appearing in the sky

Seraphim of Sarov is a popular saint both in Russia and the West. Ordained to the priesthood in 1793 at the Monastery of Sarov, he left and began a hermit's life at the age of thirty-five, withdrawing into a hut in the forest. In 1804 he was gravely injured by brigands, but miraculously recovered. Returning to his hermitage, he spent three years living as a stylite, atop a small rock, praying for the world, which was being ravaged by the Napoleonic wars. At the age of sixty-six, he became a famous *starets* with the ability to "read" people's hearts (cardiognosis) and heal. The poor and sick flocked to him, as did high dignitaries of state and church. He died on January 2, 1833, kneeling before an icon of Mary, and was canonized in 1903. His relics, scattered during the Russian Revolution, were recently rediscovered and are now in the church of Diveevo,

near Sarov, where Seraphim founded a convent. Seraphim cultivated a tender devotion for the Virgin, "Joy of all Joys," and she appeared to him several times in visions. His sayings, encounters, and mystical experiences were written down by one Nikolai Motovilov, whom he cured of paralysis, and published in 1902.

▶ Gregory Krug, *Saint Seraphim of Sarov*. Montgeron (Paris).

The icon of the Mother of God, who protected the saint, appears in the clouds. He breathed his last while praying before such an icon.

The face is an almost photographic likeness, while the figure is a bit hunched over compared to the traditional icon-painting style.

▲ *Saint Seraphim of Sarov*, early twentieth century. Saint Petersburg, Museum of the History of Religion.

The saint is shown wearing a broad stole and holding a typical monastic rosary of the "Jesus Prayer."

A naturalistic landscape of the river and the Monastery of Saint Seraphim.

Св. Преп Серафим Саровскии Чуд.

# APPENDIXES

*Index of Subjects*
*Glossary*
*Bibliography*

◀ *Praises to the Mother of God with Akathistos* (detail), originally from the Cathedral of the Dormition in the Cyrillo-Belozersk Monastery, mid-sixteenth century. Saint Petersburg, Russian Museum.

# Index of Subjects

**Acheiropoieta**: Greek for "not made by human hands"; i.e., holy images that appeared miraculously, without human intervention.

**Akathistos**: Greek for "not sitting"; a hymn to the Mother of God that is sung while standing on the Saturday of the fifth week of Lent. Attributed to Romanos the Melodist, it is an acrostic of twenty-four stanzas (*oikoi*) corresponding to the twenty-four letters of the Greek alphabet. A twenty-fifth stanza was added in the year 626.

**Amnos**: Greek for "lamb"; the square portion, bearing Christ's carved monogram, cut by the priest from the eucharistic loaf (*prosphora*).

**Analogion**: A lectern or bookstand on which icons are exhibited.

**Anastasis**: Greek for "resurrection"; icon representing Christ's liberating Old Testament figures from the confines of hell.

**Anchorite**: From the Greek *anachorein* ("to withdraw"), it is synonymous with "hermit," which derives from the word *eremos* ("desert" or "solitary place").

**Apophthegmata**: "Sayings": short stories about the deeds and wisdom of the Egyptian Desert Fathers, collected orally and then transcribed into Greek.

**Archistrategos**: Appellation for the archangel Michael, meaning "Supreme General."

**Assist**: Thin strokes of light, gold leaf, or luminous color, radiating from the face, clothing, eyes, or objects in an icon; they indicate saintliness, enlightenment, and deification of the flesh.

**Bema**: Sanctuary (from Greek, meaning "raised step, tribune"); it is the most sacred part of the temple behind the iconostasis, containing the altar.

**Cenobites**: From the Greek *koinos bios*, "common life"; monks living in a communal setting.

**Chiton**: Greek for "tunic"; a simple tunic worn at home, sometimes as an undergarment, adorned by a colored band (*stichos* or clavus).

**Chlamys**: A light cloak worn by Byzantine knights and dignitaries.

**Clavus**: (Greek, *stichos*; Latin, *clavus*) A broad ornamental band on the sleeve of the tunics (chitons) worn by Christ and the apostles.

**Cradle**: The central part of the panel, depressed in the middle, on which an icon is painted.

**Deacon**: An assistant to the priest during the liturgy, dressed in a *sticharion* and *orarion*.

**Deacon's doors**: Side doors of the iconostasis through which the deacons pass during the liturgy.

**Deesis**: Greek for "entreaty"; an icon of Christ enthroned, flanked by the Virgin, John the Baptist, and sometimes other saints.

**Diakonikon**: Small sacristy behind the iconostasis, to the right of the altar.

**Diskos**: The paten on which the eucharistic bread is arranged in small pieces.

**Dodekaorton** (in Russian, *prazdniki*): The twelve great feasts of the Byzantine liturgical year. The *despotikai* (dominical) feasts—that is, the most important ones—are preceded by a day of fasting (*preortia*), have seven days of postfeasting observance (*meteortia*), and one day of rest (*apodosis*).

**Eisodos**: Greek for "entrance"; these are icons of the Presentation of Jesus (or Mary) in the Temple, or the Entry of Christ into Jerusalem.

**Emmanuel**: Christ as a child or beardless youth.

**Epigonation**: An embroidered square vestment that hangs on the right side of the liturgical celebrant, as a mark of authority.

**Epitaphios**: A veil with an embroidered image of the dead Christ; it is carried in procession on Good Friday (*Paraskeve*) and Holy Saturday.

**Eschatology**: That which concerns the final events in history or the ultimate purpose of mankind.

**Greek benediction**: The thumb and ring finger of the right hand touch, leaving the forefinger straight, and thus forming the anagram of Christ's name: IC XC. The two joined fingers also stand for the union of human nature and divine nature in Christ.

**Hegoumenos**: The superior (or abbot) of an Orthodox cenobitic monastery (plural, *hegoumenoi*).

**Hesychasm**: From the Greek *hesychia* ("silence"), a spiritual current emphasizing silence, quiet, and freedom from the passions. Founded by Gregory Palamas in the fourteenth century, it distinguishes the essence of God, which is unknowable, from the divine energy that reveals itself in light; it is characterized by the repetition of the "Jesus Prayer."

**Hetoimasia**: The "prepared throne" on which Christ sits for the Last Judgment.

**Hexameron**: Text recounting the six-day Creation of the World. Several versions exist by different authors, among them Saint Basil.

**Hieromonk**: A "sacred monk," that is, one who has been ordained as a priest.

**Himation**: From Greek, meaning "outer garment," akin to a Roman toga, such as Christ wore over his tunic.

**Hypostasis**: Each of the three manifestations of God as Father, Son, and Holy Spirit.

**IC XC:** The initials of Jesus Christ.

**Icon:** From the Greek word for "image" (*eikon*), a holy image for use in the liturgy or in private devotion.

**Iconoclasm:** From the Greek for "destruction of images," a politico-religious movement within the Byzantine Empire that suppressed the use of holy images between 726 and 842.

**Iconostasis:** Greek for the "place of the icons," it is a screen covered with holy images that separates the *naos* from the *bema*, that is, the nave from the sanctuary, in Orthodox churches.

**Jesus Prayer:** The continuous repetition of the brief prayer "Lord Jesus Christ, Son of God, have mercy on the sinner I am."

**Katholikon:** The main church of a Greek Orthodox monastery.

**Kenosis:** Despoiling, abasement, annihilation, renunciation, and sacrifice, specifically in reference to the icons of the Baptism of Christ, the Crucifixion, and the Descent into Hell.

**Klobuk:** Semispherical head covering with lateral stripes, worn by Russian metropolitans and adorned with crosses and cherubim.

**Kontakion:** A type of liturgical hymn, a sermon in verse.

**Lavra:** From the Greek word for "alley," a road lined by the small cells (*kellia*) of Greek hermit-monks.

**Loros:** A solemn *omophorion* worn by the emperor and often worn in icons by the archangels Michael and Gabriel.

**Mandylion:** From the Arabic word for "towel," a cloth or shroud that bore an impression of Christ's face and was later sent to King Abgar of Edessa, according to legend.

**Maphorion:** Reddish purple outer garment worn by the Mother of God; it symbolizes her regal standing.

**Melismos:** "Fraction"; the act of cutting the eucharistic loaf before Communion.

**Menologion:** A collection of lives of saints, ordered according to the liturgical calendar.

**Miter:** A bishop's hat.

**Myrophorae:** The women bearing the *myron* (scented ointment) for Christ's burial.

**Naos:** The nave of a church.

**Nimbus:** Golden halo around the heads of Christ (nimbus with cross), Mary, and the saints.

**O ΩN:** Trigraph of "I am that I am" (Exodus 2:14) inscribed inside Christ's halo.

**Omophorion:** Long stole adorned with crosses and ending in three lines that stand for the orders of deacon, priest, and bishop; it is worn crossed over the chest and falling over the left arm. It derives from the imperial *loros*.

**Orans, Orant:** Latin for "praying"; a figure standing in an attitude of prayer.

**Orarion:** The long stole worn by the deacon over his left shoulder, on top of the *sticharion*; during prayer, he holds it up with his left hand. Nowadays the *orarion* is white, as is the *sticharion*, but in ancient icons it can also be red or black.

**Pantokrator:** From the Greek *pan* ("all") and *kratos* ("power"), it means "he who rules the universe."

**Paterikon:** Collections of lives of the saints, monks, and Desert Fathers.

**Patibulum:** The horizontal arm of the cross, onto which the condemned man's hands are nailed before he is raised onto the vertical arm (*stipes*).

**Phelonion:** The ancient episcopal liturgical cape, it is short in front and long in back.

**Philokalia:** "Love of Virtue"; a compilation of texts by Orthodox masters, written in the fourth to fifteenth centuries, on the Christian spiritual path.

**Philoxenia:** Greek for "hospitality," especially as concerns that offered by Abraham to the three angel pilgrims in Genesis 18:1–5.

**Podlinniki:** "Authentic texts," these Slavic painter's manuals include models for iconographers.

**Proskynesis:** Greek for "prostration"; the veneration of an icon or the cross with a deep bow.

**Proskynetarion:** Lectern or small shrine in which an icon is placed for worship and devotion.

**Prosphora:** The loaves of bread for consecration in the Eucharist.

**Prothesis:** The preparation of the bread and wine for liturgical service; also the lateral apse to the left of the altar in which this rite takes place.

**Raskolniki:** "Old Believers," a traditionalist Russian sect that did not accept the liturgical reforms instituted by the patriarch Nikon. They split from the Orthodox Church after the Council of Moscow in 1666.

**Rhipidion:** Round metal fan, adorned with a sculpted cherub or seraph, used by deacons in the liturgy.

**Riza** (*basma*): Revetment; a copper or silver sheathing conceived to protect icons and later elaborated with carvings, enamels, and precious stones. It leaves the face and hands of the figures uncovered.

**Rosary:** Made of woven wool or leather, it has two triangular leather pendants with prayers or sacred images carved into them; it is used by monks to recite the Jesus Prayer.

**Sakkos:** A bishop's tunic, derived from imperial tradition. It is open on the sides, fastened with buttons, and takes the place of the ancient *phelonion*.

**Schema:** Greek for "garment," it is a monastic stole (*analabos*) whose front is covered with crosses and inscriptions. The ordinary monk wears the *mikron schema* ("small garment"), while the monk vowed to strict ascetic observance wears the *megalon schema* ("great garment").

**Semantron:** A wooden board or shaft that is hung in a monastery and struck like a bell for the call to prayer.

**Seraphim:** From the Hebrew *saraph*, "to burn"; angelic creatures with six wings of fire.

**Spas:** Russian for "Savior."

**Starets** (*gerontas* in Greek): a spiritual man, enlightened by grace and endowed with discernment, around which a small community of disciples gathers.

**Staurotheke:** Reliquary containing a piece of the True Cross, or an icon containing a metal cross.

**Sticharion:** A simple garment worn by all those who perform a task during the liturgy: cantors, lectors, and those who prepare incense or carry candles.

**Stichos:** A band, usually golden, over the right arm of Christ's tunic; corresponds to the Latin *clavus*.

**Stipes:** The vertical arm of the cross, already planted in the ground, to which the *patibulum*, carried on the condemned man's shoulders, is then added.

**Stole** (*epitrachelion*): A single or two-piece ornamental scarf, sometimes closed by buttons, worn by priests; the bishop's *omophorion* is a more sumptuous version of this.

**Stylite:** An anchorite who, in keeping with his vows, lives on top of a pillar, from which he preaches, heals, and celebrates the Eucharist.

**Suppedaneum:** Latin for "under the feet"; a crosspiece nailed to the *stipes* of the cross, for the condemned man's feet to rest on.

**Synaxarion:** Lives of saints and movable liturgical feasts inserted in the calendar.

**Synaxis:** Assembly of angels and saints.

**Templon:** A partition with pilasters and architraves, separating the nave and sanctuary of an Orthodox church.

**Theophany:** The manifestation of a deity.

**Troparion:** A short liturgical hymn related to the feast of the day.

**Zographos:** Related to the Greek *grapho*, "to write"; an icon painter who "writes" the icons of Christ, Mary, and the saints.

## Epithets of the Virgin

**Besednaia:** "She who converses" or "instructs."

**Blachernitissa:** A Virgin and Child icon from the Church of the Blachernae in Constantinople.

**Bogoliubskaia:** The Virgin who appeared to Andrei Bogoliubskii, Prince of Vladimir and Suzdal.

**Eleousa:** "Of Mercy."

**Episkepis:** "Protectress."

**Galaktotrophusa** (or **Lactans**): "She who nurses" (a child).

**Glykophilousa:** "Of the Sweet Kiss."

**Hagiosoritissa:** Virgin *Orans*, that is, Praying Virgin.

**Hodegetria:** From the Greek *hodegos*, "guide"; it means "She who shows the way."

**Korsunskaia:** The Virgin of Cherson, a type of Virgin *Eleousa* emphasizing the embrace between Mother and Child (with faces close together).

**MP ΘY:** Greek initials for *Meter Theou*, Mother of God.

**Panagia:** "All holy."

**Platytera:** "Vaster than the heavens," because she holds in her womb the Creator of the universe. *Orans* or with the Christ Child.

**Pokrov:** The protecting veil of the Virgin.

**Psychosostria:** "The Soul-Saving One."

**Theotokos:** "She who gave birth to God," the Mother of God (*Meter Theou*).

**Tikhvinskaia:** The Tikhvin Mother of God, an icon attributed to Saint Luke; a hybrid between *Hodegetria* and *Eleousa*.

**Umilenie:** Russian for *Eleousa*.

# Bibliography

Acheimastou-Potamianou, Myrtale, ed.,
    *Holy Image, Holy Space: Icons and
    Frescoes from Greece*. Exh. cat.,
    Walters Art Gallery, Baltimore
    (Athens, 1988).

Acheimastou-Potamianou, Myrtale,
    *Icons of the Byzantine Museum of
    Athens* (Athens, 1998).

Bolshakov, Sergei, ed., *An Icon Painter's
    Notebook: An Anthology of Source
    Materials*, Gregory Melnick, transl.
    and ed. (Torrance, California,
    1995).

Carpenter, Marjorie, trans., *Kontakia of
    Romanos, Byzantine Melodist*. 2
    vols. (Columbus, MO, 1970–73).

Cavarnos, Constantine, *Guide to
    Byzantine Iconography*, 2 vols.
    (Boston, MA, 1993–2001).

Cormack, Robin, *Painting the Soul:
    Icons, Death Masks, and Shrouds*
    (London, 1997).

Elliott, James K., ed., *The Apocryphal
    New Testament: A Collection of
    Apocryphal Christian Literature in
    an English Translation* (Oxford,
    1993).

Evans, Helen C., ed., *Byzantium: Faith
    and Power* (1261–1557). Exh. cat.,
    Metropolitan Museum of Art (New
    York, 2004).

Evans, Helen C., and William M.
    Wixom, eds., *The Glory of
    Byzantium: Art and Culture of the
    Middle Byzantine Era, A.D.
    843–1261*. Exh. cat., Metropolitan
    Museum of Art (New York, 1997).

Evseyeva, Lidiya, et al., *A History of
    Icon Painting* (Moscow and
    Newcastle-under-Lyme, 2005).

Florensky, Pavel, *Iconostasis*, Donald
    Sheehan and Olga Andrejev,
    trans.(Crestwood, NY, 1996).

Galavaris, George, *The Icon in the Life
    of the Church: Doctrine, Liturgy,
    and Devotion* (Leiden, 1981).

Hetherington, Paul, trans. *The "Painter's
    Manual" of Dionysius of Fourna*
    (London, 1974).

Holy Transfiguration Monastery, trans.
    *The Great Horologion or Book of
    Hours* (Boston, MA, 1997).

John of Damascus, *On the Divine
    Images: Three Apologies against
    Those who Attack the Divine
    Images*, David Anderson, trans.
    (Crestwood, NY, 1980).

Kazhdan, Alexander P., et al., eds., *The
    Oxford Dictionary of Byzantium*, 3
    vols. (Oxford, 1991).

Kontoglou, Photes, *Byzantine Sacred
    Art: Selected Writings of the
    Contemporary Icon Painter Fotis
    Kontoglou* (Belmont, MA, 1985).

Laurina, Vera, and Vasily Pushkariov,
    *Novgorod Icons, 12th–17th
    Century* (Leningrad and Oxford,
    1980).

Lazarev, Viktor N., *The Russian Icon:
    From Its Origins to the Sixteenth
    Century* (Collegeville, MN, 1993).

Maguire, Henry, *The Icons of Their
    Bodies: Saints and Their Images in
    Byzantium* (Princeton, NJ, 1996).

Manafis, Konstantinos A., ed., *Sinai:
    Treasures of the Monastery of Saint
    Catherine* (Athens, 1990).

Mother Mary and Kallistos Ware, trans.,
    *The Festal Menaion* (London,
    1977).

——— , trans., *The Lenten Triodion*
    (London, 1984).

Nelson, Robert S., ed., *Sinai: Holy
    Images, Hallowed Ground*. Exh.
    cat., J. Paul Getty Museum (Los
    Angeles, 2006)

Onasch, Konrad, and Annemarie
    Schneider, *Icons: The Fascination
    and the Reality* (New York, 1995).

Ouspensky, Leonid, *Theology of the
    Icon*. 2 vols. (Crestwood, NY,
    1992).

Ouspensky, Leonid, and Vladimir
    Lossky, *The Meaning of Icons*,
    2nd ed., G. E. H. Palmer and
    E. Kadloubovsky, trans.
    (Crestwood, NY 1982).

Sahas, Daniel, ed. and trans., *Icon and
    Logos: Sources in Eighth-Century
    Iconoclasm: An Annotated
    Translation of the Sixth Session of
    the Seventh Ecumenical Council
    (Nicea, 787)* (Toronto, 1986).

Smirnova, Engelina S., *Moscow Icons,
    14th–17th Centuries* (Leningrad
    and Oxford, 1989).

Tarasov, Oleg, *Icon and Devotion:
    Sacred Spaces in Imperial Russia*
    (London, 2002).

Theodore the Studite, *On the Holy
    Icons*, Catherine P. Roth, trans.
    (Crestwood, NY, 1981).

Vassilaki, Maria, ed., *Mother of God:
    Representation of the Virgin in
    Byzantine Art*. Exh. cat., Athens,
    Benaki Museum (Milan, 2000).

Walter, Christopher, *The Warrior Saints
    in Byzantine Art and Tradition*
    (Aldershot and Burlington, VT,
    2003).

Weitzmann, Kurt, *The Icon: Holy
    Images, Sixth to Fourteenth
    Centuries* (New York, 1978).

Weitzmann, Kurt, et al. *The Icon* (New
    York, 1982).